JAPAN 365:
A Drawing-A-Day Project

By J Muzacz

日本 365:
毎日絵を描くプロジェクト

Jミュザックより

Copyright © 2012 J Muzacz
First Edition

Published by J. Muzacz
P.O. Box 206 Naalehu, HI 96772 USA

Library of Congress Control Number: 2012900550
International Standard Book Number (ISBN): 978-0-9853127-0-1

Printed on Earth (probably in the USA) using paper made from trees.
Designed by Christina Tran

www.jmuzacz.com
GIVE MORE | NEED LESS

For two fallen brothers,
Jacob Payne and Stanley White

And dedicated to all the victims of
the Great East Japan Earthquake and Tsunami

今は亡き親友、
ジェイコブ・ペインとスタンリー・ホワイト

そして、東日本大震災と津波で犠牲になった人々へ捧げる。

Sometimes Mother Nature's mysterious cruelty can't be helped... But no one need suffer the horrors of a man-made war.

時に母なる自然は不条理にも残酷で、その前に人は立ち尽くす。
しかし、人間が作った戦争の恐怖には、誰も苦しむ必要はない。

目次

TABLE OF CONTENTS

FOREWORD

I first met J sometime in February of 2011. That day, I was going to Hyogo Prefecture to meet BARNES, a graffiti artist just in from South Korea. While we were painting together with friends, he told me another friend of his was coming, so we went to the nearby station to pick him up. As it turned out, that friend was J.

After that, we all went to paint together. I had never heard of J or seen any of his work but now I can remember it all clearly...

With a super fine spray, he painted an incredibly realistic baby and mama frog whose tongue wrapped around my piece. Even though it was just a short time, I remember that we were able to make some wonderful art together.

Up until that point, I had not met many artists that could paint with the fine detail that J could and it left quite the impression. After painting, all us artists went to get some food and that's when I first heard about J's 365 drawing project. As I learned more about his art and what he was doing, I felt inspired by his lifestyle and way of thinking.

From the first time I did art as a child, I've naturally come into this lifestyle these last 5 or 6 years. From when I skateboarded back in the day, I was exposed to street culture and when I saw graffiti, I immediately thought, "This is it!"

Though in Japan, graffiti is thought of as just scribbles on the wall, I think it can rival fine art. From time to time, I get worried over whether graffiti is actually good or bad, but there's no doubting it's become an indispensable part of my life. The reason I do graffiti is because I simply like art. But more than that, I personally have traveled to about 10 different countries up to this point. From those experiences, only through art, even someone like me who is not terribly good at English could become friends with the local people; we paint together and through that we can share each other's culture, language, and lifestyles. Nowadays, I'm really happy I'm an artist. And along with that, it's also all thanks to doing art that I got the chance to meet J.

It's only been about 1 year since I met J, but in that time, J's 365 days of drawing project has become a reality. To draw 365 pictures from 365 different themes and ideas is something that I think is truly difficult. Also, all of J's drawings have a Japanese theme; he drew a lot of what he saw here in Japan. I am a native Japanese man and J, coming from America because he likes Japanese culture is still an American; so our viewpoints and expressions are terribly different from each other I think. But if you look at J's work, more than just Japanese people can understand the Japanese expressions because his pictures exude his essential nature, his warmth and his big heart. Moreover, in his usual determined style, the entire work is drawn from one single ballpoint pen.

There're lots of artists all over the world, but J's style of art can be done anywhere, anytime with just a ball-point pen. It's a difficult expression in Japanese, but I think that's pretty cool. In Japan, compared with other countries, it seems there are very few people doing art—especially street art—but from now I think it will expand and become essential. When I think about that kind of future, I think that J's 365 drawing project will become a vital driving force towards that. I believe that J must hope for that as well.

Everyone, please enjoy J's one-day-one-picture 365 days drawing collection. Also to J, "Congratulations! KEEP UP THE ART!!"

MAYZE

僕とこが出会ったのは、2011年の2月頃でした。

その日韓国からちょうどBARNES（バーンズ）というグラフィティライターが、日本に来ていて彼に会うために兵庫県まで行って、友達と一緒にペイントしていると BARNES が「友達が来る」と言って彼の友達を近くの駅まで迎えに行ったとき、出会ったのが こ でした。その後みんなで一緒にペイントをしました。

それまで こ の存在も絵も見たことなかったけど、今でもはっきりと覚えています。

すごい繊細なスプレータッチで親子のカエルをすぐにリアルに書いて、僕の絵にカエルの舌を絡ませてきたのを覚えています。短い時間だったけど、すごく印象に残っています。ペイントのあとアーティストみんなで食事をして、とても良い作品が書けたのを覚えています。

僕が今まで出会ったアーティストであまりこのようなタッチや絵を書いている人は少なかったので、すごく印象に残っています。ペイントのあとアーティストみんなで食事をして、「これだ！！」って思ったのが、グラフィティでした。

しかしグラフィティは日本ではただの落書きって思われがちですけど、僕は立派なアートだと思っています。けどたまに善悪の問題に対して悩む時もありますが、今では自分の生活の中で欠かせない存在になっています。

グラフィティをやっている理由はただアートが好きと言うのもありますが、僕自身、旅行が好きでこれまで10カ国ほど旅をしました。その経験の中でもアートさえ書ければ、英語が得意ではない僕でも現地の人とすぐ友達になれ

僕がアートを初めたのは子供の時からで、自然に生活の中に入ってきたのはここ5〜6年で、きっかけはスケートボードを昔にやっていてそこからストリートのカルチャーを知り「これだ！」って思ったのが、グラフィティでした。

しかしグラフィティは日本ではただの落書きって思われがちですけど、僕は立派なアートだと思っています。けどたまに善悪の問題に対して悩む時もありますが、今では自分の生活の中で欠かせない存在になっています。

一緒にペイントしたりそれぞれの文化や言葉や生活が交換できます。今では本当にアートをしていて良かったこと、そして今こうしてこと繋がっているのもすべてアートのお陰だと思っています。

こ と出会ってまだ1年ほどですが、この出会った期間で こ は365日ドローイングと言うプロジェクトを実行していました。ただ365日ドローイングをするということは365個のアイデアやテーマそして行動は本当に難しいことだと思う。それに このほとんどの絵は日本がテーマになっていて、こ が見た日本がすごく描かれています。日本人である僕が日本を見ているのと日本の文化が好きでアメリカから来ているのと日本に対する見かたや表現は大変違ったものだと思います。この作品を見れば、日本人以上に日本の表現をうまくとらえていて こ 本来の心の温かさや広さがすごくにじみ出ています。

そして この こだわりのスタイルの1つがボールペン1本で描いているということです。世界中にはたくさんのアーティストがいると思いますが、このスタイルはどこでも絵を書くことができ、日々の生活で、もっとも親しみのあるボールペンを使っています。日本語での表現では難しいですが本当にかっこいいと思います。日本では他の国に比べるとアートをやっている人はほんのわずかですが、これからもっとアートは広がっていくと思ういし、必要となっていくと僕は思います。そのような未来を考えるとこの365日ドローイングは、かかせない原動力と大切な1冊になると思います。そして、こもそう願っているでしょう。

是非、みなさんも1日1枚、365日のこの絵を堪能して下さい。これからも…"KEEP UP ART!"

そして本当におめでとう。

MAYZE

DISCLAIMER

To read this book means to get an unbiased visual glimpse into Japan.

As with any artwork though, there remains a piece of the artist as creator; be it emotion, a little ephemeral soul power (theoretically), a drop of sweat (literally) or blood (figuratively), the occasional tear (so what?) However, I set out not with any particular mission to sway viewers this way or that, or to convince viewers that cows are cuter living and deer are actually obstinate and ravenous clothes eaters. Just hey, here is Japan. Here is Japanese something. Whether language, culture, landscape, history, fashion, animal, vegetable, mineral, something rare, cool, weird, fantastic, disgusting, ancient, old and wise, modern, young and silly-- the only pre-requisite is that it be something Japan.

Completing the task required concentration, dedication, exploration, an open mind and a little talent. (Note that talent comes last among the aforementioned.) There was no mysterious greatness latent within me necessary to complete a 365 project like this. With just the spark of an idea and that ever-pervasive buzzword perseverance, I believe anyone can become a champion of something365, if they so choose.

For me personally, regarding my life and work as an artist, the reasons for sticking to ball pen and paper remain. To find freedom in simplicity, to stay attentive and focused daily as in creative meditation, to see the faintest shadow or highlight and smallest detail, to cultivate a basic skill and attempt to master a medium that is perfect for lightweight long-term travel (bike touring and backpacking) because it's so portable and readily accessible; and philosophically then, there exists a tangible reason to wake up and learn something new everyday. I have yet to become that professional "fine" artist who shells out big bucks for top-of-the-line canvas, brushes and oil paint. Rather, I enjoy making do with what I can scrounge and salvage, or better yet-- what I already have. If it turns out that that is a pen and paper, forcing me back to the most basic of design elements—a single line—so be it. No color, no technology, no shortcuts, no tricks.

Regarding the text, as yet there are many errors both in my English explanations, and surely in my talented translator's best attempts to capture the essence of the ridiculous wordplay I wrote as captions for some of the drawings. Perhaps it is better to let the artwork speak for itself sometimes. But, if you like back stories and learning interesting tidbits of history and culture, then your trivial side will thus be fulfilled through reading along as well.

I apologize to anyone offended or misrepresented in the following pages. Every attempt was made to edit content and draw things suitable for all ages, while giving credit where credit was due. (As such, I decided not to reference Hokusai's graphic depiction of an octopus taking advantage of that young woman.) And, as with every project of mine—perhaps other perfectionist artists can also attest—I find that it is never completely finished and most certainly remains far from perfect; so at some point I just had to call it quits.

If you have comments, questions, suggestions or critiques about any of the content please feel free to contact me. I appreciate your attention to detail and creative criticisms, and will make sure to the best of my ability that future editions are thus corrected thanks to your valuable insights.

So now, read on and enjoy the work! Think about the time and place depicted. Reflect on the people as old friends. Remember aspects of your own culture that might somehow relate and renew your childlike curiosity in the totally new and unknown, too. All the drawings and this book were definitely fun and challenging to draw and publish. I only hope it is equally as fun, educational, eye-opening and satisfying a reading experience for you.

Peace,
J Muzacz

自己紹介

この本を読むと日本を視覚的に、偏見なく、奥深くちらりとのぞきこむことができる。

どのアート作品にも言えることだが、そこには物を生み出す者としてアーティストの片鱗が残る。それが、感情であることもあるし、魂の一部であることもあるし、汗や血のしずくのこともある。(文字通り!)そして時には、涙のことも…

けれども、ぼくは決して読者をあるイデオロギーに染めようとか、夕食のテーブルに乗っている死んだ牛より緑の牧草の上を転げまわっている牛のほうがずっと可愛いじゃないかということを誰かに説得しようとしているわけではない。(そして、のちには、トイレにながされるんだけど)共通項は、これ、日本だよ!日本の何かがここにあるよ。ということだけなんだ。

それが、言葉だったり文化だったり歴史だったりファッションだったりする。めずらしくてかっこよくて変で素晴らしくて古くて新しくて自然で、なんかには気持ち悪いものもある。たった一つの条件は、日本に関係するものといことだけだ。

365日のアートは自分に課した忍耐力の追求で、ボールペンで絵を描くという個人的な創造活動だ。都会のコンクリートジャングルの巨大な壁が僕にスプレイでペイントしてくれよと迫ってこない海沿いの小さな漁村。

僕の毎日絵を描くというプロジェクトは最初、友達や近所の人、ネット上でこの人からほんの少し褒められて励まされるだけのものでよかったんだけど、スケッチのコレクションが僕んちの棚の上でほこりをかぶっているだけ、という存在でなくなってきた。こうしてついにはただ単に、スケッチのコレクションが僕んちの棚の上でほこりをかぶっているだけ、という存在でなくなってきた。この課題をやり遂げるにあたり、何もぼくには隠された不思議な特別の能力があるわけではない。(才能はそれらの中では、最も必要とされないことに注目!)このプロジェクトを完了するにあたり、何かを365日続けるチャンピオンになれるだろう。

僕は、今までの自分自身をアーティストだと自負している。僕がボールペンと紙だけを使うことにこだわったわけは、単純なものだ。そして:毎日を創造的な瞑想ととらえ、シンプルなものの中に自由を見つけるためだ。そして、ほんのわずかな影やハイライトや詳細をよく見るために、そして、基礎的な技術を磨くために、そして自転車でリュックを背負って丁寧に生きるために、

ての長旅にぴったりの軽量の媒体を極めようと試みて。朝起きる理由を持つことと、そして毎日何か新しいことを学ぶために。僕はトップクラスのキャンバスや絵筆や油絵具に大金を払うアーティストであったことはない。

僕の英語の説明に大きな間違いがあるかもしれないし僕の優秀な翻訳者達が、絵の説明として僕が書いたおかしな言葉遊びを翻訳しようとしてがんばってくれたんだけど、その中にもミスはたくさんあるかもしれない。ときには、アートはアート自身に喋らせることにしよう。しかし、もし絵の歴史的、文化的背景のほんのひとくちを味わってくれたら、きっとあなたの知的好奇心も満足されることだろう。

僕が書いたことにでもし誰かの気持ちを害するようなことがあったり、間違ったことを描いてしまっていたら、心からお詫びします。描く物事を正当に評価しようとして、内容を重視していろんな人の年齢に合うものを描こうとした。(例えば、北斎の絵で蛸が女性にいやらしいことをしているところを描いたりしたが、絶対にこれで完成!なんてないし、僕のすることすべてに完璧という言葉とだが、絶対にこれで完成!なんてないし、最も確かなことは、ある地点で、これで終了!にしてしまわなければいけなかった。というわけで、これで終了!

ご意見ご感想ご質問があれば、どうかご遠慮なく僕に連絡してください。建設的な批評をしてくださったことに感謝するとともに、将来出版する本では、その貴重で深い洞察に基づくことに感謝するとともに、将来出版する本では、その貴重で深い洞察に基づくアドバイスを生かし最善を尽くしてミスを訂正することをお約束いたします。

では、楽しんで読んでください。描かれている人たちを昔からの友人だと思ってみてください。描かれた時と場所を思い浮かべてみてください。新しくて知らないものに対する、子供のようなきらきらした好奇心をもう一度味わってみてください。本を出版することは僕にとって本当に楽しくて、新しい発これらすべての絵を探してみてください。この本があなたにとっても、楽しくて、新しい発見のある満足できる経験になることを願って止みません。

平和の気持ちをこめて、

Jミュザック

ix

ACKNOWLEDGEMENTS

To everyone who supported this JAPAN 365: Drawing-A-Day project financially by way of donating to claim a postcard or book perk, your trust in my artistic endurance and faith in my ability to continually produce quality drawings daily is what propelled me through the most difficult days. My humble appreciation, a full ninety-degree bow and enormous thanks go to (in no particular order):

このJAPAN365を支援してくださったすべての人達へ、一日一枚プロジェクトを、絵ハガキや本を買うことによって経済的に支えてくれて感謝しています。毎日クオリティの高い絵を描き続けるという僕の芸術における忍耐力と能力を信じてくれて、ありがとう。皆さんの信頼は僕が一番苦しい時に勇気づけてくれました。僕の心からの感謝を９０度のおじぎとともにここに述べたいと思います。（順不同）

Laura Ornelas,
Minori Ogawa,
Lindsey,
Denise Driver,
JoAnna Chin,
Mariel Reyes,
Jessie Steinberg,
Coleman Riedesel,
Julien Turcotte,
Cindy Phung,
BE Photography,
Micah Steffenson,
Christina Tran,
Ciane Brewster,
Marcus Bowers,
Daniele Prati,

Ruby Ku,
Christie Zangrilli,
Mark Henry,
Hazel Cruzado,
Christina Vattathil,
Shogo Horiuchi,
Astrid Boutry,
Flourent Grouazel,
Ian Schranz,
Steve Slack,
Kate Guillemette,
Leanne Valenti,
Joyce Shek,
Romeo Bruni & Family,
Karina MacDonald,
Katrin Ahnert,
Norinaka J Matsuya,
Robert Lam,
Harold Sears,
Elizabeth Donohoe,
Katie Benedict,
Jordan Kramsky,
Melissa Hunt,
Doran Bostwick,
Veronica Meewes,
Kelsey Hinkel,
Marc Greyvenstein,
Robyn Elliott,
Adam Wright,
Lee Hampson,
Nicola Gell,
Aralyn Hughes,
Ashley Marshall,

Melissa Milford,
The Reynero Family (Mike, Yoli, Dez & Kalob),
Penny Cameron,
Lorenzo Orselli,
Assumpta Power,
Elaine Oblath,
Sarah Dyer,
Kenneth Soares Jr.,
Killian Power,
Desmond Pagen,
Amadeus Moisl,
Jake Wright,
Park Wonmi a.k.a. Winnie,
Emily Koller,
Vicky Quilty,
Coleman Riedesel,
Tiffany Moreno,
Sue Stenton,
Clodagh Power,
Katelyn Nguyen,
Liz Thomas,
James Hart,
Jennifer Krafft,
Meredith Wheelock,
Kiki and Takeshi Yoshida,
Jessica Roberts,
Sanka Jayasuriya,
Kyle & Sandi Lowder,
Yosefina Kim, and
Michael Dixon.

Special thanks go also to the Donors who invested in a signed copy of the Limited Edition Hardcover:

サイン入りの限定ハードカバーを購入してくださった人々へ特に感謝の意をこめて:

Jeannie Wu,
Alexandra Almaguer,
Betty Clark,
Warren Lam,
Melissa & Jeff Purser,
Yuki Takata,
Amanda Burdin,
Paul Henry,
Matthew Little,
Cary Fujikawa,
Romeo Bruni,
David Foster,
Jeff Matsuya,
Arien Muzacz,
Sindi Gaxiola Tran,
Colin Moon,
Timothy Wilkinson, and
Alex Maciulaitis.

Thanks to the generous Art Lover Benefactors who claimed Original Drawings:

原画を購入してくださった芸術を愛する人々へ感謝の意をこめて:

The Chou-Esteban Family,
the Esteban-Pretel Family,
Millie May for Ernie & Family in Aomori, and
Tony Vu.

And to the lone Patron of JAPAN 365, grabbing custom artwork and putting his picture in the pages that follow:

特別注文の絵を本に掲載するようオーダーしてJAPAN365をご支援くださった方へ感謝の気持ちを込めて

G. Andrew Grzymala!

どうもありがとうございます！おおきに！

Of course, to those who could not support financially but instead spread the word to friends or family, took a look, posted a comment, shared a link, sent a postcard, talked to someone about this cool picture some guy drew of Japan; many thanks go to you, too.

The production of this book was a miraculous feat in-and-of-itself in that I am far from fluent in Japanese and yet JAPAN 365 provides readers with a fully bilingual experience, rightfully allowing Japanese speakers equal access to content drawn in their backyard. This was made possible purely through the gracious translation work and tedious copy editing-- all the endless hours of it-- by Sammi Hawkins, Yukari Kusuda, Minori Ogawa, Yuki Takata, Jennifer Krafft, Matthew Farrell, Mario Acito, Hiroko Hirono, Betty Clark, Hideki Kaku and Tetsushi Takeuchi. It takes a tight team to translate and edit 365+ pages of titles, names, captions, history, poetry, babbling, explanations, and the list goes on…

It also takes a genius designer to turn nearly 400 pages of pen scribbles into a published product as aesthetically pleasing as what you now hold in your hands. Christina Tran (sodelightful.com) took it upon herself to lead production (with extraordinary organizational experience) AND design every single page with immaculate precision. She is not only caring when it comes to balance and bleeds; she is professional and insightful, too, often pulling layout stunts I never even dreamed possible. She makes total digital sense out of the complete mess I made with a stack of sketchbooks and handful of pens. For that, I am forever indebted.

On all twenty-five chapter's intro page you will notice an authentic Japanese kanji calligraphy title. These are all original works produced specifically for this book, brushed in the traditional style by Kiyomi Yamashina. Shodo—the Way of artistic writing (kanji character calligraphy)—is an involved art form that takes years of practice to perfect; and extreme focus, concentration, a calm mind, great posture and a soft, artful touch to do well. Yamashina-san does it very well, and because of her ink-dipped expertise the chapter intros are that much better.

Last but not least, I am grateful to my colleagues, students, friends and acquaintances in Japan, my patient and supportive partner-in-crime Yuki, friends online around the world and my friends and family holding it down back home in Texas, New York and Hawai'i. Without your support, bright ideas, honest criticism, tears, laughs and love, I would be nothing; certainly lacking meaning and nowhere near the contentment and productive state that allowed me to focus on a major endeavor like the Drawing-A-Day project and this book, anyway.

Please keep teaching me, and hold me to keep teaching you. After all, we rub elbows with people in this short life for good reason. So let's continue cultivating things beautiful or useful with our interactions. Rephrasing the wise words of rapper Biggie Smalls (Rest In Peace)—"Stay positive and love the life you live!"—Perhaps the only good advice I am qualified to give. Everything else ought to fall right into place.

Hopefully this final product is at least partly worthy of all your undeserved kindness.

Doumo Arigatou. Ookini. Thank you.

もちろん、経済的には支援できなかったけれども、口コミで友達や家族に紹介してくれた人々、見てくれてコメントを書いてくれた人々、絵ハガキを送ってくれた人々、日本を描いたクールな絵について誰かに話してくれた人々、どうもありがとう！

　この本を作るにあたり、読者がニカ国語で読めるように日本語と英語で書いた。これによって、日本の人達も自分の国について描かれたものが目にできるようにと思った。僕の日本語が流暢であるってことからまったく程遠いのに、このような素晴らしいことができたのは、翻訳と編集を忍耐強く何時間もしてくれた人達のおかげによるものだ。Sammi Hawkins（サミー　ホーキンス）、楠田ゆかり（Yukari Kusuda）、小川美農里（Minori Ogawa）, 高田優希（Takata Yuki）、廣野弘子（Hirono Hiroko）、Jennifer Krafft, Matthew Farrell, Mario Acito, Betty Clark, Hideki Kaku and Tetsushi Takeuchi.

　みんなが力を合わせて協力して、365ページ以上もの題名と名前と紹介の文章と歴史と詩と、僕のたわいもないおしゃべりと、背景を説明した文などを翻訳して編集してくれた。

　そして、ペンで描いただけの４００ページの紙を、今手に持っているように洗練された美しい出版物にするには天才的なデザイナーが必要だ。さまざまな組織で豊かな経験を積んだクリスティーナトゥラン（sodelightful.com）がその仕事を引き受けてくれ、ミスーつない完全な正確さですべてのページをデザインした。バランスや印刷の裁ち切りのことだけ気にかけているわけではなく、彼女はプロフェッショナルで洞察力に満ちている。僕が考えもしなかったレイアウトをしょっちゅう見せてくれたし、僕がこしらえた山積みのスケッチブックやペンをうまく完全にデジタル化してくれた。そのことで僕は一生クリスティーナに恩を感じることだろう。

　２５章すべての序論のページで本格的な漢字の書を目にするだろう。山科紀代美が伝統的に書道の筆でこの本のために特別に書いてくれたものである。書道とは芸術的に文字を書くことで、熟練するには何年もの練習を必要とする。張りつめた集中力と穏やかな心、正しい姿勢、そして優しくて芸術的な筆運びを必要とする。山科さんは、大変書道が上手で、墨で書かれた彼女の本格的な書は序論をより良いものにしてくれた。

　最後になりましたが、僕が一番言いたいことです。日本での僕の職場である学校の先生方、僕の生徒達、友達、知りあった人達、皆に感謝しています。我慢強くていつも支えてくれる共犯者の優希、世界中に広がった僕のネット友達、そしてテキサス、ニューヨーク、ハワイにいる家族と古くからの友人に感謝の気持ちを捧げます。皆さんの支え、素晴らしいアイデア、正直な批評、涙、笑い、愛がなければ、今の僕は、存在しません。少なくとも、このドローイングアデイ（一日一枚）プロジェクトのような大きな試みをやってみようという建設的で満ち足りた精神状態にはなってないと思います。

　どうかこれからも僕にいろいろと教えて下さい。僕も何か教えることがあるかもしれません。結局、私達は短い人生の中でよいことのために、縁を結ぶのです。だから、ふれあいの中で、美しいもの、役に立つものを育んでいこう。今は亡きラッパー、ビギースモールの座右の銘を引用します。「ポジティブでいろ。自分の生きる人生を愛せよ。」僕が贈ることのできる唯一のアドバイスかもしれません。そうすれば、他のすべてのことは自然とうまくいくばずです。

　願わくば、この本があなた方が僕に与えてくれた溢れるほどの優しさに少しでも応えるものでありますように。

どうもありがとう。
おおきに。サンキュウ。

"I realized that I had this once-in-a-lifetime opportunity to depict Japan from within and with fresh foreign eyes and attitude of a westerner born and raised in America."

INTRODUCTION

365枚の絵を毎日描きました。まったく普通の、どこにでもあるボールペンを使って。

日本にインスピレーションを与えられ、僕は日本の絵を、2011年兎年の一月一日に描き始めた。そして、毎日12月31日まで描き続けた。僕は間人（たいざ）という小さな漁村に住んで、間人は京都府をずっと北へ行けるところまでたどり着く町だ。日本海に囲まれる丹後半島の北東部の海岸に面した町だ。

2010年の秋の日だった。その時、急にひらめいた。自転車で山の中を走っていて迷ってしまったんだ。僕が好むと好まざるにとに関わらず、日本を内側から描こう、とその時決めたんだ。僕はこのチャンスを人生で一度きりだと思っているんだけど、日本を人生で一度きりだと思っているんだけど、アメリカで生まれ育った西洋人としての目と感覚で、日本を描こう、と決めたんだ。

毎日の生活や、旅行、写真や僕の空想をもとに、大抵は絵をできるだけ具体的なものにした。その絵がなんだかわかるために、もっとわかるように。この写実主義が多くの人に受け入れられて普遍的に理解されますように。常に、開かれた心で描こうとしたから、僕の題材の選択（思いつきで決める）以外は、何の偏見もないと信じたい。テーマはいつも芸術的なものとかエキサイティングとかいうわけではないんだけれど、文化的なものとか、歴史的に重要なものとか、いろんな種類のテーマを盛り込んでみた。

僕の絵は記念写真よりはインパクトがあると思う。一つ一つのペン先に芸術的な感情と感性をこめたから。遠近法をとり入れ、バランスのとり方やコントラスト、細部を詳しく描くことでそれぞれのこの特徴をだした。そして視覚的に必要なところには特に入念に注意を払い仕上げた。

それから3月11日が来た。世界中は恐ろしい新聞記事を、テレビやネットで映し出される光景を、見つめた。未曾有の災害で日本という国は永遠に変わってしまった。空前のマグネチュード9．0の地震が東北の海岸沖で起こり、そして巨大な津波が街を飲み込んで数えきれない悲劇をうみだしてしまった。日本は世界で有数の先進国でしかも地震や災害にはこの上ない備えをしていたにも関わらず、最大20メートルもの波は海岸を舐めつくし瓦礫を掻きまわし悪魔の黒い水は家の中になだれ込んだ。車、バス、飛行機をひっくり返し、人々はより高いところを求めて逃げまどい、水の中を命をかけて泳ぎ、そして早すぎる死を迎えた。

そのあと、僕は後世の人々のために日本の生活や歴史を記録する責任があるような気がした。海沿いの小さな村の田舎の生活を直接目にする機会がない人々に見せるために、または、発展しつつある自分達の都市がいつ怒り狂った海に飲み込まれるかもしれないから。JAPAN365は、この不思議で多様な面をもつ国の美しくも趣き深い、人々の顔や場所を僕なりに描こうとしたものだ。

僕が日本についての本を読んだり、調べたり、日本人の同僚や友達に聞いたりして、より深く学んでいくにつれ、僕のこの個人的なこの企画は僕の手を離れだんだん独りで歩きだしていった。一つの作品を描き上げるのに一日に3時間づつ集中して何日間か、かかることもあり、描いた当人の僕でさえすごいなと思って眺めたりした。

僕は10年近くもの間グラフィティと壁画アートをやってきたんだ。大きくてすてばやく描いた。そして時には完璧に法に順守しているというわけでもないアートも手掛けた。これらの経験からぼくは、自分の精神状態がどうであれ、周りの環境がどうであれ、どんな邪魔が入ろうとも、とにかく集中して早く描き上げることを体得した。とりあえず、仕事を終わらせることってことだ。そして、本当にあらゆる場所で絵が描かれたってことだ。時には暗闇の中で、描いた。

本当にあらゆる場所で絵が描かれたってことを歌った歌を紹介しよう。マナティーマンのヒットシングル、JAPAN365だ。

「ボートで、バスで、車で、電車で、太陽の下で、ビーチで、ベンチで、雨の中で、川の側で、テントの中で、朝に、夜に、神社で、お寺で、庭の中で、ああ、そうだとも。」

(http://soundcloud.com/manateemann/japan-365 で聞いてみてください。)

最後に、僕の作品を本にして出版する理由は理論上雪だるまのように増えていった。時を閉じ込めた日本の素晴らしい美と不思議を僕なりにわかろうとした。それを多くの人と、分かち合いたい。僕の作品を通して文化の交流を促進しようと思う。そして、日本の豊かな歴史の、独特な、それでいて普遍的な側面に興味を持つ人々に僕が日本について何か教えたくなったら、これから新しく日本にやってくる人々に僕が日本について何か教えたくなったら、この蓄積された膨大な数の絵を使えるという特権を存分に味わおうとしよう。

端書き

Three-hundred-and-sixty-five pictures penned with an ordinary, everyday, borrowed-from-the-office ballpoint. One image of or inspired by Japan for every day of the Year of the Rabbit 2011, beginning on the first of January and sketching through the last hours of the thirty-first of December.

The epiphany hit me while lost on a mountainside bike ride in autumn of 2010. I realized that I had this once-in-a-lifetime opportunity to depict Japan from within and with fresh foreign eyes and attitude of a westerner born and raised in America. So, while home-based in a traditional fishing village called Taiza on the northeastern coast of the Tango Peninsula, nestled between cloud-cloaked mountains on the Sea of Japan as far north inaka (rural) Kyoto Prefecture as you can go; JAPAN 365: Drawing-A-Day was born.

Deriving subject material from my local life immersed in a small, time-tested Japanese community, travels around Japan, friend's photos, the news, my imagination, I focused primarily on concrete images so you don't have to hold some pretentious art school critic credentials to understand what you are looking at. Hopefully this literal realism keeps my work accessible to a wide audience and tells a universal story. Always drawing with an open mind, I don't believe any great bias exists other than that of my somewhat random selection of subject matter, though that too was gradually intended to cover a wide variety of themes, not always altogether artistic or exciting, but culturally or historically significant nonetheless.

Why attempt such a project for 365 days? The reasons started few and simple. Yet as the course of any year entails, surprises, downfalls, comedies, tragedies, struggles and strength all coalesce into an amalgam of experience, constantly redefining the individual self and its environment. Whereas JAPAN 365 started as a personal quest of artistic endurance, pushing the creative enve-lope even on days perhaps uninspired, tired, or any other plethora of excuses to be had, it grew from there and developed a life of its own. Sharing drawings online with friends and receiving positive responses like, "You should host an art show!" or "make a book!" enough times for me to actually believe them planted the ink-scented seeds which would eventually grow into this book.

Then, on March 11, as the world read horrifying headlines and watched images of devastation splashed on TV and computer screens, Japan was forever changed by the strongest earthly tumult in the country's recorded history. An unprecedented 9.0 magnitude earthquake off the Tohoku coast caused numerous aftershocks and, most dev-astatingly, a massive tsunami. With as much disaster preparedness as humanly possible in one of the world's most developed nations, Japan was still caught off guard by the unbe-lievable 20-meter-tall waves crashing along the coast and sweeping debris and deathly black water into homes, tossing cars, buses, planes, and forcing people to higher ground, to swim for their lives; or worse, prematurely into the next life.

After that, I felt a responsibility to con-tinue recording a people's history for future generations; to share it with those people who may not ever get to witness the rural life of a small seaside village first-hand, and with those whose great and thriving cities may one day be swept away by the rising, angry seas. JAPAN 365 became my humble hand-drawn snippet in time of this mysterious and diverse country's most beautiful or intriguing faces and places.

And referring to the myriad locations where pictures were drawn, here is the hook from the hip-hop track "JAPAN 365" by Manateeman:

*"On a boat, on a bus, in a car, on a
train, in the sun, on a beach, on a
bench, in the rain, by a river, in a
garden, in the morning, late at night,
at a shrine, in a temple, in a tent--
that's right."*

(Hear it at http://soundcloud.com/manatee-mann/japan-365)

As I learned more through reading, re-search and talking with Japanese colleagues and friends, the personal drawing project began flowing through me. There were days when three hours at the sketchbook helm produced a work even I was astounded to sit back and see. Much more powerful than a still snapshot or digital photograph, each pen stroke of every drawing is laden with artistic emotion and sensibility, accenting perspective, balance, contrast, details; and elaborating for emphasis where desired for enhanced visual appeal.

Here, I must pay homage to almost 10 years creating large-scale works as a self-taught graffiti and mural artist. For it is that style of huge and quick, outside in the elements, sometimes in the dark and sometimes not altogether "legal" painting experience which trained me to work fast and stay focused, no matter my mental state, situational distractions or otherwise obstructive environment. Regardless of freez-ing rainfall or searing sunburn - get the job DONE (amazingly enough, almost always in one painting session!)

At last, the reasons for publishing this collection in book form theoretically snowballed. To share my humble interpreta-tions of the splendid beauty and mystery of a truly timeless Japan; to promote cultural exchange through images which transcend language barriers; to incite and inspire future curiosity about many unique yet universal aspects of Japan's rich history. My work essentially evolved into a responsibility to record folk history. Now, I find myself with the great privilege of using this amassed collection of drawings to teach others about Japan, hopefully for many years to come.

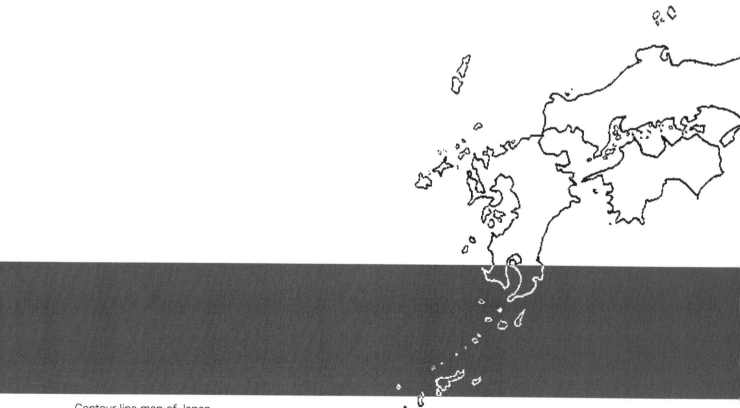

Contour-line map of Japan
日本の地図

LANDSCAPE 景色

Sesshu's forthcoming winter. Depicted in the sumi-e (traditional ink brush) style by Sesshu Toyo, a Japanese Suiboku-ga (one-color) painter and zen (experiential wisdom) priest of the Muromachi era (1336-1573). Praised as a master painter for having completely revolutionized the suiboku-ga style.

雪舟等楊、雪舟の水墨画、室町時代(1336年～1573年)の水墨画家で禅宗の僧　雪舟等楊によって描かれた。水墨画の様式を大きく作り変えたことで、日本を代表する画家として名を広めた。

Jagged coastal rock formation. Rocks now sticking up at a 45-degree angle that used to be flat land or seabed. Mother nature had a little indigestion. Kashima-cho, Matsue City, Shimane Prefecture. Photo: James Hart

海岸の荒々しい岩、海面から45度に突き出ている岩。母なる自然が作り出した自然の彫刻。松江市　島根県
写真：ジェイムズ・ハート

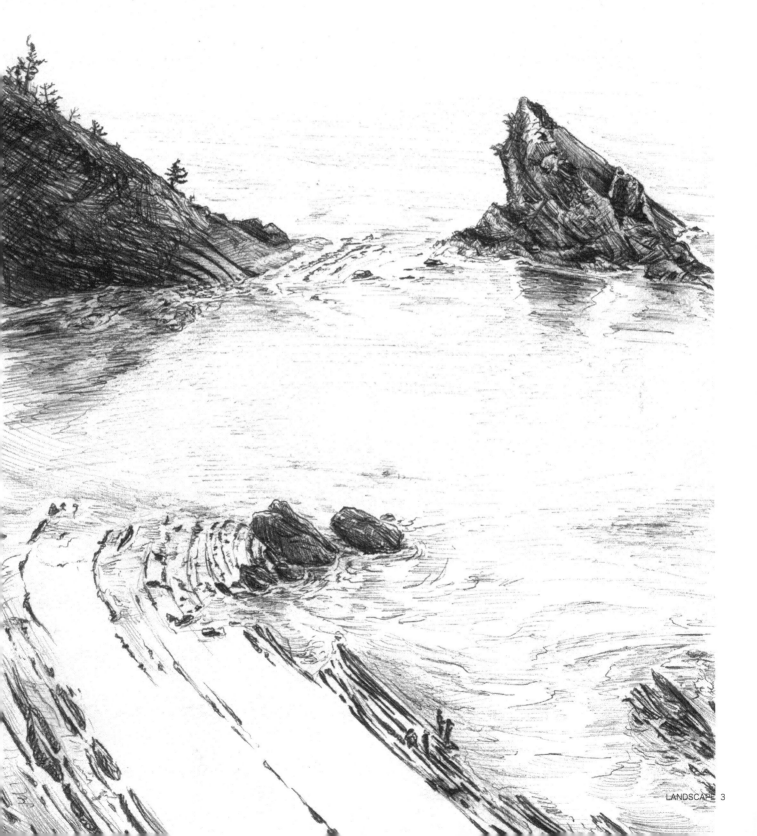

Mountain reflection in a lake.
山中湖に映る逆さ富士。

Chuzenji Lake, Nikko National Park, Tochigi Prefecture.
中禅寺湖、栃木県、明治35年(1902)。

Jade Gorge and Mt. Myojosan. The tallest limestone cliff in Japan, popular for rock climbing. Huge jade boulders litter the riverbed, only recently discovered in the 1930s.

ヒスイ峡谷と明星山。日本で一番高い石灰岩の崖。ロッククライマーに人気がある　小滝川の中にヒスイの巨石がゴロゴロしている、1930年代に発見されたばかりだ

Itoigawa Global Geopark, Niigata Prefecture || 糸魚川ジオパーク。　新潟県

Genbudo, unique rock formations of columnar jointing. Hyogo Prefecture
玄武洞、みごとな柱状節理の岩肌。
兵庫県

Photo: Yuki Takata || 写真：高田優希

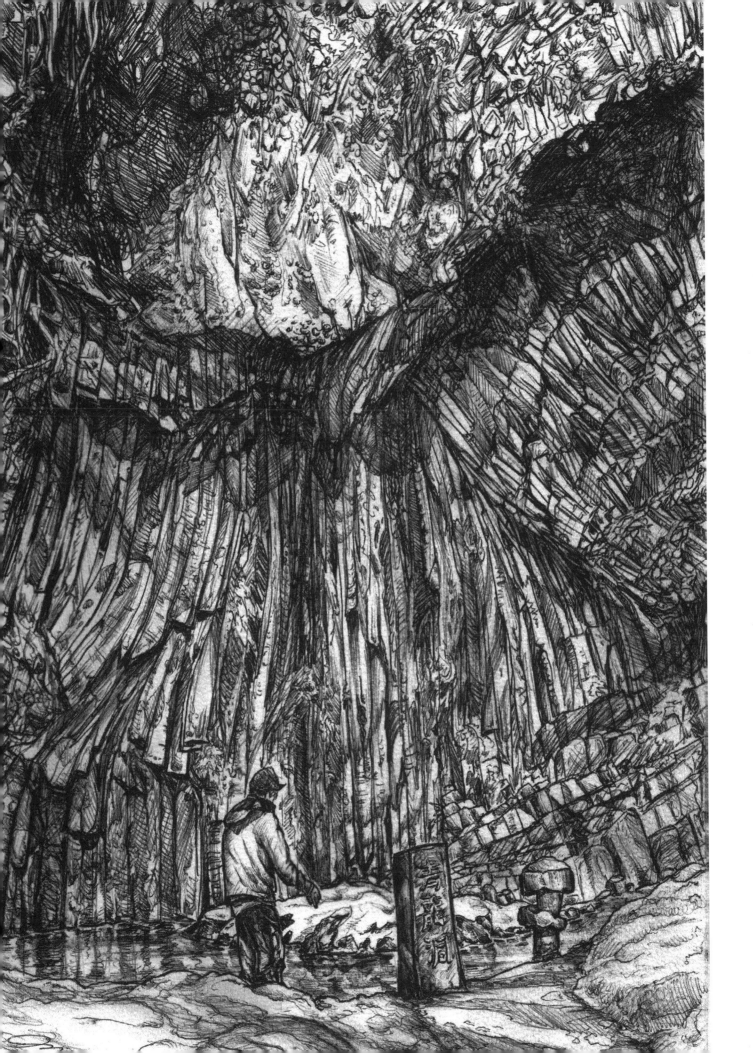

Shira Ito no Taki, White Thread
Waterfall, at the foot of Mount Fuji.　➤
富士山麓の白糸の滝。

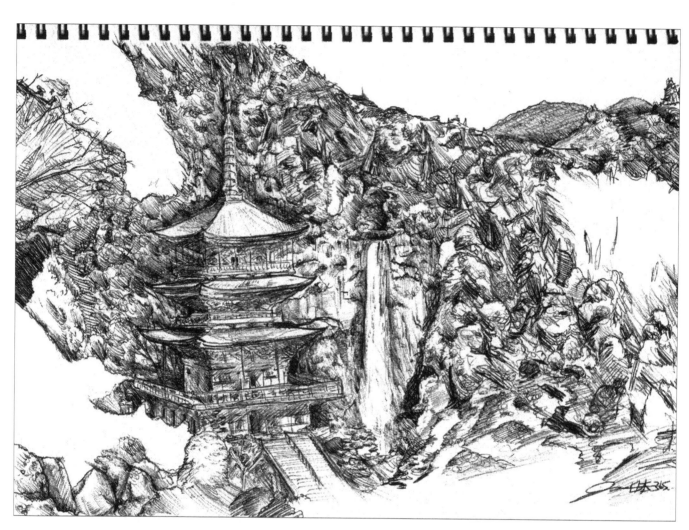

Nachi no Taki, Nachi Waterfall, one　⬆
of the tallest and most picturesque
waterfalls in Japan, postcard-perfect
every time with that 5-tiered pagoda
in the foreground.
Wakayama Prefecture

那智の滝、日本で高く素晴らしい滝のひ
とつ。5段の仏塔が写ったポストカード。
和歌山県

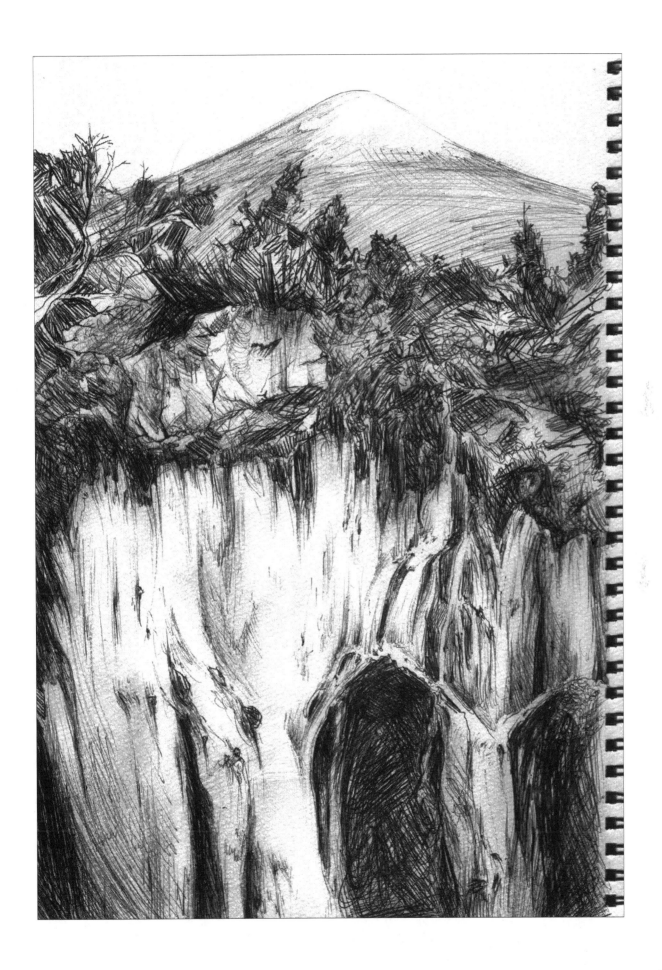

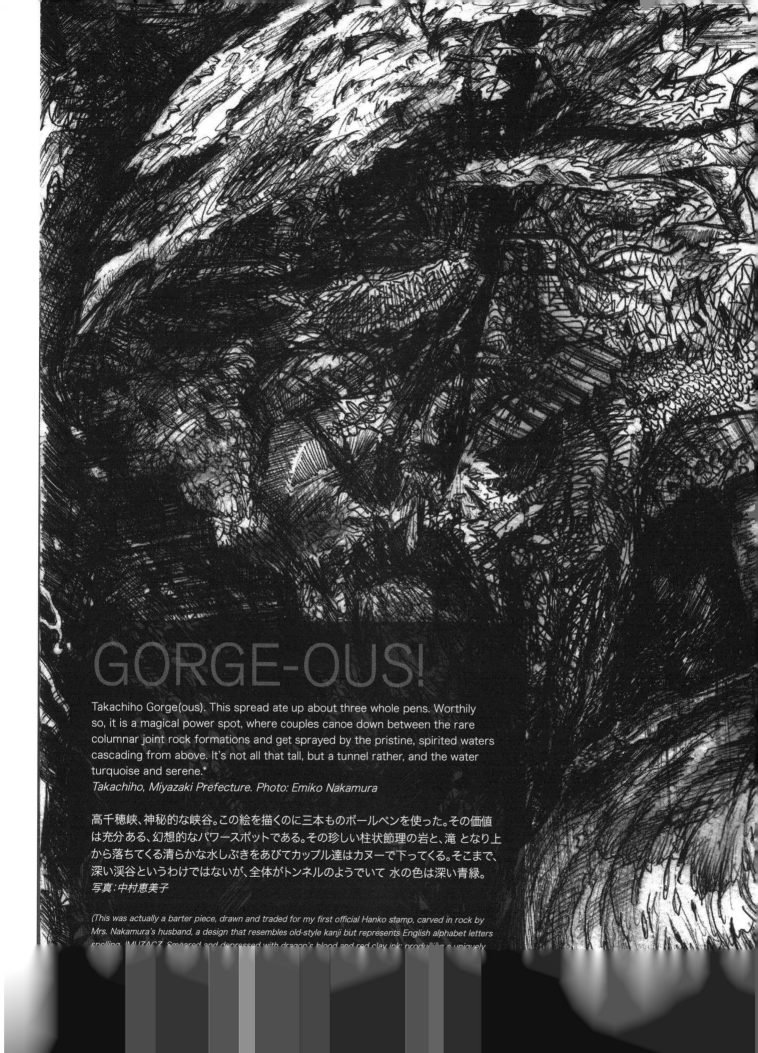

GORGE-OUS!

Takachiho Gorge(ous). This spread ate up about three whole pens. Worthily so, it is a magical power spot, where couples canoe down between the rare columnar joint rock formations and get sprayed by the pristine, spirited waters cascading from above. It's not all that tall, but a tunnel rather, and the water turquoise and serene.*
Takachiho, Miyazaki Prefecture. Photo: Emiko Nakamura

高千穂峡、神秘的な峡谷。この絵を描くのに三本ものボールペンを使った。その価値
は充分ある、幻想的なパワースポットである。その珍しい柱状節理の岩と、滝 となり上
から落ちてくる清らかな水しぶきをあびてカップル達はカヌーで下ってくる。そこまで、
深い渓谷というわけではないが、全体がトンネルのようでいて 水の色は深い青緑。
写真：中村恵美子

(This was actually a barter piece, drawn and traded for my first official Hanko stamp, carved in rock by Mrs. Nakamura's husband, a design that resembles old-style kanji but represents English alphabet letters spelling MUZACZ. Smeared and depressed with dragon's blood and red clay ink, producing a uniquely

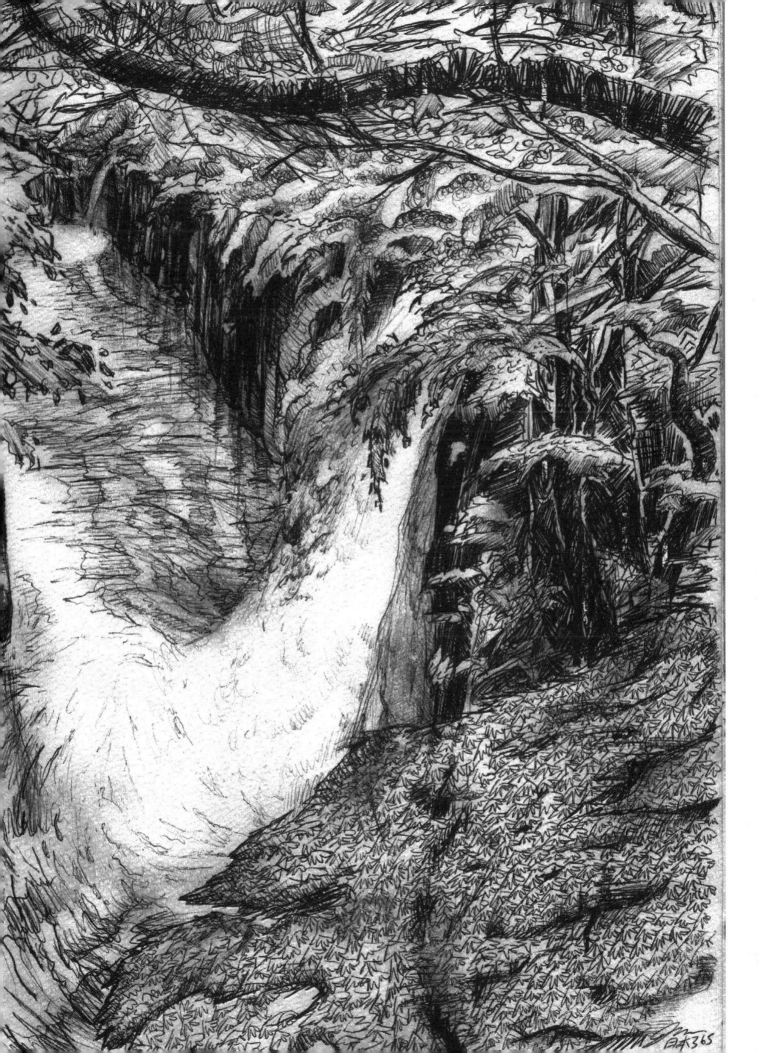

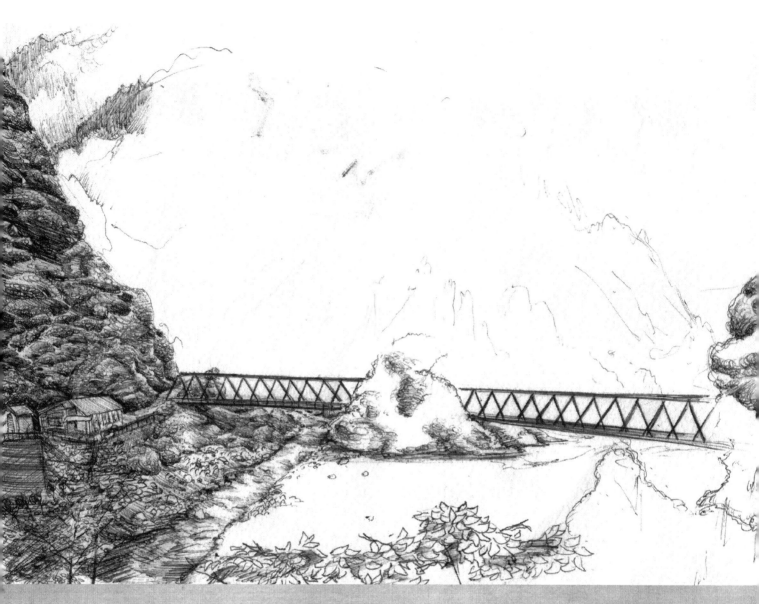

Bridge to the Devil's Bath, a highly sul-furous too hot hot spring at the end of the line in Kurobe Gorge. Take the rickety hour-long train ride through 47 tunnels to the last stop and walk 30 minutes through the fog. Suddenly some strange white alien algae grows in the river where the hot devil water meets the icy cold. This coupled with the river's artificial turquoise color, like the ponds in a miniature golf course (though likely caused by fine rock silt called glacial milk) leaves an eerily exotic impression on those who made the trek.

地獄谷温泉への橋。黒部渓谷の奥には硫黄の臭いが立ちこめるとても熱い温泉がある。ガタガタ揺れるトロッコ列車に乗り一時間、47本ものトンネルを通って最後の駅で下車。霧のなかターコイズ色の川沿いを歩くこと30分。すると突然、川の中で熱い湯と冷水が交わる水流の中に白い海藻のようなものが見えた。

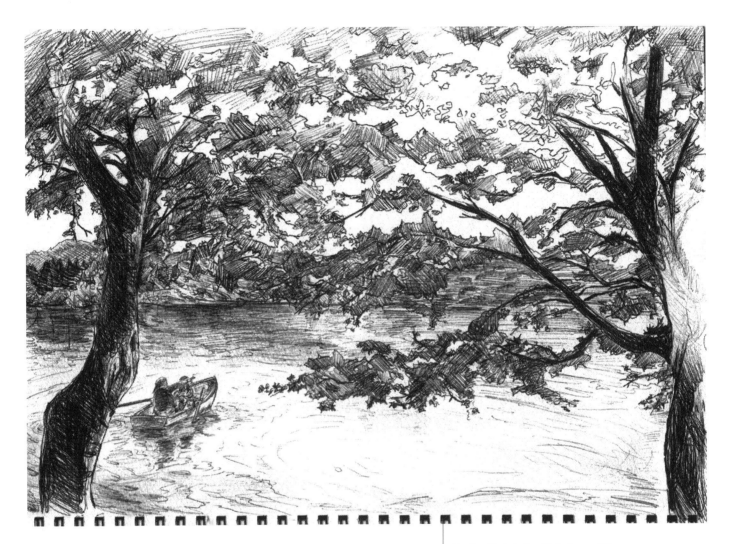

Nanko Park Lake. Shirakawa City,
Fukushima Prefecture
Photo: Penny Cameron
南湖公園。白河市　福島県
写真：ペニー・カメロン

Rolling hills of Hokkaido, land typical of the northeastern region, much like Texas, right down to the cattle and fields of wheat.

北海道の丘、アメリカのテキサス州によく似ている大地、牛馬、麦畑。

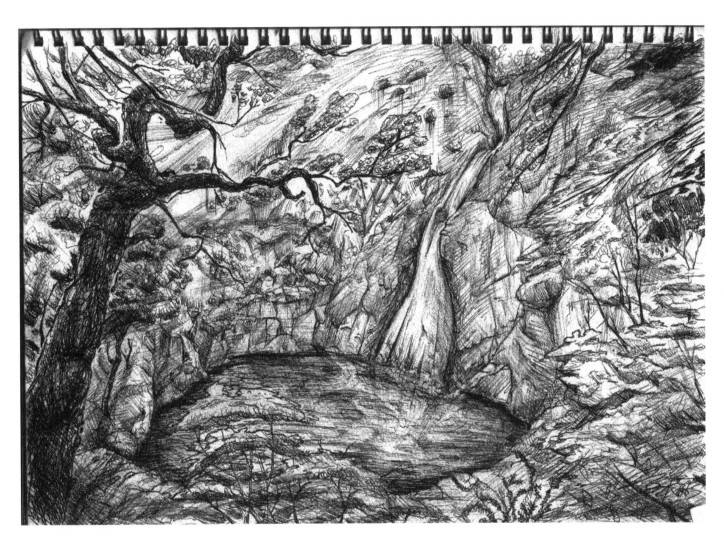

Waterfall pool in Hokkaido wilderness.
北海道の大自然にある滝壺。

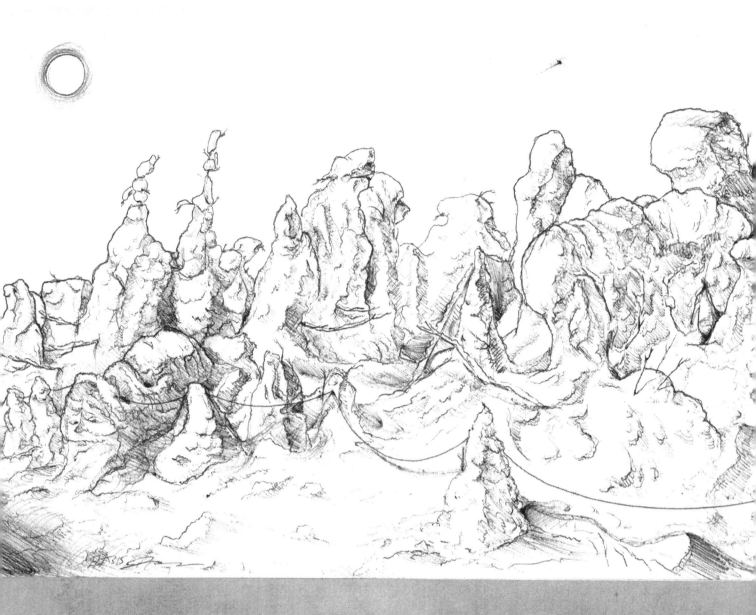

Yamagata Prefecture's Mt. Zao. Due to the unique climate on Zao, trees are covered in layers of snow and ice, forming these huge sculptures that you can take a lift over and ski through, day and night. At night they are fantastically illuminated, casting strong shadows and really bringing the abstractions to life.

山形県の蔵王山。蔵王は特殊な気候だから、木が雪と氷に埋れて、巨大な彫刻のような形になる。リフトに乗る時その木が見える。木の下でスキーもできる。夜には木々が美しくライトアップされ、映し出された影の抽象的な形は、まるで命を吹き込まれたようだ。

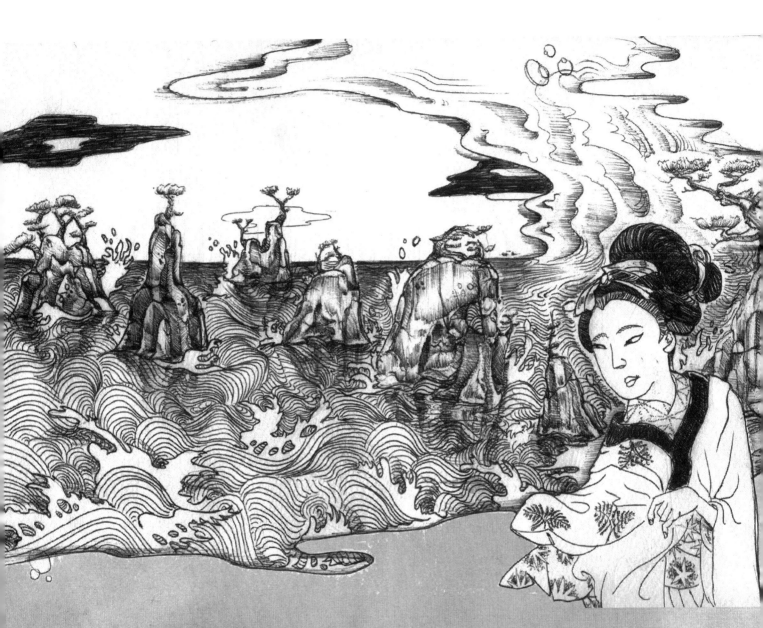

Miyagi. Matsushima-style. Matsushima is one of the Top Three Views of Japan (Nihon Sankei) hosting some 260 pine-covered-islands, or matsushima. This area struck the wandering poet Matsuo Basho with a loss for words more than 300 years ago, as he composed this haiku and left it for us to ponder:

"Matsushima ah!
A-ah, Matsushima, ah!
Matsushima, ah!"

宮城県の松島。松島は日本三景の
一つで260本の松で覆われている。
300年以上前にこの地に来た松
尾芭蕉は、あまりの感動に言葉を
失い、俳句を作って、現代の我々に
考えさせてくれる

「 松島や
　 ああ、松島や
　 松島や 」

Morioka City + Mount Iwate
盛岡市と岩手山。

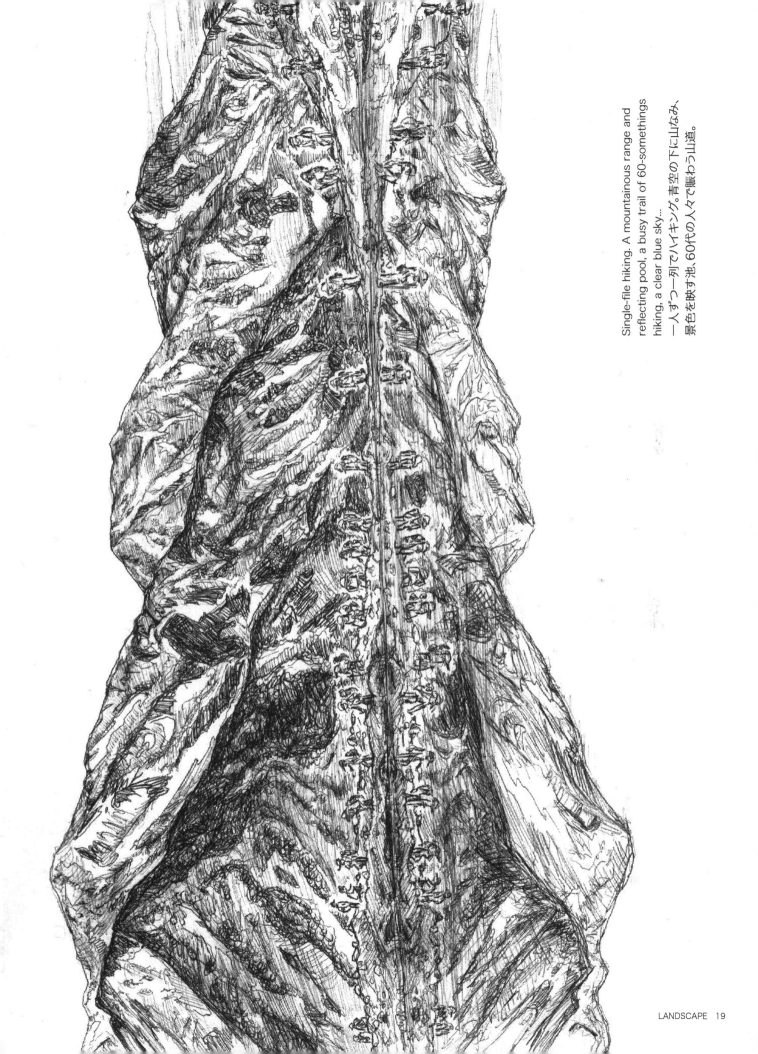

Single-file hiking. A mountainous range and reflecting pool, a busy trail of 60-somethings hiking, a clear blue sky...

一人ずつ一列でハイキング。青空の下に山なみ、景色を映す池、60代の人々で賑わう山道。

Sakurajima Island, view from Dolphin
Port. Kagoshima Prefecture
活火山の桜島が見える所、イルカ港から。
鹿児島県

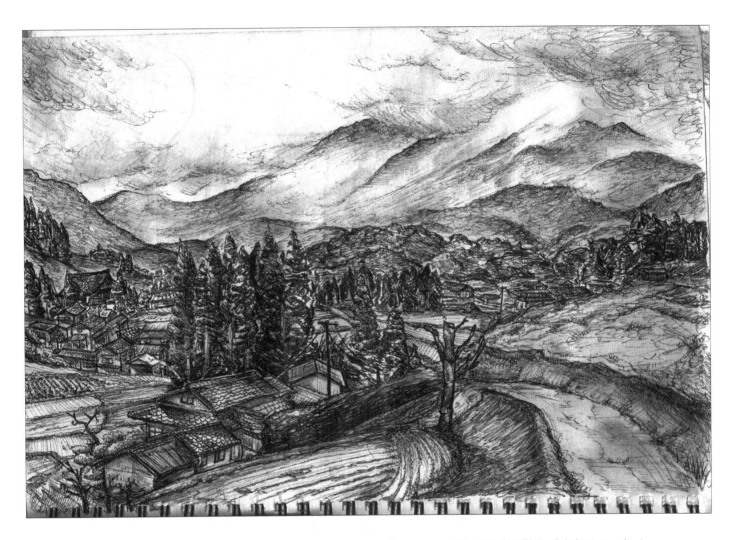

A cold and rainy morning walk to start the year, near Couch Surfing host Victoria's place. Takachiho Mountains, Miyazaki Prefecture

寒い雨の朝の散歩。今年初めの一歩。カウチサーフィング(CouchSurfing.com)ホストのビクトリアさんの自宅近く。高千穂高原 宮崎県

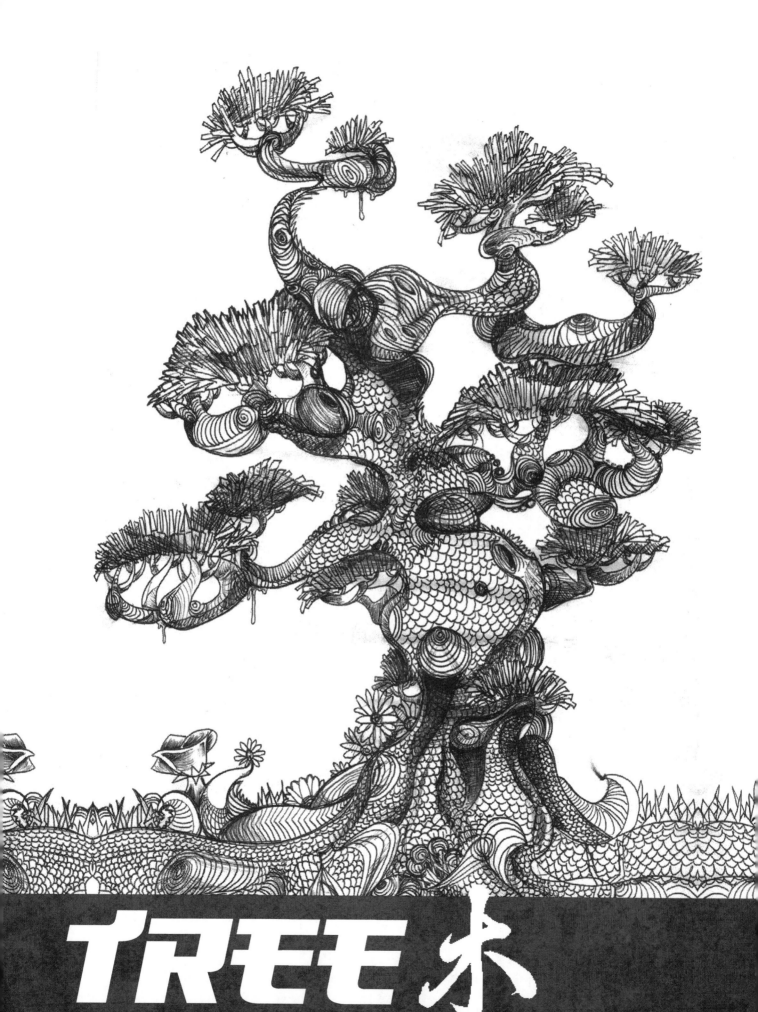

TREE 木

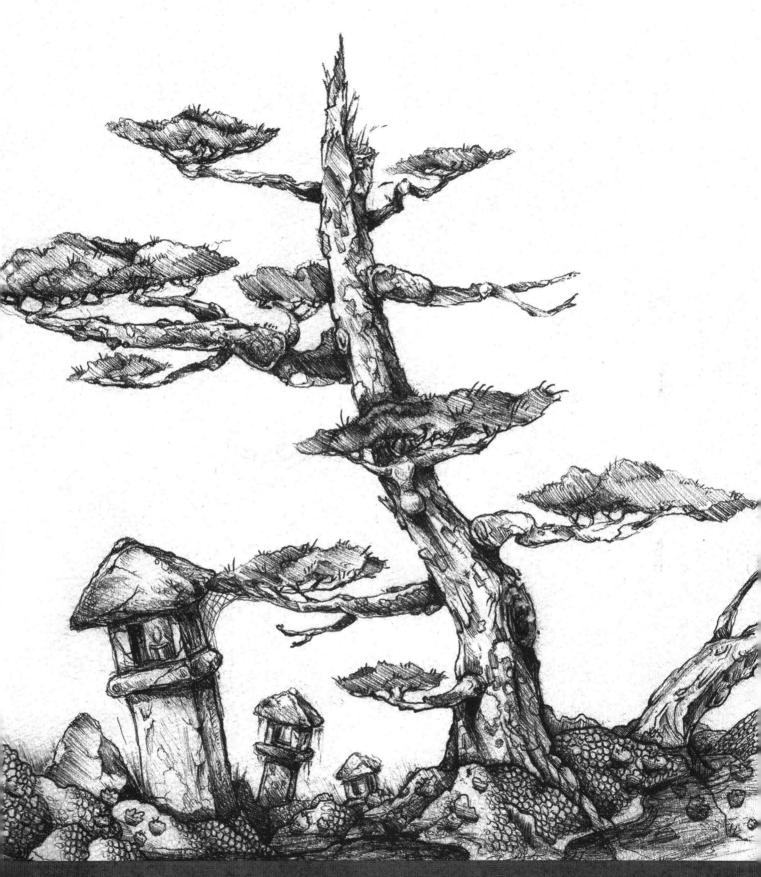

Flood, Big Water, Overflow. A flood-inspired matsu (pine tree), battered, yet standing tall through it all. The school playground became the sea, 30cm of water filling the ball field after the nearby Takeno river overflowed its banks. Welcome to rainy season.

洪水、大水、氾濫。学校のグラウンドが海になったのに、この松の木はまだ立っている。近くの竹野 川が溢れてきた。さすがに梅雨だ。

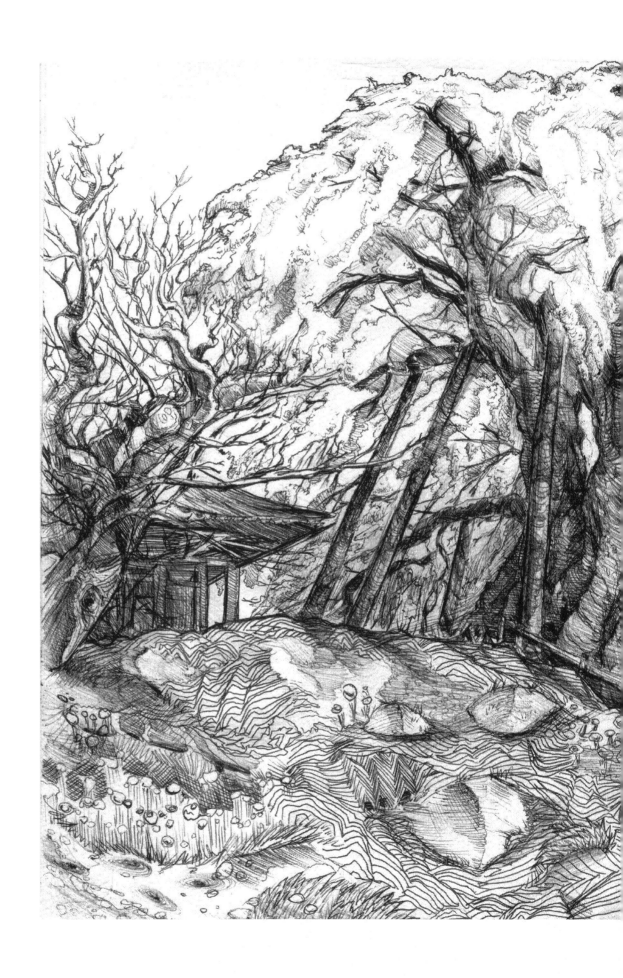

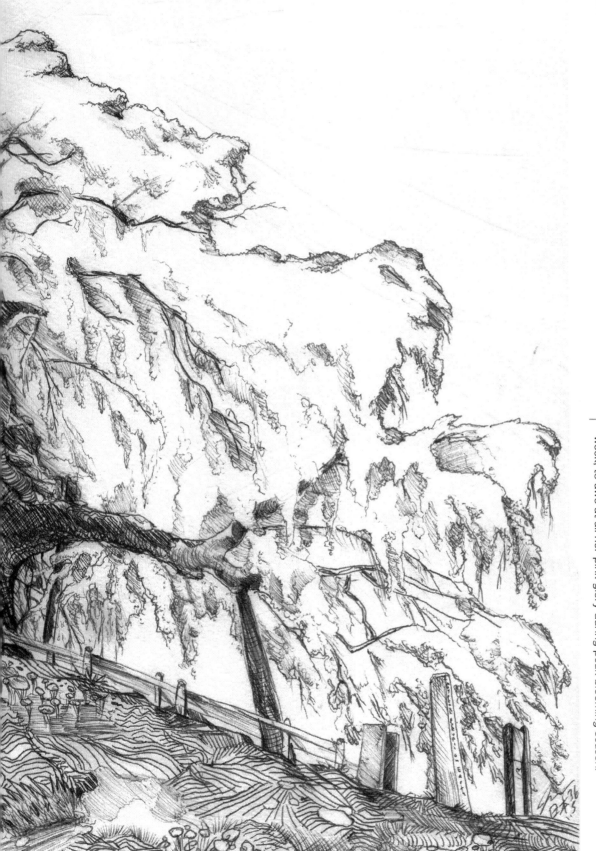

三春滝桜。福島県三春町にある樹齢 1000 年以上の滝桜。日本で一番古い桜の1つであり、2011、三月の東北関東震災の、ちょうど1ヶ月後に、咲いた。それは被災者にとって希望を象徴するものであった。桜は日本人の精神の象徴として、春に何かを始めるときに読む詩を、より素晴らしいものにしてきた。この古木は福島第一原子力発電所から 50 キロしか離れていないにもかかわらず、一週間で、60,000 人以上が見事な桜を花見の季節に見にやって来た。

Miharu Takizakura, The 1,000-year-old Sakura, cherry tree in Miharu Town, Fukushima Prefecture. One of the oldest cherry trees in Japan, whose blossoms just a month after the great disasters in March 2011 bloomed regardless; a strong symbol of hope for victims. The sakura has always produced Japan's great springtime poetry of renewal and fresh starts. And, despite this particular Grandmother Sakura being just 31 miles from the Fukushima Daiichi Power Plant, more than 60,000 people made the pilgrimage to visit her in a single week, to awe at all her pink glory during peak blooming season.

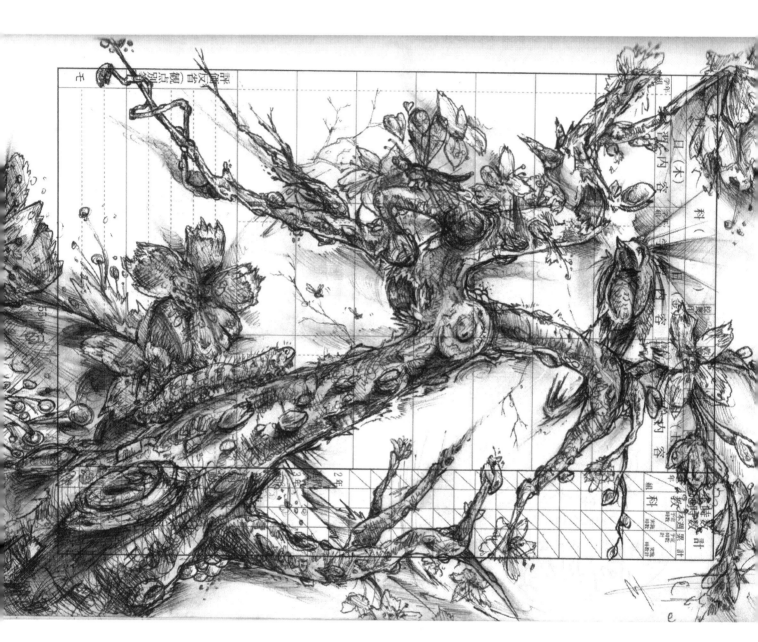

Cherry tree branch freestyle. Did you know there are 300,000 cherry trees in Macon, Georgia? Every year, a three-week festival is held there to celebrate all things pink when all those trees are in bloom. No lie.

桜の手。アメリカのジョージア州メーコン市には３０万本の桜が生えている？ 毎年桜祭が開催されている。ほんとほんと！嘘じゃないよ！

(Cute old people #3)
"Cherry blossom head!"
（かわいい年配の方、第三）
「桜 のあたま！」

Take, Bamboo. Excellent photo com-
position courtesy Greg Ferguson
竹の写真。素晴らしい構図、グレッグ・フ
ァーグソン の好意 により

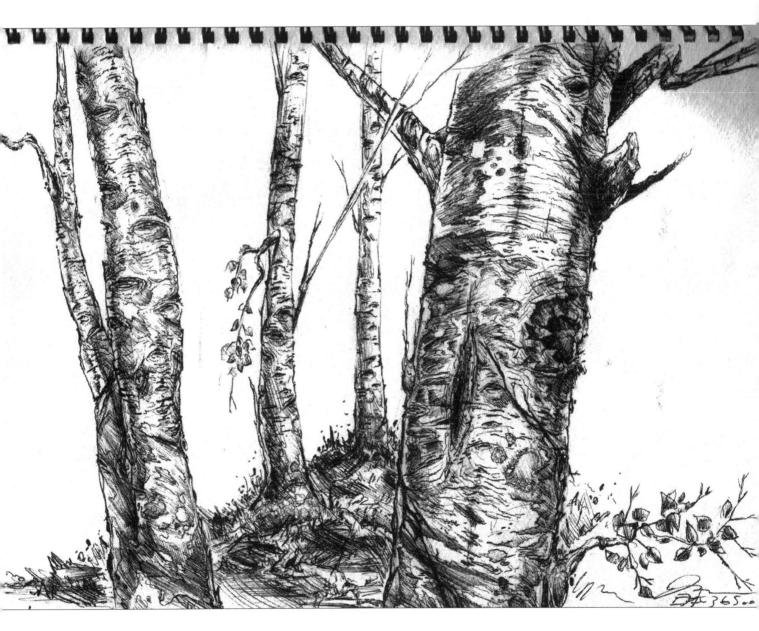

Shirakaba, silver birch trees in north-
ern Hokkaido.
北の北海道シラカバの木。

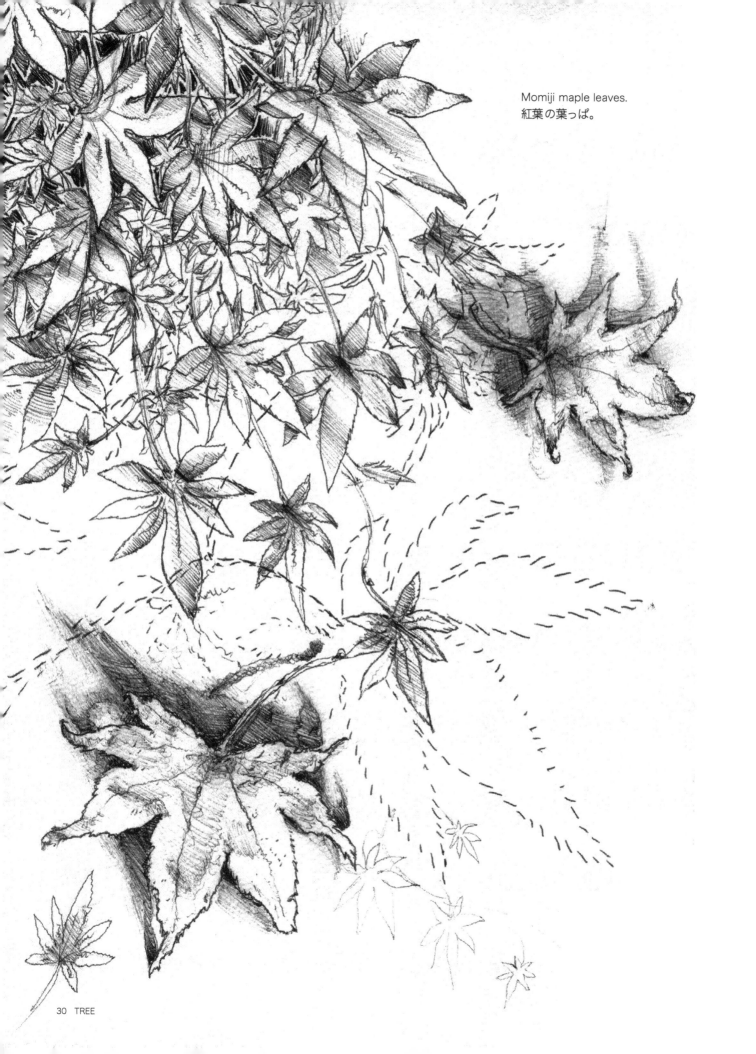

Momiji maple leaves.
紅葉の葉っぱ。

"A thin layer of soil rose to the waist, the neck, then clear above a farmer who remained hidden below a new floating world. This happened all the time. An unseen artist lifted this blossoming plum tree or that tender peony or whole rivers and flooded plains. The farmer looked up expecting to see wiry ends of pine roots and to catch falling worms for fish bait, but again he only saw the swollen bellies of clouds. He went back to work. In the distance one red mountain crawled up another mountain into clouds, a nearby birch's limbs beat like wings of a learning bird, and below the farmer's feet, small rocks began to fly." —*Matthew Little*

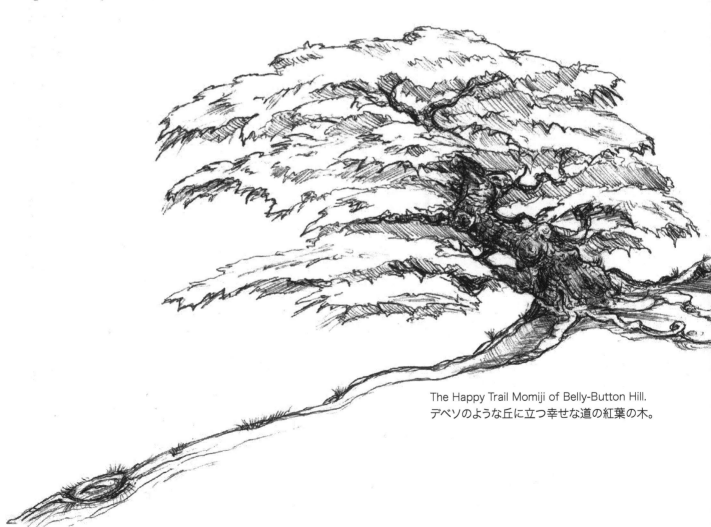

The Happy Trail Momiji of Belly-Button Hill.
デベソのような丘に立つ幸せな道の紅葉の木。

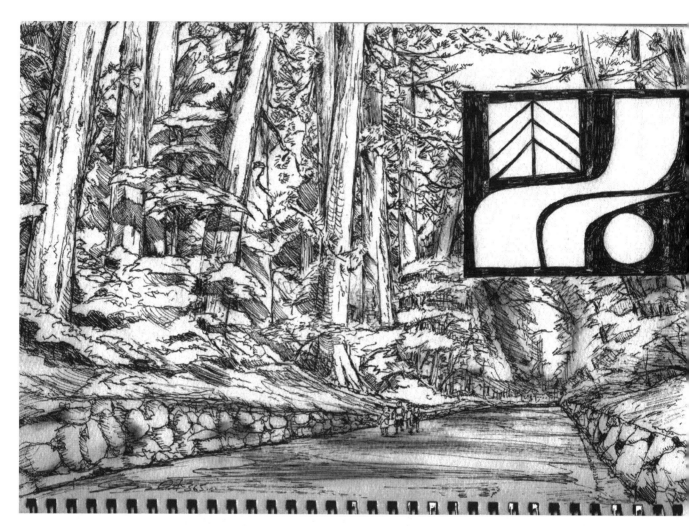

Tochigi Prefecture. There is an avenue of cedar trees around 400 years old lining a 35km stretch of road that is the Guinness world record holder for the "longest tree-lined avenue." Nikko National Park also found in Tochigi is a UNESCO World Heritage Site for its wealth of Shinto shrines, other cultural value sites and natural beauty like that of Kegon Falls. Who says Tochigi doesn't have anything famous?! There are also delicious Gyoza (Chinese-style dumplings) to scarf down in between your otherwise over-consumption of nature and culture. Let's visit Tochigi!

栃木県。ギネスに『世界で一番長い並木道』として認定 された、35kmに及ぶ樹齢400年のスギの木通り。日光国立公園は、神社や文化的価値のある場所、華厳の滝などの自然の美しさが世界遺産となっている。栃木には何もないと誰が言っただろう？もちろん、美味しいギョウザもある。自然と文化を十分に楽しめる。栃木へ行こう！

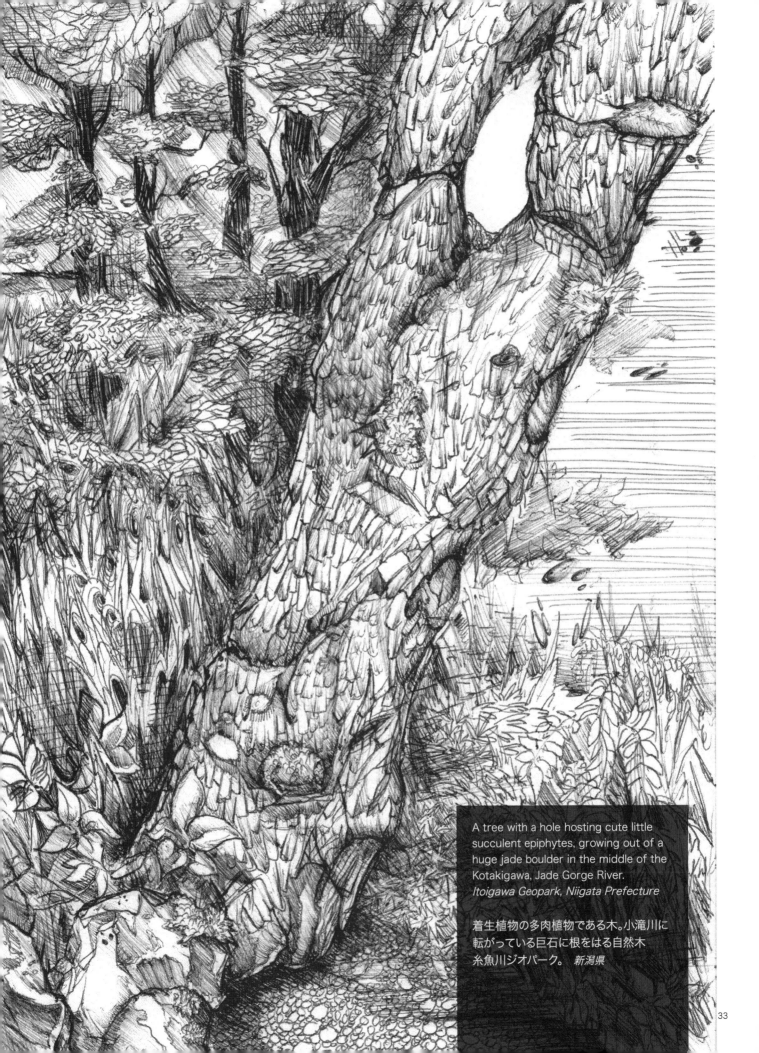

A tree with a hole hosting cute little succulent epiphytes, growing out of a huge jade boulder in the middle of the Kotakigawa, Jade Gorge River.
Itoigawa Geopark, Niigata Prefecture

着生植物の多肉植物である木。小滝川に転がっている巨石に根をはる自然木　糸魚川ジオパーク。　新潟県

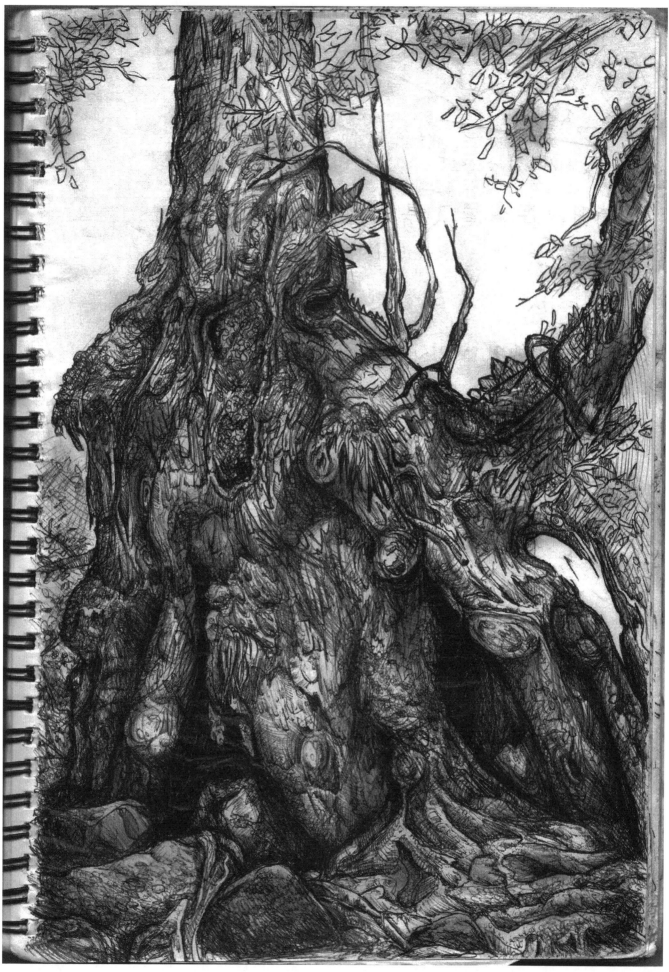

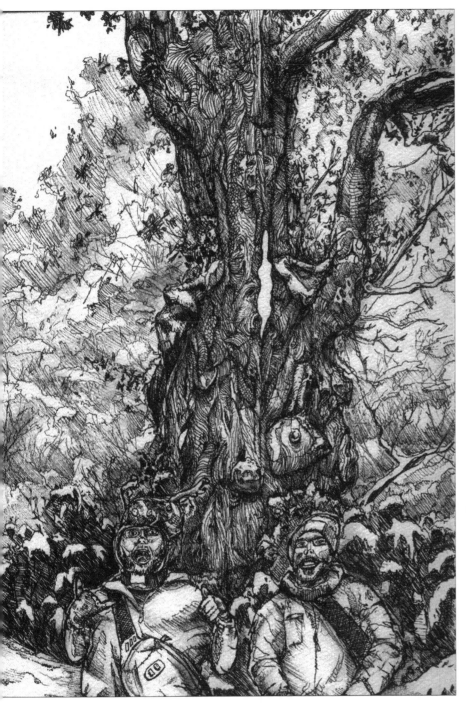

Jomon Sugi, the oldest-known tree in Japan. People say it is around 7,200 years old (whereas science claims it closer to three or four thousand years—still really old), found high up in the primeval virgin forests of Yakushima Island, a four-hour ferry ride south from Kagoshima. One of the first dedicated UNESCO World Natural Heritage Sites in Japan, since 1993. Takes a 9-hour round-trip hike to go see this granddaddy/grandmammy cedar, following the old mine car train tracks and then ascending, in our case venturing on Christmas Day, through 30 cm of snow... As I write, it has been about eleven months since we met Jomon Sugi, so solemn and wise up on the mountain. I have drawn a couple hundred pictures since then and time feels long, though I wonder how time has passed for him/her?

縄文杉、日本最古の木。推定樹齢7200年と言われているが、科学者によると、推定樹齢は3000-4000年とされる（それでもかなり古い）。屋久島は鹿児島からフェリーで4時間のところに位置し、縄文杉は屋久島スギ原始林の奥深い所にある。1993年に日本初のユネスコ世界自然遺産として登録された。この古木を見るためには9時間程の登山が必要であり、まず古い鉱山の車道の跡を辿り、山を登る。僕たちの場合は、クリスマスの日に30センチ積もった雪道を歩いた。賢くて、厳かな縄文杉に会ってから、11ヶ月が過ぎさり、その間僕は何百枚もの絵を描いて過ごした。縄文杉はその間、どのように過ごしただろうか？

◀ Yakushima virgin forest.
屋久島の原始林。

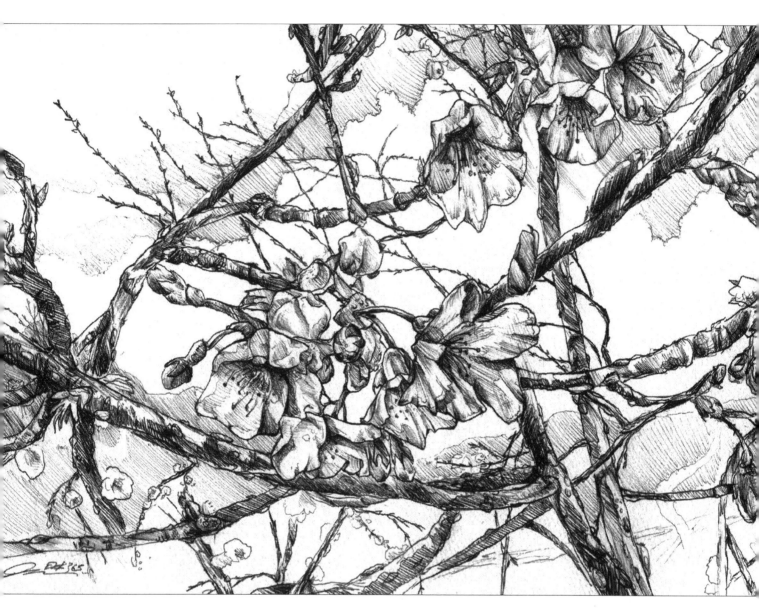

The nice lady at the bookstore requested a drawing of the ubiquitous sakura cherry blossoms, so I drew these for her from my sister's photo. Excellent perspective courtesy Arien Muzacz

本屋さんの女性の店員は、到る所に咲いている桜の絵を求めた。
写真：エリエン・ミュザック

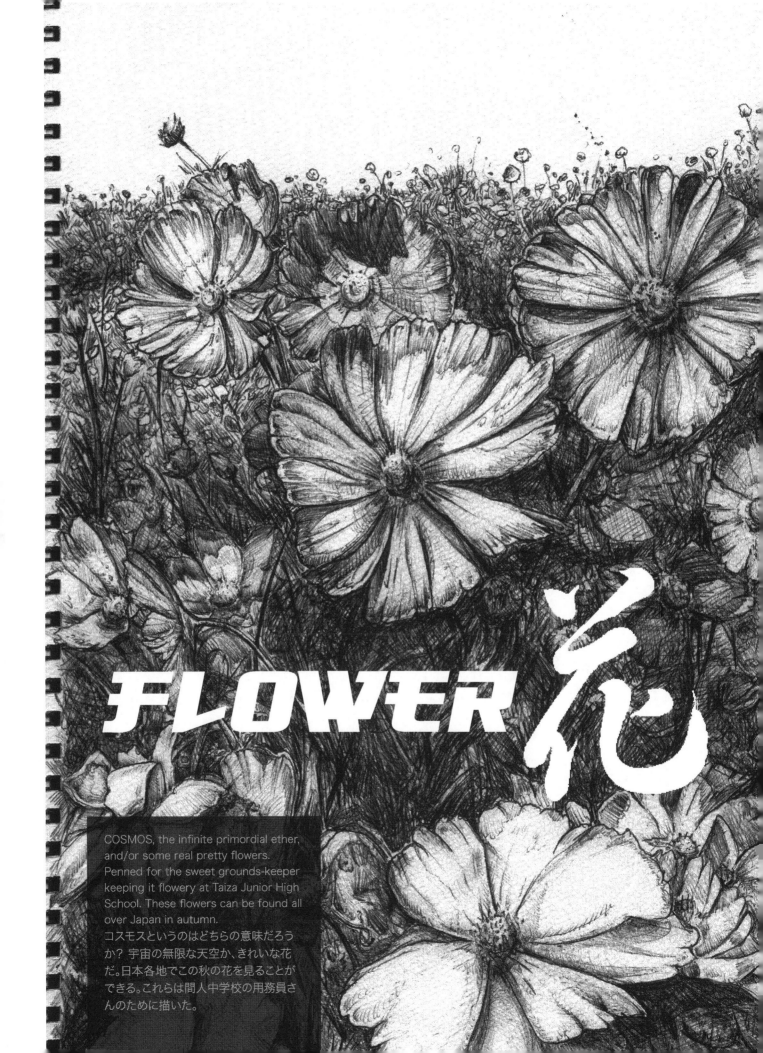

FLOWER 花

COSMOS, the infinite primordial ether, and/or some real pretty flowers. Penned for the sweet grounds-keeper keeping it flowery at Taiza Junior High School. These flowers can be found all over Japan in autumn.
コスモスというのはどちらの意味だろうか？ 宇宙の無限な天空か、きれいな花だ。日本各地でこの秋の花を見ることができる。これらは間人中学校の用務員さんのために描いた。

Japanese Black Swallowtail, depicted 'architecturally' with reference to Watanabe Seitei's 1890 woodblock print. Hydrangea flowers called ajisai are native to southern and eastern Asia and are a long-flowering summer bloom in brilliant hues of pink, magenta and blue.

アーキテクチャラルな描き方。渡辺省亭の1890年版画のように描いてみた。アジサイは南アジアと東アジアに自生する。

Rainy season still-life by the wet morning window.
雨の日の静物画濡れた朝の窓の傍で。

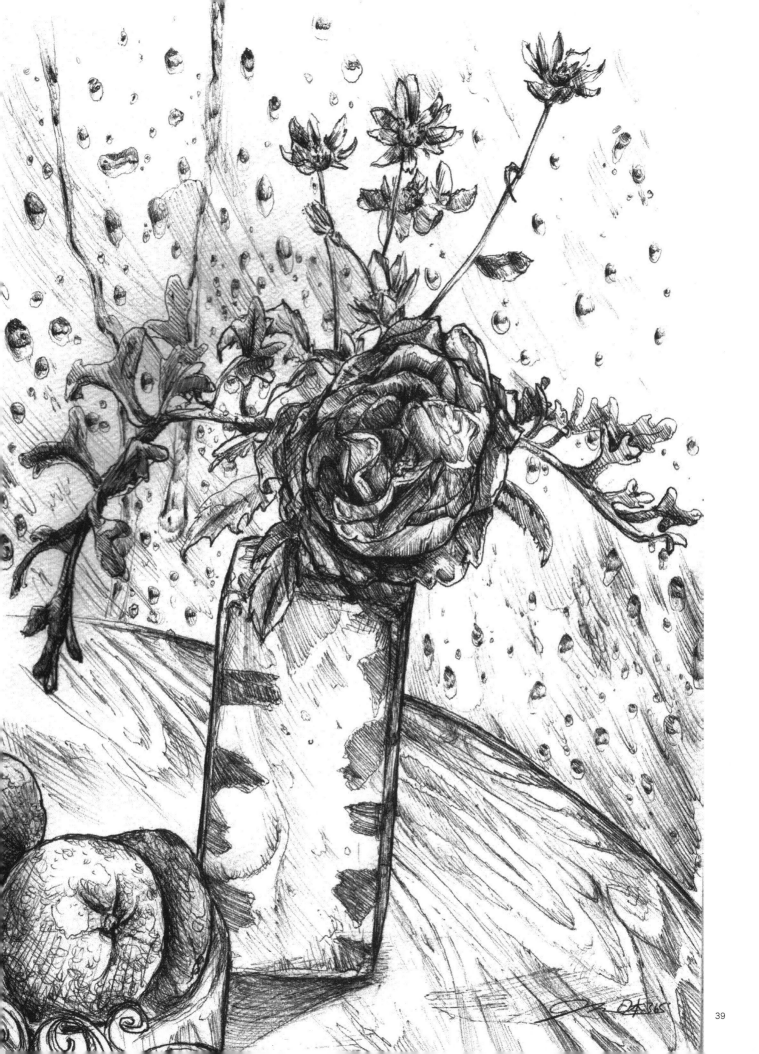

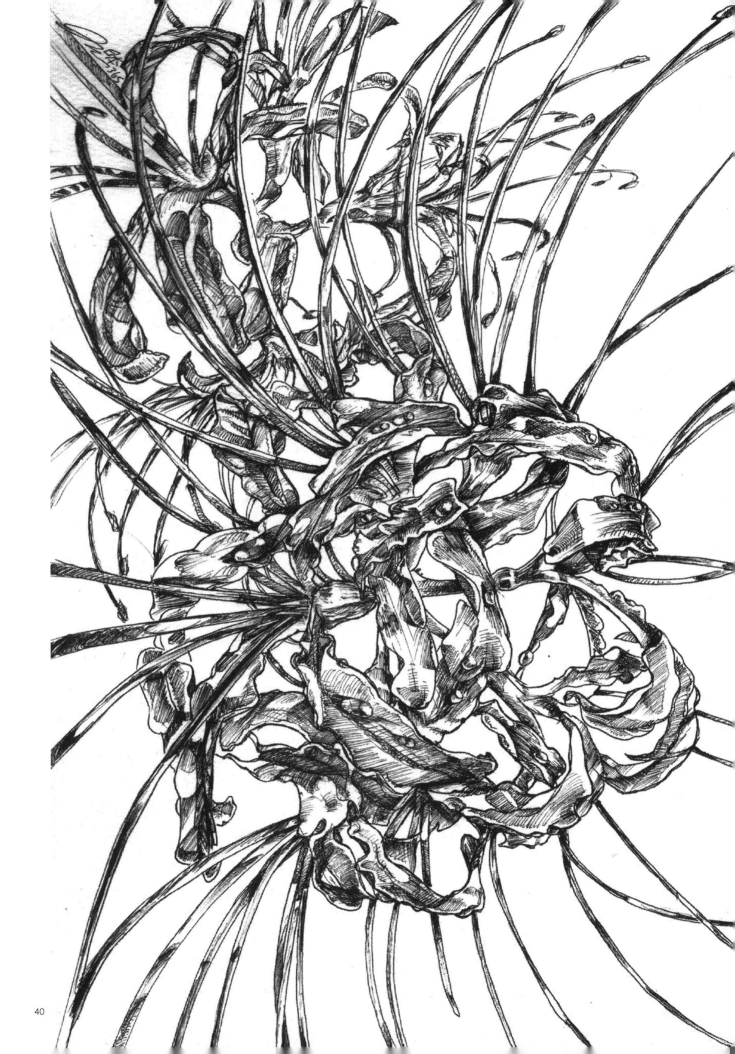

40

Higanbana 彼岸花

Poisonous spider lily that grows in Japan, traditionally associated with death. Apparently, it was planted in graveyards to keep burrowing animals from eating the dead because its bulbs are poisonous. The flower and leaves never appear at the same time, so it also symbolises people (lovers) who are kept apart and cannot meet. Other names for this flower in Japanese include:

- Higanbana, "flower of the autumn equinox," the time of year when the plant flowers. ("Higan" also refers to the other shore of the Sanzu River, i.e. the afterlife.)
- Manjushage, from the Buddhist Lotus sutra about a red flower.
- Shibito-bana, the flower of the dead.
- Yuurei-bana, the flower that looks like a ghost.

有毒性のユリ科の植物で、日本に分布している。昔から食べると死ぬと言われており、鱗茎には毒がある。実際は動物が穴を掘り返し死体を食べないようにと、墓地に植えられたようだ。彼岸花と花が咲き終わった頃に葉が出始めることから、会えない恋人たちの象徴とも言われている。呼び方の由来:

- 彼岸花:秋の彼岸から開花するため。
- 曼珠沙華:法華経などの仏典に由来。天界に咲く花という意味で、彼岸花とは対極。
- 死人花(しびとばな):死を呼ぶ、とも言われているため。
- 幽霊花:幽霊のようにも見えるから。

RICE

米の一粒。米の一粒一粒に魂が宿っていると言われている。農家の人の汗と努力と愛情が田んぼに入り、稲となり、米に宿るからかもしれない。または、神道の教えで、お日様の神、大地の神、雨や地球の神からきているのかもしれない。古代の神話では、天照大神が、子孫である初代天皇、神武天皇に米を授けたそうだ。山口てつひろさんは東京でレストランを経営する若い人で、米に魂があると感じることは、日本人のDNAの一部だと思っている。日本全国の学校の生徒達は、学校給食は残さず食べるよう指導されており、つまり、米の一粒も残すことはいけないことなのだ。もったいないから無駄にしない。

A single grain of rice. Each grain is said to have a spirit or a soul. Perhaps that of the farmer whose sweat and hard labor and love went into cultivating the field and growing the plants, harvesting and distributing, or perhaps a Shinto spirit of the sun, earth, rain, or wind. In ancient history, the Sun Goddess, Amaterasu, gave grains of rice to one of her descendants, the mythical first emperor Jinmu (Jimmu). Tetsuhiro Yamaguchi, a young restauranteur in Tokyo, believes that the "spirit of rice" is part of the Japanese DNA. And children at public schools all over the country are encouraged (have no choice but) to finish every morsel of food in their school lunch, thus not leaving even a single grain of rice in their bowl. Mottainai (waste not, want not).

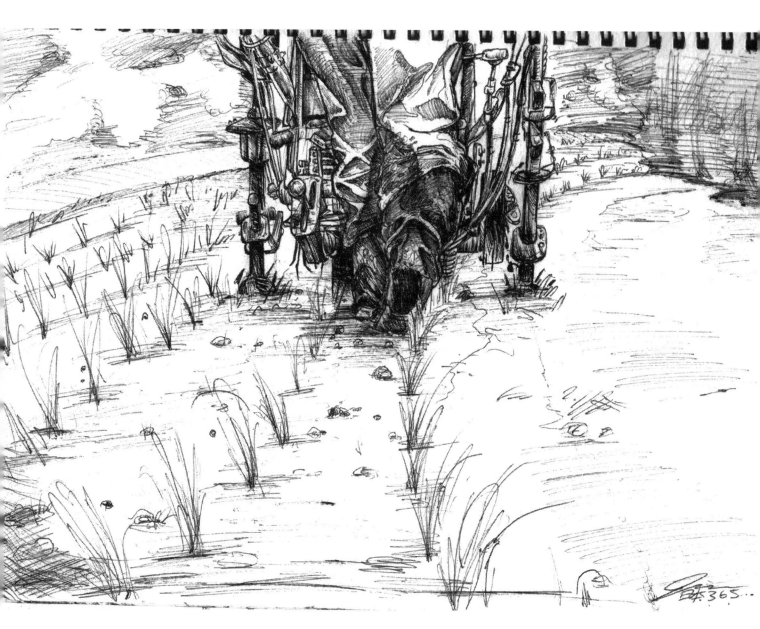

Rice planting made easy; muddy boots push the machine.
泥靴で操る機械。簡単になった田植え。

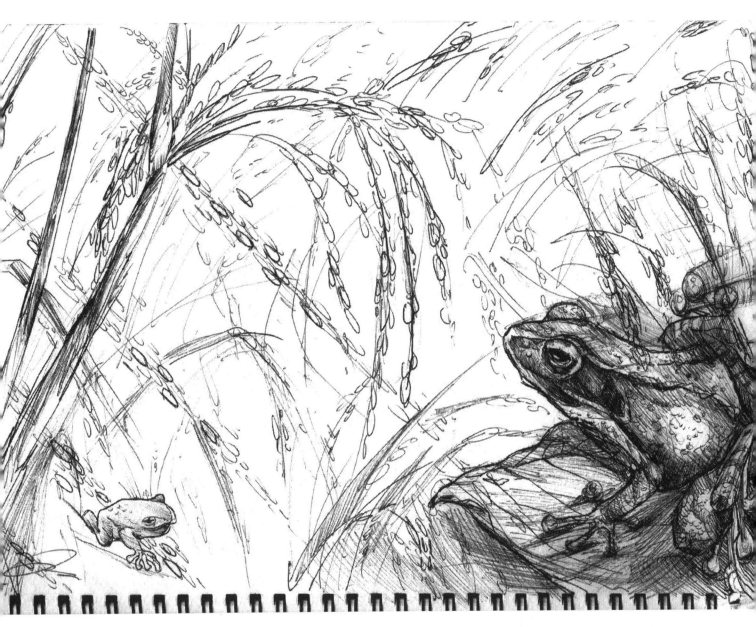

Rice paddy frogs. Late summer rice fields brimming full of stalks about ready for harvest host the most rambunctious and noisy frog orgies of the year. (And on a "flatter" note, there are sadly countless squished frogs on the road every morning that didn't hop quite fast enough across the road as big heavy cars rolled by the night before.)

稲田の蛙。晩夏、もうすぐ収穫期を迎える稲田が、にぎやかな蛙の交配期の場になる。(しかし、うっかり車道にジャンプし車にひかれてしまう蛙も少なくない)

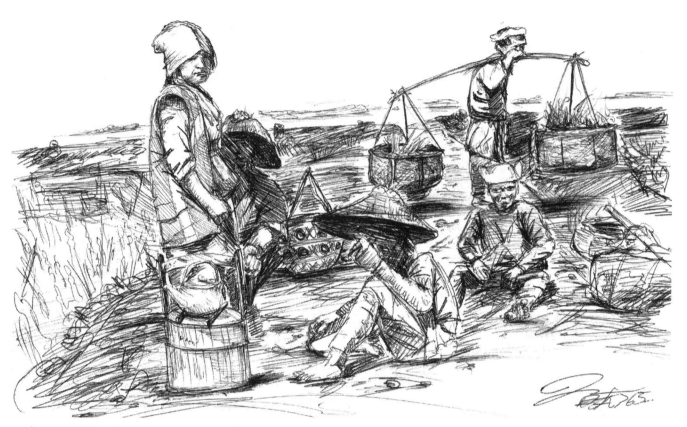

▲ Mid-*Meiji* era farm workers taking a short rest.
野良仕事で一服。当時の農民たちの生活がわかる。

Hanging stalks of rice to dry. Nice farmer in *Yamanashi* Prefecture is hanging her rice on the traditional bamboo drying racks, *ineki*, for a few weeks so the water and sugar in the stems of the plant can drain down into the rice and the sun can bake superpowers and extra flavor into the grains. More and more farmers, however, are turning to the faster mechanized method of chopping stalks up with the rice on the day of harvest and wasting all that precious stem goodness. Don't you like the old-fashioned method?

米を乾燥させる。山梨県の農家の人は昔ながらの竹の稲木に二三週間稲穂を掛けておく。稲穂の茎の中にある水分が米に溜まって太陽に干されることによってうまみが増す。最近では多くの農家が機械で稲刈りの日に茎を切り取り労働を短縮していて茎の部分の栄養素を無駄にしている。昔のやり方の方がいいかもね？

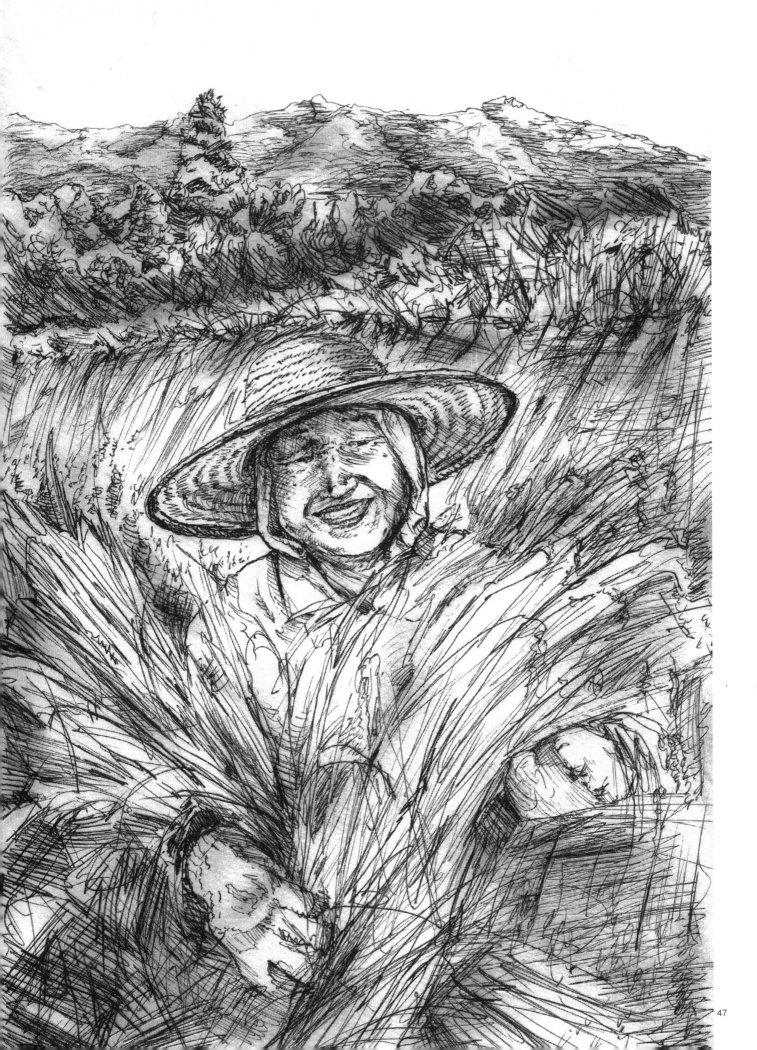

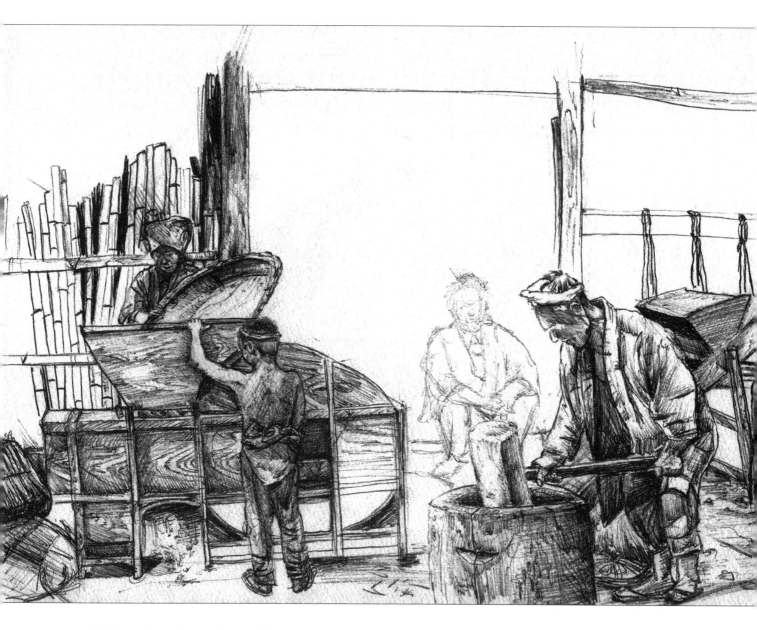

Polishing rice and pounding mochi
(Japanese glutinous rice cake).
精米と餅つき、明治10年代。

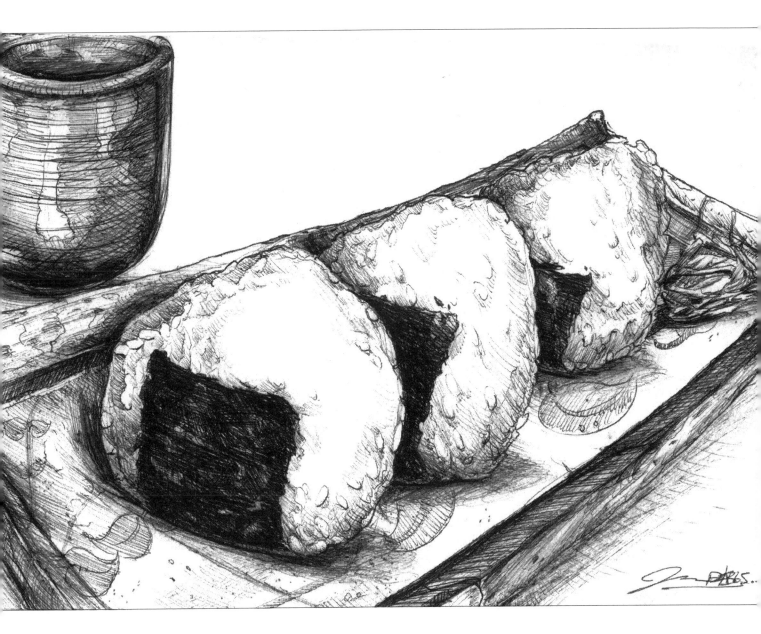

Plump juicy rice balls wrapped in *nori*
seaweed affectionately called *onigiri*.
小太 りなおにぎりだ！

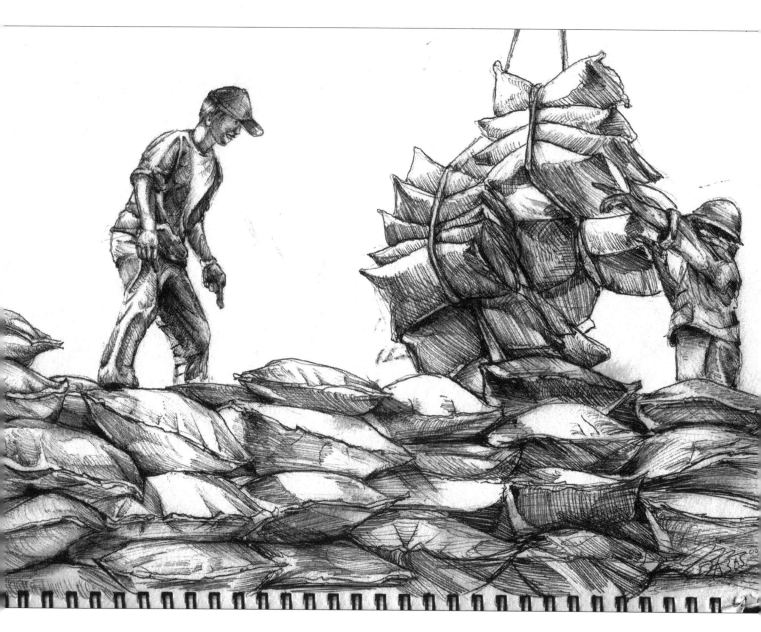

Rice shipment. This scene actually depicts men in Myanmar who are unloading shipments of rice from Japan, a country that in 2008 was hoarding 25% more rice than the entire country could eat! Yet, for some reason Japan was still importing rice from the United States. (In order to re-route rice rations to help feed struggling Myanmar because of the US-imposed embargo, perhaps?)

コメの輸送。ミャンマー人 の男が、日本から送られてきたコメを荷降ろししている。2008年、全国で食べる事ができたコメの25%を貯蔵していた国。それでも、何かの理由で、日本はまだ米国からコメを輸入してた。(おそらく、米国に通商停止を強要されあえいでいるミャンマーへの食糧支援のため米の割り当てを変更したからか)

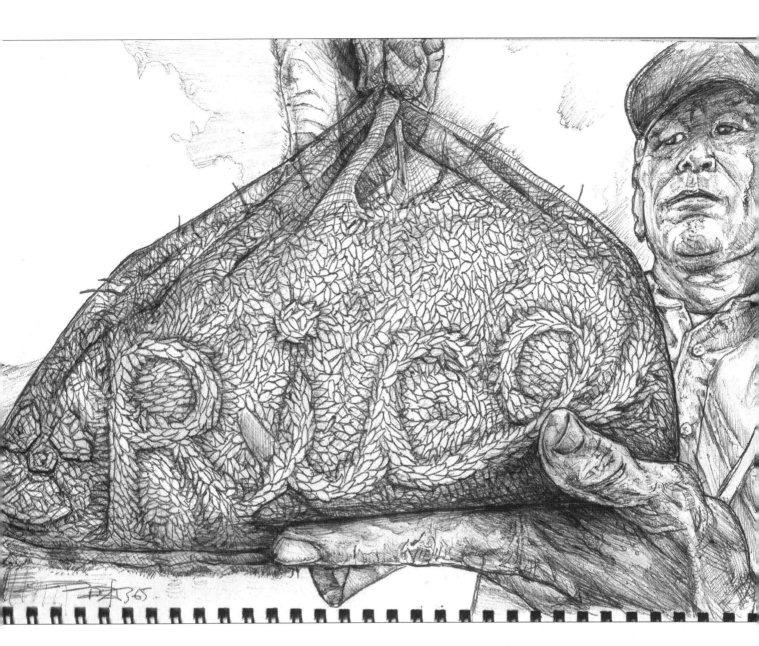

(Radioactive?) Rice. An official from Chiba
Prefecture holds a bag of rice to be tested
for radioactive contamination.
（放射能米？）米が放射能汚染されていないか
調べる千葉県の職員。

Young lady eating rice.
食事中の女性、明治13年(1880)。

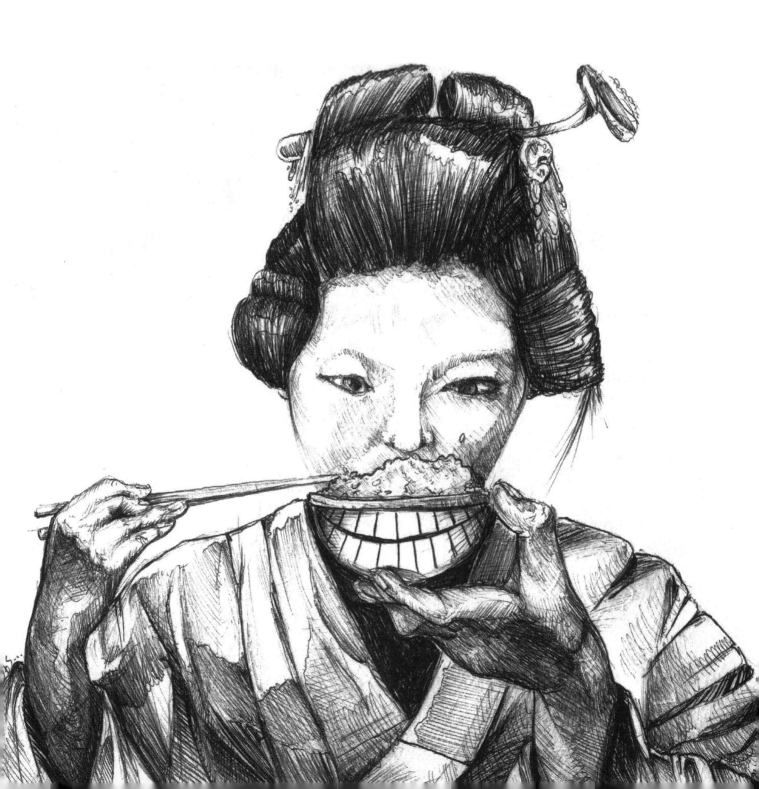

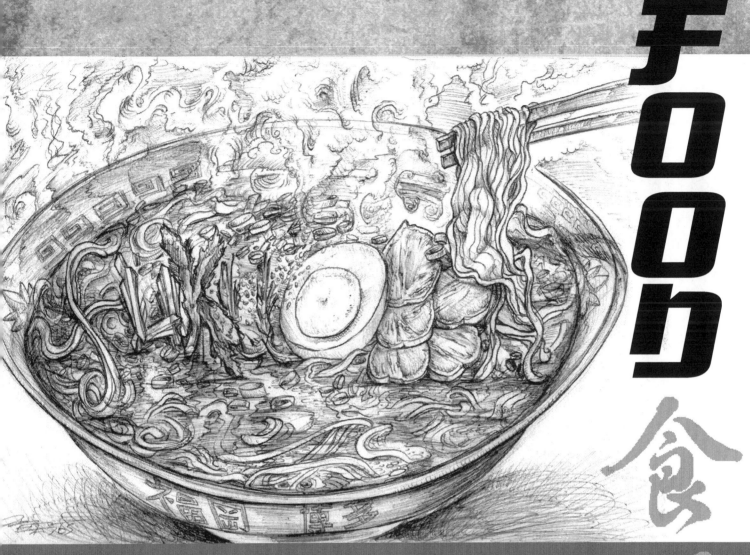

Famous Fukuoka Ramen. There are all kinds of ramen, like miso, shoyu, butter corn, chilled, ika-sumi (black squid ink), and monkey to name just a few. Regional varieties vary, but Hakata ramen which has a rich, milky broth and distinctive accoutrements like crushed garlic, beni shoga (pickled ginger), spicy pickled mustard greens (karashi takana), sliced negi (leek) and an egg, is lately one of the most popular and well-known famous ramens in Japan. Side note, before eating ramen, recommended viewing of Tampopo (which means Dandelion), a 1985 comedy by Juzo Itami, starring a handsome young Ken Watanabe that revolves around ramen culture and rituals like meticulous preparation, water temperature, eating styles, proper slurp volume, etc.

有名な福岡ラーメン。日本には味噌、しょうゆ、バターコーン、冷麺、イカスミ、猿ラーメン、どんな種類だってある。地域によって様々だが、博多ラーメンはこってりした白いスープが特徴だ。にんにくに紅しょうが、からし高菜、ネギ、そして卵が入っており、人気があって有名なラーメンだ。ところで、ラーメンを食べる前に、伊丹十三の『タンポポ』を観ることをおススメする。若いときの渡辺謙が俳優として出演している。ラーメンの文化、繊細さ、お湯の温度、食べる作法、音の立て方など詳しく説明されている。

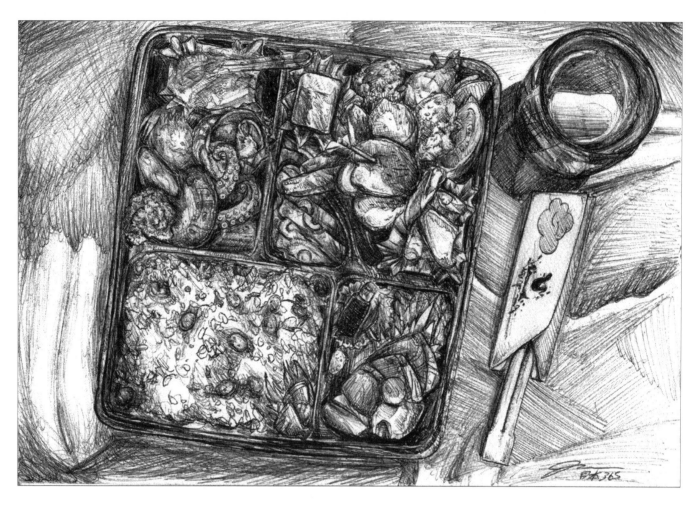

▲ Bento, Japanese lunch-box. A sashimi (raw seafood) still-life.
日本のランチボックス、お弁当。お刺身の静物画。

Natto no Taki. Ibaraki Prefecture, es-
pecially the capital city Mito, is known
for natto. Natto is a disgustingly deli-
cious fermented soybean food, con-
sumed humorously throughout Japan.
It comes single-serving in cute little
disposable styro-foam packages, it's
cheap and very good for you. It has
anti-cancer and anti-aging benefits,
and is the stickiest, slimiest food you
will probably ever eat. Mito Art Tower,
designed by Arata Isozaki, is being
slimed by a cascade of huge natto. In
Japanese this phenomenon is called,
Natto no Taki, or Natto Waterfall.

「納豆の滝」。茨城県でも特に水戸市は
納豆で知られている。納豆は大豆を発
酵させたもので、とても美味しく、日本中
で食べられている。スチールの容器に小
分けに入っており、安くて体にいい。抗
がん作用、アンチエイジングの効果もあ
り、人生で出会った中で一番ねばっこい
食べ物だ。磯崎新が設計した水戸芸術
館タワーに納豆がねばついてる。この現
象を「納豆の滝」という。

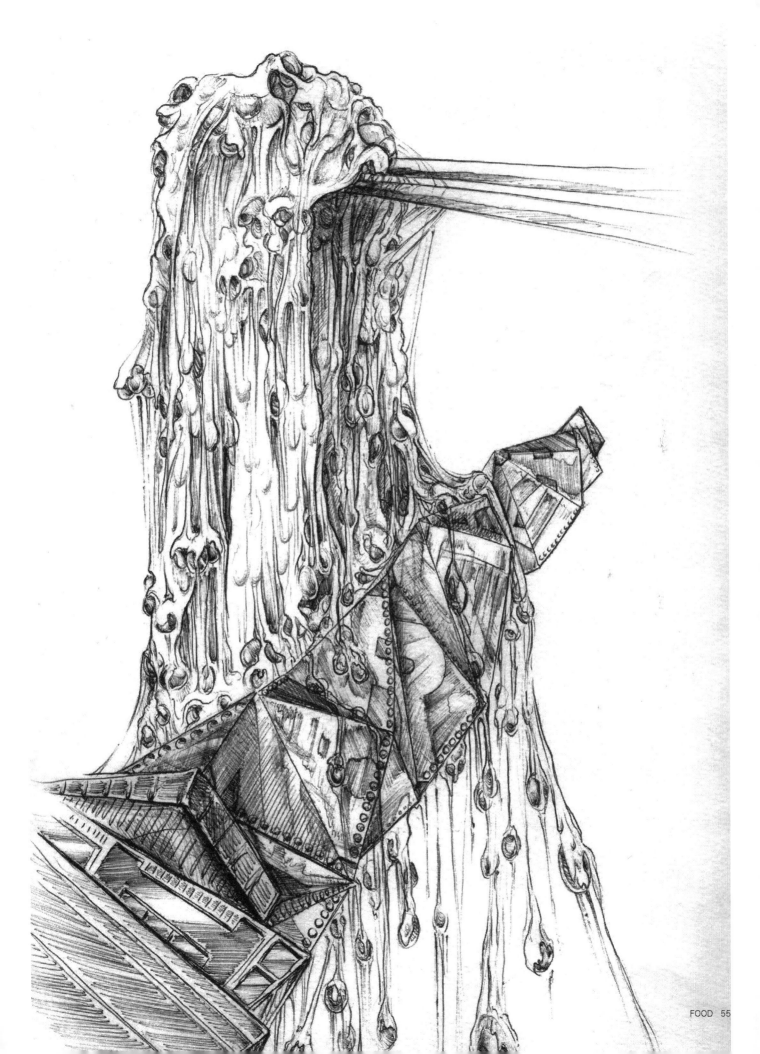

Yet another daikon, take three. Literally. Triplets freestyle rap dance party!
更に別の大根。第3段！3組のフリースタイルのラップダンスパーティ！

Zen zai on the brain. (Skull refer-
enced from Leonardo Da Vinci's 1489
sketch) + (Zen zai, mochi filled with
sweet azuki beans) = an anatomically
delicious combination
頭の中はぜんざい。骸骨はレオナルド・ダ
ビンチの1489年スケッチから。

▲ Funny Piman (green pepper). Very
clever veggie art; Scared to become
salad? LMAO Thx Shinya <3<3 by way
of bff Adam ;D for the iiiiiiinspiration
via FB sharezz..LIKE!
面白いピーマン、野菜のアート、サラダに
なるのは怖いかな?

◀ Francisco Jose de Goya was a
famous modern Spanish painter and
print-maker of the 18th-19th century,
regarded as one of the Old Masters.
Goya also happens to be the Oki-
nawan name for bitter melon. Thanks
to Goya's etching, Tantalo (1799),
Goya meets Goya!

18世紀から19世紀、スペインの有名 な
芸術家であり版画家でもあるフランシス
コ・ホセ・デ・ゴヤ。沖縄弁でこの野菜は
所謂「ゴーヤ」。アーティストゴヤの1799
年の「タンタロ」と言う作品のおかげで、
ゴーヤとゴヤが出会った!

Wasabi, a wild root found five minutes from my house, in a trickling stream down to the sea. Wasabi grows in water or very moist areas, and when grated fresh, the unique spicy flavor magically disappears after 20 minutes.

わさび、僕の家から5分のところの、海へ通じる小さな小川で見つけた野生の根。わさびは水の中またはとても湿った所で育ち、独特の辛さがあり、20分後に辛みは消えてなくなる。

Kuri, chestnuts. Delicious when roasted.
焼いておいしい栗。

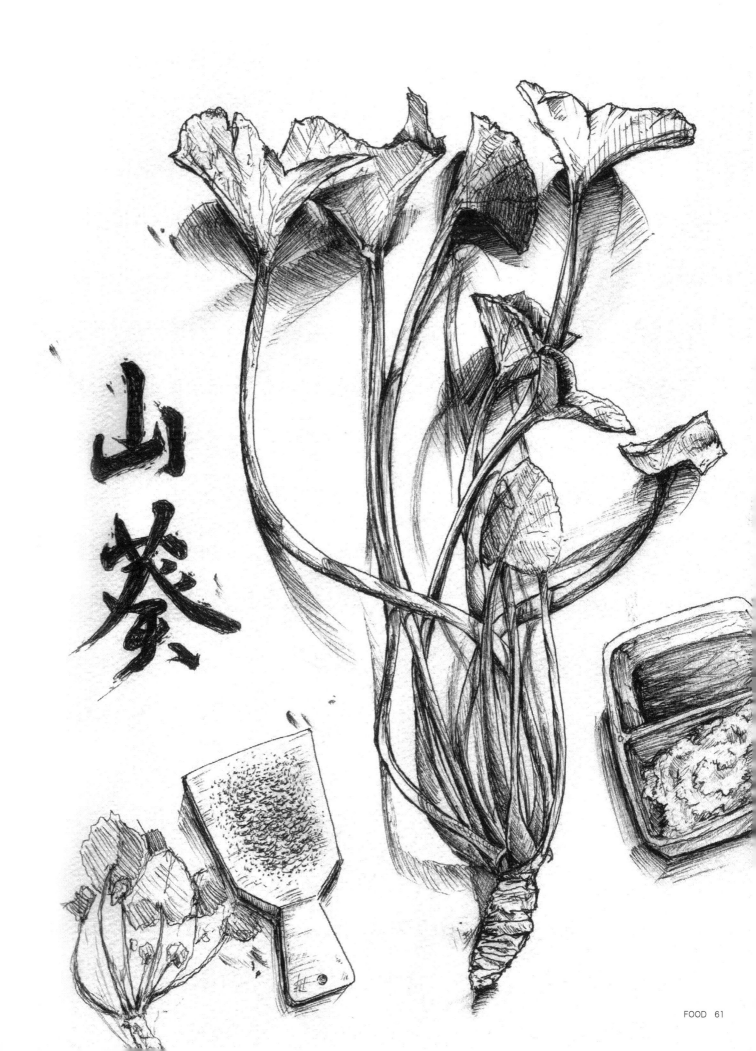

山葵

How 'bout them apples? Aomori Prefecture, famous for its delicious and diverse array of apple cultivars, produces the most apples of all prefectures in Japan.

りんごを食べませんか？様々な種類のリンゴがあり、その美味しさで有名。 青森県

Persimmon + Pagoda, Kaki no ki and
Horyuji Temple in the background.
World Cultural Heritage Site, Nara

柿の木と仏塔。法隆寺を背景にして。世
界遺産の地、奈良県

Adam eyeballing the blueberry soft cream, pit-stop to see Senmaida, the thousand terraced rice fields. Noto Peninsula, Ishikawa Prefecture
千枚田の道の駅。ブルーベリーソフトクリームを見て興奮するアダムさん。
能登半島　輪島　石川県

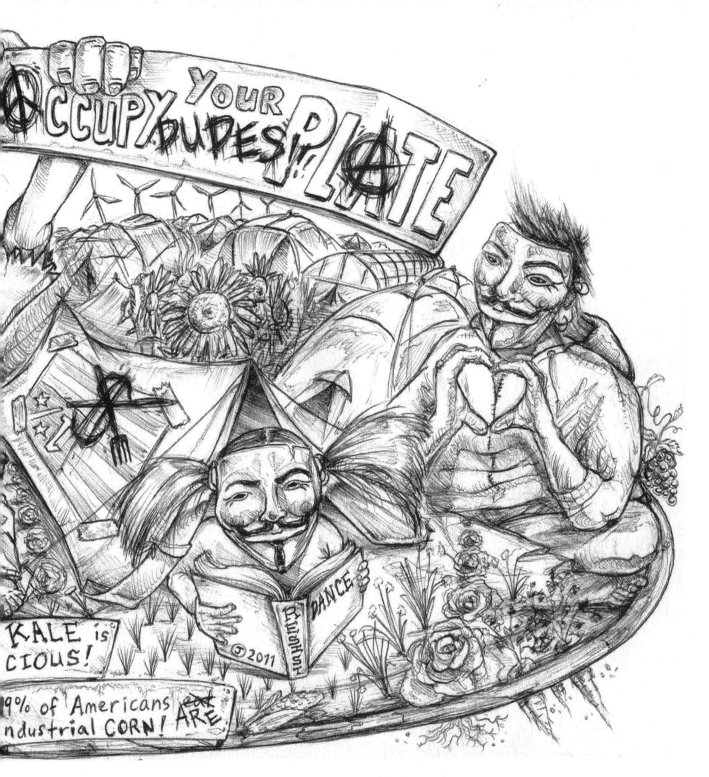

OCCUPY Your Plate, Dudes! Design for Austin Green Art's OCCUPY Your Plate Campaign (representing for my AGA family in Texas). If you look closely you can see little kome (rice plants) and negi (leeks) along with kabu (radish), ninjin (carrots) and kyabetsu (cabbage).

あなたのプレートを占拠するぞ！オースティン・グリーン・アートの『OCCUPY(占拠)』キャンペーン(僕のテキサスの仲間用)。近くで見ると小さな米粒やネギ、カブ、人参、キャベツが見えるよ。

かりんは昔、金のりんごと呼ばれていた。
かりんのジャムはなかなか美味しい！ポ
ルトガル語でかりんはマルメロという。と
ころで、日本人がよく使う「ママレード」と
いう言葉の言語は、実はポルトガル語だ。

Quince (Karin, in Japanese) known in
ancient times as the "Apple of Gold."
The name "marmalade" comes from
the Portuguese word for this fruit,
"marmelo." Truly, quince makes a real
nice jam!

テ TEA

Gen Mai Cha, "The People's Tea." Gen mai cha, brown rice tea, is one of my favorite types of green tea. Depending on the type of leaves used, whether or not they are fresh, dried, roasted, pure, blended, powdered, punched-in-the-face, extracted, teleported, transmigrated, get a make-over, party all night, eat their veggies, etc. Depicted as a simple yin-yang pattern, in-yoo in Japanese, formed by a warm mixture of green tea leaves and the popped/roasted brown rice kernels. Sometimes referred to colloquially as "popcorn tea" because a few grains of rice pop during the roasting process like popcorn.

玄米茶、「庶民的なお茶」。玄米茶は僕の一番好きなお茶。葉の種類は多岐にわたり、新鮮なまま、乾燥させる、焼く、交ぜる、顔にパンチ、抽出、瞬間移動、改造、パーティでオールナイト、食べる・・・、などなど。これは温い茶葉と炒った玄米を使って陰陽の図柄を描いたもの。焼くときに時々玄米がはねるので、「ポップコーン茶」とも呼ぶ。

This type of tea was originally drunk by poor Japanese, as the rice served as a filler and reduced the price of the tea; which is why it is also known as the "people's tea." Today though, it is consumed by all segments of society. Shizuoka Prefecture accounts for 45% of Japan's overall tea production. Green tea plantations date back to 1241, when a monk named Shoichi Kokushi returned from Sung China to his native Shizuoka with green tea seeds in hand. Shizuoka's climate, water quality, and proximity to major ports established the area as a major player in the green tea game, that continues to thrive for national distribution as well as exporting worldwide, if the price is right.

この種類のお茶は元々貧しい日本人によって飲まれていた。米でお茶の量を増してお茶の値段を押さえようとした。と言う訳で庶民のお茶として知られている。しかしながら今日では様々な人々によって消費されている。静岡県は日本のお茶の生産量の45%を占める。お茶の生産は1241年に始まり国師聖一という僧が宋から日本へ帰国する際にお茶の種を持ち帰った。静岡の気候、水質そして、大きな港に近いことが静岡を有名なお茶の生産地にした。日本だけではなく、世界中にお茶の供給をする努力を続ける。

And did you know? Green tea should typically only be steeped for a short time, and specific water temperatures should be observed. Gen mai cha in particular, the first steeping should be for about 1 minute 20 seconds at approximately 98 degrees Celsius. Further steeping of the same leaves, add hot water at 90 degrees Celsius to the pot of tea leaves and immediately pour. Other kinds of green tea like sencha, bancha, matcha, gyokuro-cha, kuki-cha, and houji-cha will vary. Steep and enjoy accordingly!

それから、お湯を注ぎ短時間置いておく。お湯の温度に気をつける。特に玄米茶は、最初は98度のお湯で1分20秒置く。同じ葉を使う場合、次は90度のお湯で、すぐに注ぎいれる。煎茶、番茶、抹茶、玉露茶、茎茶、ほうじ茶、お茶の種類によってそれぞれの楽しみ方がある。

Tea fields with a view of Mount Fuji. These perfectly sculpted hedges are actually millions of green tea leaves, ripened by the sun, and possibly by radioactive waves. After the Fukushima nuclear power plant disaster, nothing within a wide radius is 100% safe as the wind can carry contaminated particles a long way.

富士山が見える茶畑。きれいに刈り込まれた生け垣にみえるのは、実際に無数の茶葉なんだ。太陽の日差しを浴びて育った。しかし放射能も浴びてきたのかなぁ。原発の後、必ずしも安全だとは言えない。

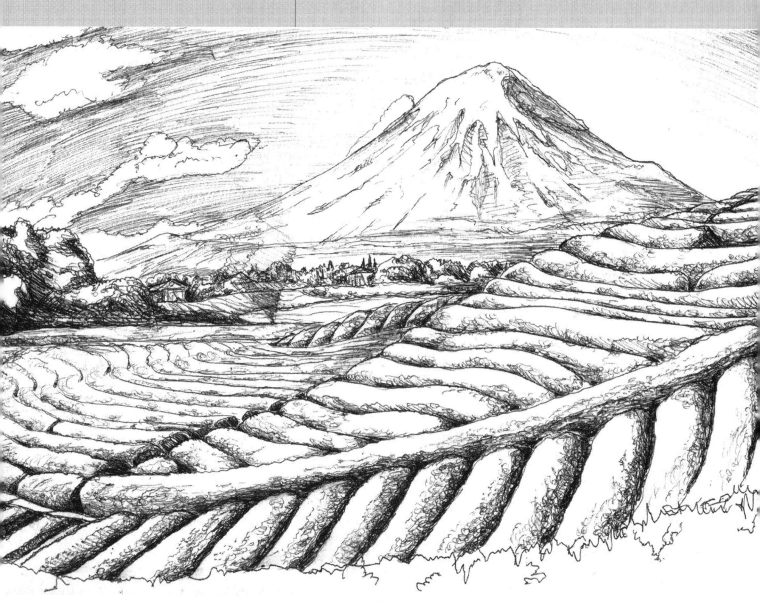

People working in the field with a view of the Sea of Japan. Here tending the tea, a typical coastal farming scene; afternoon sun, fishermen, a few sea-birds in the distance... You can almost smell the miso soup cooking.

海が見える畑に働く人々。ここは、日本海の近くの茶畑。西日、漁民、カモメが現れる。味噌汁の匂いが漂ってくる。

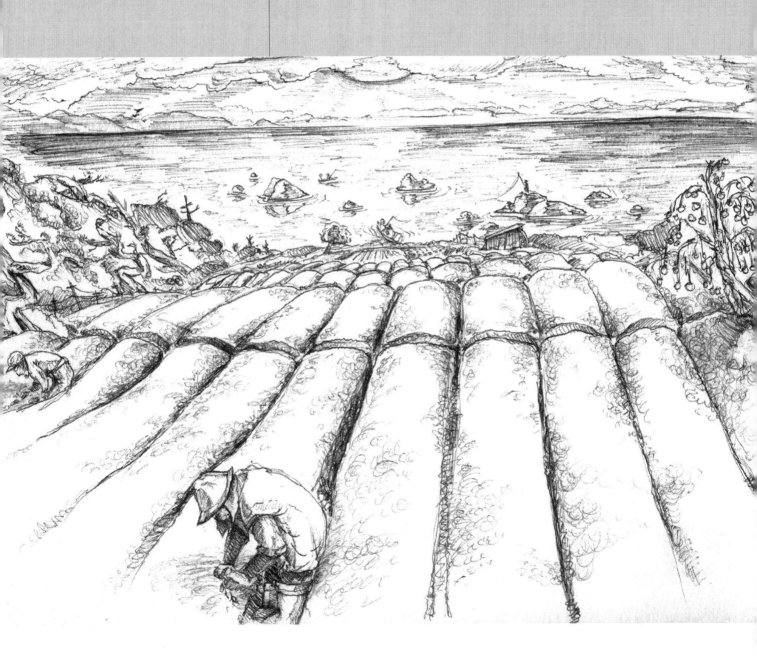

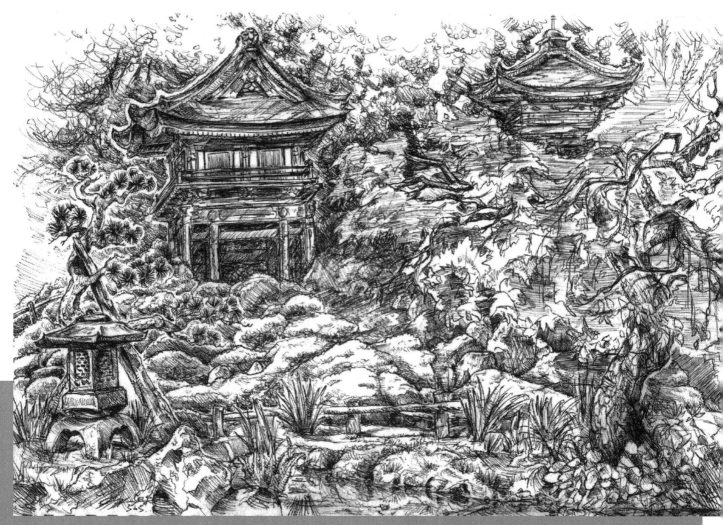

The oldest public Japanese Tea Garden in the United States (since 1894) is in San Francisco's Golden Gate park. Originally created as a "Japanese Village" exhibit for the 1894 California Midwinter International Exposition. When the fair closed, Japanese landscape architect Makoto Hagiwara and superintendent John McLaren reached a gentleman's agreement, allowing Mr. Hagiwara to create and maintain a permanent Japanese-style garden as a gift for posterity. He became caretaker of the property, pouring all of his personal wealth, passion, and creative talents into creating a garden of utmost perfection. Mr. Hagiwara expanded the garden to its current size of about five acres where he and his family lived for many years until 1942 when they, along with approximately 120,000 Japanese Americans, were forced to evacuate their homes and move into internment camps. When the war was over, the Hagiwara family was not allowed to return to their home at the tea garden and in subsequent years, many Hagiwara family treasures were removed and new additions were made.

Today, the Japanese Tea Garden endures as one of the most popular attractions in San Francisco, featuring classic elements such as an arched drum bridge, pagodas, stone lanterns, stepping stone paths, native Japanese plants, serene koi ponds and a Zen garden. Cherry blossom trees bloom throughout the garden in March and April.
(Excerpt from japaneseteagardensf.com)

アメリカで一番古い公共の日本庭園（1894年）はサンフランシスコのゴールデンゲイトパークにある。元々、1894年に開催されたカリフォルニアのミッドウインター国際博覧会で、日本の村という展示品として制作された。博覧会が終わった後、日本人の建築家、萩原　まことと指導監督者のジョン　マクラーレンが、後世への贈り物として日本庭園を造って永久に残すことに賛同した。萩原氏は、管理人となり私有の財産と情熱と創造的才能をすべて庭造りに注ぎ込んで、できうる限りの完璧さで作り上げた。萩原氏は庭園を現在の面積、20.234kmに拡張して1942年までもの長い年月を家族とともにそこで暮らしたが、その年、およそ12万人もの日系アメリカ人とともに強制収容所に送られた。戦争が終わっても萩原家の家族は庭園にある自宅に帰ることは許されず、その後、萩原家の財産の多くは運び出され、庭園には新しい物が付け加えられた。今日、その日本庭園は、サンフランシスコで最も魅力的な観光地の一つとして名声を保持している。太鼓橋、あずまや、石の灯篭、飛び石、日本古来の植物、鯉の泳ぐ穏やかな池、そして、禅宗の庭園という日本の伝統的な要素を特色としている。3月、4月に庭園のいたるところで桜の花が開く。
「japaneseteagardensf.com」より抜粋

Sadou, also called chadou or cha-no-yu, is the traditional etiquette of preparing and drinking tea. The tea ceremony was perfected by Sen no Rikyu in the Azuchi-Momoyama period (1576-1600). One of the most fundamental elements is that the host follows various rules in every procedure of the tea ceremony. In the serving of tea, te-mae, the host puts matcha (powdered tea leaves) into a tea cup and adds hot water. It is whipped with a chasen (bamboo whisk) until it gets foamy, and is then served, to be sipped with extreme focus and intensity. Another important element is a shared sense of communication (though often non-verbal through gesture) between the host and the guests throughout the ceremony. The host prepares with deep sincerity everything from tea utensils, a hanging scroll, ikebana (flower arrangement), a vase or vessel and other amenities to go with the environment, season or occasion. From such activities, the guest is obliged to feel the host's warm hospitality and is filled with gratitude and humility.

茶道（または茶の湯）は、日本の伝統文化の一つだ。安土桃山時代に千利休により大成された。季節に合わせて選ばれる花や茶道具、非言語 コミュニケーションでのおもてなしを味わえるとても楽しい世界 だと僕は思う。

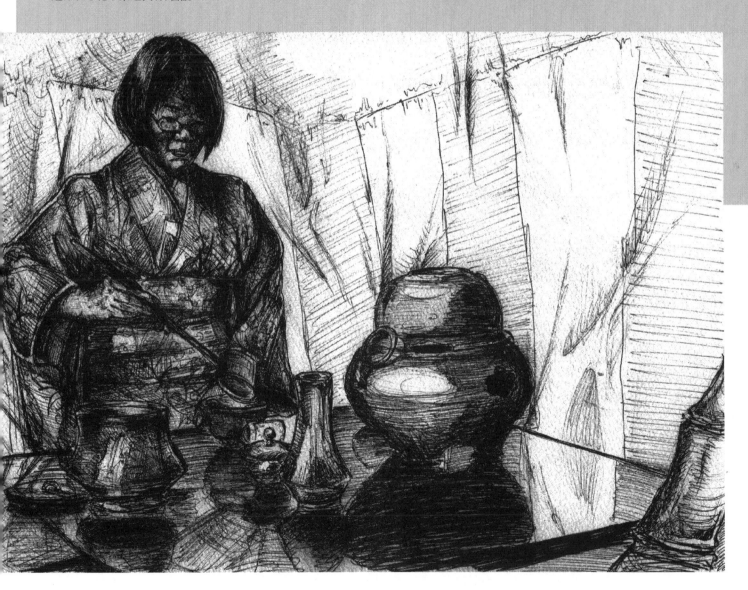

TOHOKU

東日本大震災

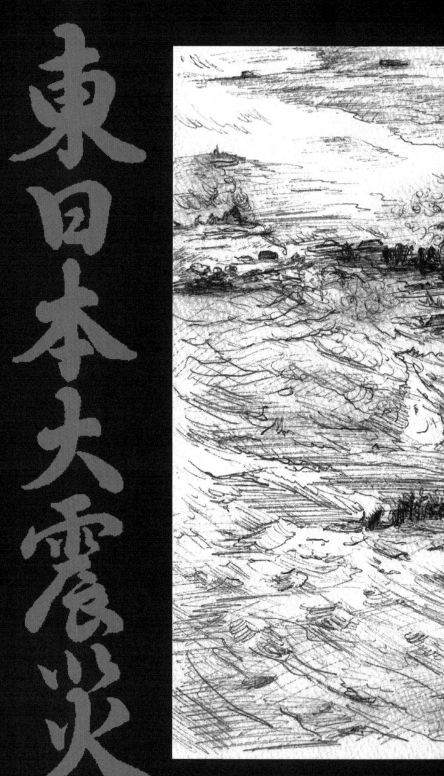

Tsunami encroaching on land, flowing over roads and washing away airplanes and 18-wheelers as if they were tiny plastic toys.

津波が道路を越えて襲いかかっている。まるでお風呂に浮かぶアヒルの人形のように、飛行機や18の車が流されていた。

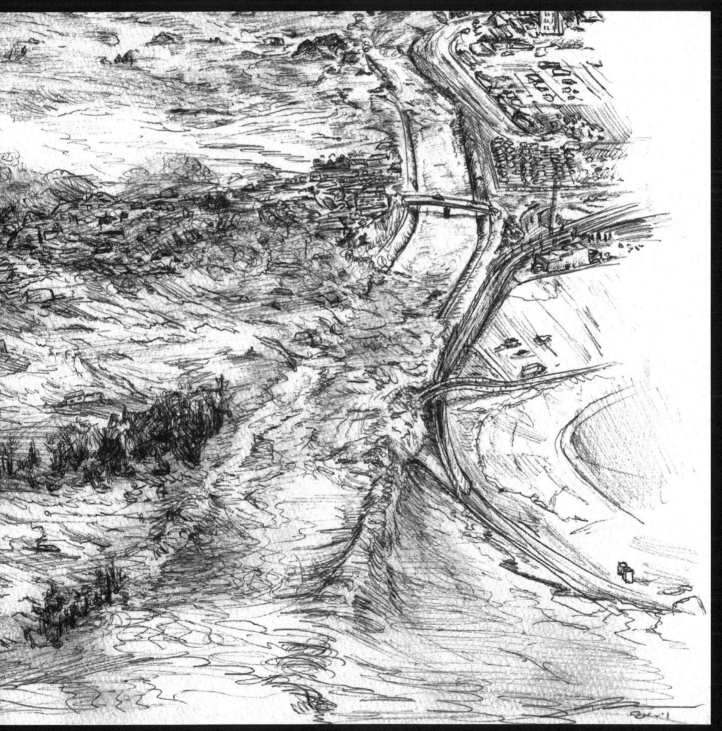

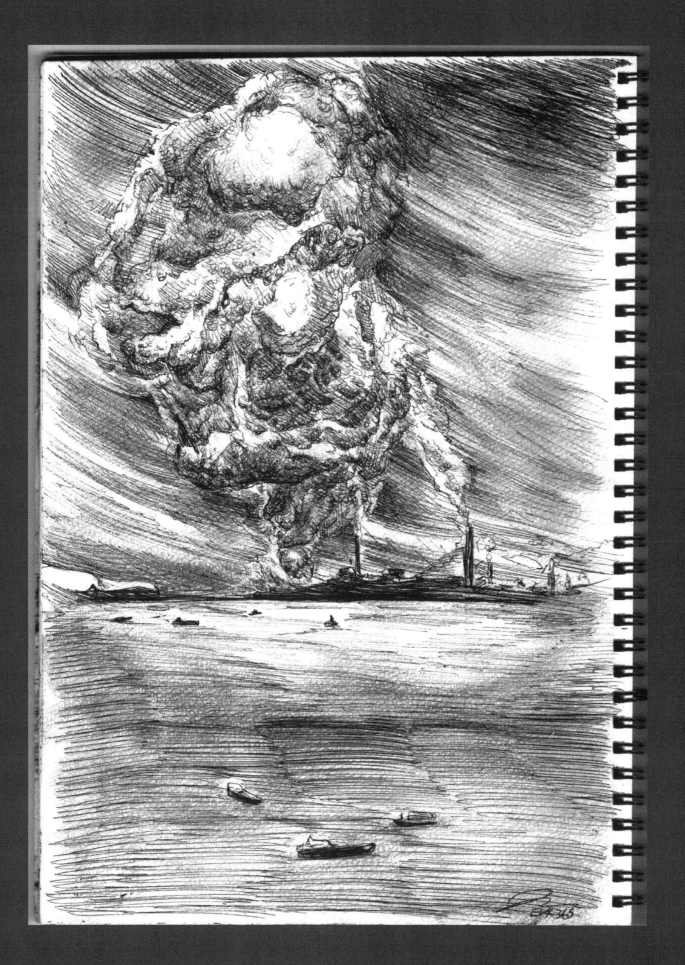

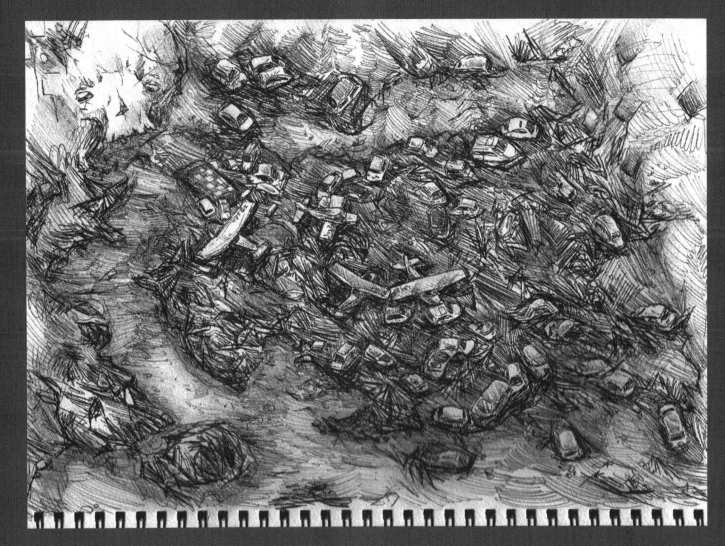

▲ Cars and planes, swept away in the massive tsunami (10m high upon landfall along parts of the coastline), mixed up with lumber and other massive debris at Sendai Airport.

車や飛行機が材木やガレキとともに巨大な津波の渦に流されていた（海岸線の10mも越えた波だった）。仙台空港にて。

◀ Fukushima Nuclear Power Plant explosion, fire burning into the night reflected in the water as boatmen watch, stupefied.

福島原発の爆発。夜空に燃え上がる様子を船頭達がただただ眺めているようであった。

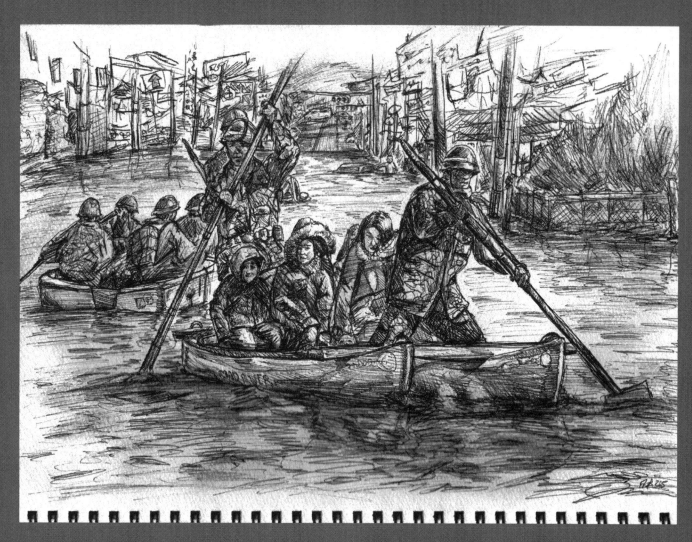

Urban rescue, this is no Venice.
街での救助。ここはベニスじゃないのに。

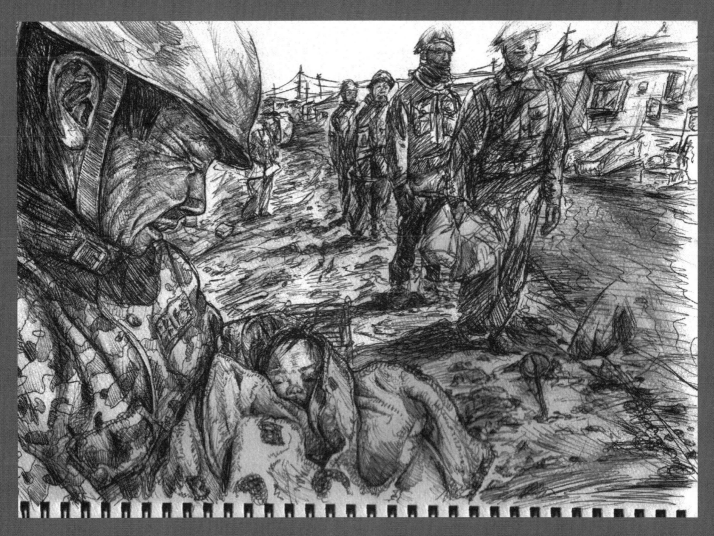

An officer smiles as he holds a
4-month-old baby girl who was res-
cued in Ishinomaki, Miyagi Prefecture
on March 14, 2011.

2011年3月14日、ある警察官が、宮
城県の石巻市で救出された生後四か月
の赤ちゃんを抱いて微笑んでいる。

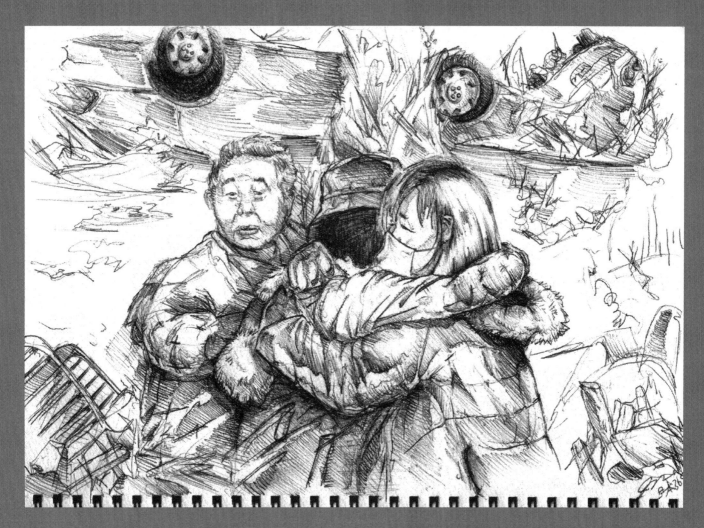

Never Forget. From the walls of the junior high school where I work, a tribute to the Great Disaster, victims reunited in embrace amidst the rubble.

ずっと忘れない。大災害を受けた被災者が、ガレキの中で再会を果たした。僕が働いていた中学校の壁から。

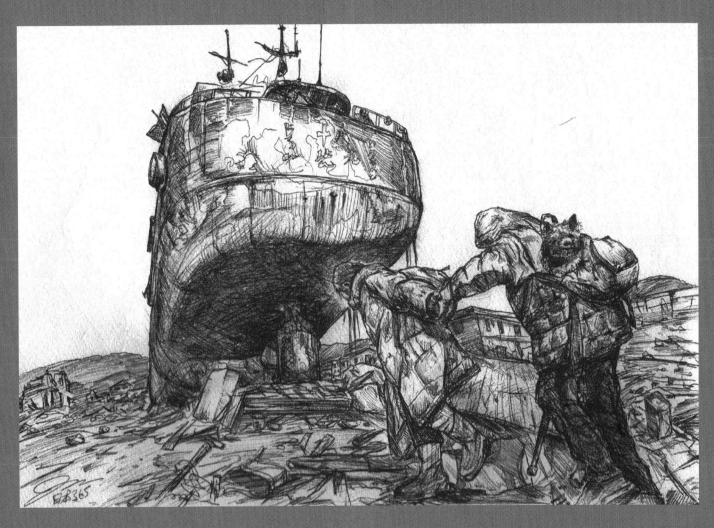

Walking where their house used to be...
我が家があった所へ。。。

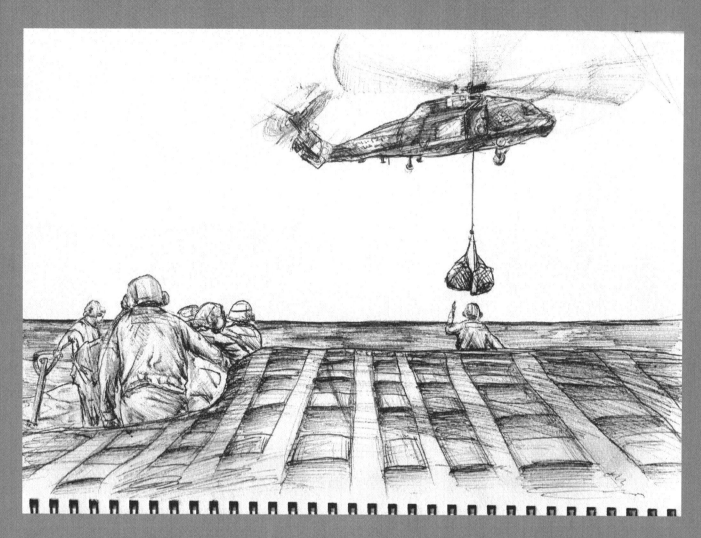

Supply drop
救援物資が落とされる

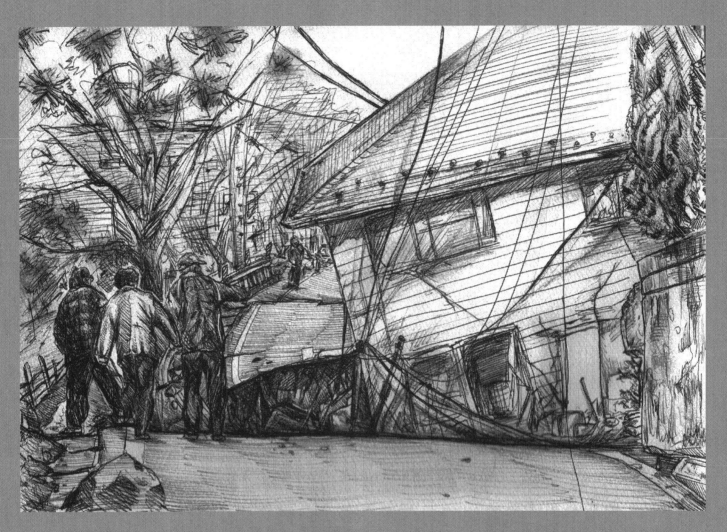

Remember the board game LIFE, and there was that house called the "split-level"? Yeah, this is real life. Neighbors survey a house together after the earthquake.

「人生ゲーム」を知ってるの？懐かしいだろう！それと違って、現実に起こったことだ。東北地方太平洋沖地震の後に近所の人たちが家の破損を見ている。

A woman shares her onigiri, rice ball, with her dog at an evacuation center for pets and their owners near a devastated area hit by an earthquake and tsunami in Kesennuma, March 17, 2011.

3月17日2011年、津波で壊滅した気仙沼の避難場所ではペットの犬と飼い主がおにぎりを分け合っている。

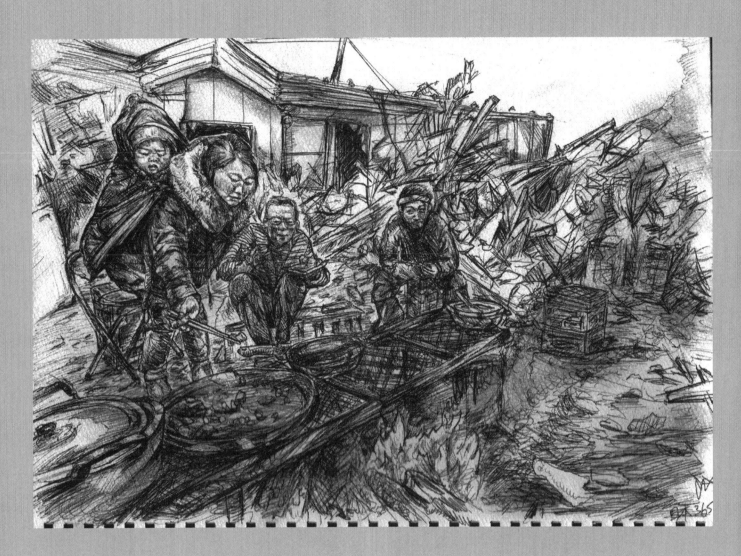

Disaster BBQ...
被災後の食事。。。

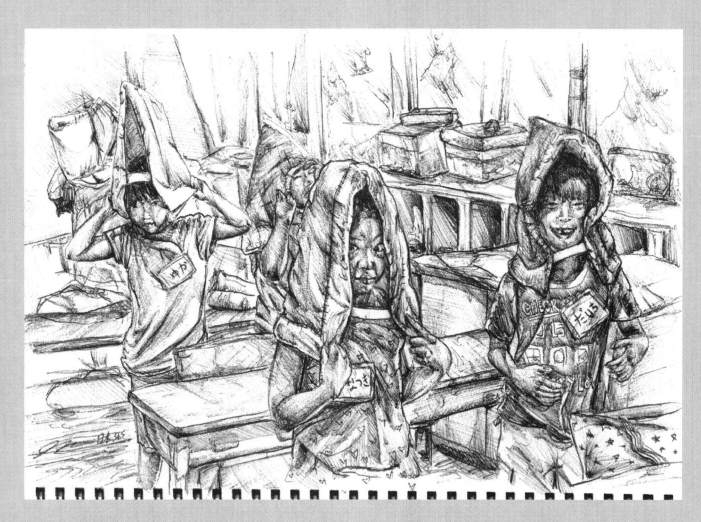

Disaster prevention. Pillow + Head = Safety + Cute!
防災。枕をのせた頭＝かわいくて安全。

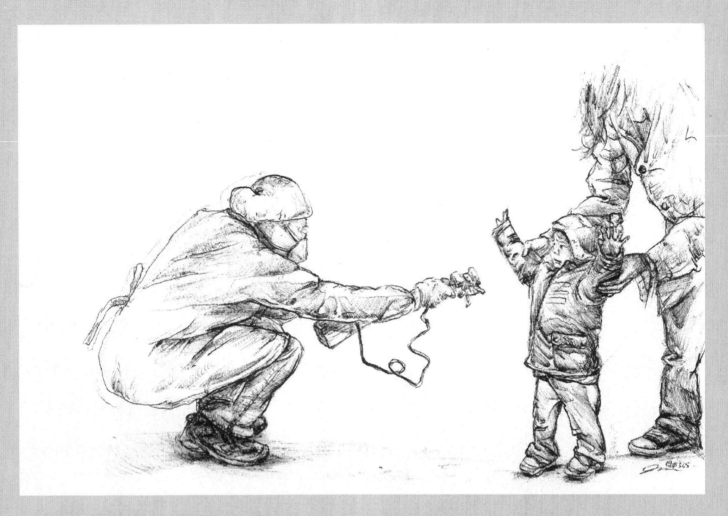

Stick 'em up! Checking for radiation.
手を挙げろ！放射線の検査。

No Man's Land. Excerpt from *National Geographic*, December 2011:

"A lone animal rights activist walks along the Fukushima coast. The power plant lies just over the hill, less than half a mile away. Weeks after other tsunami-hit regions were cleared of debris, cleanup crews hadn't yet been dispatched to this area because of radiation levels. Despite stiff penalties for illegally entering the zone, some animal rescuers defied restrictions as they sought to aid pets and farm animals that had been left behind."

ナショナル　ジオグラフィックより抜粋、２０１１年１２月：

「 無人の地、動物愛護団体の人が、福島県の海岸に沿って独り歩く。８００メートルも離れていない、丘を越えた向こうに原子力発電所がある。他の地域の瓦礫が片付けられた後、数週間経っても、この地域には、だれも派遣されてこない。高い放射能レベルのためだ。法律で禁止されたこの地区に入ると罰則が科せられるにもかかわらず、人々は、取り残されたペットや農場の動物を救い出そうとして、自ら法に逆らった。」

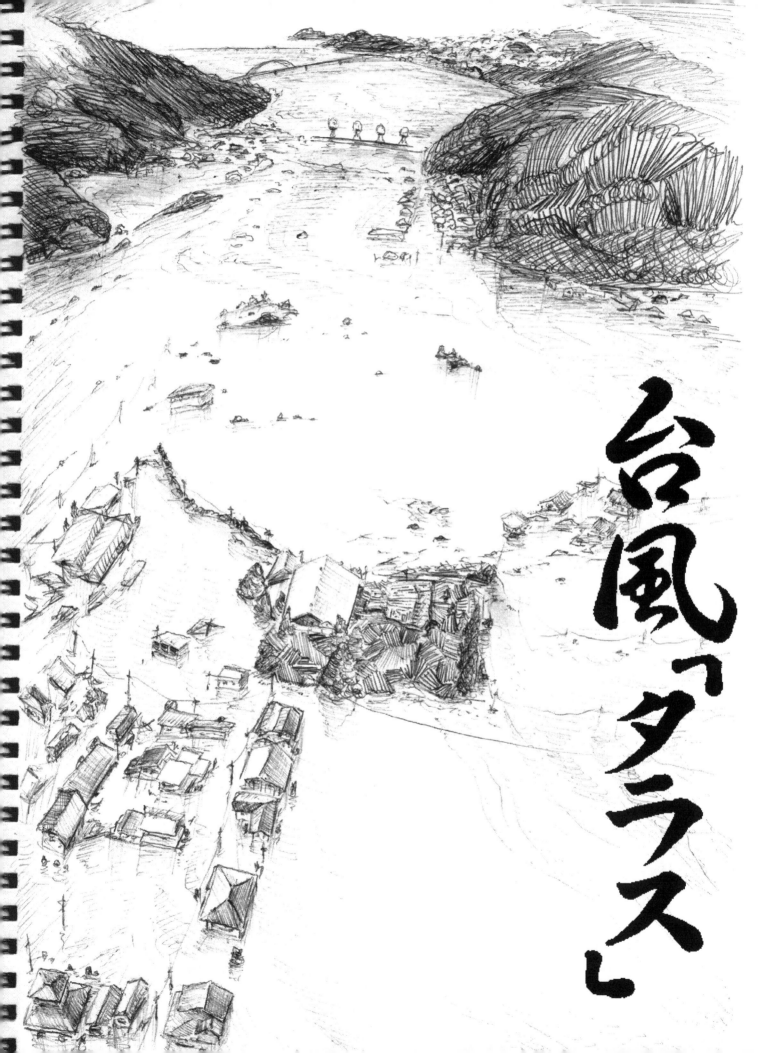

台風「タラス」

TALAS [TYPHOON NO. 12]

Talas is a word from the Filipino language that means sharpness.　フィリピノ語で「タラス」意味は鋭利。

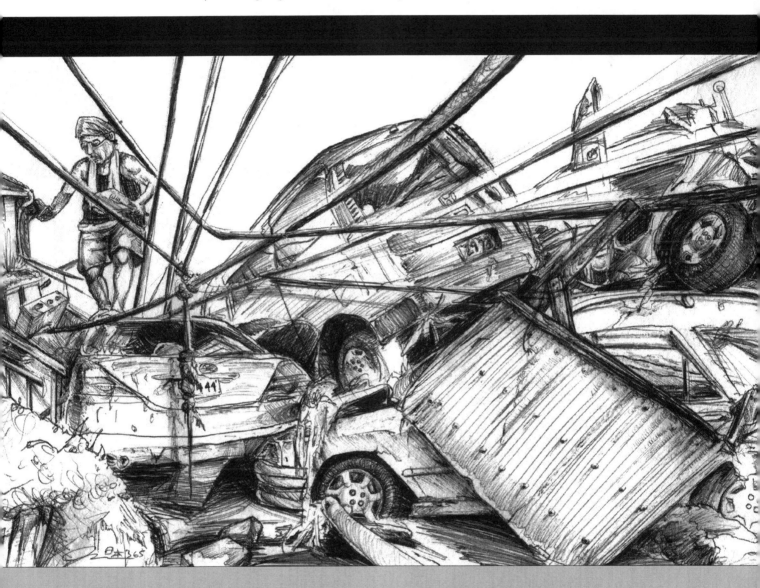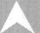

◀ TALAS #1, THE FLOOD

River absorbs Kiho Town in Mie Prefecture. Record rainfall, landslides, 68mph winds...

タラス1番、洪水

三重県の紀宝町が川で水浸しになった。
大雨、山崩れ、風速も27m/s

▲ TALAS #2

Strewn like toy cars amidst debris in the aftermath...

タラス2番

台風の後で、車が壊れたおもちゃのよう

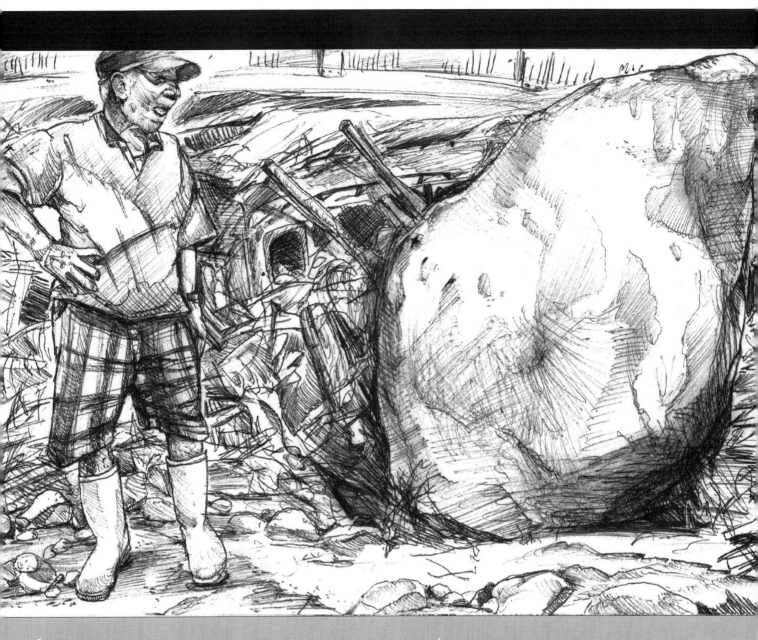

TALAS #3

Rescue mission through flooded
streets utilize the bucket seat...

タラス3番

道に溢れた水をクレーン車で運び出す

TALAS #4

Unwanted guest in this guy's brand
new "rock garden" courtesy Talas'
powerful floodwater...

タラス4番

この男性の作ったばかりの石庭に有難
迷惑な岩がドスンと落ちてきた

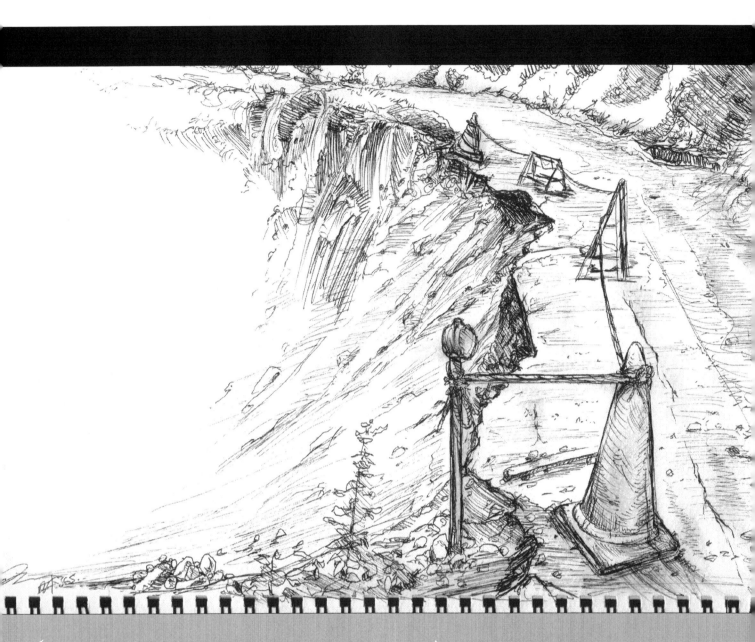

TALAS #5

This train's next stop? River. Stalled commuter looks on in disbelief at the buckled bridge (or rather, unbuckled). Time to install that zip-line...

タラス5番

次の電車の駅は？川です。通勤途中の男性が呆然と墜落した橋を見ている。ジップラインを据え付けるべきであるかなー

TALAS #6

Road knocked out by a landslide en route to Ojiro Gorge in the Hachikita mountains of Hyogo Prefecture.

タラス6番

兵庫県の八北山中にある小代渓谷通り道は山崩れで崩落した。

ɒNIᴍ

「蓮の花虱を捨るばかり也」小林一茶

"I went to where stray cats were hovering at the end of a long winter day and found an octopus in a plastic bag on concrete. Still locked in one panicked byzantium tentacle was an ear-shaped piece of reef carried from the reflected face of the moon.

"Earlier, K. practiced English by telling me of his rabbit. 'Last typhoon,' he said, 'probably a weasel,' then gestured, sank teeth into my rabbit's right front limb. 'Too small,' he said, gestured, to keep living after that. The rank remains of goat meat hung on his breath."

"At heavenly shores
lotus flowers stretched ahead
I sit with flung lice."

-Haiku by (Kobayashi) Issa, translation and commentary by Matthew Little

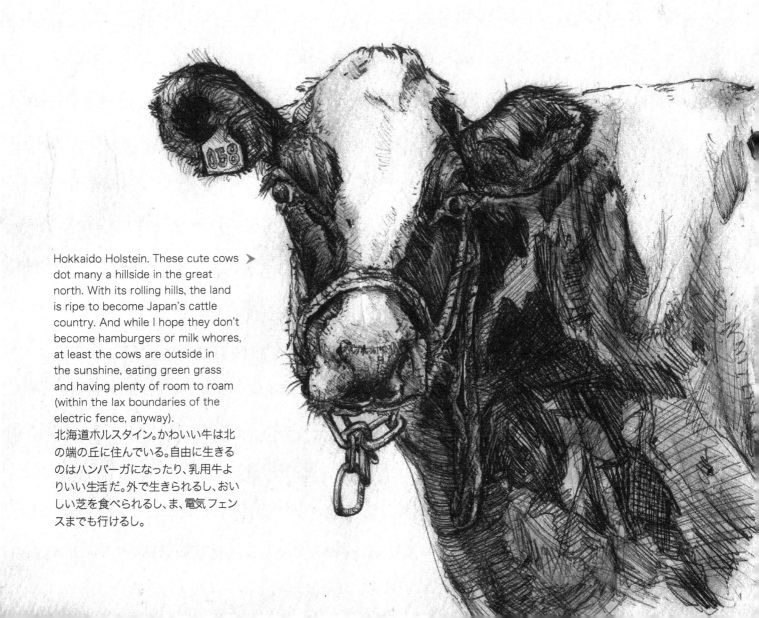

Hokkaido Holstein. These cute cows
dot many a hillside in the great
north. With its rolling hills, the land
is ripe to become Japan's cattle
country. And while I hope they don't
become hamburgers or milk whores,
at least the cows are outside in
the sunshine, eating green grass
and having plenty of room to roam
(within the lax boundaries of the
electric fence, anyway).
北海道ホルスタイン。かわいい牛は北
の端の丘に住んでいる。自由に生きる
のはハンバーガになったり、乳用牛よ
りいい生活だ。外で生きられるし、おい
しい芝を食べられるし、ま、電気フェン
スまでも行けるし。

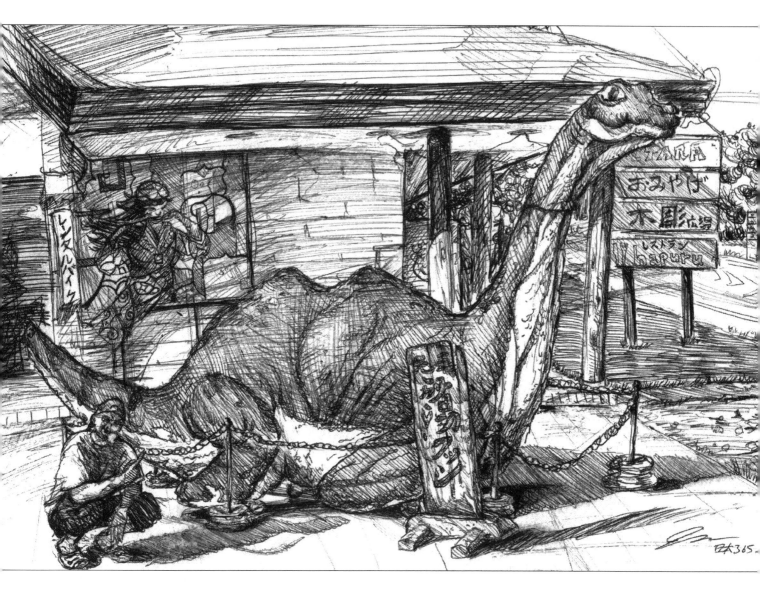

Kusshi the Lake Monster! This lake monster resembling a certain green brontosaurus trash sculpture (RIP Nosy) played a serious tune of nostalgia on my heart strings. Apparently "Kusshi" of Lake Kussharoko (play on "Nessy" of Loch Ness) lives mysteriously in the deep, terrorizing couples peddling those huge and audaciously cliche swan-shaped paddle boats. Kusshi also sells pistachio soft cream.

屈斜路湖のクッシー！　昔ぼくが作った恐竜の彫刻によく似ていて懐かしい。イギリスのネス湖のネッシーみたい、クッシーは屈斜路湖に住んでいてスワンボートで湖に入ってくるカップルを驚かそうをする。また、ピスタチオ味のソフトクリームも売っている。

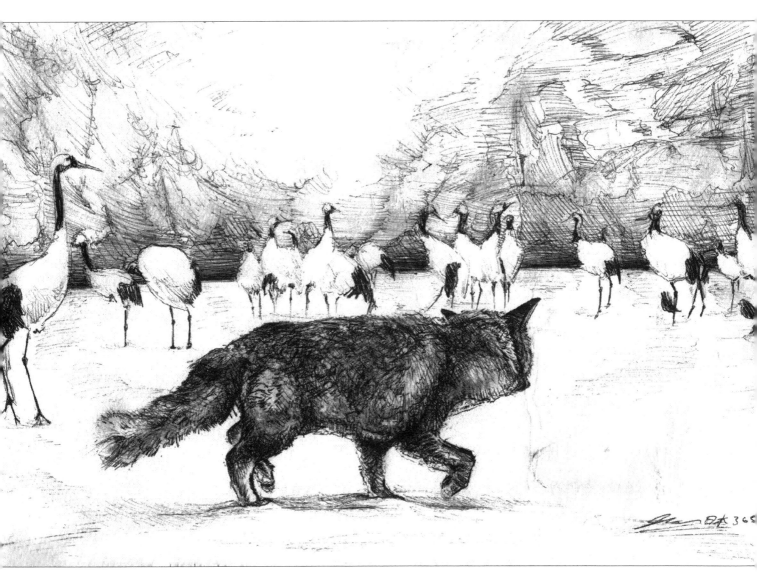

A red fox stalks red-crowned cranes,
not very inconspicuously, in such a
snowy-white wintry setting.
Photo: Roy Toft
この赤い狐は赤い頭の鶴を尾ける。白い
雪景色の中目立ち過ぎてばれればれだ。
写真：ロイ・トフト

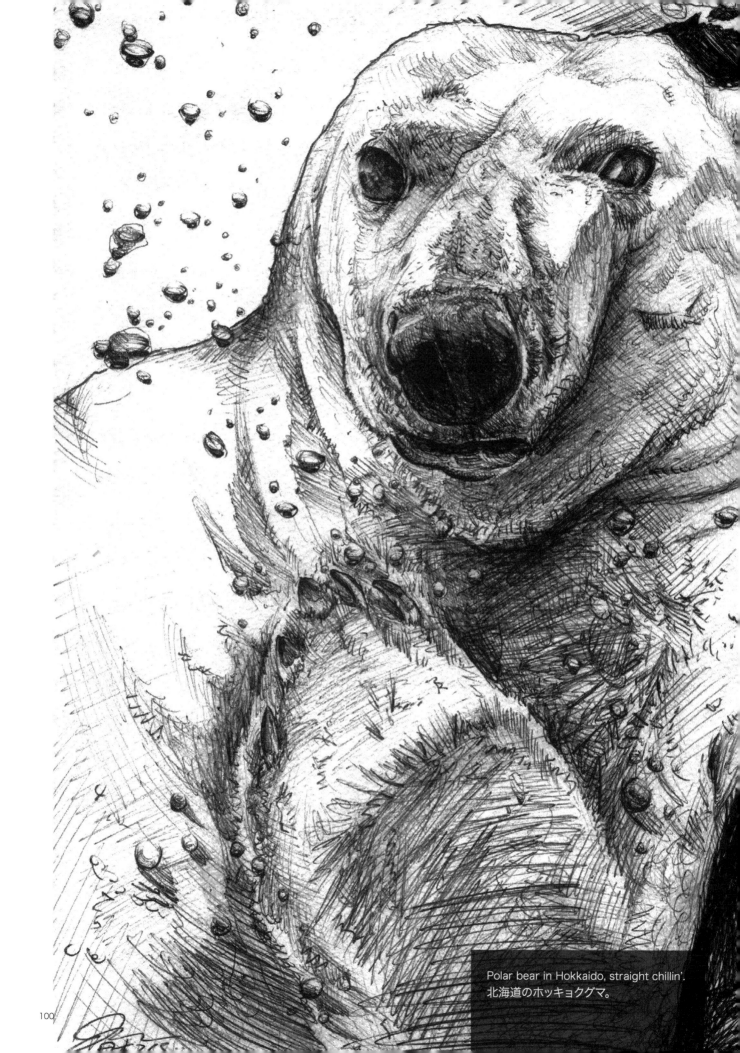

Polar bear in Hokkaido, straight chillin'.
北海道のホッキョクグマ。

100

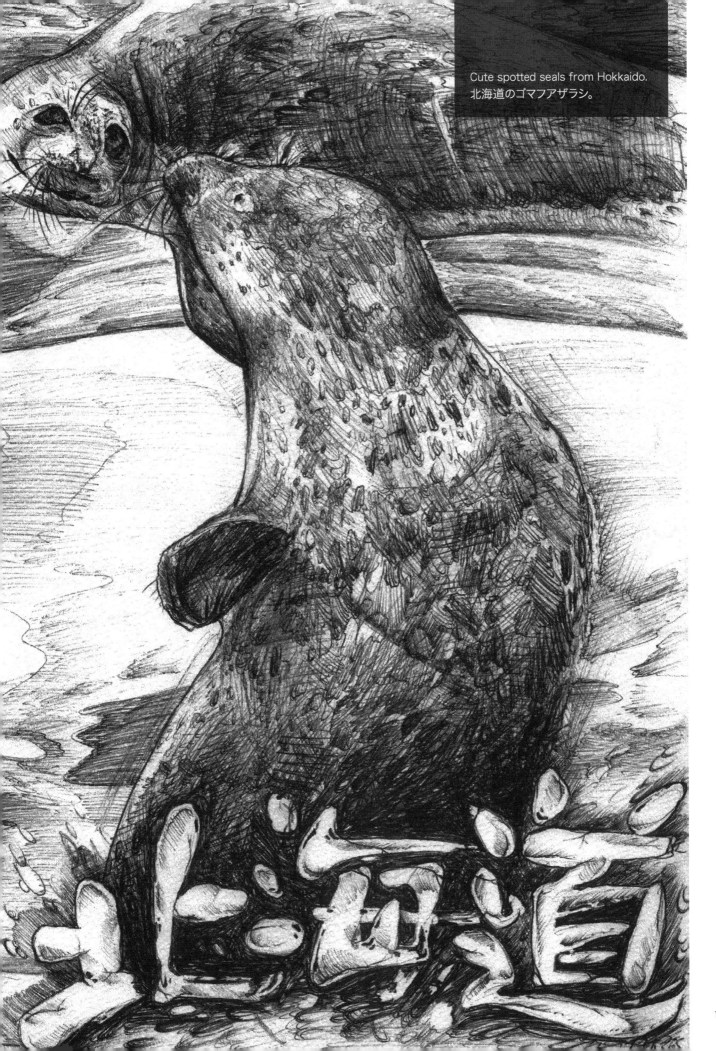

Cute spotted seals from Hokkaido.
北海道のゴマフアザラシ。

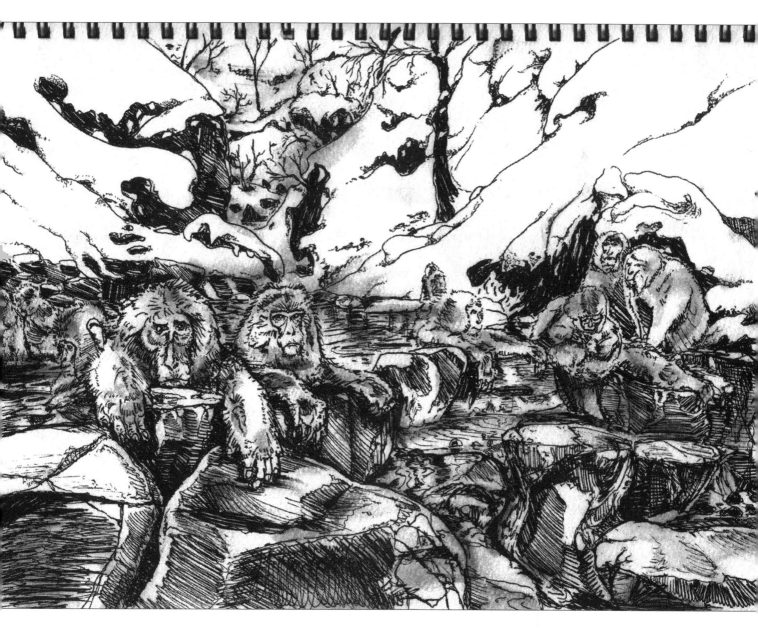

Monkeys (Saru) in the onsen, and
they don't look too happy. Jigokudani,
Nagano Prefecture
温泉ザルたちはあまり楽しそうではない
ね。長野県 地獄谷

Tanuki. This raccoon dog animal has huge testicles, and for that and some other less humorous reasons, it is a ubiquitous symbol of good luck, wealth and prosperity throughout all of Japan. Statues and wood carvings large and small can be found out in front of houses and shops all over the country. But beware! After nightfall, they are ravenous, scavenging beasts. I know this because one night, while camping on Miyajima, a bold and daring tanuki tried to eat the Cup Ramen right out of my cold, hungry hands!

タヌキ。大小様々なタヌキの像や木彫りを、店先や家の玄関など日本全国至るところで目にすることができる。巨大な睾丸は幸運、富と繁栄を願ってのことである。ある日、私が宮島でキャンプをしていた時、彼らは大胆 にも私のカップラーメンを盗み食いしようとした。可愛い彼らには要注意！夕暮れの後、貪欲な獣に変身するのを私は知っている。

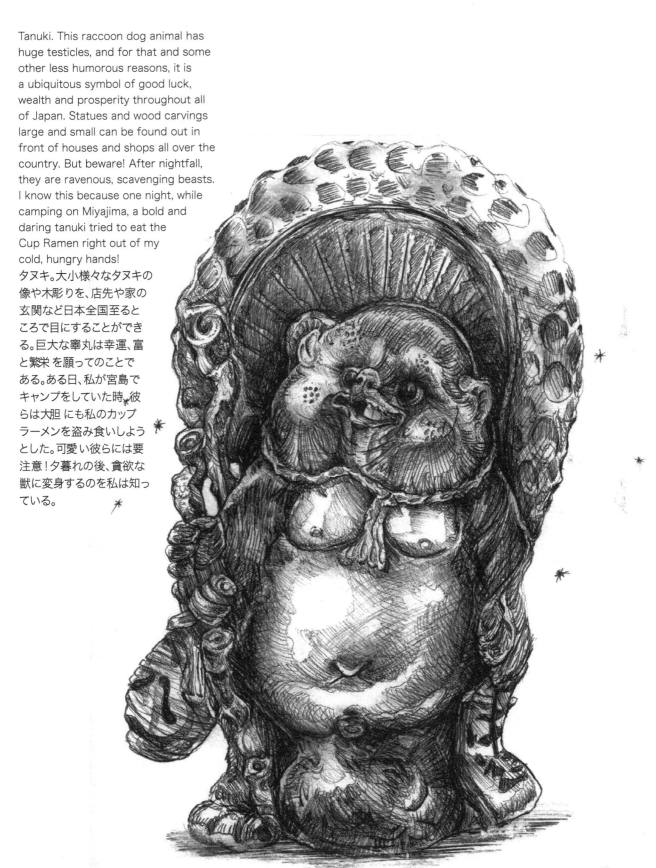

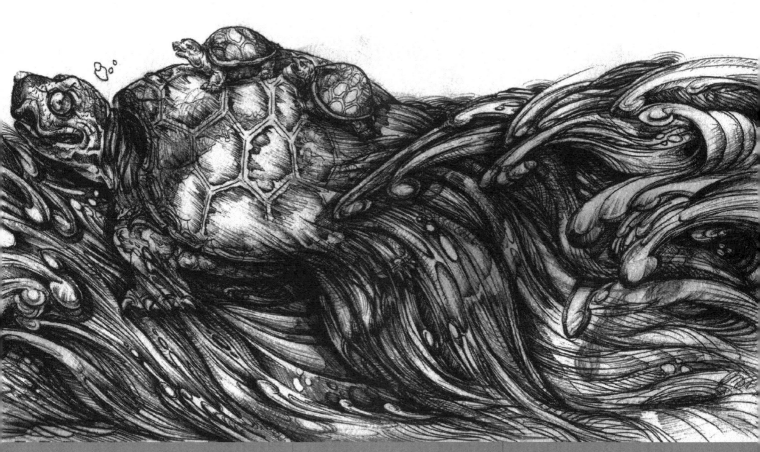

The Legend of Urashima Tarou. According to traditional Japanese beliefs, the tortoise is a haven for immortals and the world mountain, symbolizing longevity, good luck, and support, and is the iconic god symbol of seafaring people. This minogame is so old it has a tail of seaweed growing from its shell. Urashima Jinja, a shrine on the western coast of the Tango Peninsula in northern Kyoto Prefecture contains an old document describing a man named Urashimako, who left land riding on a turtles back in 478 A.D. and visited a world far below the sea where people never die, to feast and dance with the Mistress of the Sea. He thought he was there for just three years. But, he returned in 825 A.D. (having been gone more than 300 years!) with a tamatebako, origami cube that can be opened from any side. Ten days later he opened the paper cube and a cloud of white smoke was released, turning Urashimako into an old man, truer to the earthly years he had lived. Then, after hearing this story, Emperor Junna ordered Ono no Takamura to build a shrine to commemorate Urashimako's strange voyage, and to house the tamatebako and spirit of Urashimako.

浦島太郎の物語。日本のおとぎ話によると、亀は不死の天国から来ており、長寿、幸運、援助の象徴で、航海をする人にとっては神の象徴でもある。浦嶋神社は京都の丹後半島の西にある。西暦478年に浦島子が亀に乗って竜宮城へ行った。彼は毎日お祭り騒ぎで楽しんでいたが、3年経っただろうと思い帰ってきたら300年も経過していた！帰って10日した頃に、彼は玉手箱を開け、元の世界の姿に戻り年老いた姿となったのだ。この話を知った淳和天皇は、玉手箱と浦島子の魂を祀るために、小野篁に浦嶋神社を造らせたそうだ。

Amami rabbit (endangered species).
Estimated number of Amami rabbits
(pentalagus furnessi) only 2000-4800,
living on Amami-oshima and Tokuno-
shima Islands of Ryukyu.

アマミノクロウサギ（絶滅危険種）。奄美
大島と徳之島に生息しているアマミノク
ロウサギは2000〜4800匹と推測され
ている。

"Cute" Nara deer. Cute until they start eating your clothes and harassing innocent little tourist children just trying to munch their waffle cones in peace! Natural population control? Where are all the bears? Nara Park, Nara Prefecture

奈良の鹿。可愛いけど、服を噛んだり、鹿せんべいをあげようとする子供を追いかけ回すときは別。鹿の頭数は自然に増えたり減ったりしてるのかな？熊はいないのかな？
奈良公園　奈良県

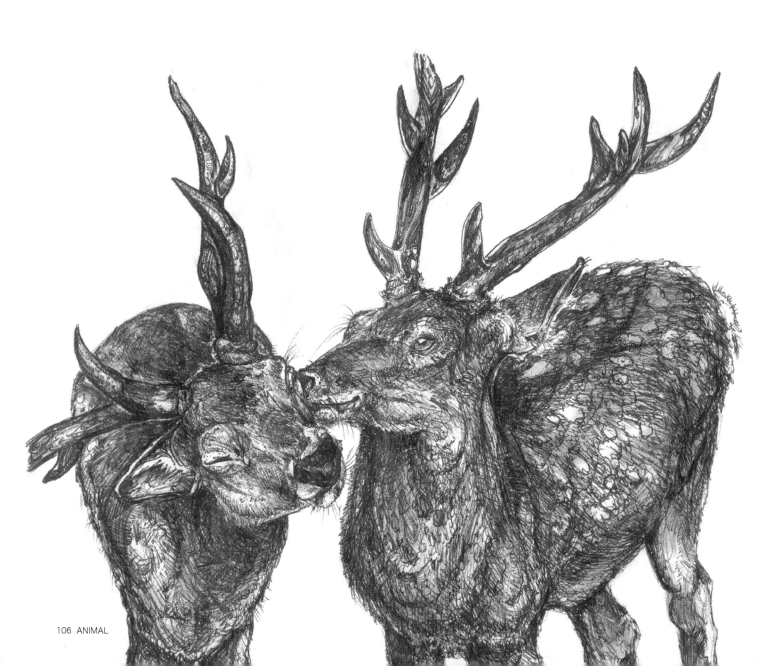

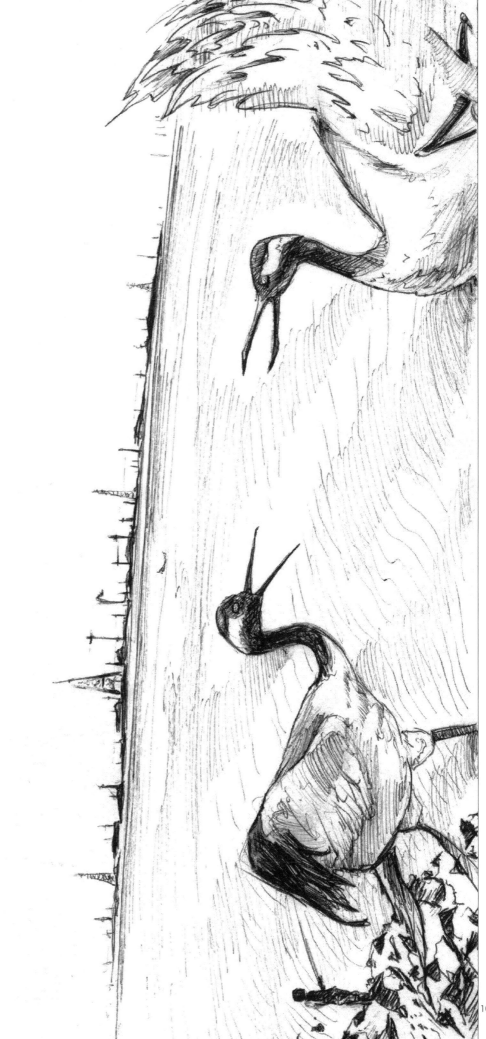

Crying cranes in the tidal flat.
干潟で鳴く鶴。

107

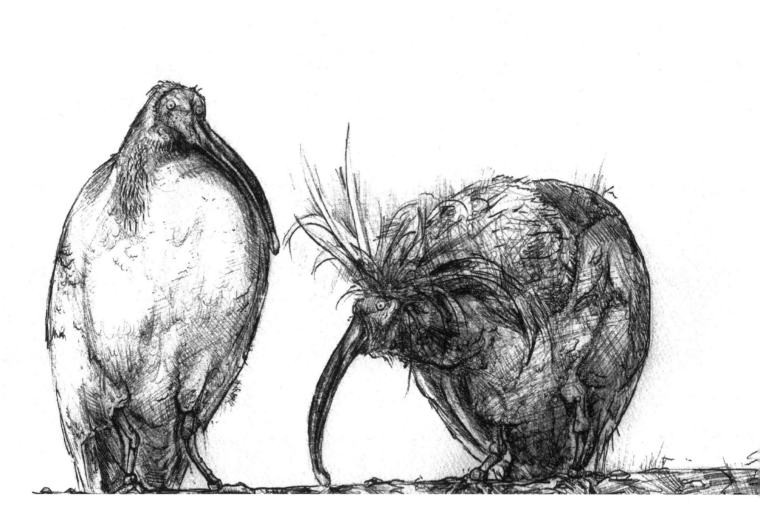

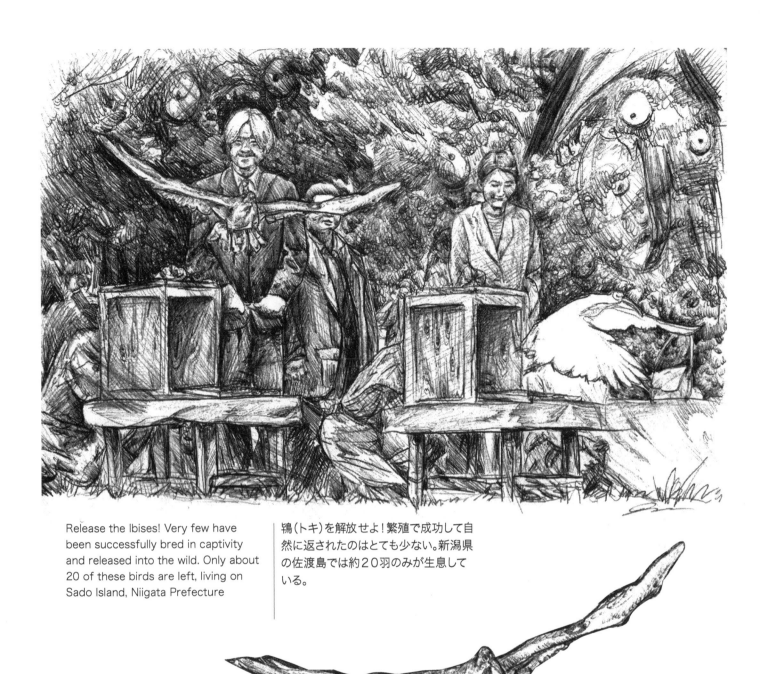

Release the Ibises! Very few have been successfully bred in captivity and released into the wild. Only about 20 of these birds are left, living on Sado Island, Niigata Prefecture

鴇（トキ）を解放せよ！繁殖で成功して自然に返されたのはとても少ない。新潟県の佐渡島では約２０羽のみが生息している。

≪ Toki, white-plumaged Japanese Crested Ibis (Nipponia Nippon). Endangered species on the brink of extinction.
絶滅の危機に瀕する、白い羽のトキ。

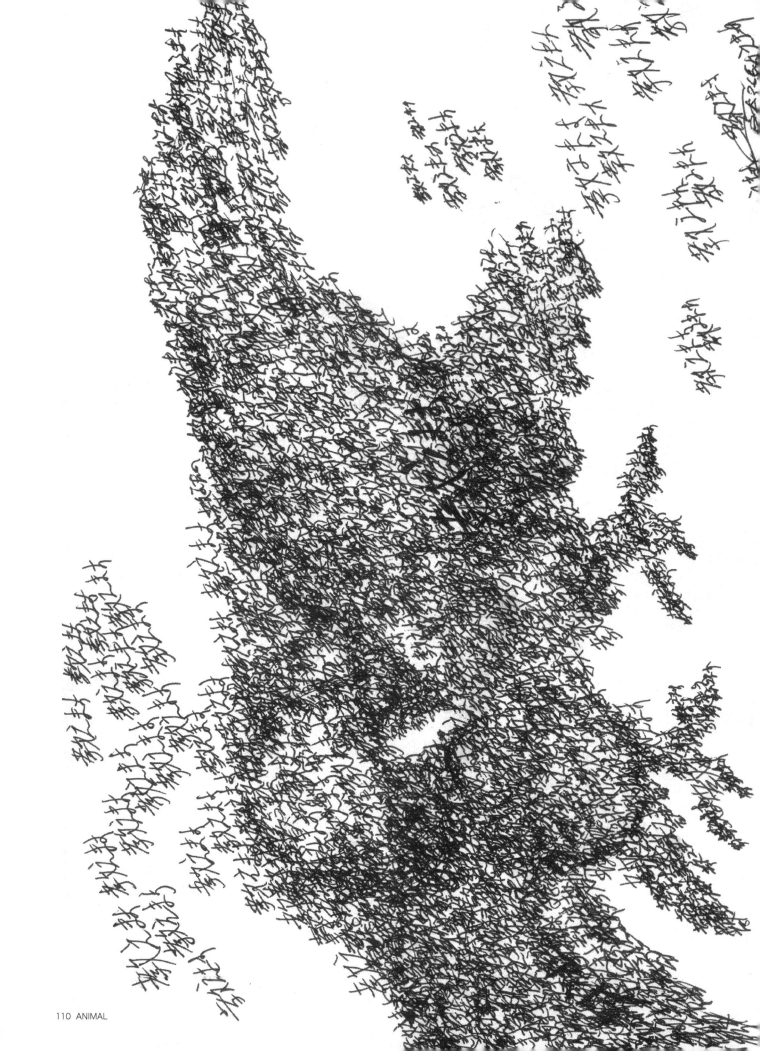

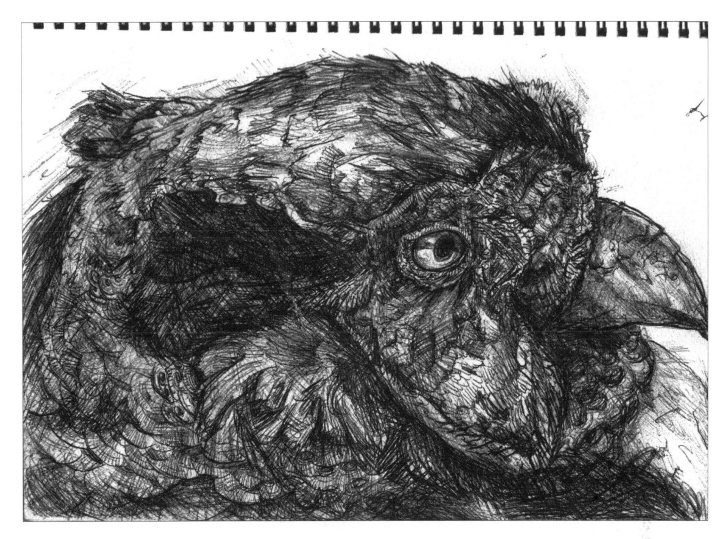

▲ Japanese pheasant.
日本の雉。

◀ 教える - Oshieru: kanji which means to teach, inform, instruct. Scribbled many times to form an amorphous shape resembling a bird of prey like taka (falcon, hawk) or tombi (black kite).

何回も「教えます」と描いた漢字だけで、鷹みたいな形を作った。

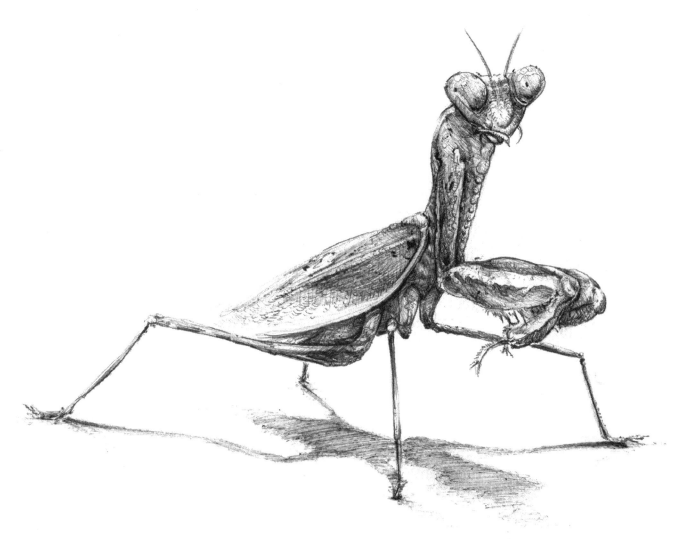

Kamakiri (version 1.0) Japanese pray-
ing mantis in Shimane Prefecture.
島根県でみつけたカマキリ。

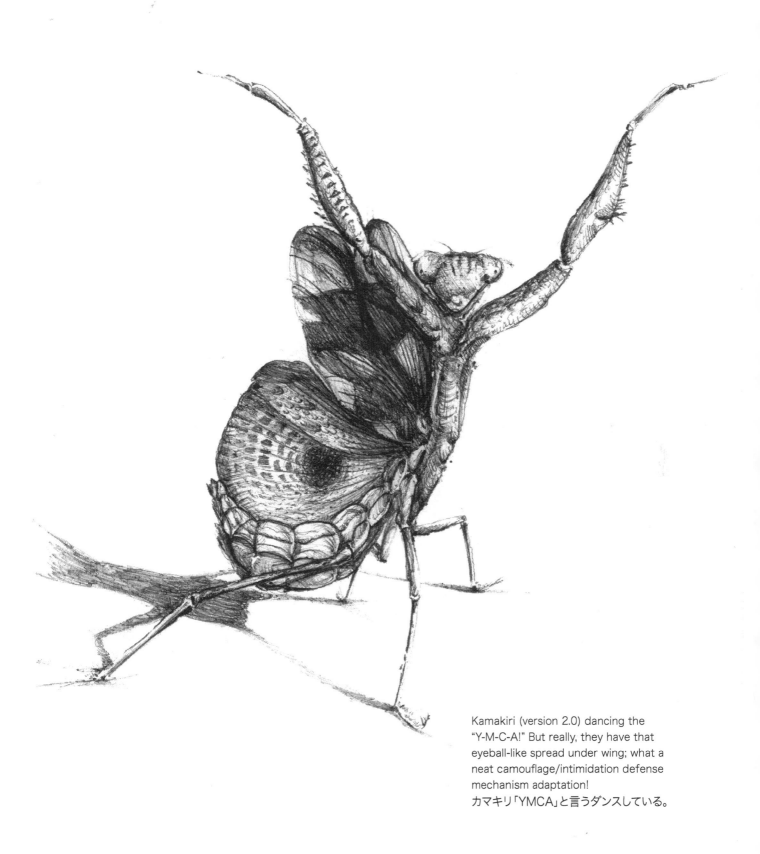

Kamakiri (version 2.0) dancing the
"Y-M-C-A!" But really, they have that
eyeball-like spread under wing; what a
neat camouflage/intimidation defense
mechanism adaptation!
カマキリ「YMCA」と言うダンスしている。

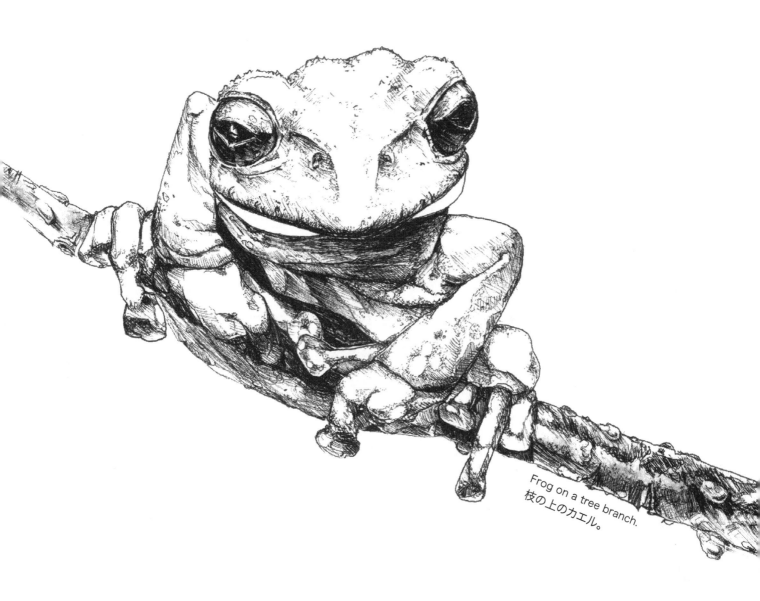

Frog on a tree branch.
枝の上のカエル。

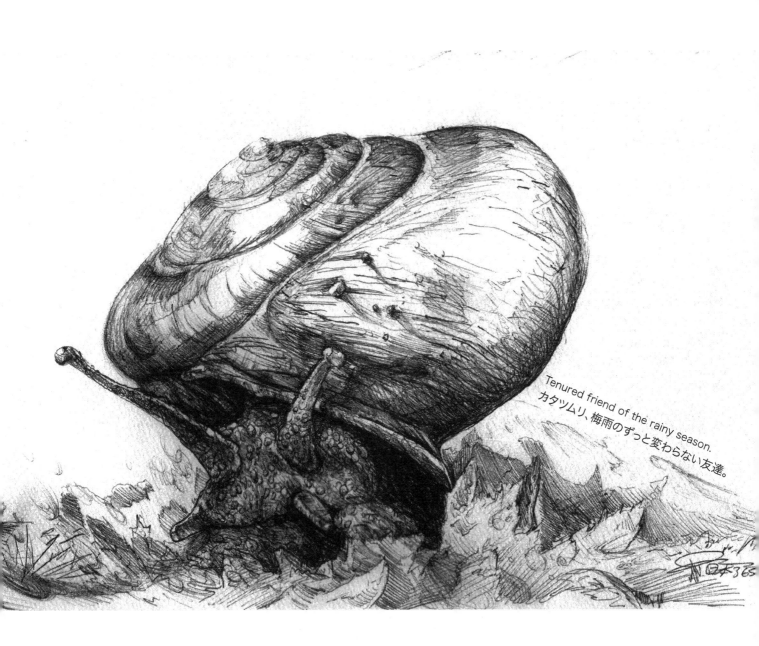

Tenured friend of the rainy season.
カタツムリ、梅雨のずっと変わらない友達。

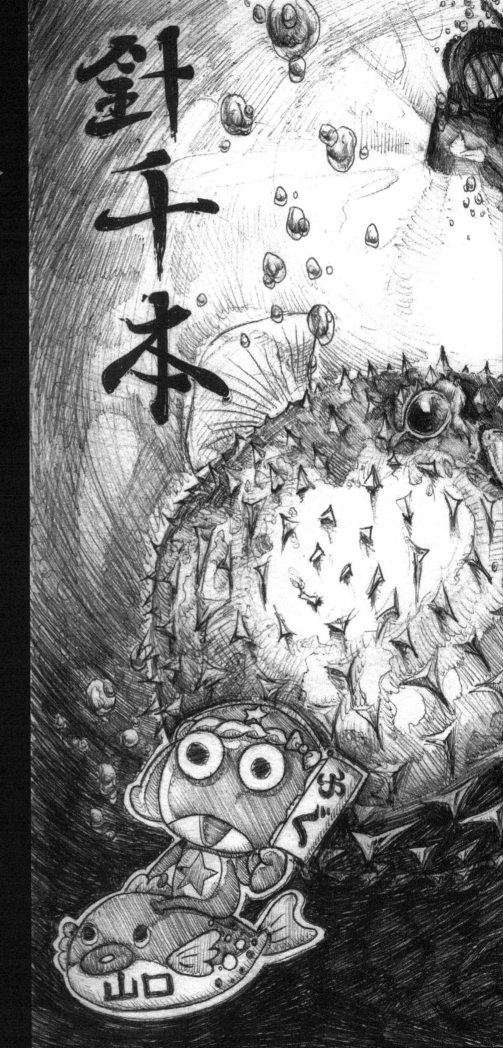

Blow fish and balloon fish are 'same same but different.' Fugu, means blowfish, they don't have spikes, and the kanji is 河豚, which means "river pig." Balloon fish, a.k.a. porcupine fish, is the fish with 1000 spikes, hence its name 針千本, hachi-sen-bon. Shimonoseki in Yamaguchi prefecture is famous for its fugu (which can kill you if prepared improperly), thus a dish can run you around 10,000 yen or about $120 USD! But Kita-Kyushu, a town just across the bridge from Shi-monoseki, has comparable fugu fare for a fraction of the price. Contrary to popular belief, it is not at all dangerous when eaten at restaurants prepared by proper chefs. It is a delicious and artistic dish, usually prepared as thinly-sliced sashimi, so thin in fact that it is almost transparent, and arranged like cherry blossom petals on a huge plate whose hand-made design you can see through the delicate fugu sashimi. Unrelated, the kanji for dolphin, 海豚 (iru-ka), means sea pig. And yes, Kororo the communist frog is in fact riding the fugu (not the balloon fish that the scuba diver is approaching with caution) and flying a flag.

ふぐとハリセンボンは同じようでいて違う。ふぐには、針がついておらず漢字では河豚と書く。ハリセンボンには名前の通り針がたくさんついている。山口県の下関はふぐで有名だ。調理の仕方を誤ると死ぬこともある。ふぐ料理には一万円、120ドルぐらいかかるものもある。下関から橋を渡ったところにある町、北九州では、比較的安い値段でふぐを食することができる。それとは関係ないが、いるかの漢字は海豚である。そして、この旗を上げている共産党のカエルが乗っているのはふぐであって、スキューバダイバーたちが近づく時に気をつけているハリセンボンではない。

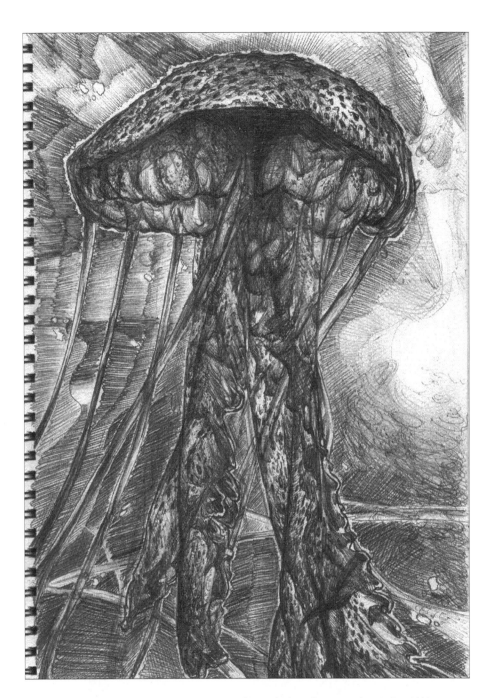

Peanut butter and "jellyfish" sandwich for lunch today. These bad boys plague the cooling shallows along the Sea of Japan coastline after Obon (Buddhist Day of the Dead) in October, thus signalling the end of swimming season, and the onset of my seasonal depression.

今日の弁当はピーナツバターとクラゲだ。お盆の後、クラゲは日本海の海岸の浅瀬にやってくる。それは海水浴シーズンの終わりを意味し、私の季節性うつ病が始まる。

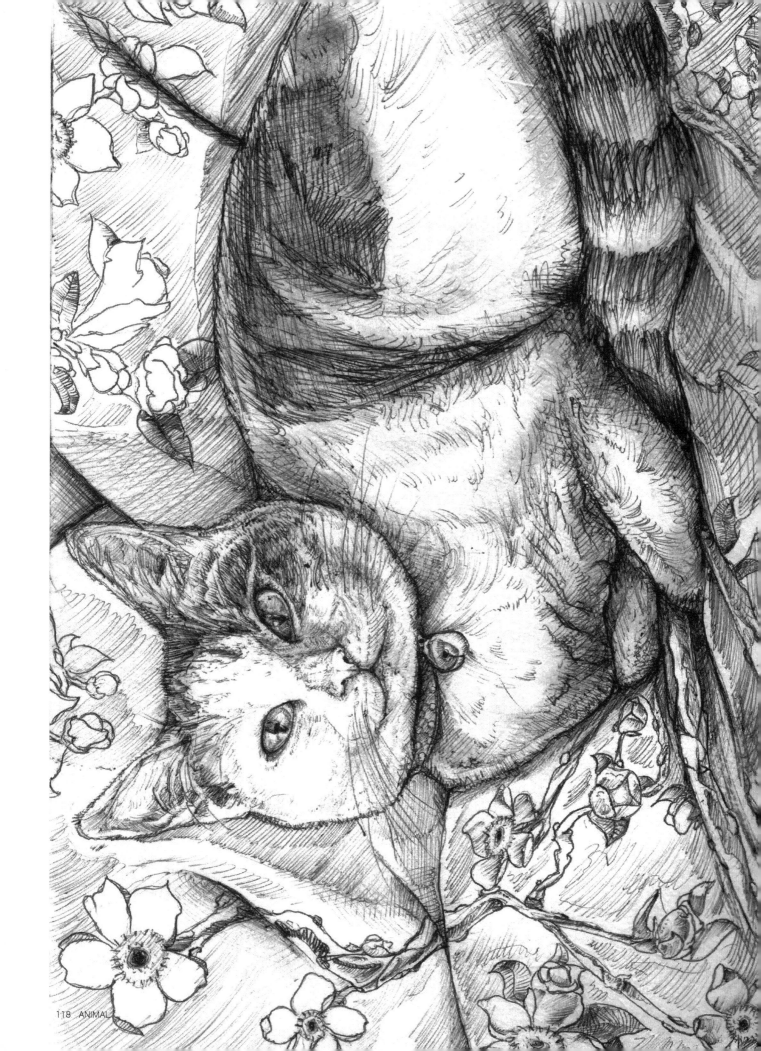

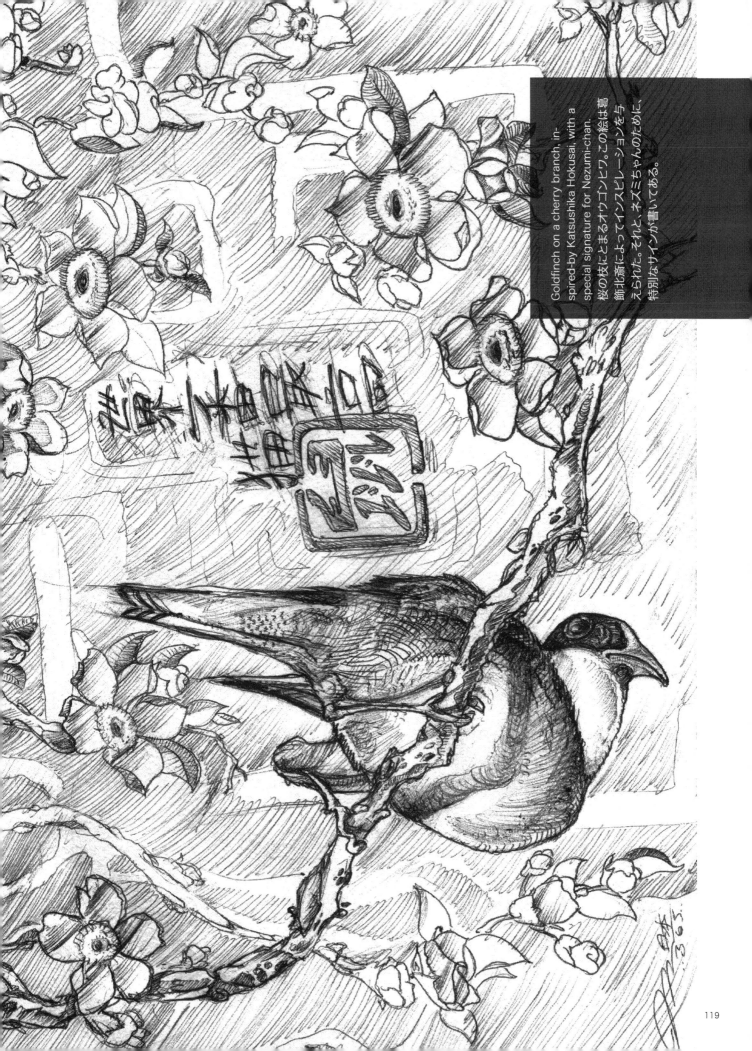

Goldfinch on a cherry branch, inspired-by Katsushika Hokusai, with a special signature for Nezumi-chan.

桜の枝にとまるオウゴンヒワ。この絵は葛飾北斎によってインスピレーションを与えられた。それと、ネズミちゃんのために、特別なサインが書いてある。

119

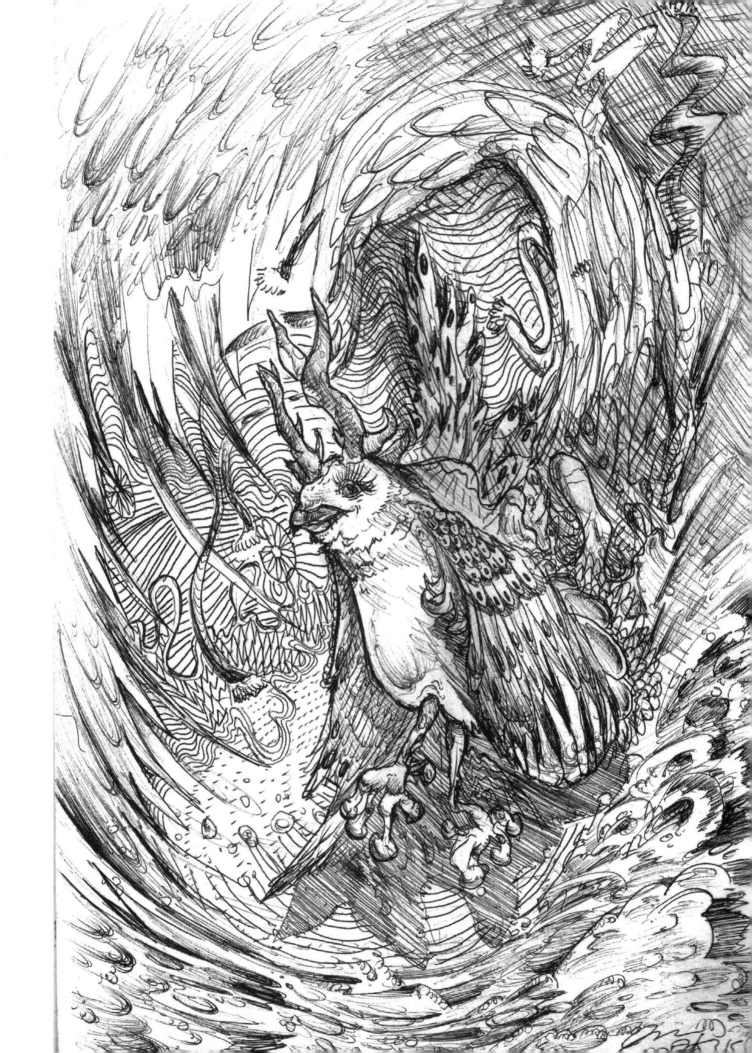

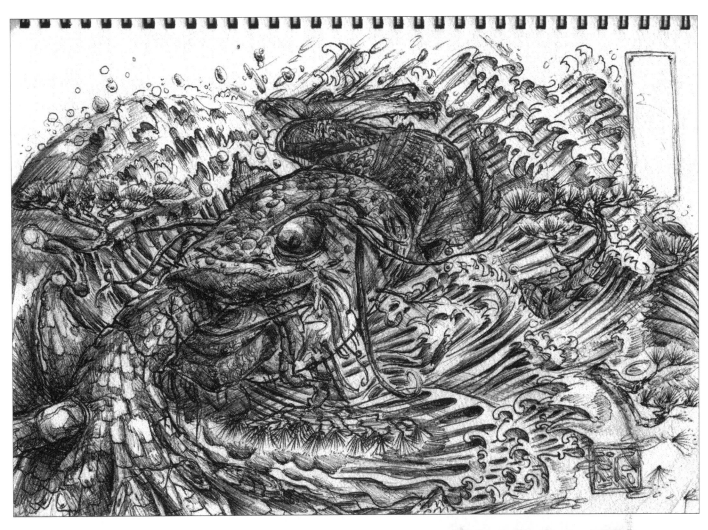

Crazy koi fish eating a bonsai tree.
盆栽を食べているおかしな鯉。

◄ Fantastic fat-lip zombie phoenix.
素晴らしく唇の厚い、ゾンビの火の鳥。

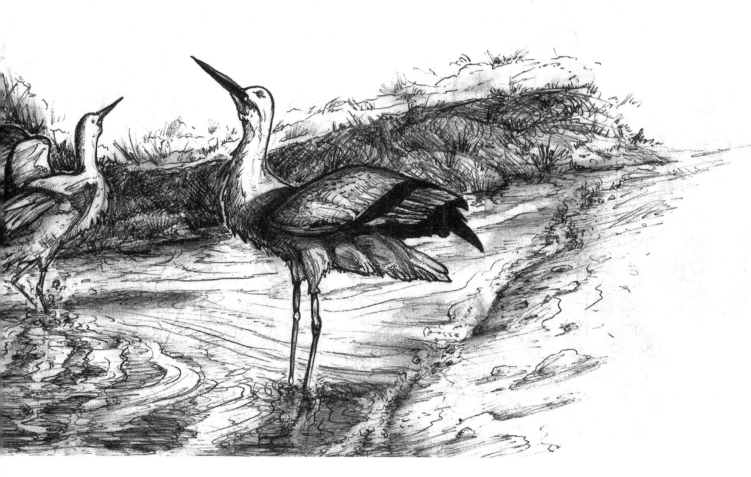

Kounotori, Oriental White Storks
at Kounotori no Sato Koen, Hyogo
Prefectural Homeland for the Orien-
tal White Stork. Shouun-ji, Toyo-oka,
Hyogo Prefecture
コウノトリ。兵庫県立コウノトリの郷公
園。豊岡市　祥雲寺　兵庫県

GODS & YOKAI

神々と妖怪

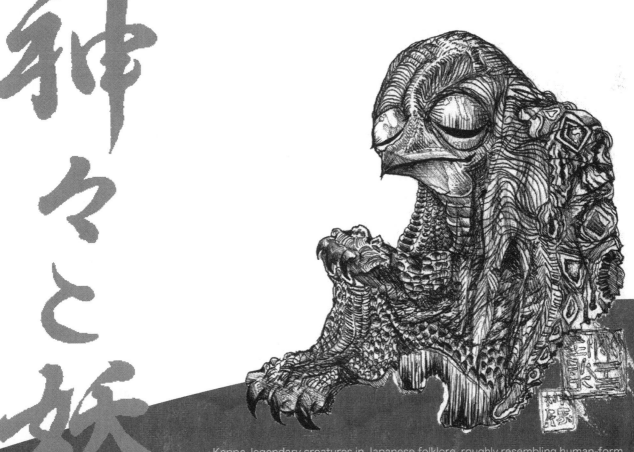

Kappa, legendary creatures in Japanese folklore, roughly resembling human-form, but with attributes like webbed feet and scales, fitting of their environment as they are said to reside in or near ponds and rivers. Pranks like passing gas loudly and looking up women's kimonos are characteristic of kappa. However, they can be tricked into serving humankind, too, because their word is like gold. Apparently they taught humans the art of bone-setting. And they really like cucumbers.

河童（カッパ）は日本で伝承された伝説上の生き物だ。人間の形に見えますが、水かきのある足と鱗もある。川と池に住むと言われているので環境に応じたものだろうか。うるさいおならをこくことや女の人の着物の裾を覗くことは河童らしい悪戯だ。しかし、河童はうそを言わないから、人間にも役に立つものです。骨の接ぎ方を教えてくれたらしい。そして、胡瓜が大好きだそうだ。

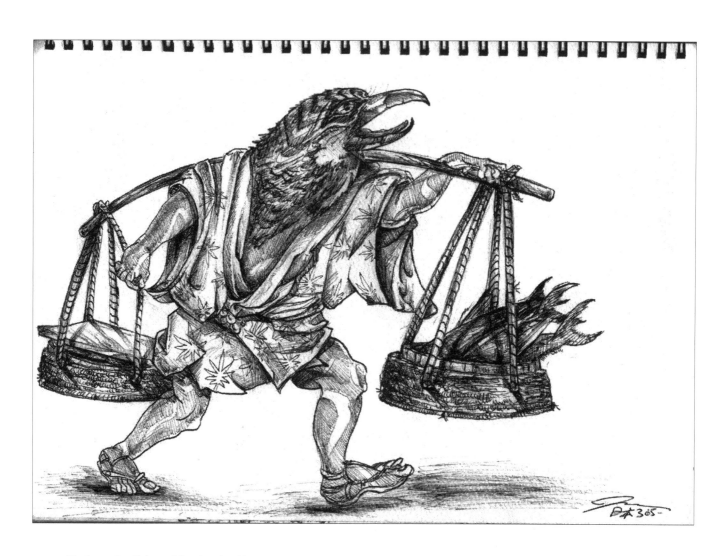

Birdman the fish peddler, inspired by
Utagawa Kuniyoshi.
魚売りの鳥人、歌川国芳風に。

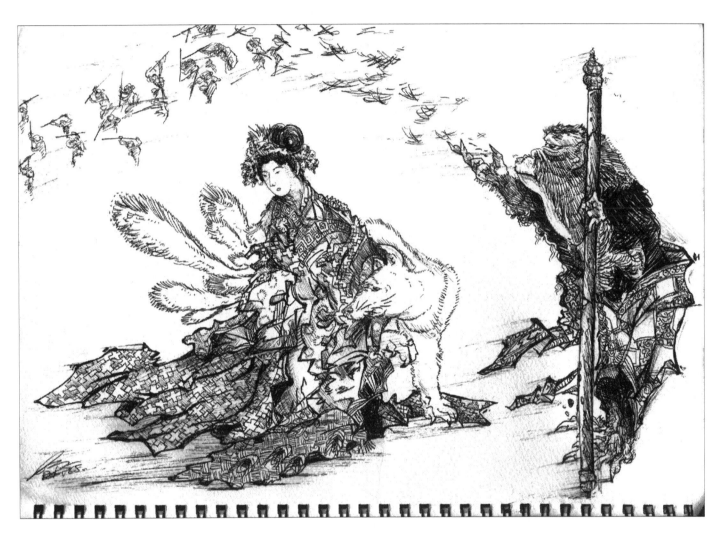

Nine fox tails, a lady and a magic monkey's stick soldiers march. Actually Songoku from the Chinese legend, "Journey to the West," who can turn his coarse monkey hairs into ninja soldiers.

九つの尾の狐、女の人と棒を持った魔法使いの猿は飛んでいる。実は「西遊記」という中国の伝奇小説の孫悟空だ。孫悟空の粗い毛が忍者に変化することができる。

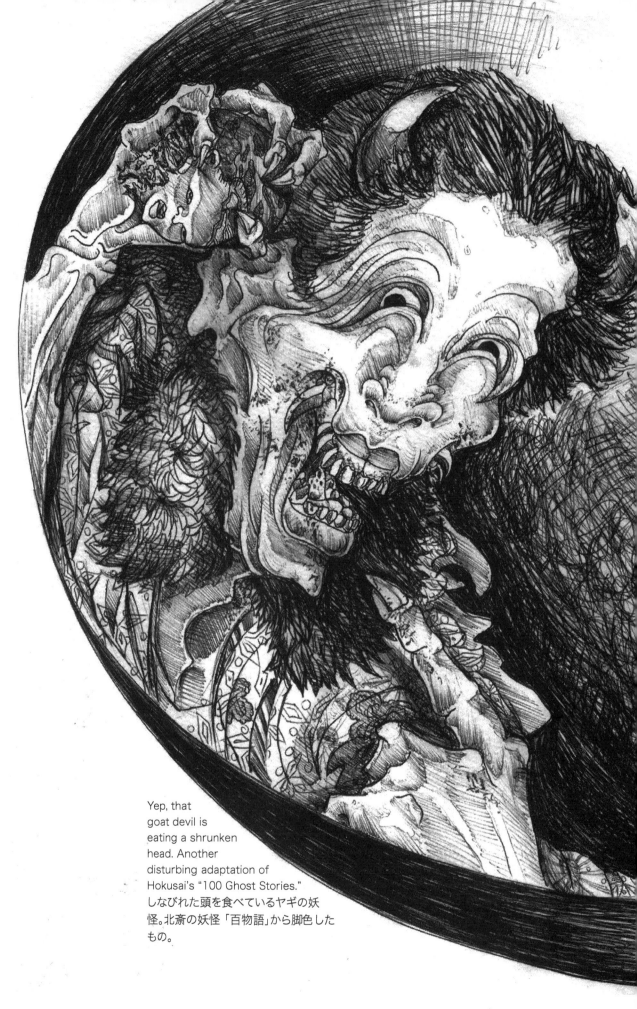

Yep, that goat devil is eating a shrunken head. Another disturbing adaptation of Hokusai's "100 Ghost Stories." しなびれた頭を食べているヤギの妖怪。北斎の妖怪「百物語」から脚色したもの。

Stone cold fox statue. The fox is considered the messenger of Inari, the god of cereals, and the stone foxes often referred to as Inari can be found en masse at Fushimi Inari shrine in Kyoto. The key often seen in the fox's mouth is to the rice granary. In Japanese folklore the fox is a sacred, mysterious and somewhat mischievous entity capable of "possessing" humans.

石でできた狐の像だ　狐は稲荷神の使いで穀物の神様である。京都市の伏見稲荷大社には狛犬の代わりに、狐の像が多くあり「稲荷」と呼ばれている。稲荷の口の中によく見られる鍵は米倉の鍵。狐は古来より日本人にとって神聖視されていて、神秘的でしかも狡賢い動物である。人間 に憑くこもできると言われている。

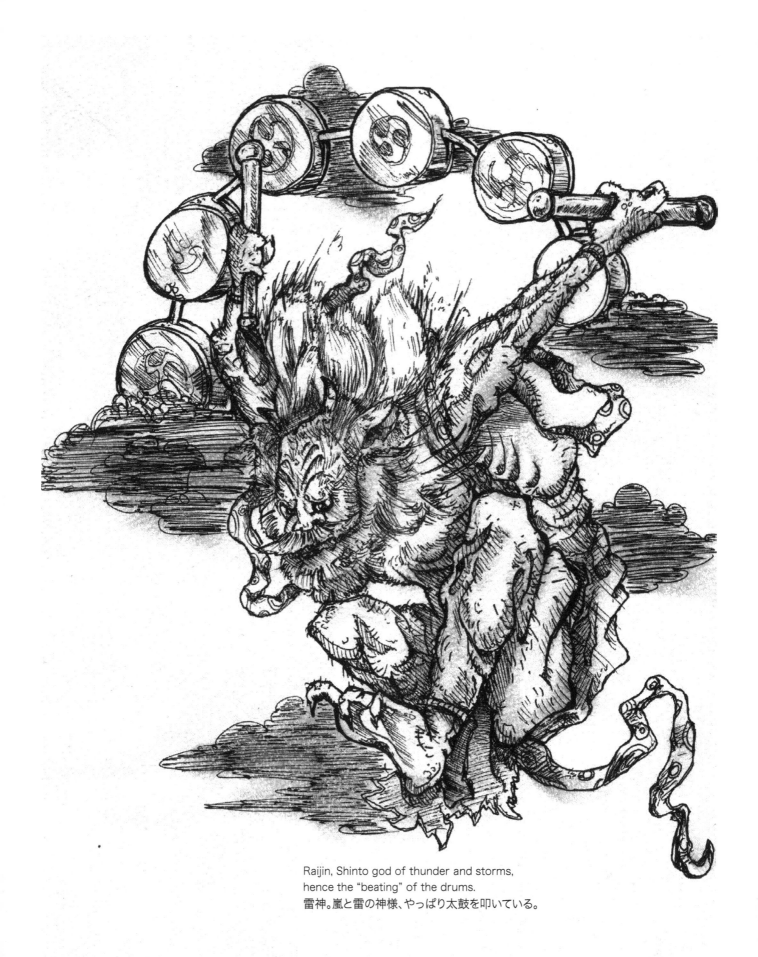

Raijin, Shinto god of thunder and storms,
hence the "beating" of the drums.
雷神。嵐と雷の神様、やっぱり太鼓を叩いている。

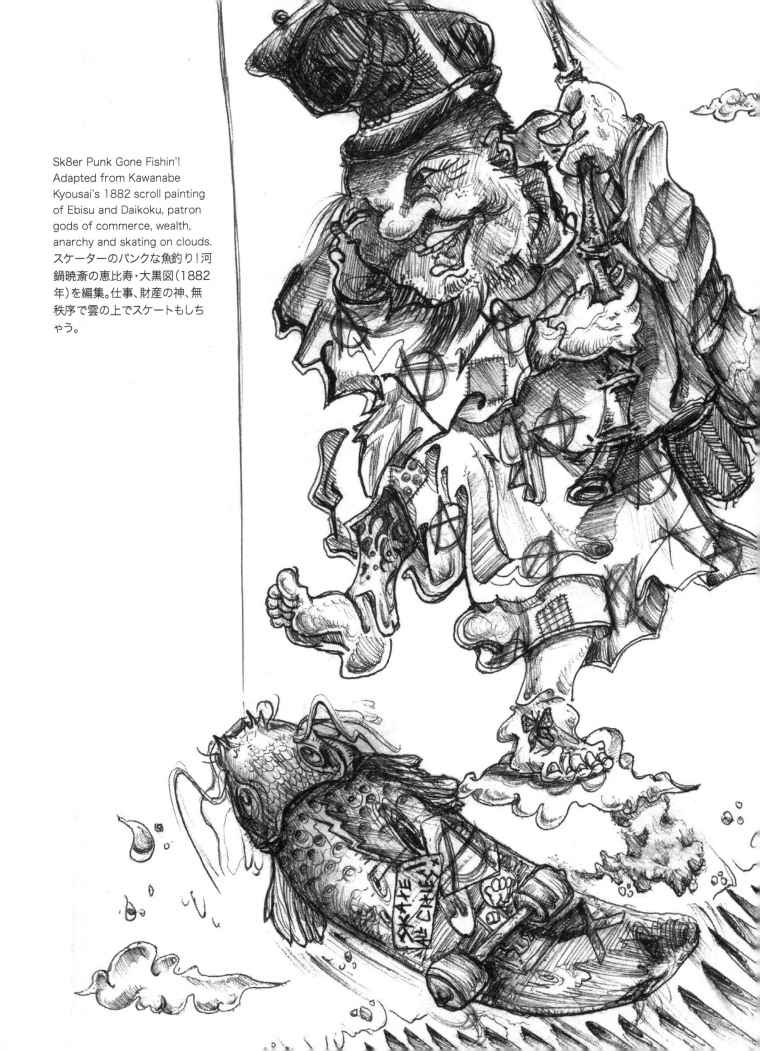

Sk8er Punk Gone Fishin'!
Adapted from Kawanabe
Kyousai's 1882 scroll painting
of Ebisu and Daikoku, patron
gods of commerce, wealth,
anarchy and skating on clouds.
スケーターのパンクな魚釣り！河
鍋暁斎の恵比寿・大黒図（1882
年）を編集。仕事、財産の神、無
秩序で雲の上でスケートもしち
ゃう。

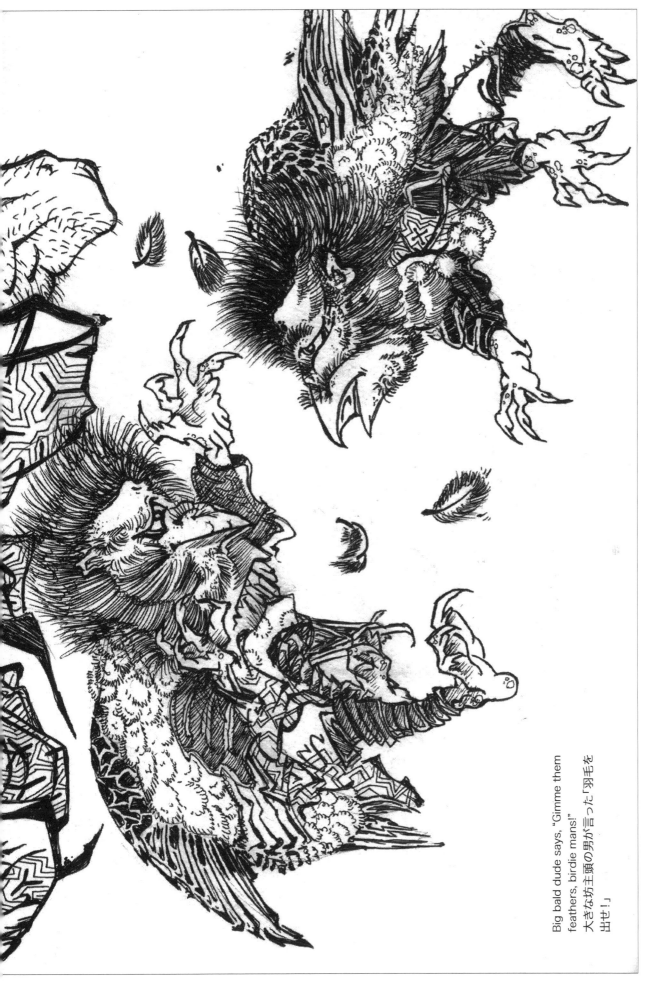

Big bald dude says, "Gimme them feathers, birdie mans!"

大きな坊主頭の男が言った「羽毛を出せ！」

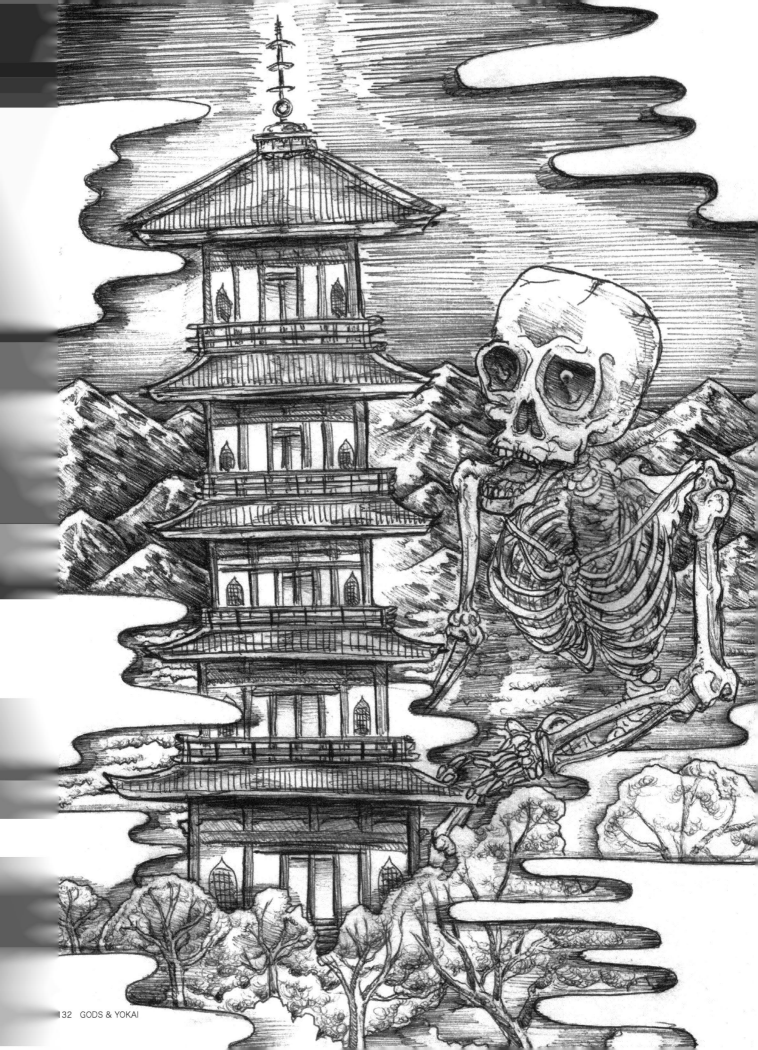

"Peek-A-Boo!" Adapted from Hokusai's print, one of the better known works from perhaps his darkest, most unsettling series, "Hyaku Monogatari" or "One-hundred Ghost Stories."
「いないいないばあ！」北斎の「百物語」、「妖怪百物語」から脚色した。

Gashadokuro, a giant skeletal assemblage of dead soldier bones and starvation victims neglected and left to rot. Inspired by the work of Matthew Meyer for his book about yokai called "The Night Parade of One Hundred Demons."
戦死や餓死して、埋葬されなかった者の骸骨などでできた「がしゃどくろ」マットマイヤーの作品からインスピレーションをうけた。

NEXT SPREAD

A three-eyed man and his glasses salesman. You'd need a pretty big blanket to pull the wool over his eyes.
三つ目の男と彼の眼鏡 セールスマン。彼の目を覆うために、けっこう大きな毛布が必要なんですが。

Rokurokubi. These long-necked women are the legendary monsters called Roku-roku-bi. During the day they appear to be normal women; however, during the night they can stretch their necks to incredible lengths and enjoy frightening people.
この長い首の女たちは伝説の化け物のろくろ首だ。昼間に普通の女性の姿をしているが、夜に首が延ばせるようになって、人を驚かして楽しむことがある。

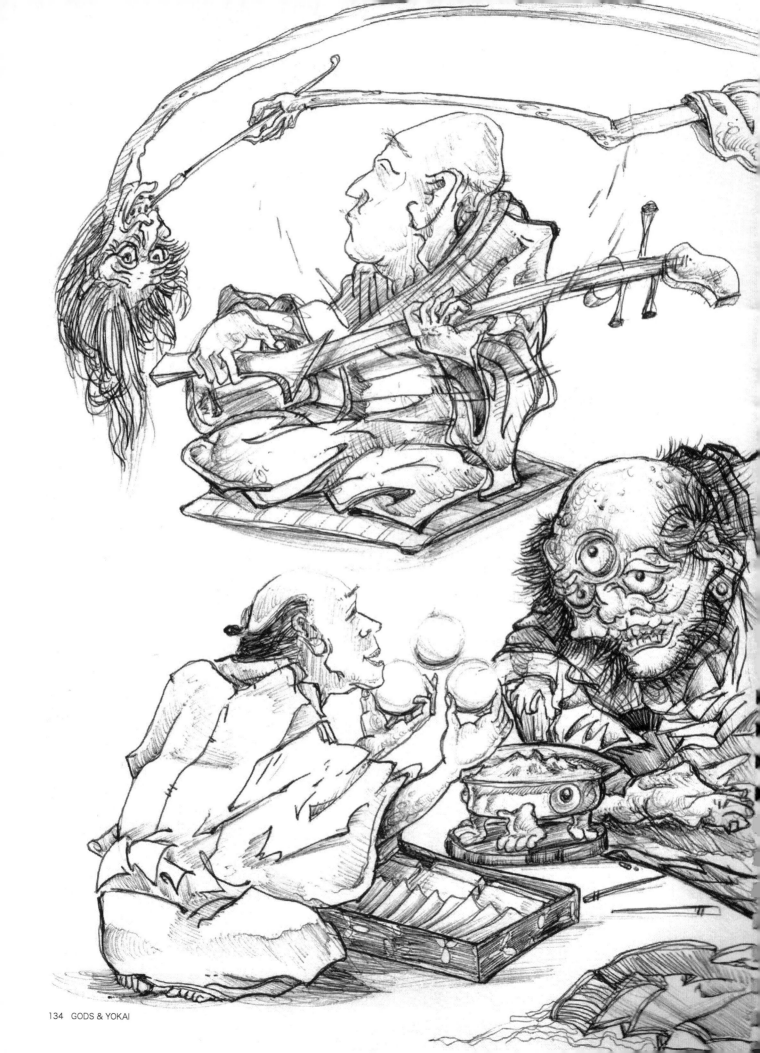

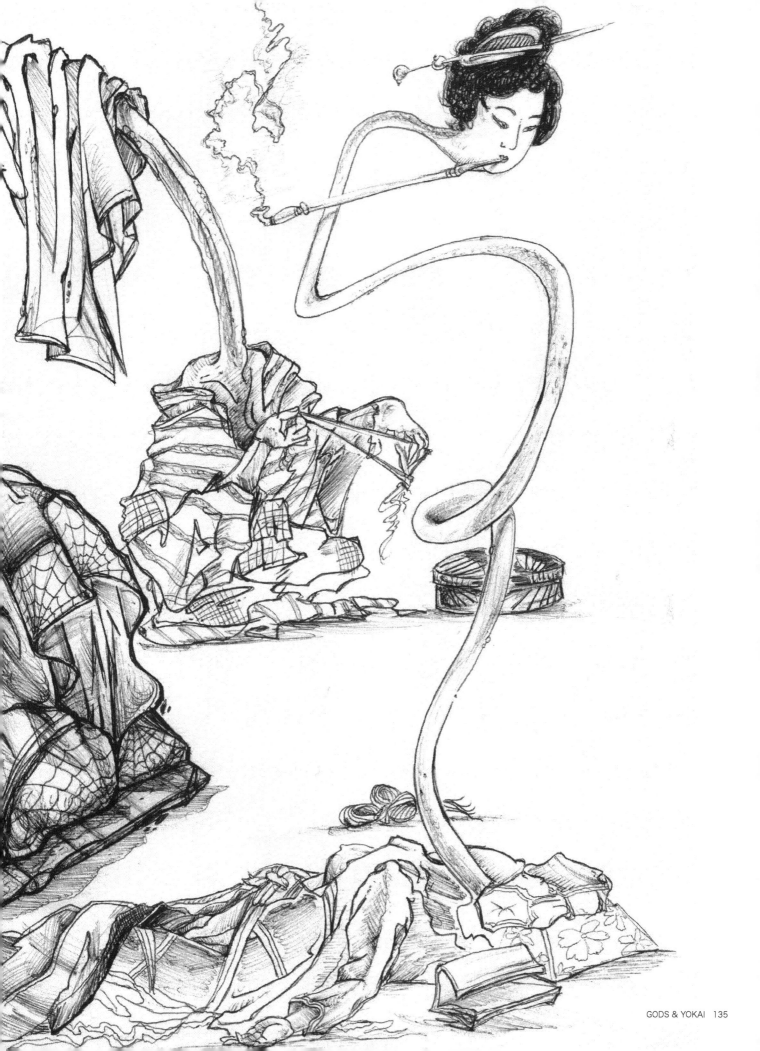

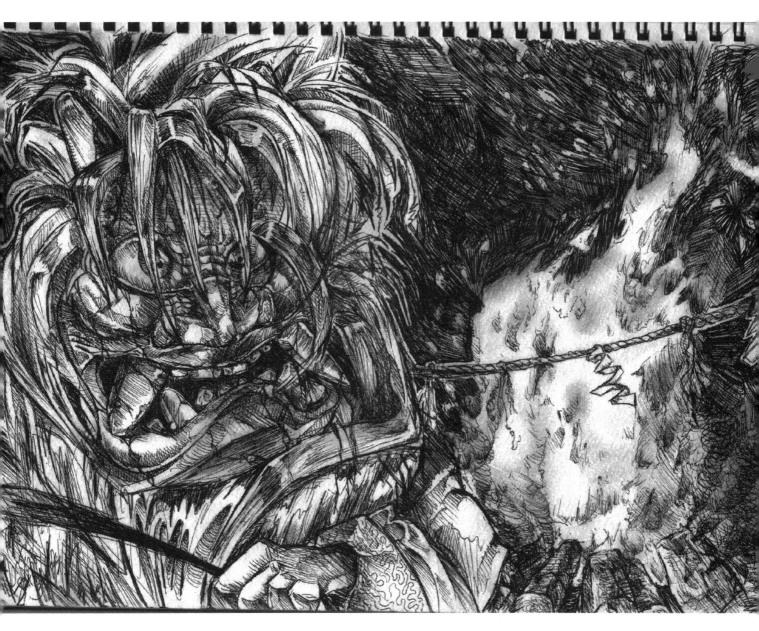

Namahage. Akita's Namahage Festival is held on December 31st on the Oga Peninsula, observed since ancient times as a ritual for cleansing people's souls and blessing the new year. The word "namahage" comes from a local word for the blister a lazy person gets from spending too many winter hours sitting under the kotatsu (heated table) plus the word for "peel." The suggestion is that the visiting kami (spirit, natural force or essence) would peel off these blisters.

ナマハゲ。秋田県のナマハゲ祭りは男鹿半島で12月31日に行われる。ナマハゲと言う言葉は怠け者の人がこたつにあまりにも長い時間座っていてできたマメを方言でいったもので皮を剥くと言う意味もある。ナマハゲの神様が家にきてマメの皮を剥くそうだ。

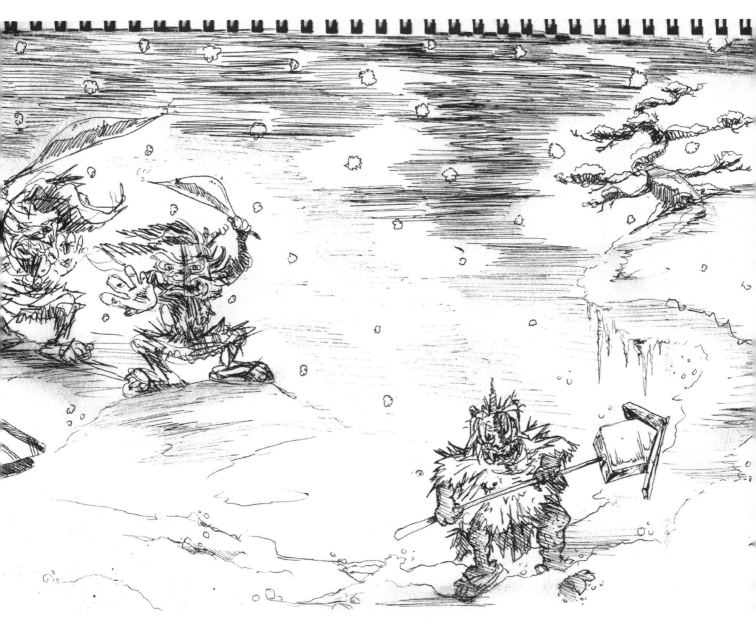

▲ Namahage creeping in the snow.
ナマハゲが雪の中、こっそりとやって来る。

NEXT SPREAD
Gods of Fortune, Shichi-Fukujin, here four of the seven. Fukurokuju with the huge head, Ebisu with the fishing rod, and Hotei the painted pot-belly figure, along with Daikokuten seemingly molesting his namesake, a huge daikon.
七福神の4つ。頭が大きい福禄寿、釣り竿を持つ恵比寿、太鼓腹の布袋。そして、大根と変なことをしている大黒天かなぁ。

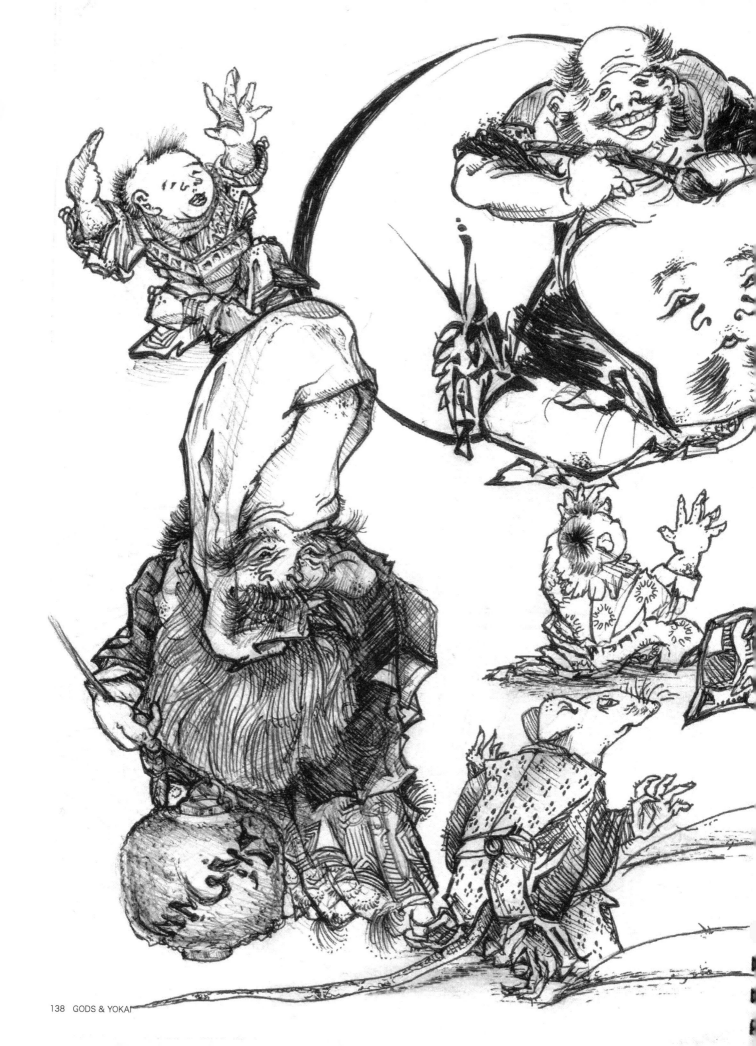

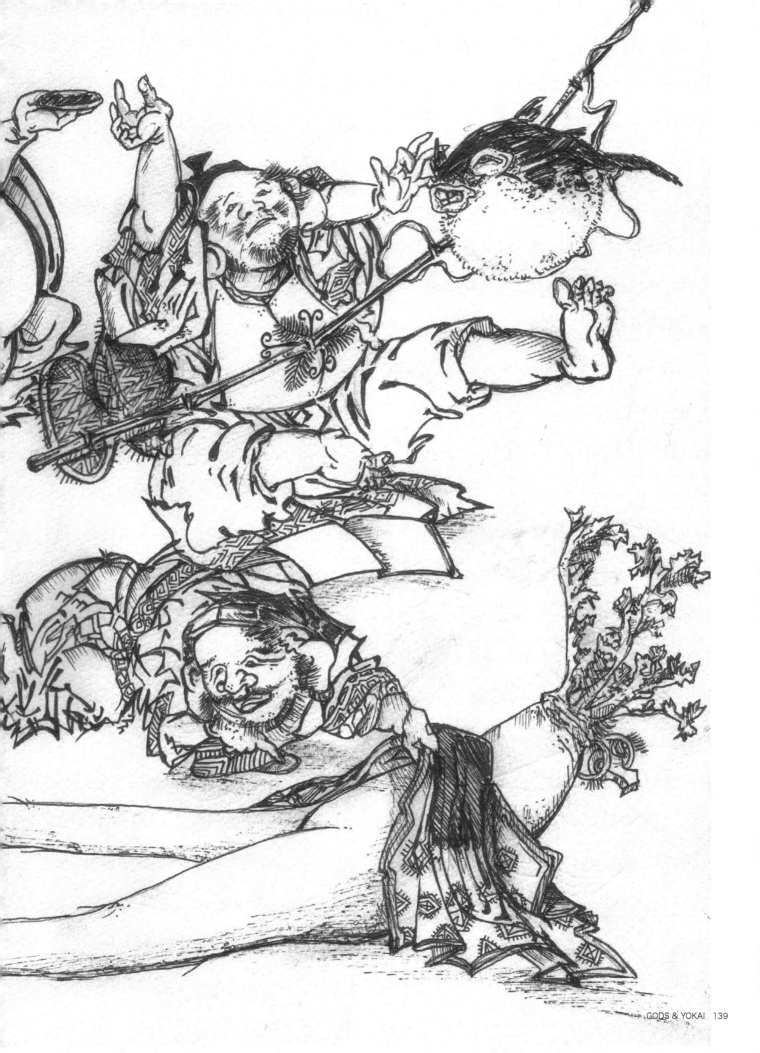

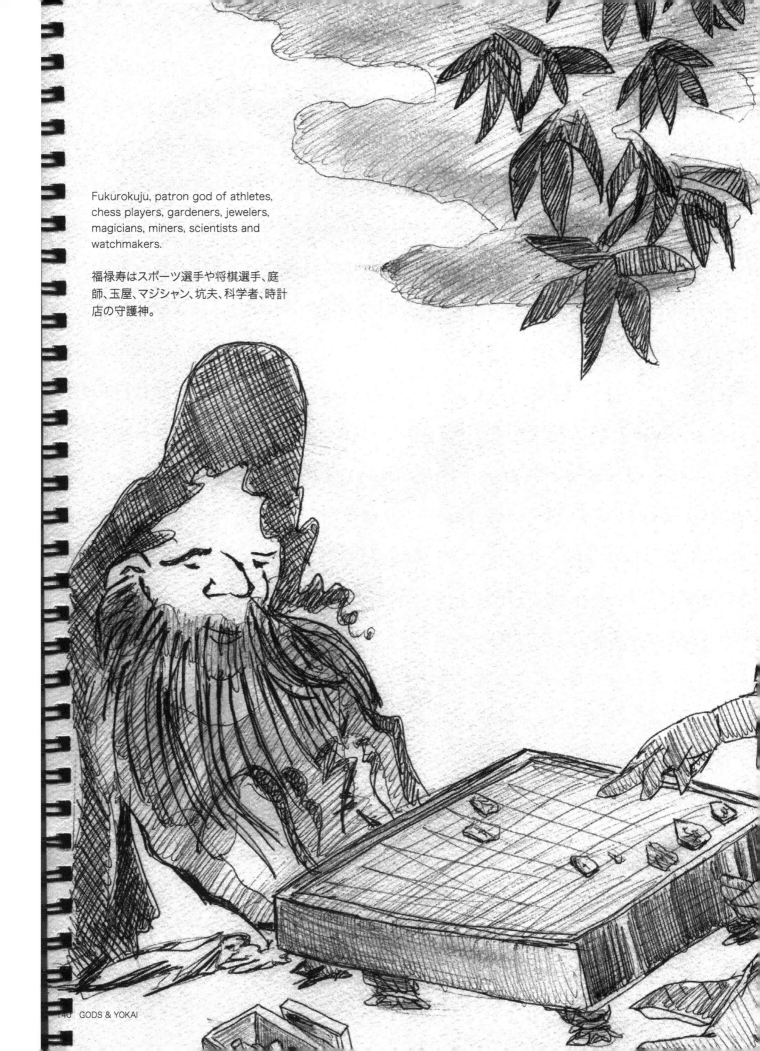

Fukurokuju, patron god of athletes, chess players, gardeners, jewelers, magicians, miners, scientists and watchmakers.

福禄寿はスポーツ選手や将棋選手、庭師、玉屋、マジシャン、坑夫、科学者、時計店の守護神。

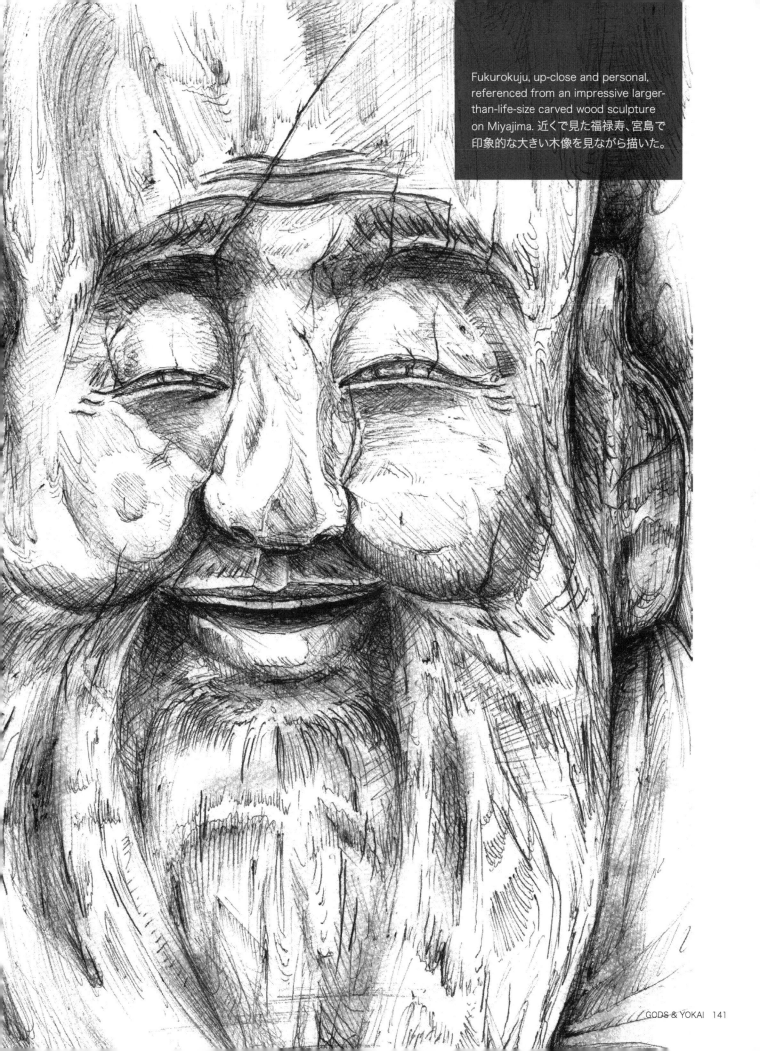

Fukurokuju, up-close and personal, referenced from an impressive larger-than-life-size carved wood sculpture on Miyajima. 近くで見た福禄寿、宮島で印象的な大きい木像を見ながら描いた。

Appropriate for the Setsubun holiday, throwing soybeans at your door to dispel the evil Oni demons, as depicted by this old wooden mask. Eat as many dried soybeans as your age for health and happiness this year. Then, throw the remainder at incoming demons.

節分。この絵に描かれているような鬼を追い払うために豆まきをする。年の数だけ豆を食べ、その年の健康と幸せを願う。「鬼は外、福は内!」

北斎と国芳

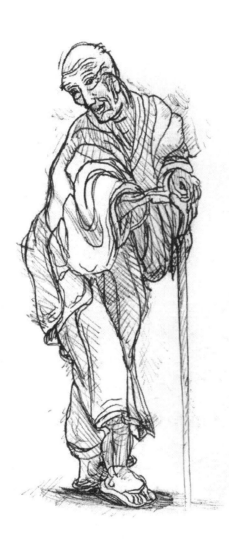

Katsushika Hokusai, self-portrait
as an old man.
葛飾北斎の未来の自画像。

HOKUSAI &
KUNIYOSHI

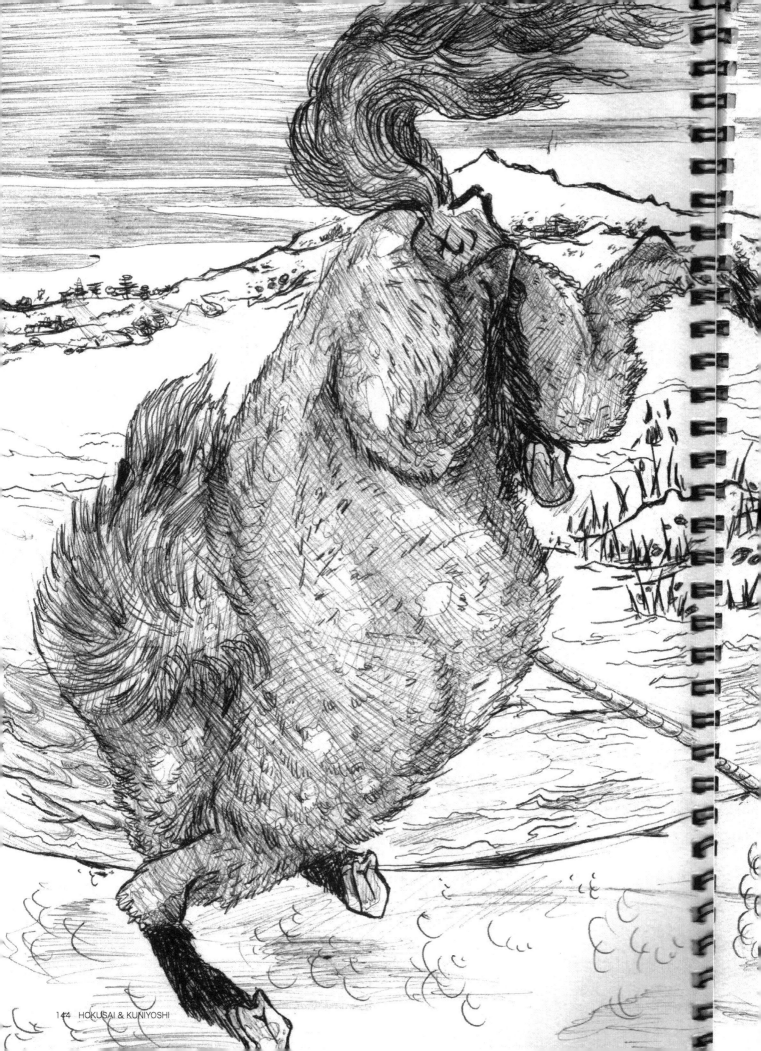

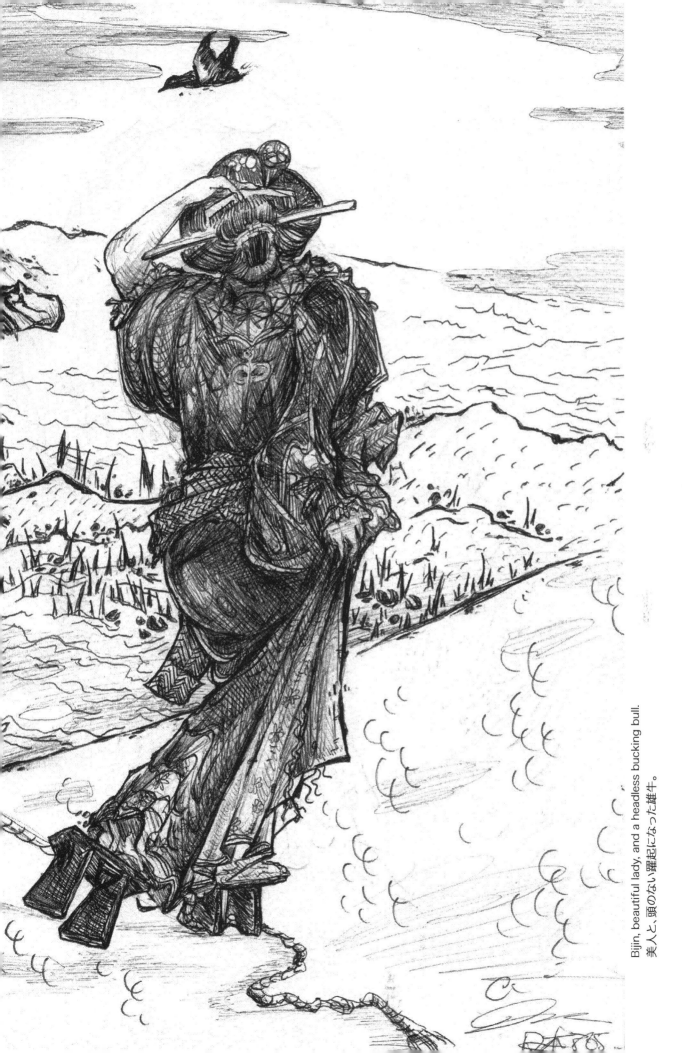

Bijin, beautiful lady, and a headless bucking bull.
美人と、頭のない躍起になった雄牛。

145

▲ Oh, go fly a kite! Or let the demon kite
fly you, rather. 凧を上げよう！それとも、
悪魔の凧があなたを空に上げようか？

A ball pen rendition of Sakuragawa ▶
Gihinari's, "Actor Ichikawa Dan-
jurou II as Uirouri (Medicine seller)
Shikishi-ban" (1818-1830).

桜川慈悲成「二代目市川団十郎の外
郎売り、色紙版」（1818–1830年）
のボールペン描写。

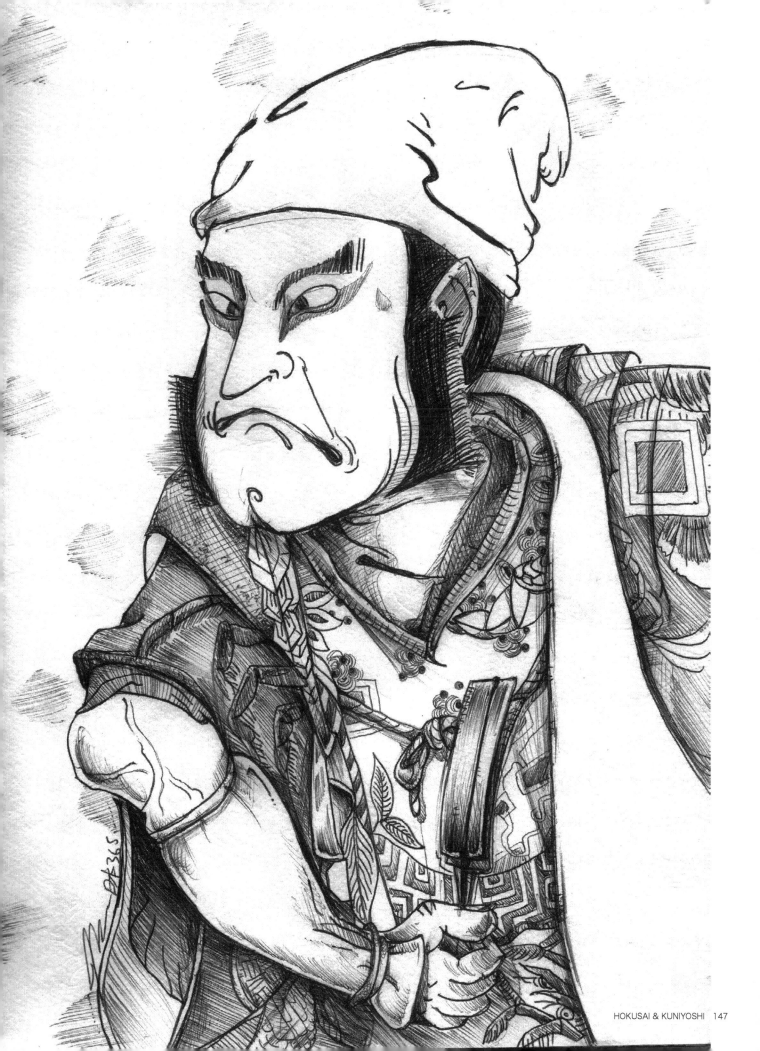

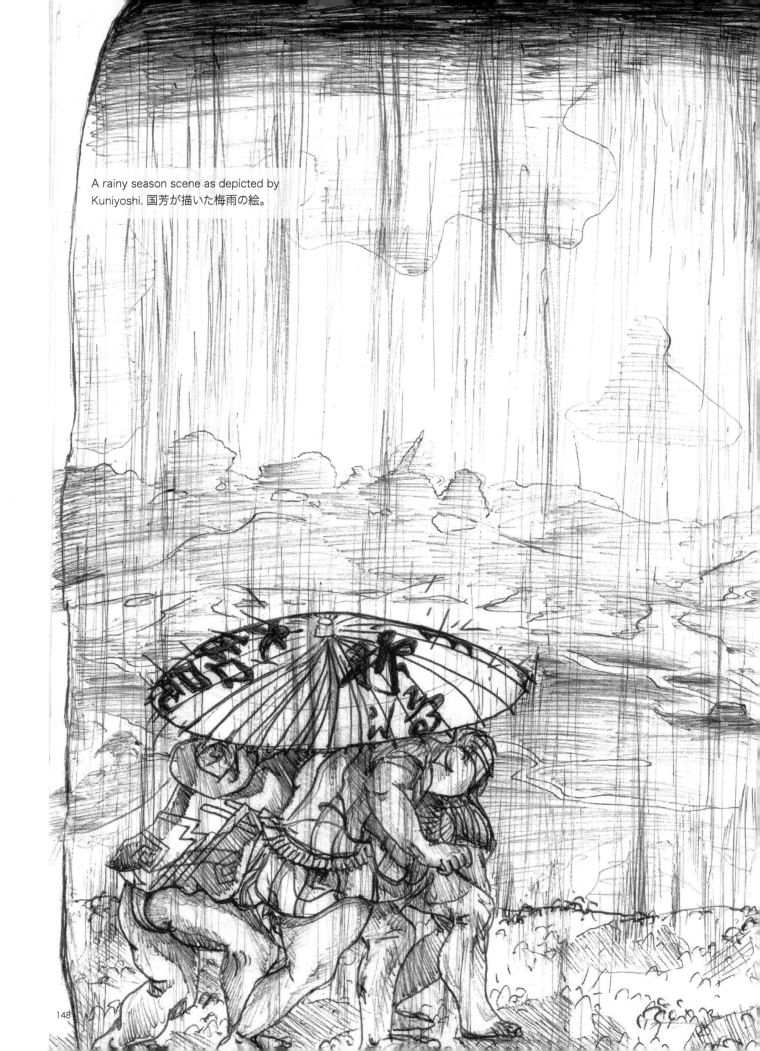

A rainy season scene as depicted by Kuniyoshi. 国芳が描いた梅雨の絵。

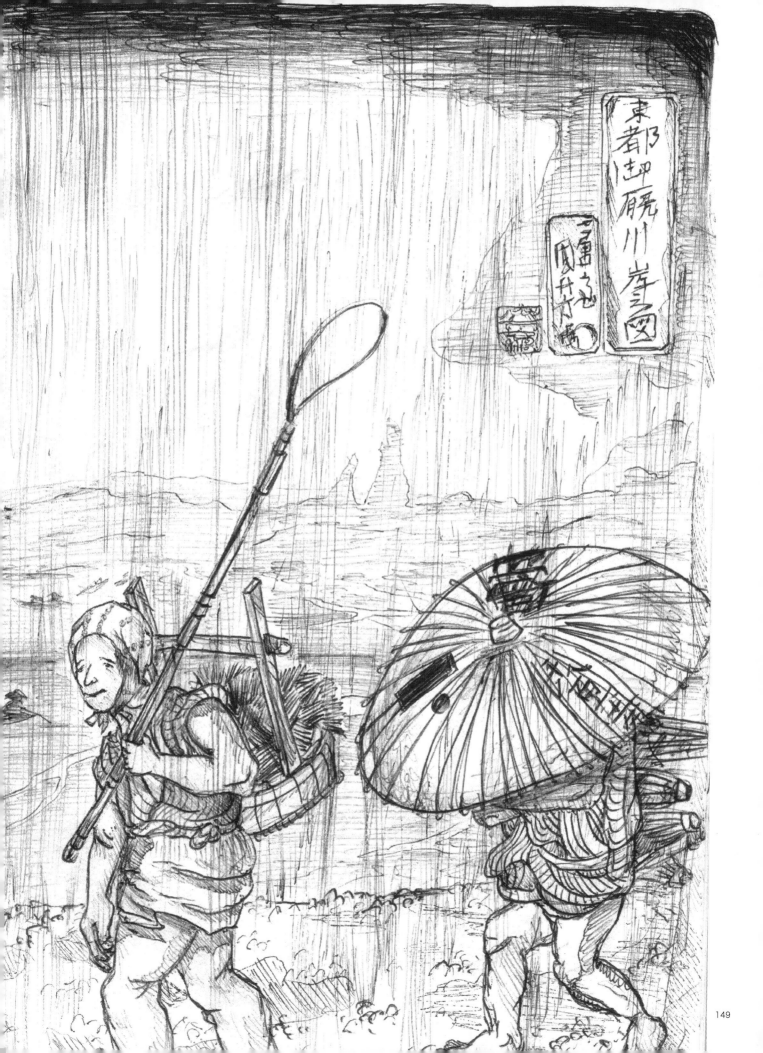

149

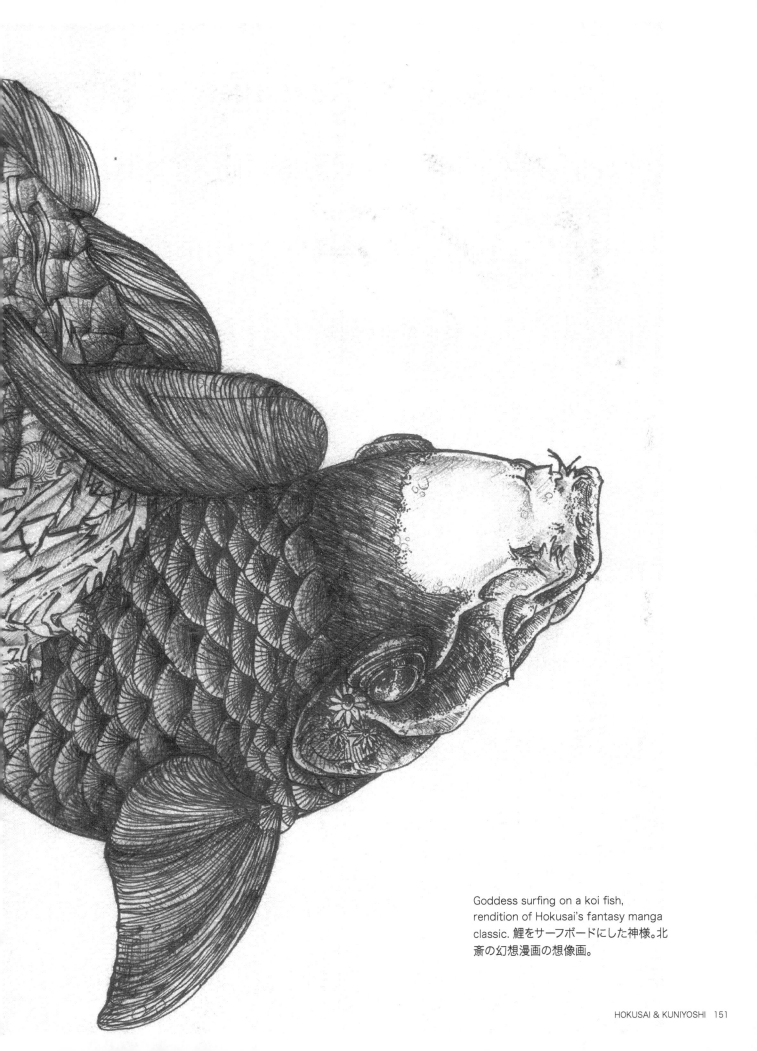

Goddess surfing on a koi fish,
rendition of Hokusai's fantasy manga
classic. 鯉をサーフボードにした神様。北
斎の幻想漫画の想像画。

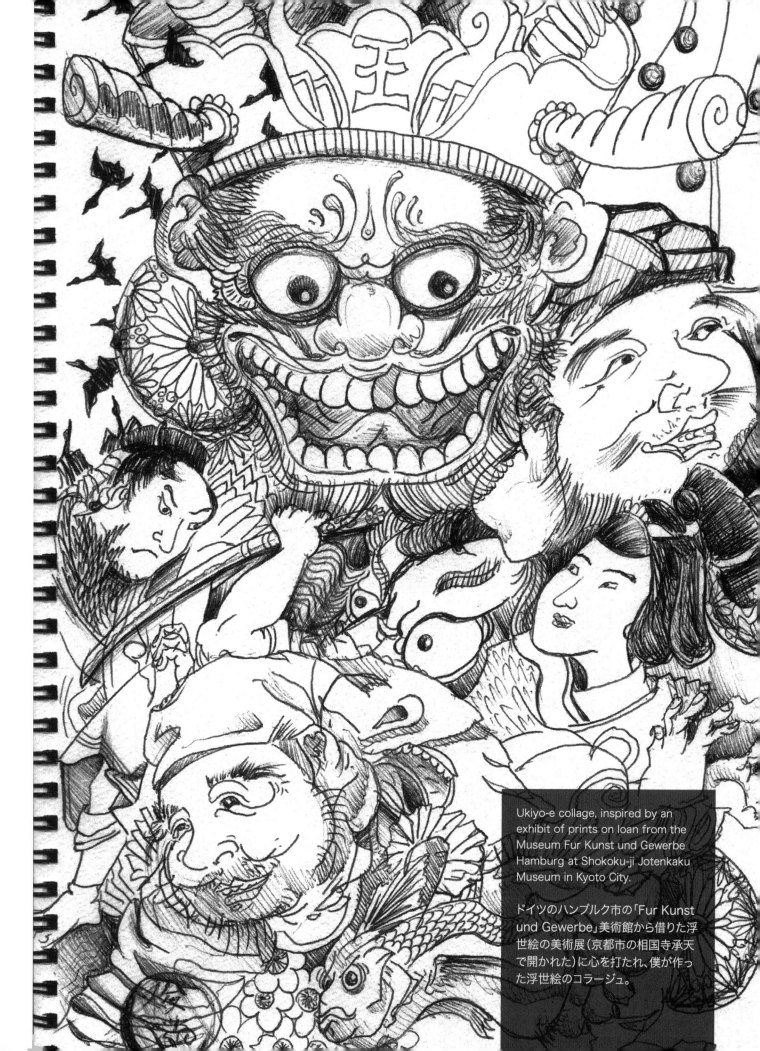

Ukiyo-e collage, inspired by an exhibit of prints on loan from the Museum Fur Kunst und Gewerbe Hamburg at Shokoku-ji Jotenkaku Museum in Kyoto City.

ドイツのハンブルク市の「Fur Kunst und Gewerbe」美術館から借りた浮世絵の美術展（京都市の相国寺承天で開かれた）に心を打たれ、僕が作った浮世絵のコラージュ。

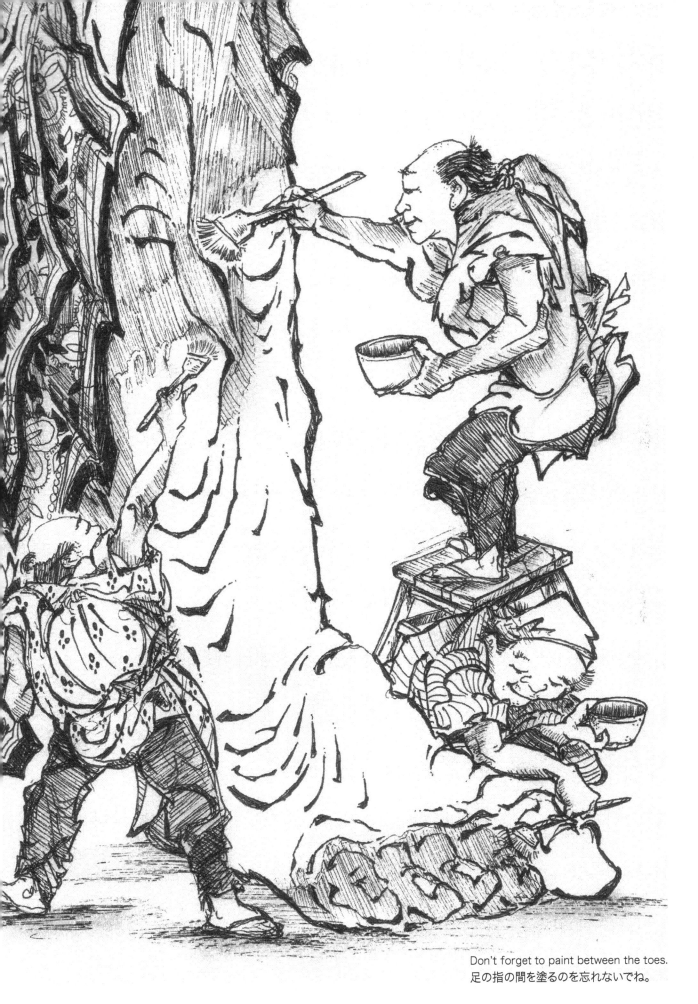

Don't forget to paint between the toes.
足の指の間を塗るのを忘れないでね。

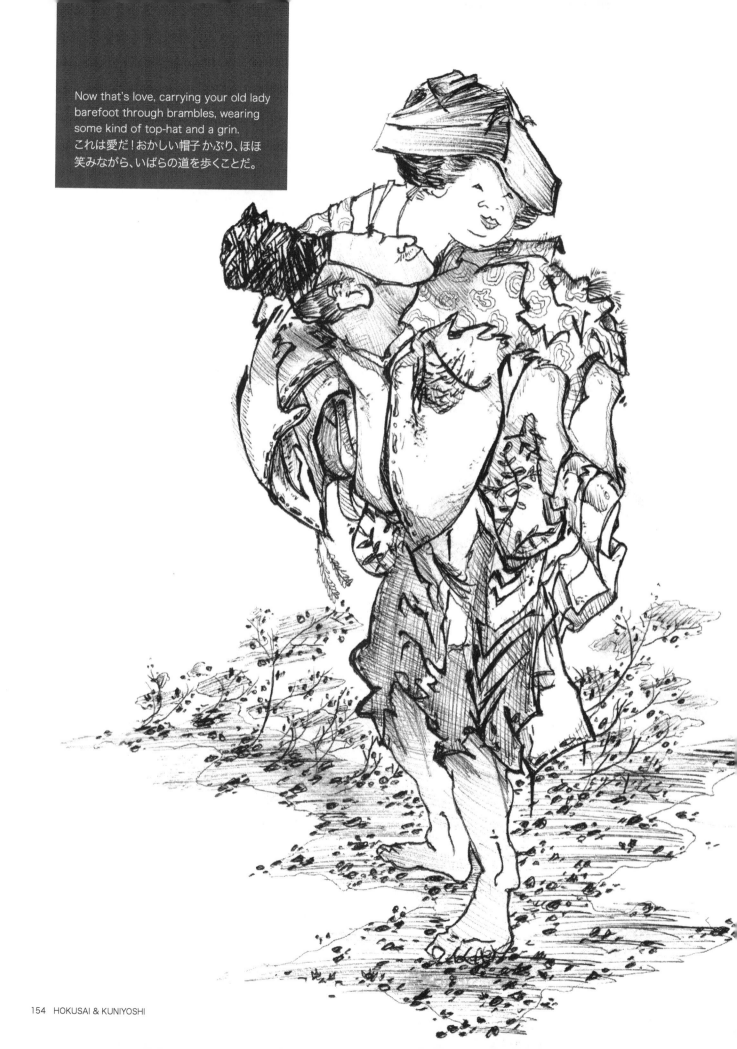

Now that's love, carrying your old lady barefoot through brambles, wearing some kind of top-hat and a grin. これは愛だ！おかしい帽子 かぶり、ほほ 笑みながら、いばらの道を歩くことだ。

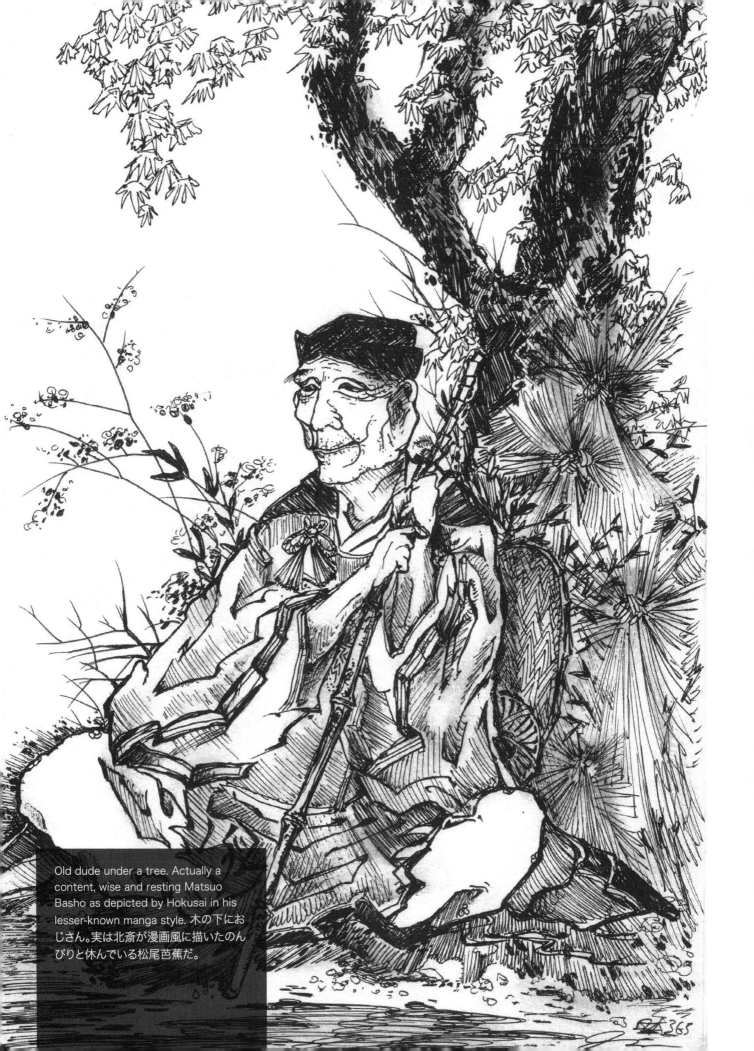

Old dude under a tree. Actually a content, wise and resting Matsuo Basho as depicted by Hokusai in his lesser-known manga style. 木の下におじさん。実は北斎が漫画風に描いたのんびりと休んでいる松尾芭蕉だ。

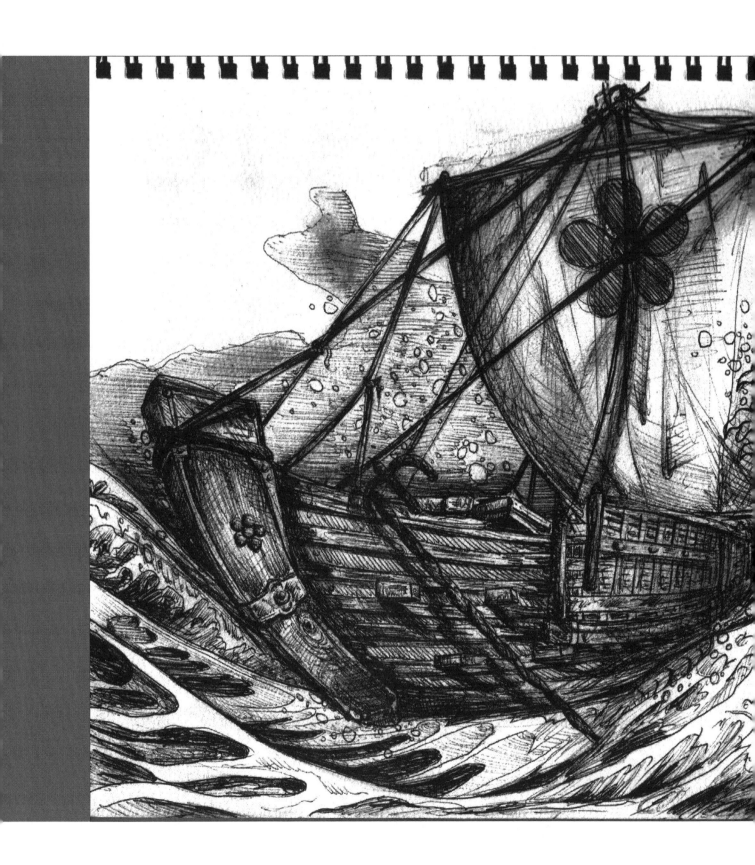

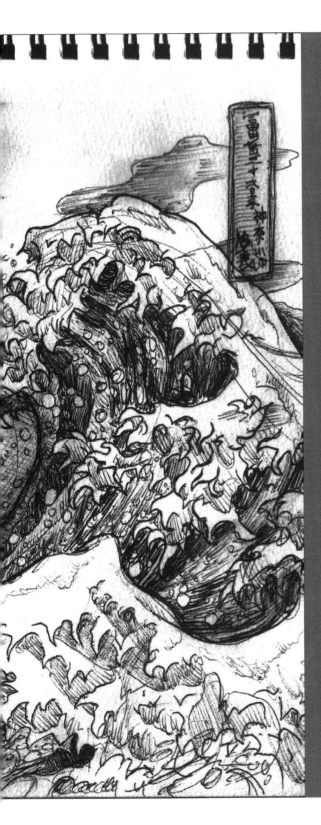

Kita mae ships in the Edo era linked the Hokkaido, Tohuku and Hokuriku regions with Osaka and Hyogo by sea route. At that time Toyo-oka City in Hyogo was a prosperous relay station. That ship, mashed up with "The Great Wave Off Kanagawa," an ukiyo-e print by Katsushika Hokusai circa 1830, one in his most famous series, 'Thirty-six Views of Mount Fuji' (Fugaku sanju rokkei)

江戸時代に北海道から東北・北陸と大阪・兵庫 を海路 で結んだ交易船「江戸前船」。当時、豊岡は寄港地として栄えていた。葛飾北斎「神奈川沖浪裏」(富嶽三十六景 1830)との合わせ技

京都三十六景

「鼻先にちゐぶらさげて扇かな」小林一茶

36 VIEWS

1 静寂な古い石
Some peaceful old rocks

静寂な古い石。龍安寺は15世紀に作られた枯山水の石庭でユネスコの世界遺産に登録された。

Some peaceful old rocks, stoic and crisp, unflinching power, which somehow feels like floating. Karesansui, dry landscape, rock garden dating back to the 15th century at UNESCO World Heritage site Ryouanji, the Temple of the Dragon at Peace in Kyoto City.

"I'm crude as a featherless bird. If I hadn't been told one of these famous stones at Ryoanji was always hidden from view, I wouldn't have thought to count. Anyway, they say our two wide eyes can't quickly distinguish beyond three or four of the same thing in a group.

"Instead of hunting the hidden stone, I counted tiny gravel moons raked in orbits around the moss and grey centerpieces. The task wasn't infinite, but I quit after five or six, forgetting where I began and worried where I might end.

"That night, R. and I ate soba and entertained the international fascinations of curious children. K., seven or eight, had learned some English and I sang with him about how we say what we feel. Then in easy time we counted to ten and a little beyond. Good luck contemplating stones, pilgrims. My work is talking with children."

"Enlightenment!
Buzzing around my nose I think
I fanned it away."

Haiku by (Kobayashi) Issa,
translation and commentary by Matthew Little

OF KYOTO

2 清水寺
"Pure Water" Temple

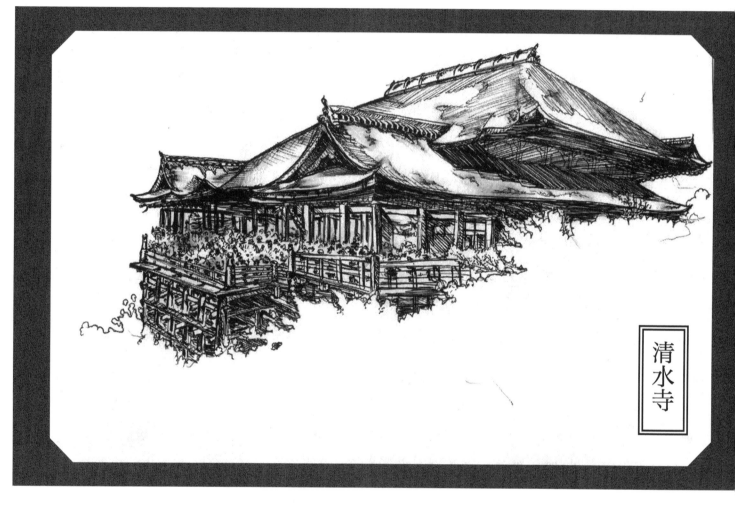

清水寺。多くの恋人 たちが飛び降り心中
した清水寺の舞台。生き残るかもしれな
いと言う話もよく聞かれる。京都市

Kiyomizudera, "Pure Water" Temple.
View of the crowded balcony where
countless lovers have leaped to their
demise, after a tale once told them
they might survive the fall. Kyoto City

3 清水寺で大鹿を発見
Moose sighting at Kiyomizudera

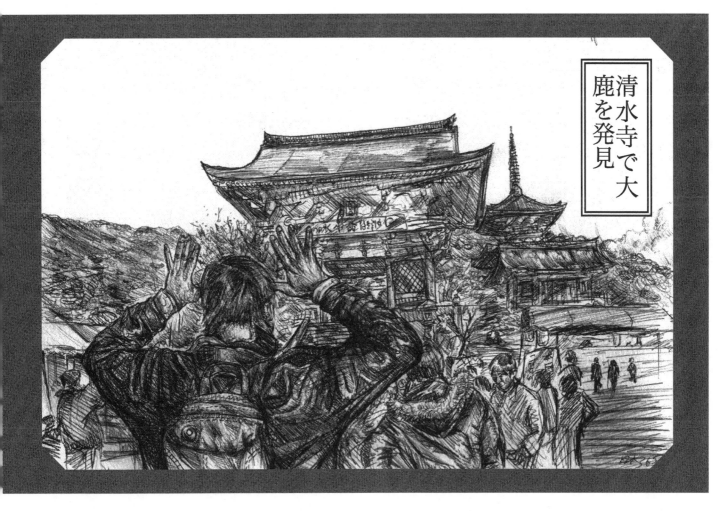

<div style="text-align:right">清水寺で大鹿を発見</div>

清水寺で大鹿を発見。日本三清水のきれいなお寺。夕日の時、是非見てください。でも、清水寺の舞台から飛ばない方がいいでしょう。
写真：チェンル・ゼング

Moose sighting at Kiyomizudera. Nice temple which boasts the "Top 3 Clean Water of Japan!" Recommended viewing at sunset; just don't go leaping off the balcony.
Photo: ChenRu Zheng

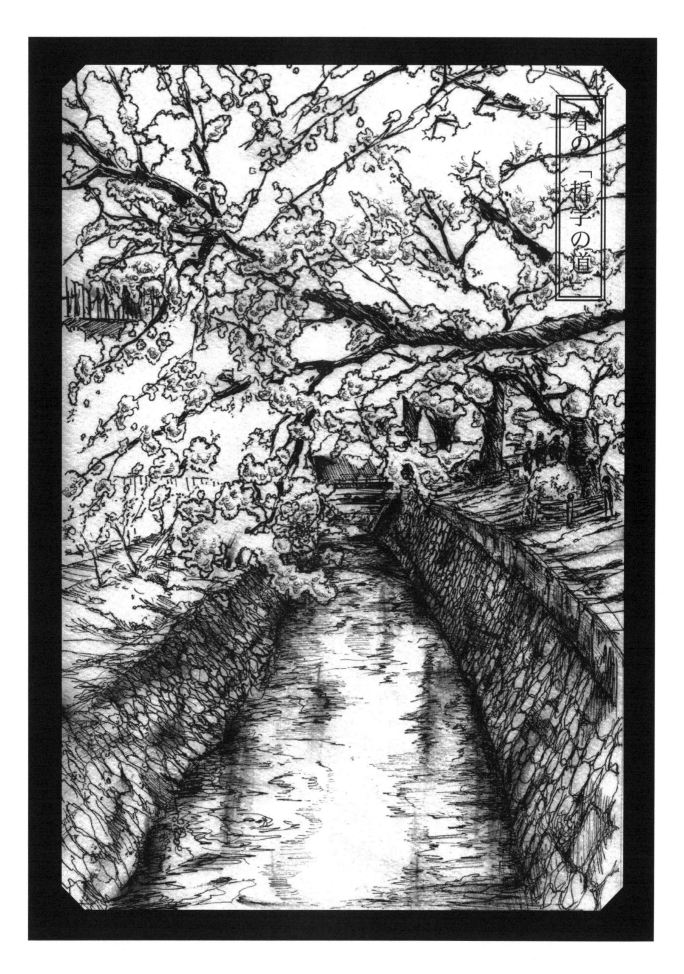

◄ 4 春の「哲学の道」 Philosopher's Path in spring

春の「哲学の道」。カップルや観光客かがみんなぶらぶら歩いて、芸術家や哲学者が作品を作ったり売ったりする。筆書きや写真撮影の音、食べ頃のタケノコ料理の味で、少し悟りを得たのだろうか？

Philosopher's Path in spring. When couples, tourists and seekers stroll, and craftspeople and artists lounge to create and sell their wares, perhaps each to achieve enlightenment in some way, between swishing brush-strokes, snapping photos and scarfing the seasonal delicacy, delicious baby bamboo treats.

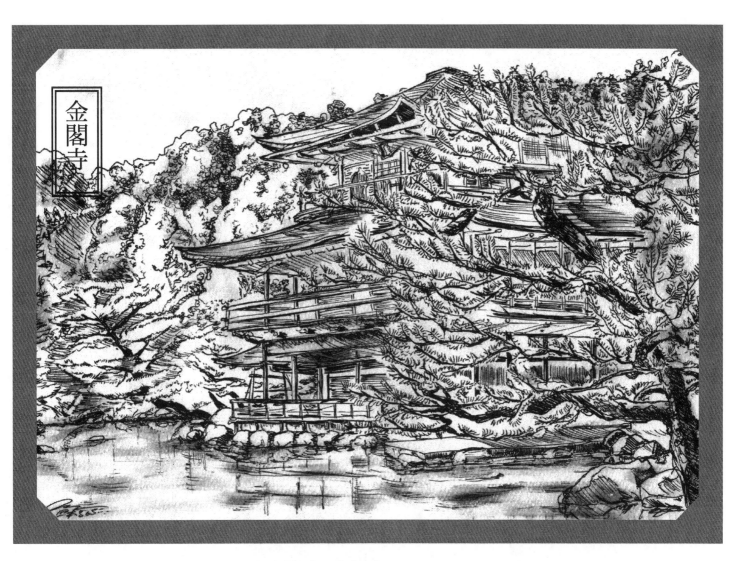

金閣寺

▲ 5 金閣寺。京都市 Kinkakuji, Temple of the Golden Pavilion. Kyoto City

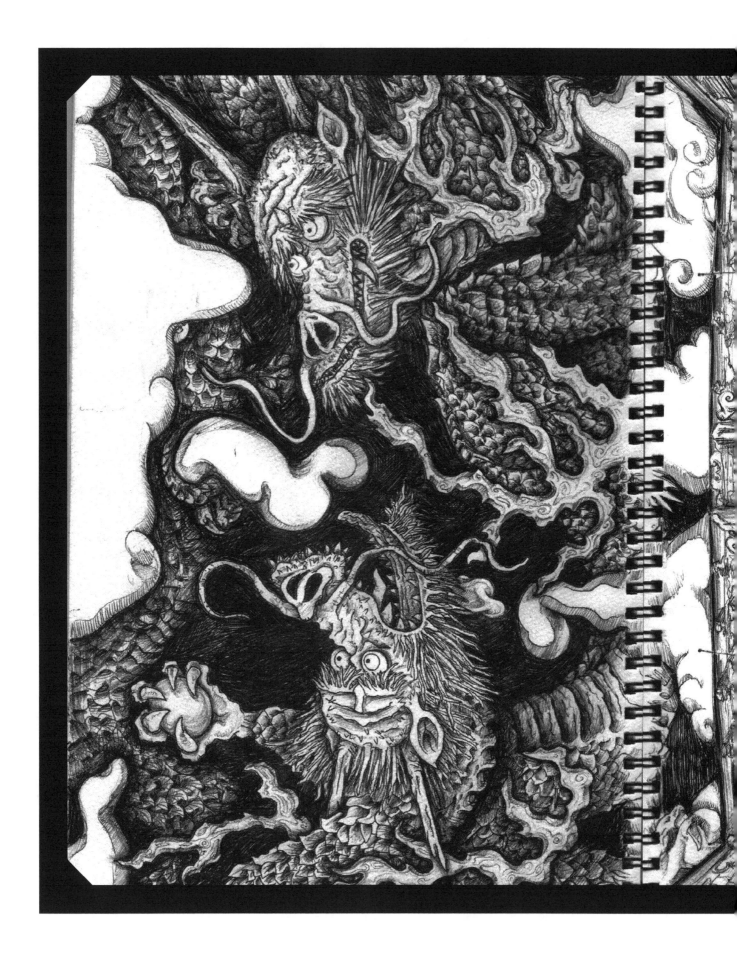

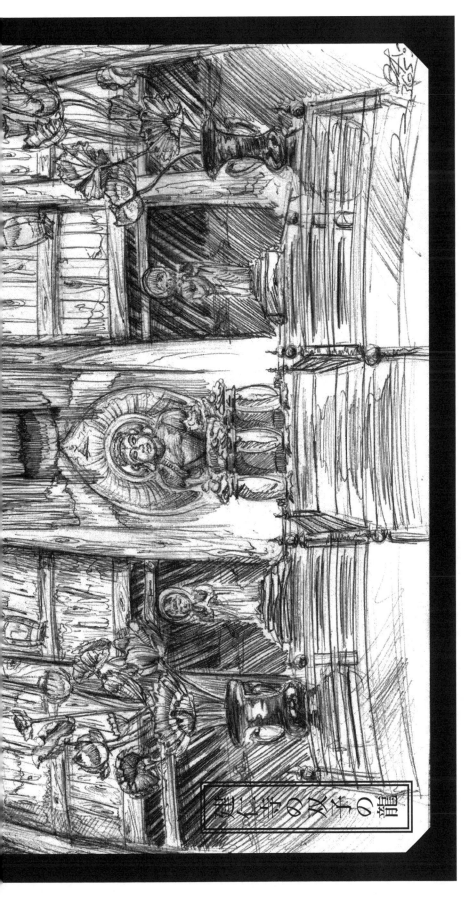

6 & 7 建仁寺の双子の龍
Twin Dragons of Kennin-Ji

建仁寺の双子の龍、年賀状第三。建仁
2年(1202年)に創建した。小泉淳作
は建仁寺の巨大な天井画を描いた。
天井画 は2002年に800年記念祭
のために納められた。およそ108枚分
の畳の大きさ。小泉淳作は高品質の墨
江を使って、伝統的な厚い和紙に描い
た。北海道の小学校の体育館で2年間
をかけて制作した。僕はボールペンで
スケッチブックのA4厚紙に6時間かけ
て描いた。
写真：リード・ハウザー

Twin Dragons of Kennin-Ji, Nengajo
#3. Kennin-Ji Temple was founded in
1202. This painting was installed in
2002 to mark the 800-year anniver-
sary of the temple, and it is appro-
priately epic and huge, 11.4m by
15.7m (the size of 108 tatami mats)
covering the golden Buddha altar
room ceiling, painted by artist Koi-
zumi Junsaku. He used top-quality
ink on thick, traditional Japanese pa-
per. He painted it in an elementary
school gymnasium in Hokkaido, and
it took almost two years. My ball
pen rendition on thick A4 sketch-
book took about six hours.
Photo: Reed Hauser

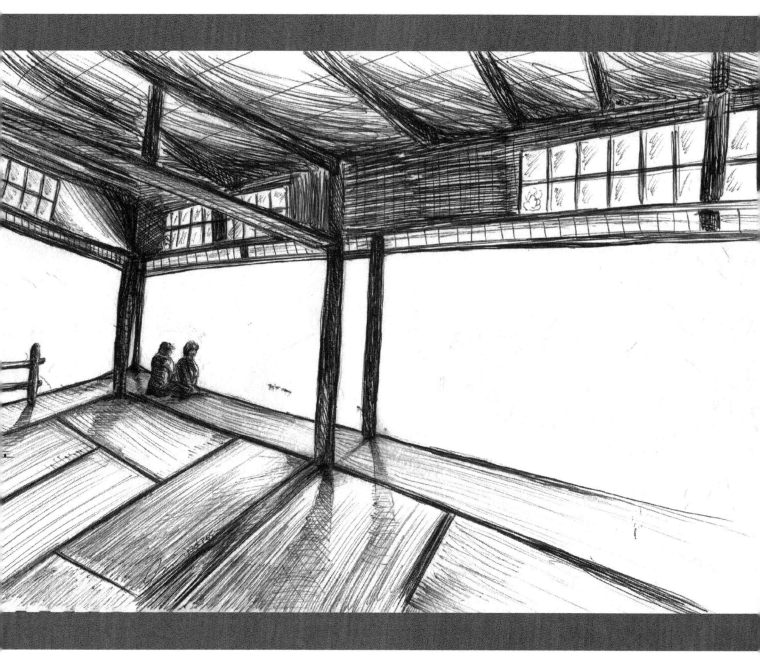

Inside looking inside-out into the white void outside coming in... View from the tatami meditation room out into the Zen garden at Shisendo Temple in Kyoto City

座禅が行える畳の部屋。真っ白な空間からみつめる。詩仙堂京都市

9 詩仙堂の座禅が行える畳の部屋
White void outside in favor of garden inside

詩仙堂の座禅が行える畳の部屋。まるで白い空間から庭園が浮かび上がっているよう。

White void outside in favor of garden inside, outside become white inside-out, right? Tatami meditation room at Shisendo Temple

10 伏見稲荷、春
Fushimi Inari

伏見稲荷、春。終わりのない門をカップル
が歩いている。

Fushimi Inari. Couple strolling through
the (never-ending) gates in spring.

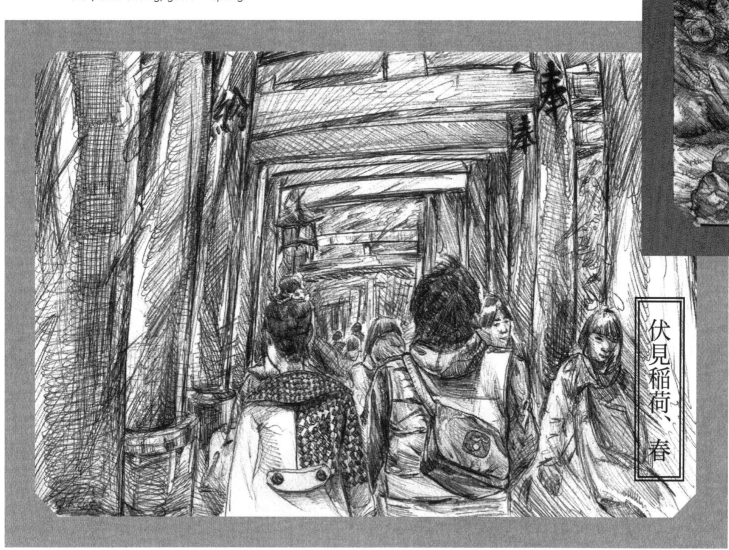

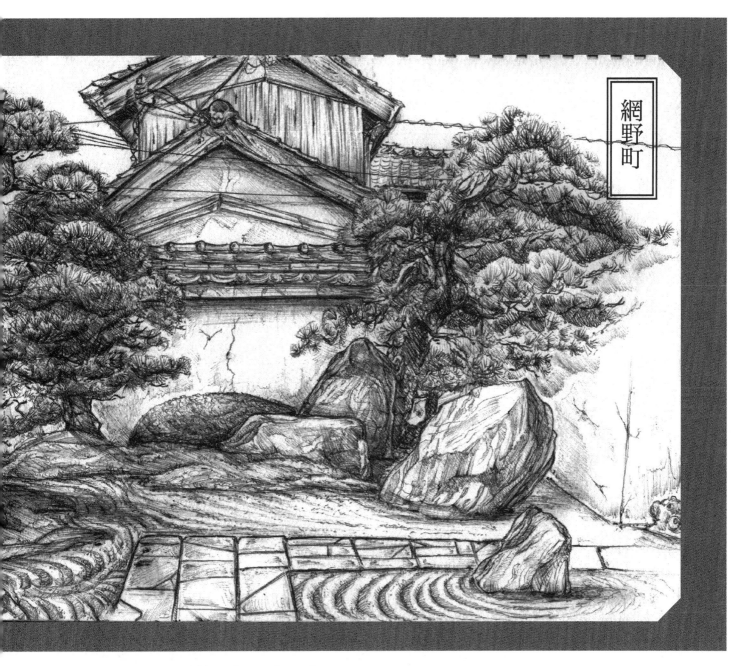

網野町

11 網野町、田勇織物の枯山水の庭
Amino Taiyu Kimono Rock Garden

網野町、田勇織物の枯山水の庭。(この絵を描いている様子はJAPAN 365のキャンペーンサイトIndieGoGoで動画で見ることができる。)収録してくれたFeltonsと、素晴らしい眺めと落ち着いた雰囲気のある 場所を勧めてくれたYuki、Orlandの根気、私たちに緑茶を差し入れてくれて彼らの庭を使わせてくれた田勇織物の優しいスタッフに、心から感謝。白壁の向こうの素朴な裏道からは想像できないような、静かな庭だ。

Amino Taiyu Kimono Rock Garden. (Live drawing process documented for the JAPAN 365 IndieGoGo campaign's stop-motion video.) Special thanks go to the Feltons for recording, Yuki's recommendation of an excellent view and peaceful location, Orland's patience, and Amino Taiyu Kimono's lovely staff for bringing us green tea and letting us use their tranquil space, off an unassuming alley street; you would never know the rocky tranquility just beyond the plastered white walls. Except for those peeking black pine (matsu) hands, coaxing intrigue and showcasing nature's grandeur in such flawless manicured imperfections.

12 & 13
古家にスケッチコラボ
Sketch collaboration on an old Japanese mansion

古家にスケッチコラボ、「SITCH、FES、MAZE、EZBU、PEAS」と言うアーティストの落書き。

Sketch collaboration on an old Japanese mansion with a little new graffiti to spice up the scene and get on some nerves. Featuring SITCH, FES, MAZE & EZBU, and with a throwback shout-out to PEAS.

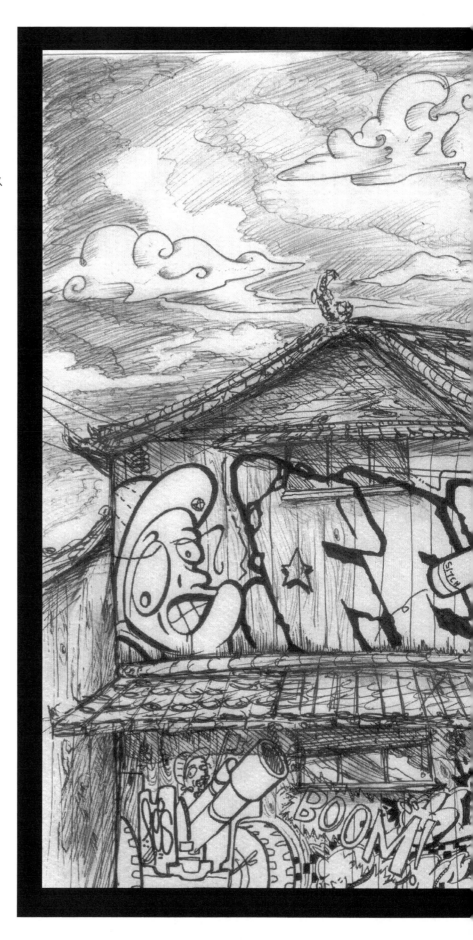

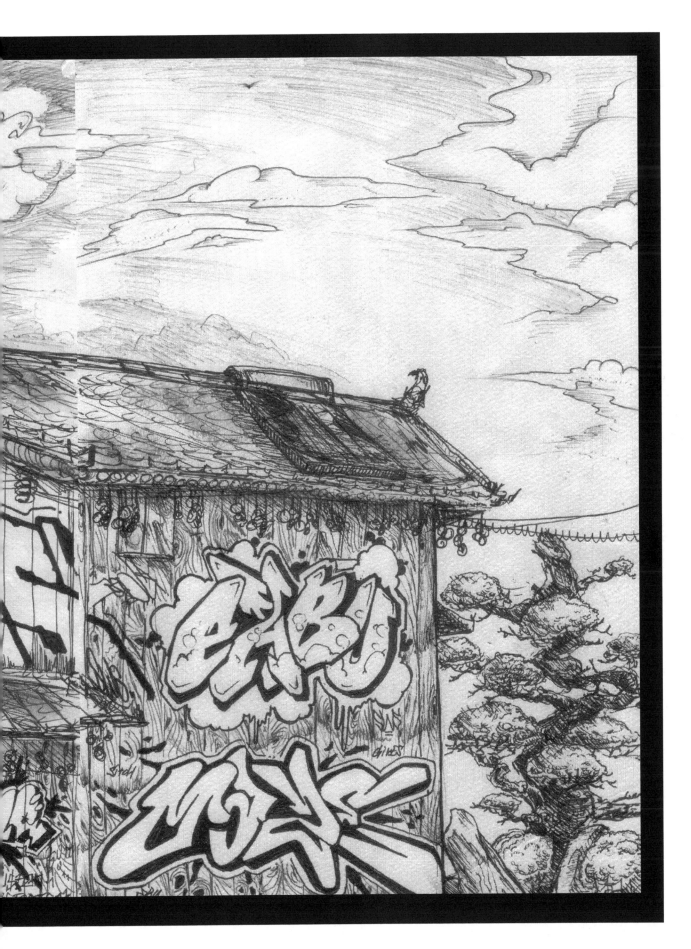

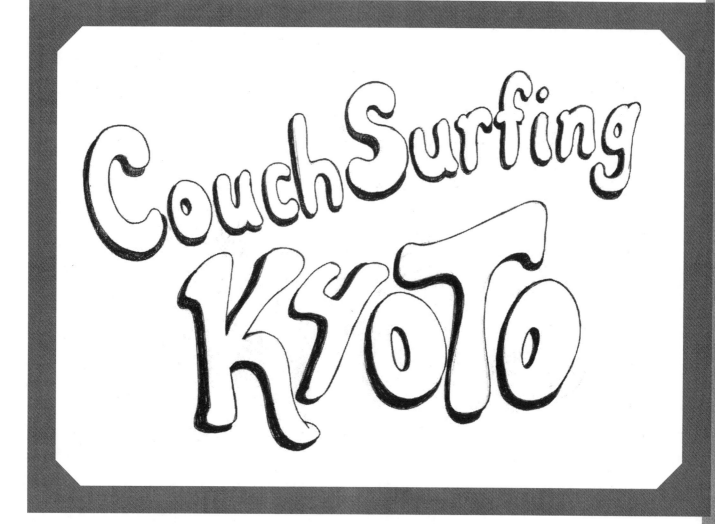

14「Couch Surfing」

「Couch Surfing」のロゴに似せて。京都の「Couch Surfing」のデザイン。Resembling the Couch Surfing logo font, free-handed bubble letters for the Kyoto Couch Surfing T-shirt design.

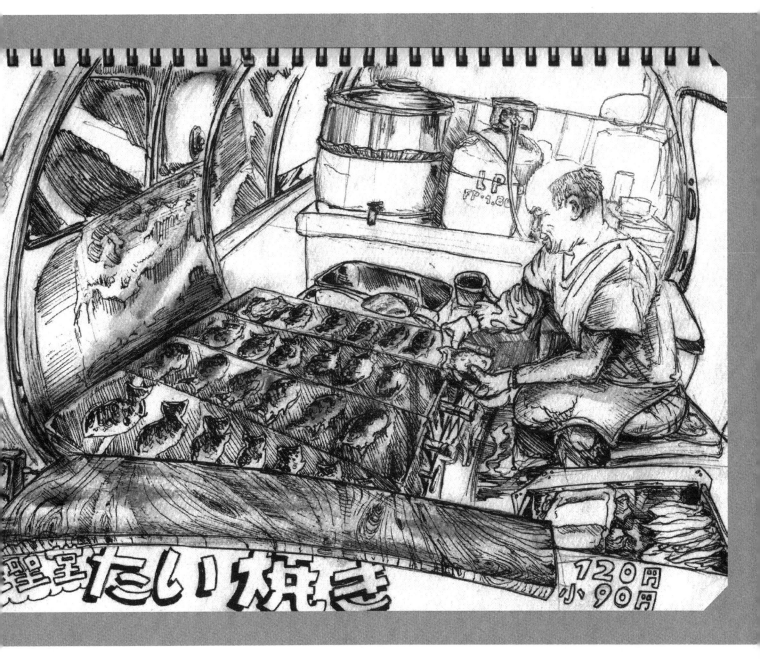

15 たいやき Taiyaki

たいやき、タイの形をしたおやつで、おじさんがライトバンで楽しそうに焼いていた。おじさんは、効率的な、車のキッチンでクーラーボックスの上に腰かけて、シモンまさとの古い歌「泳げ　たいやきくん」を大音量でかけていた。おじさんは、バスを待っている僕にただで、一つごちそうしてくれた。魚の形のふわふわのホットケーキの中に甘い小豆が詰まっていたよ。僕のおなかがあったかくなって、おいしかったよ！カスタードもあるんだって！

Taiyaki, a baked seabream shape treat prepared happily by this old man in his van. He was blasting Shimon Masato's classic workman's tune, "Oyoge! Taiyaki-kun" from his efficient mobile kitchen, sitting on an icebox, and he even gave me a freebie, sweet-red-bean-filled fluffy fish pancake while waiting for the bus. Warm and yummy in my tummy. Also available in custard flavor!

16 「Maiko-san」

「Maiko-san」は京都の象徴でもある舞妓さん。彼女たちは舞妓の姿をしているが、実はそうではない。いま、京都では、一日だけの舞妓体験が流行っている。1万円程あれば、誰でも本格的な舞妓さんに変身できるそうだ。
写真：高田優希（タカタ　ユウキ）

Maiko-san is one of the best-known symbols of Kyoto. These girls are wearing maiko kimonos, but they aren't real maiko. Now, here in Kyoto, anyone can become a classical maiko-for-a-day, if you have 10,000 yen.
Photo: Yuki Takata

17 相撲をとるおじさん。
Some old dudes playing Sumo.

相撲をとるおじさん

油善の着物職人

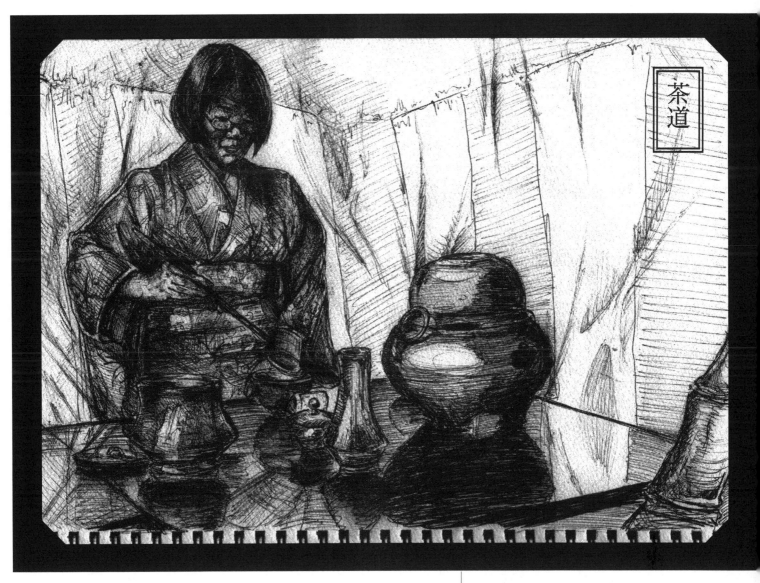

茶道

19 茶道 ∧
Sadou

茶道（または茶の湯）は、日本の伝統文化
の一つだ。
Sadou, also called chadou or cha-no-yu, is the traditional etiquette of preparing and drinking tea.

≪ 18 油善（あぶらぜん）の着物職人
Hataya-san (Kimono weaver)

油善（あぶらぜん）の着物職人、はたや
さん。3000本以上の絹の糸を手作業
で機械に取り付け、着物の生地に複雑
なデザインを織り込むために、パンチで
穴をあけた紙を用いる。紙はまるでモー
ル信号のようだ。物凄い早さで糸を紡
ぎ、糸車が、ルーブゴールドバーグの不
可解で複雑な絵の実験のように回転す
るさまは、思わず見入ってしまうもので
ある。伝統的な素朴な日本の家の中で
けたたましい音を立てて十基ほどの織
機が同時に動いている。京都府京丹後
市網野町

Hataya-san (Kimono weaver) from Aburazen in Amino. Hand tying 3000+ silk threads to the machine which then uses a design fed like morse-code with holes punched in paper to weave intricate designs into the kimono fabric, shooting threads at finger-breaking speed with rotors spinning and wheels turning like some wild and complex Rube Goldberg experiment is a sight to behold, and quite the racket with a dozen machines going at the same time in an otherwise unassuming traditional Japanese house!
Amino Town, Kyotango City, Kyoto

大きな鯛

▲ 20 大きな鯛
Tai, sea bream

日本海で釣り上げた、大きな鯛。日本では縁起の良い魚とされ、お祝いの席に欠かせない。そのため、七福神の一人恵比寿は釣竿で鯛を釣り上げた姿をしている。

Tai, sea bream, is believed to be a fish that brings good luck because its name resembles "medetai" (happy) and its color is lucky red. Hence, one of Shichifukujin (the seven Gods of good luck) is always holding a sea bream. Yuki Takata, "What a nice catch!"

21 京都府北部 ≫
Mr. Takata

京都府北部、網野町と峰山町にある老舗のパン屋タカタベーカリー。網野店のオーナーである彼の筋肉質な腕は、68歳になった今でも現役でいる証拠だ。40年近く朝早くから夜遅くまでパンや焼き菓子を作り続けている。
写真：高田優希（タカタ　ユウキ）

Mr. Takata, the brains and brawn behind one of north Kyoto's longest-running bakeries, Takata Bakery, with stores in both Amino and Mineyama, sitting on his backyard stoop. Check out those ripped triceps; that's some serious baker's muscle!
Mineyama Town, Kyotango City, Kyoto Prefecture
Photo: Yuki Takata

京都府北部

自動販売機

▲ 22 どこにでもある
Ji-dou-han-bai-ki

どこにでもある、光る自動販売機。ジュースの缶がこれ以上なかったらどうするのか？思い出そう、リデュース、リユース、リサイクル！ 霊山歴史観京都市

Ji-dou-han-bai-ki, vending machines, are everywhere...glowing. What if there were no more cans of juice in there, kid? Remember to reduce, reuse and recycle. Outside the Ryozen Museum of History, Kyoto City

23 天橋立の近くのお寺 ▶
Contemplating

天橋立の近くのお寺。素晴らしい漢字の石刻を見て、考える。
Contemplating. This kanji stone-carving is the coolest. At a temple near Amanohashidate.

24 米の収穫の機械
Rice harvesting technology

米の収穫の機械。古そうに見えるけど、この小さなトラクターは重い米を手作りの稲木まで運ぶのに運ぶのに役に立つ。
Rice harvesting technology. It may look ancient, but this little tractor helps modern-day semi-traditional farmers move heavy bundles of kome, rice stalks, to their huge hand-made bamboo drying racks called ineki.

丹後町

25 丹後町
Brisk morning jog

朝のジョギング。丹後町の棚田で。
写真：トーマス・ブリンモア
Brisk morning jog down a path be-
tween rice paddies of Tango.
Photo taken by Brynmor Thomas of
his lovely wife Liz.

天橋立

⌃ 26 股のぞきをすると天橋立は空に架かる橋のように見える
Mata Nozoki at Amanohashidate, the Bridge to Heaven

股のぞきをすると天橋立は空に架かる橋のように見える。その橋には八千本の松が生えていて、カップルで訪れると別れると言われている。京都府宮津市日本三景
Mata Nozoki at Amanohashidate, the Bridge to Heaven. Peeking through one's legs to see a dragon fly to heaven (or less poetically, a bridge to it) and suddenly, the sky and sea are mysteriously reversed! Fun fact, there are more than 8,000 pine trees on the man-made land bridge, and couples should not visit there together because it is rumored they will split shortly thereafter, perhaps one going bay-side, and the other going seaside. One of the "Top Three Views of Japan" (Nihon Sankei). Miyazu City, North Kyoto Prefecture

27 天橋立の灯籠祭り
Pop an ollie over the Bridge To Heaven.

天橋立の灯籠祭り。スケートボードで天橋立 を飛び越えようか？
Ukiyo-e-inspired sketch for EXTRACTION 2011, an epic live graffiti painting and skate contest event at Miyazu Skate Park. Graffiti wall, DJ event, skate contests, emcee battles and more, right next to the infamous Mipple (not what you are thinking, it's just a department store). The event coincides with the annual Amanohashidate Fireworks and Lantern Festival during which 10,000 lanterns are lit and float out into the bay after dark. Then larger floats are burned, and finally the finale of 3,000 fireworks explodes over the water to a soundtrack of some kitsch classical music and a lady ruining the moment talking logistics about who bought all the fireworks. "Just let us watch the pretty colors, lady!"

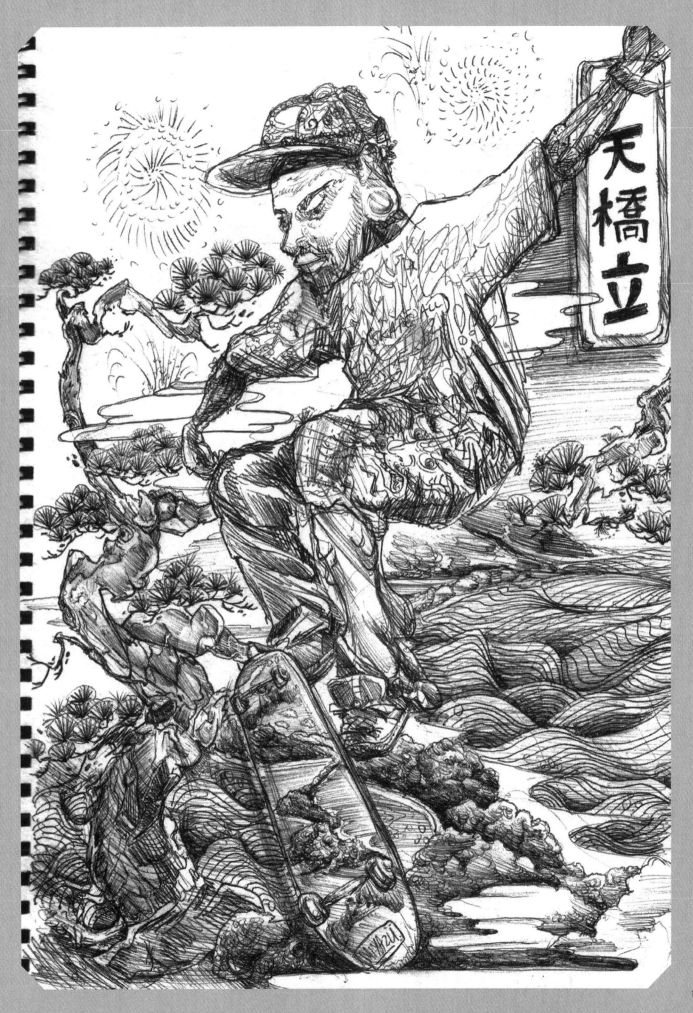

天橋立

185

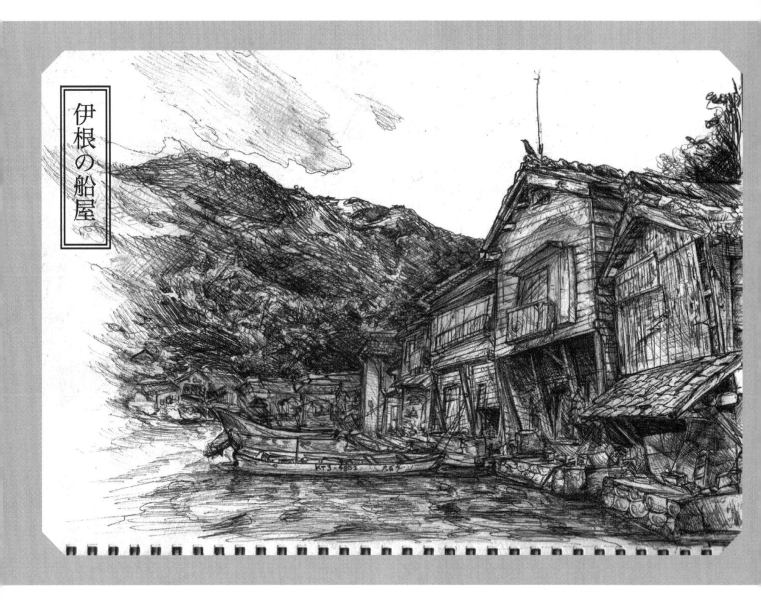

伊根の船屋

▲ 28 伊根の船屋
Ine no Funaya, famous
boathouses of Ine Bay

丹後半島
Tango Peninsula

29 丹後松島
Tango Matsushima ➤
Norikaki

丹後松島1920年代丹後半島の平
浜の海苔かき（海苔を取っている）
Tango Matsushima Norikaki. Gather-
ing seaweed on Hei Beach, 1920s.
Tango Peninsula, Kyoto Prefecture

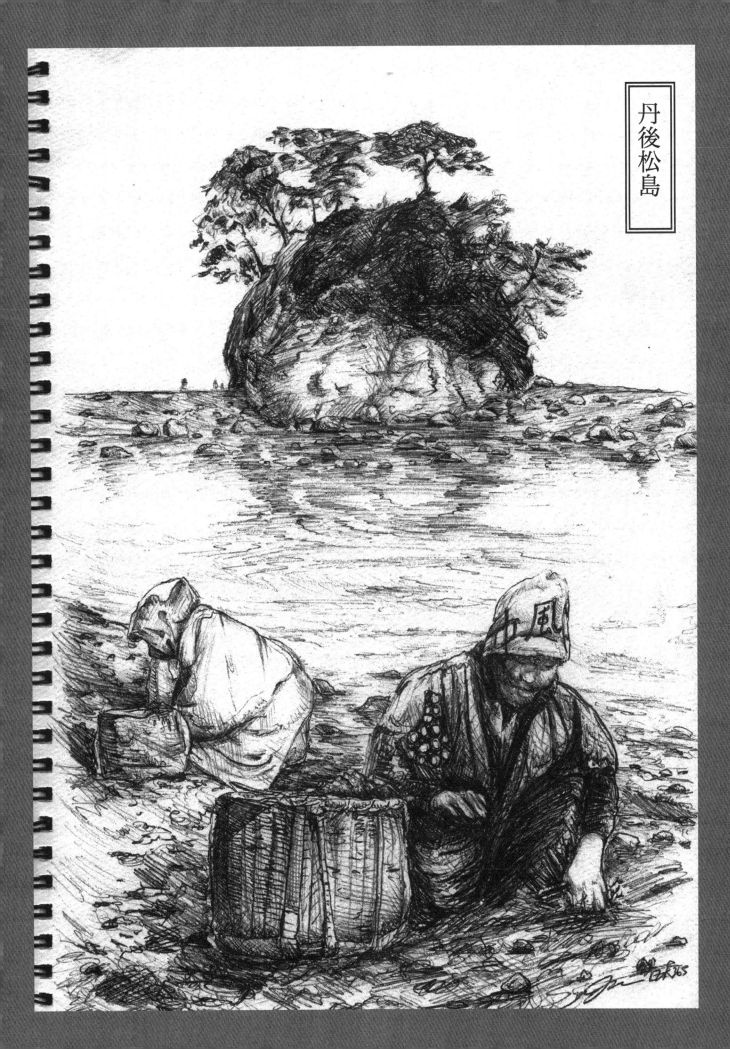

丹後松島

30 経ヶ岬の灯台
Lighthouse at Kyouga-misaki

経ヶ岬の灯台。日本で有数の大きくて明るい白亜の灯台は180°以上海に囲まれ京都府丹後半島の北端に立つ。最先端の電灯を設置するため工事中のところ。

Lighthouse at Kyouga-misaki. One of Japan's biggest, brightest and most impressive lighthouses, surrounded by an expanse of the Sea of Japan more than 180 degrees, protecting the northernmost tip of the Tango Peninsula (and Kyoto Prefecture). Depicted under construction as it was getting a cutting-edge crystal light installed.

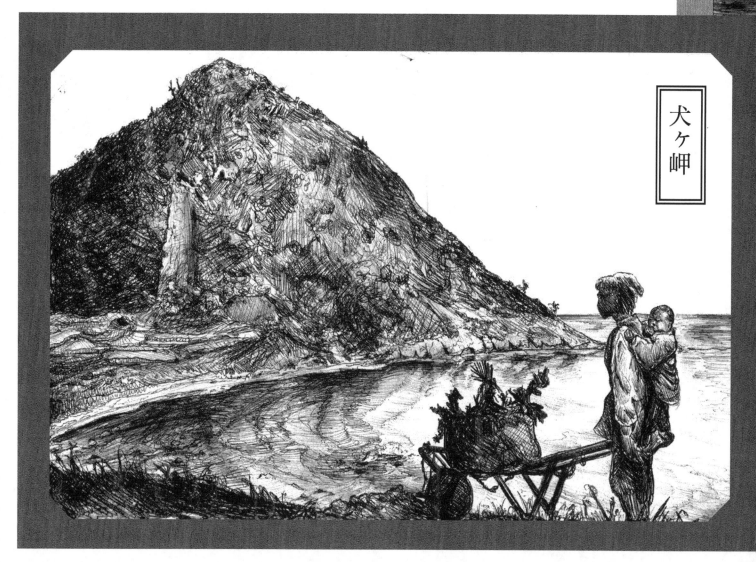

犬ヶ岬

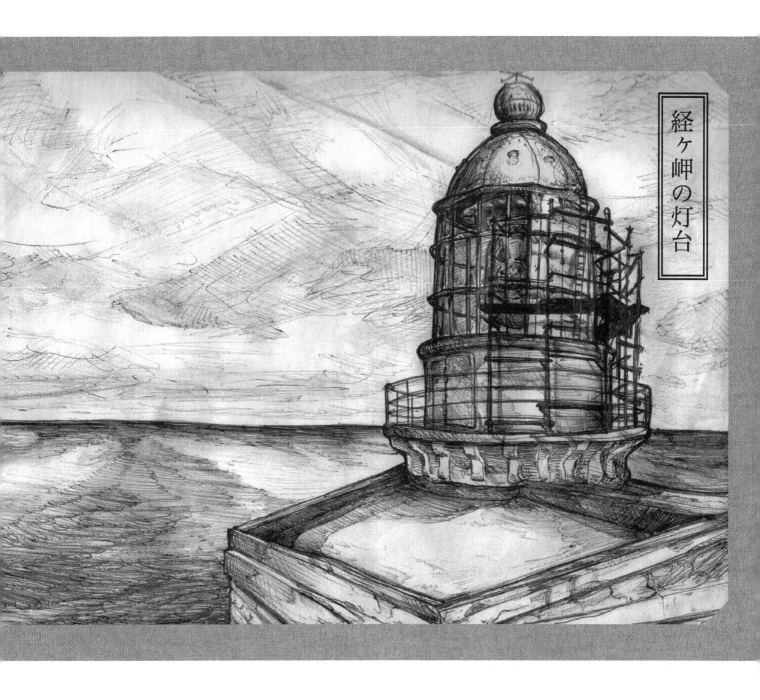

経ヶ岬の灯台

31 犬ヶ岬
Inuga-misaki

犬ヶ岬。赤ちゃんと女性と一輪車。1900
年頃撮影された写真。
Inuga-misaki, Dog Cape. Image of a
woman with a baby and a wheelbarrow
(circa 1900).

32 イカ釣り舟
Ika fune, squid boat at Taiza port

イカ釣り舟。間人港（たいざこう）にて漁師達は夜、大きな灯りをともして船をだし、イカを水面におびき寄せ捕まえる。イカは新鮮なまま、刺身で食べられたり、天日干しにされたりする。

Ika fune, squid boat at Taiza port. These fishermen go at night and turn on their huge bright lights to attract the squid to the water's surface for an easy catch. Squid to be eaten fresh or hung out in the wind and sun to dry.

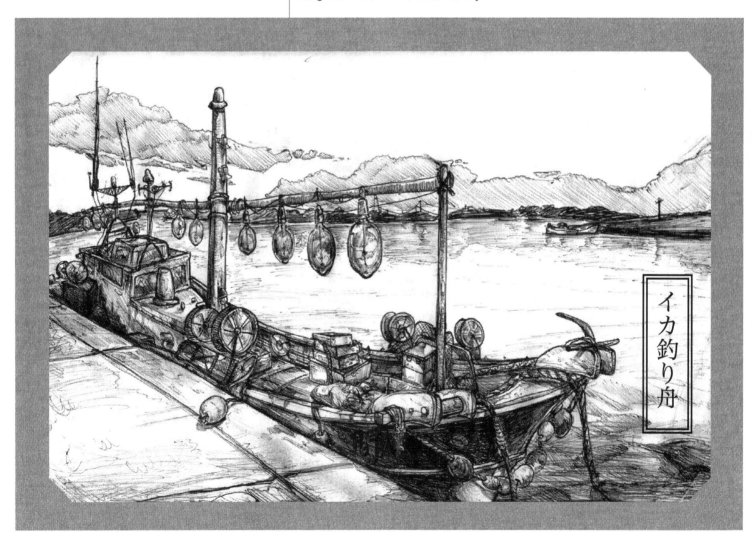

イカ釣り舟

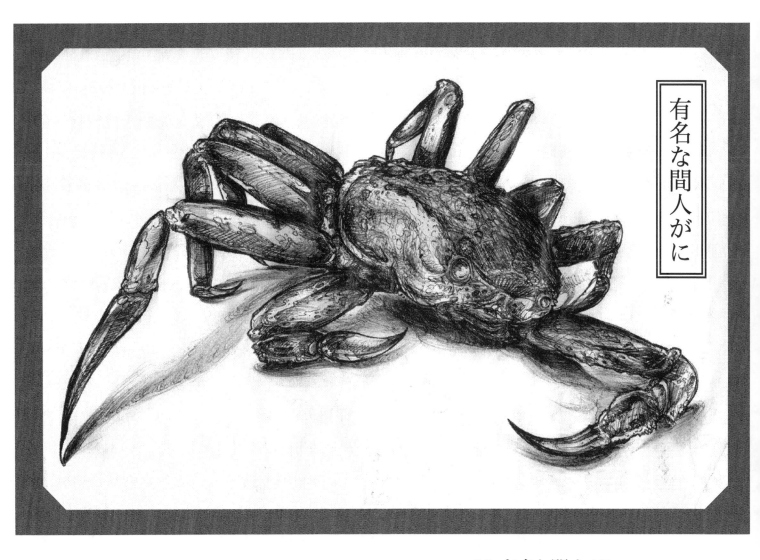

33 有名な間人がに
Taizakani, famous
Taiza winter crab

34 間人皇后（はしうどこうごう）と幼い息子の
聖徳太子の像。立岩と日本海をみつめて佇む。

Hashiudoso, statue of Empress Hashiudo
and her son, facing Tateiwa (standing
rock) and the Sea of Japan.

間人皇后

住み慣れた家

35 ふるさとの住み慣れた家。農家の夫婦。丹後半島
Furusato, one's "old home." A couple of rice farmers of
the Tango Peninsula.

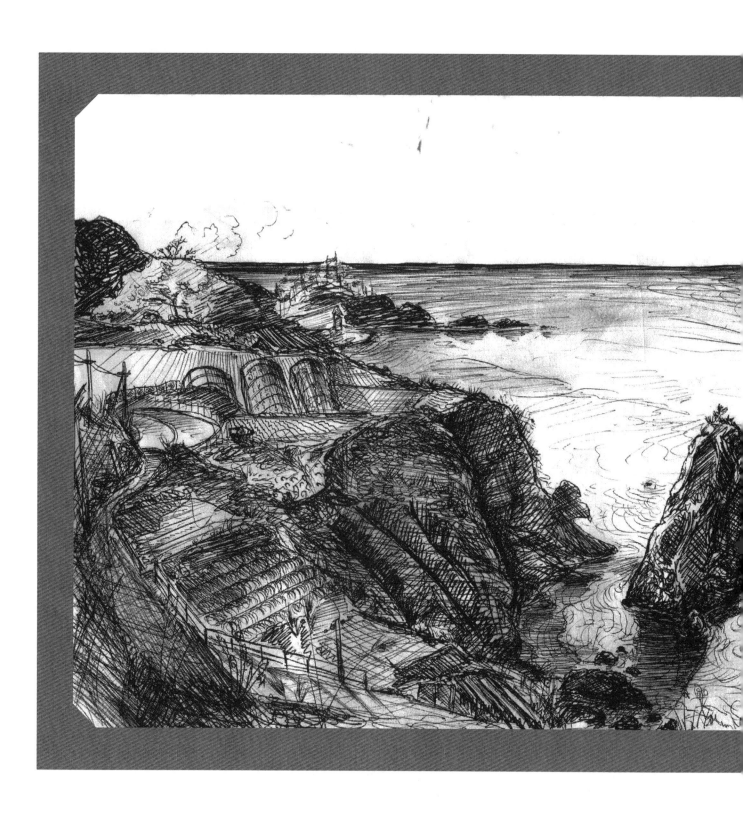

屏風岩

36 屏風岩
Byobuiwa, standing-screen rock.

屏風岩。山陰海岸ジオパークと丹後、天橋立国立公園を結ぶ海岸線において、絶好の写真スポットだ。
Byobuiwa, standing-screen rock. A major photo-op tourist stop along the San'in Kaigan Geopark and Tango-Amanohashidate National Park coastline.

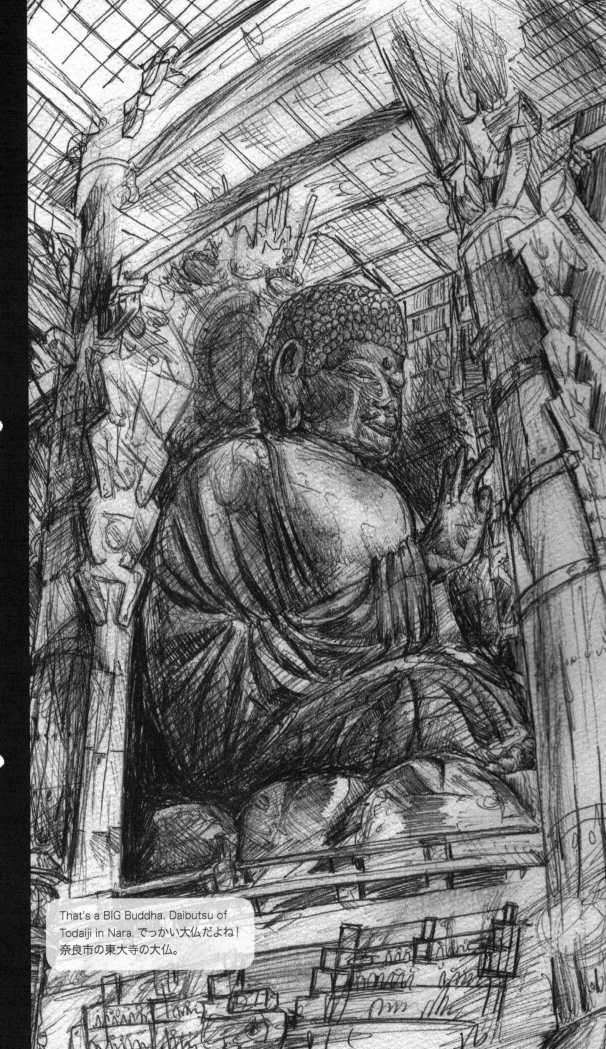

寺院と神社

That's a BIG Buddha. Daibutsu of Todaiji in Nara. でっかい大仏だよね！奈良市の東大寺の大仏。

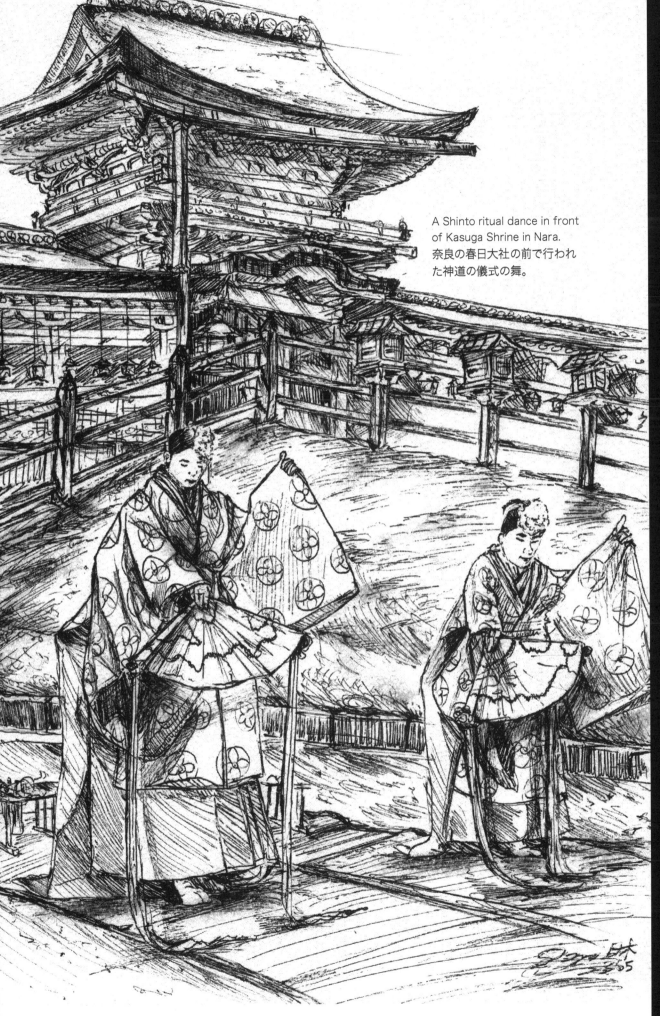

A Shinto ritual dance in front of Kasuga Shrine in Nara.
奈良の春日大社の前で行われた神道の儀式の舞。

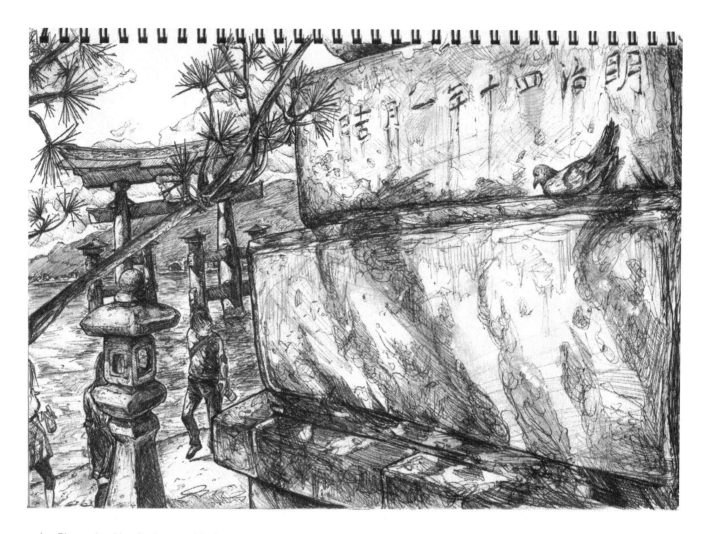

▲ Pigeon basking in the speckled
sunlight amidst the tourist masses'
view of Itsukushima Shrine's "floating"
torii gate on Itsukushima Island,
popularly known as Miyajima. One
of Japan's "Top Three Views" (Nihon
Sankei). Hiroshima Prefecture

日本三景の厳島神社を観光する群衆の
中で、ハトは日向ぼっこをしていた。
広島県

Sacred space, speckled shadows. ➤
A vibrant torii gate (think glossy
varnished vermilion paint) during
cherry blossom season. Tsuwano,
Shimane Prefecture
Photo: Greg Ferguson

桜の季節。神聖な場所にまばらな影が
映る。活気に満ちた鳥居だった(朱色
で上塗りをしているようだ)。津和野市
島根県写真:グレッグ・ファーグソン

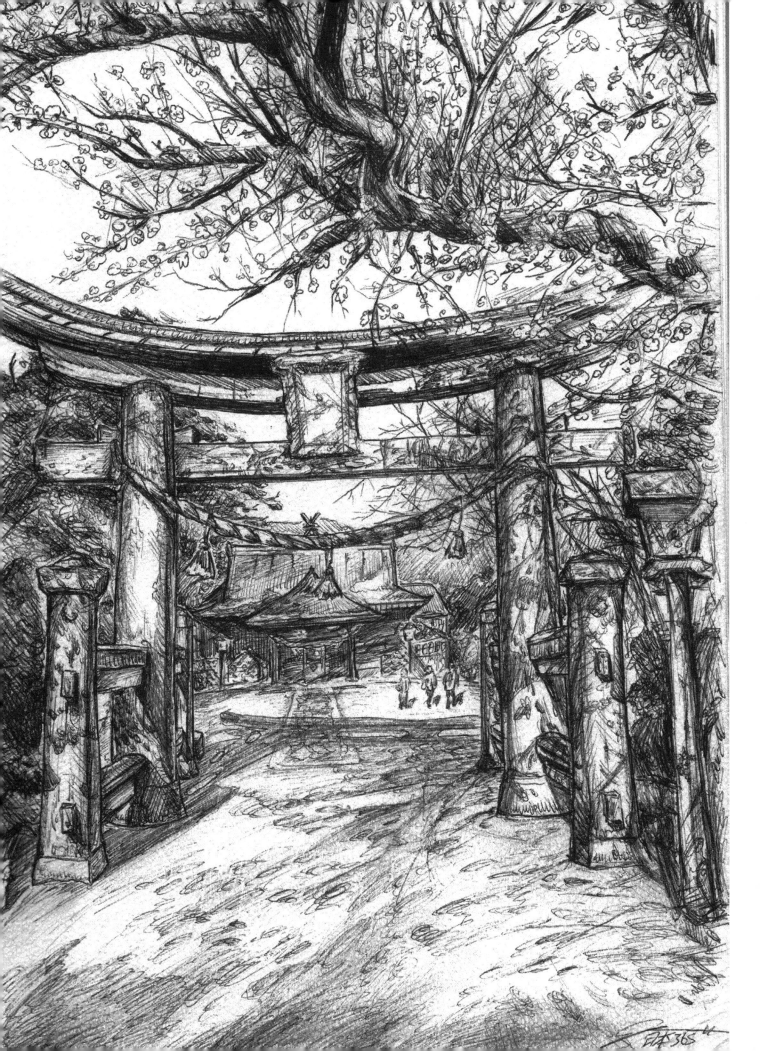

Big rope shrine (drawn left-handed) in
Tsuwano called Taikodani Inari Jinja.
The big rope is made using the stalks
of a variety of rice specially grown for
making mochi. Did I mention this was
drawn left-handed? Ol' righty needed
a rest! Shimane Prefecture
Photo: James Hart

太鼓谷稲成神社にある餅
米の茎で作った綱。左手
で描いた、右手を休ませ
なきゃ！島根県写真‥
ジェイムズ・ハート

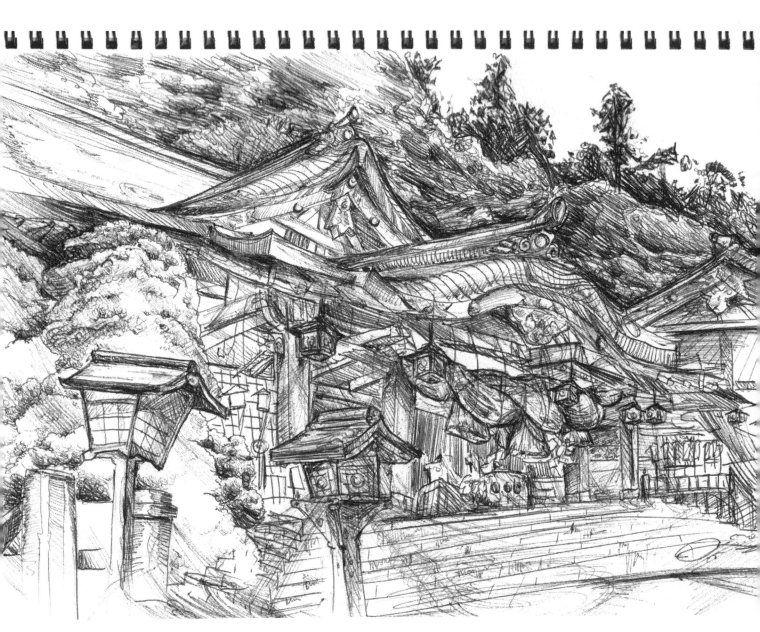

Big mochi-rice-rope shrine, drawn
right-handed.

太鼓谷稲成神社を今度は右手で描いてみた。

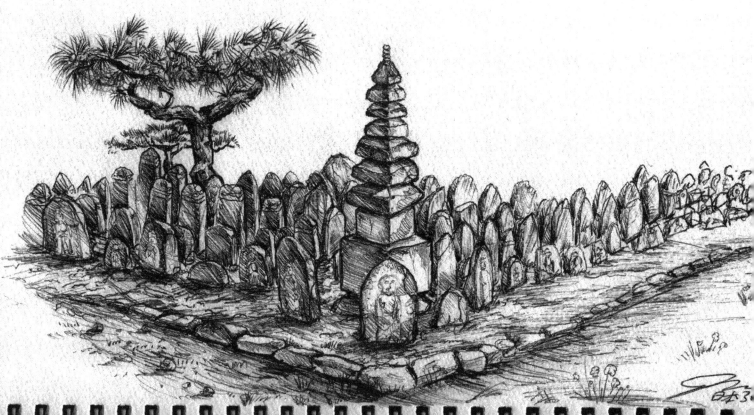

Tombstones huddled together, as in life.
人生と同様に、墓碑が群がる。

Shoro, Bell Tower of a Buddhist temple, which houses a huge bonsho bell rung on New Year's Eve 108 times to dispel evil spirits (or man's 108 earthly desires) for a prosperous year ahead. Sahara-chan playing with bowlfuls of snow in the foreground.
Takachiho, Miyazaki Prefecture

寺の鐘楼にある大晦日に鳴らされる梵鐘。好い一年 のために１０８回鳴らし、煩悩を追い払う。（表）Saharaちゃんが雪玉で遊んでいる。高千穂　宮崎県

乗り物

Dudes on Bikes. Mie Prefecture
Photo: Amber Hill
自転車を乗る奴ら。三重県
写真：アンバー・ヒール

The Shinkansen bullet train, a symbol of Japanese perfection, cutting-edge technology and punctuality. In its 45-year history, the trains have an average arrival time within six minutes of schedule and an amazing safety record, with no casualties from accident or derailment; just one person getting stuck in the door, apparently. Reference photo in Chris Willson's "Modern Japan" series (www.TRAVEL67.com)

新幹線は日本の最先端テクノロジーと正確さの象徴。45年の新幹線の歴史で、平均の到着時刻の誤差は6分以内という驚異的な記録を持つ。事故や死傷者もいない。「www.TRAVEL67.com」のクリス・ウィルソンの "Modern Japan"写真を参照した。

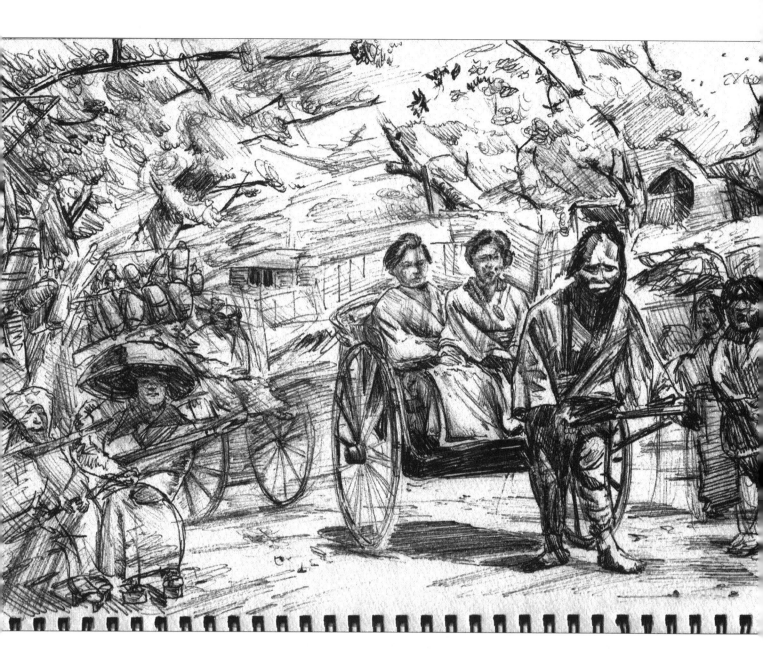

Jinrikisha, Human-powered car. Excerpt from a photo entitled Mankai no Sakura, Cherry tree in full bloom. Tadayoshi Collection, Shirahige, Tokyo
人力車。忠義コレクション、東京・白鬚

Ride the Dream. Steamboat from Japan to San Francisco in the early Taisho era (1912-1926).
夢をのせて。大正初期、日本人たちを乗せてサンフランシスコ港に入る汽船。

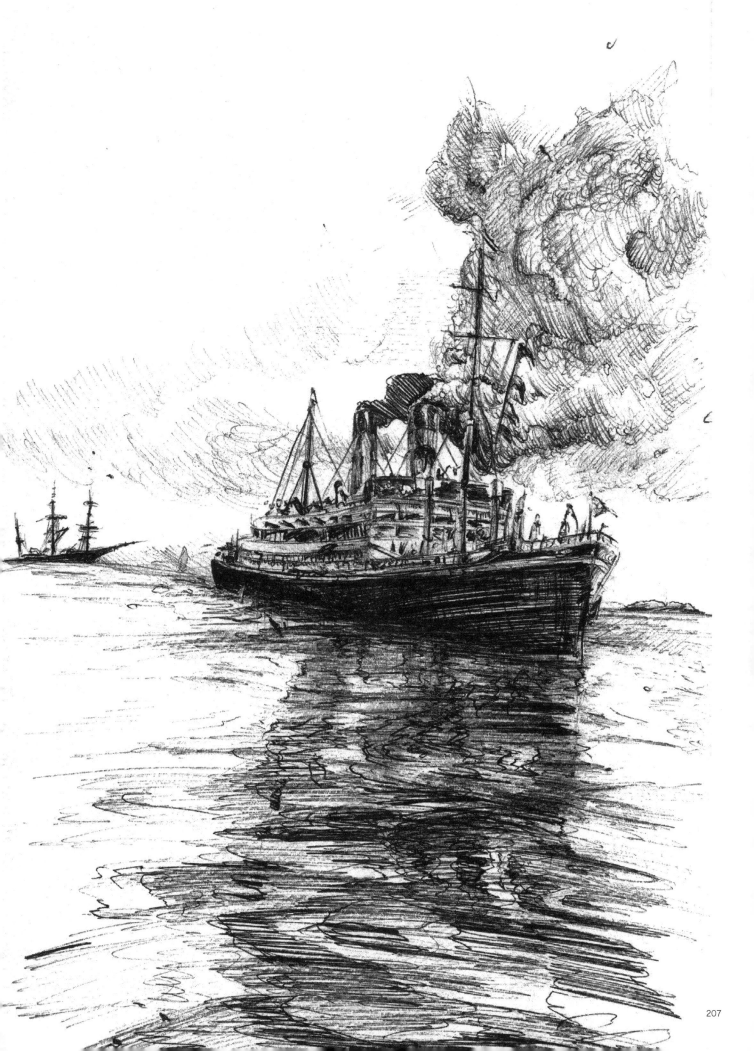

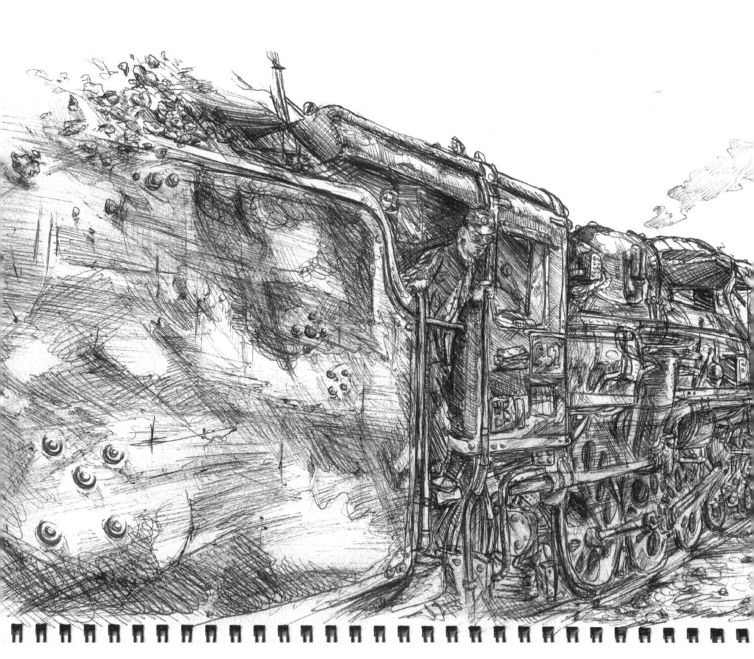

SL Train. Runs between Yamaguchi
City in Yamaguchi Prefecture and
Tsuwano-cho in Shimane Prefecture
Photo: James Hart
ＳＬ機関車。山口市から島根県津和野町
まで走る。写真：ジェイムズ・ハート

Nara Dreamland, an abandoned theme
park in Nara. Screw Twister roller
coaster in the late afternoon sunlight.
人気 のない奈良ドリームランドで。西日に
照らされたジェットコースター。

Rockin' the Olde Buggy. Classic car, though the norm for its time, from the Mid-Taisho Era (1920) during a funeral procession.

クラシックカー、大正9年（1920）ごろ。
葬儀に駆り出された当時の新型車。

Car culture. Imported Peugeot. Many car lovers gather and have a meal or BBQ together on Sunday. Cars from many different countries are loved in Japan. Photo: Yuki Takata

Peugeotちゃん クルマ文化。日曜日に集まるクルマ好きたち。様々な国のクルマが日本では好かれているようだ。
写真：高田優希（タカタユウキ）

Nico-Nico Car, the ubiquitous public school G-ride, equipped with a sick sound system, used for both promoting school-related propaganda and bumping tunes like the Japanese rendition of Mary Had A Little Lamb, Beethoven's Ninth, or top hits from The Last Samurai soundtrack.
学校の「にこにこカー」と言う車。

Hemp Car Project. Hemp Car Festival event in
Asahikawa, Hokkaido. A converted bus fueled
entirely by hemp oil.
ヘンプカープロジェクト。北海道県旭川市のヘンプカ
ー祭り。このバスはヘンプ（麻）オイルで走る。

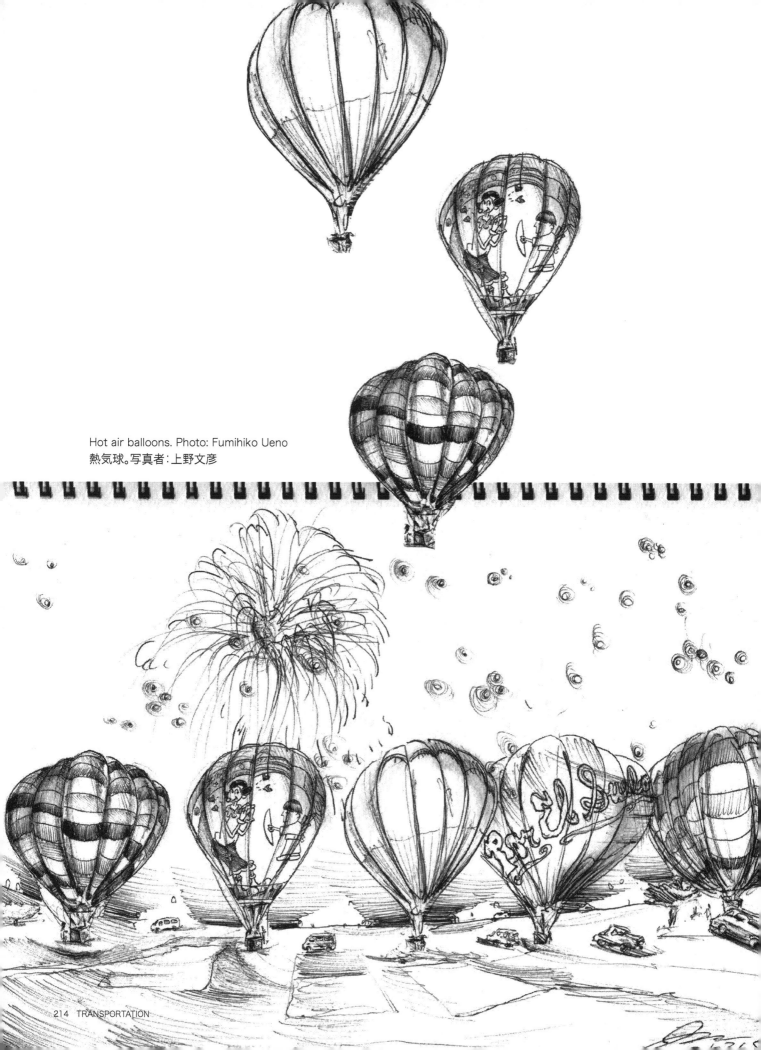

Hot air balloons. Photo: Fumihiko Ueno
熱気球。写真者：上野文彦

Shimanami Highway, bike-friendly bridges from Onomichi in Hiroshima to Imabari in Shikoku, is the western route to cross the Seto Inland Sea. It is called Nishi-Seto Expressway. This route consists of nine long-span bridges and connects seven islands. The ride, including 12.8 kilometers of highway (only for vehicles, bikes take a local road for these stretches on Ohshima and Ikuchijima Islands) is 59.4 kilometers.

島並高速道路は、広島県の尾道市から四国の今治市までの瀬戸内海の西側にある道路。自転車に乗る人のための安全な橋がたくさんある道路だ。別名「西瀬戸自動車道」（５９．４キロ）と呼ばれ、７つの島を繋ぎ、９つの長い橋をもつ。大島から生口島にかけての１２．８キロは高速道路で、自転車は下道を走らなければならない。

Chopper Style. This old dude was already cool, and then he put a hand-bag puppy in his saddle bag. Now he is just plain outta sight! Photo: Chris "Two L's" Willson

改造車に乗った男。それけで十分かっこいい。だけど、子犬をサドルバッグに入れてる！めちゃめちゃかっこいい！ 写真：クリス・ウィルソン

What a sweetie! Getting a lift in
Omagari City (1953).
花館、相乗り。大曲市花館、1953年。

Tako (Octopus) Bike delivery. "Oh!"
says Tako. Kobe
タコの自転車配達か。とにかく、いい自転
車だろう？「おっ」といっているタコ。神戸

Mama-cherry rental bike with a
basket, riding across the blue bridge
to Amanohashidate, protecting her
tender arms from hazardous UV rays.
レンタルのママチャリを乗っている女性。
天橋立 にある青い橋の上こいでいる。

落書き

GRAFFITI

◀ Exploding AICHI Prefecture.
愛知県。

▲ SAITAMA Prefecture.
埼玉県。

Iwate Prefecture's kanji rockin' a blockbuster-style piece, busting through the schedule book. Iwate is the second largest prefecture after Hokkaido, so she deserves the big, bold blockbuster style.

岩手。岩手県は日本で二番目に大きな都道府県だから、こう言う感じ強くて岩っぽい字を描いた。

NYE freestyle graffiti/kanji of "Yoi o-toshi wo," which is simply the spoken informal form of "Happy New Year!" A relatively quick piece, or rather furiously energetic (sloppy) 良いお年を! that I do declare a fitting end to the year's madcap drawing escapade.

「良いお年を！」落書き。エネルギッシュな感じで（でもいいかげんに）。これで、無計画だった絵の完成を宣言できるー！

Ehime Prefecture is known for its ship-building industry, mikan (a fruit like a tangerine, blossom pictured), pearls and Matsuyama Castle. Also the famed hometown of Marqido, from the talented experimental noise duo "10."

愛媛県は造船業、みかん、真珠、それに松山城でよく知られている。それと、「10」という前衛的な素晴らしいバンドのマークィドさんの出身地でもある。

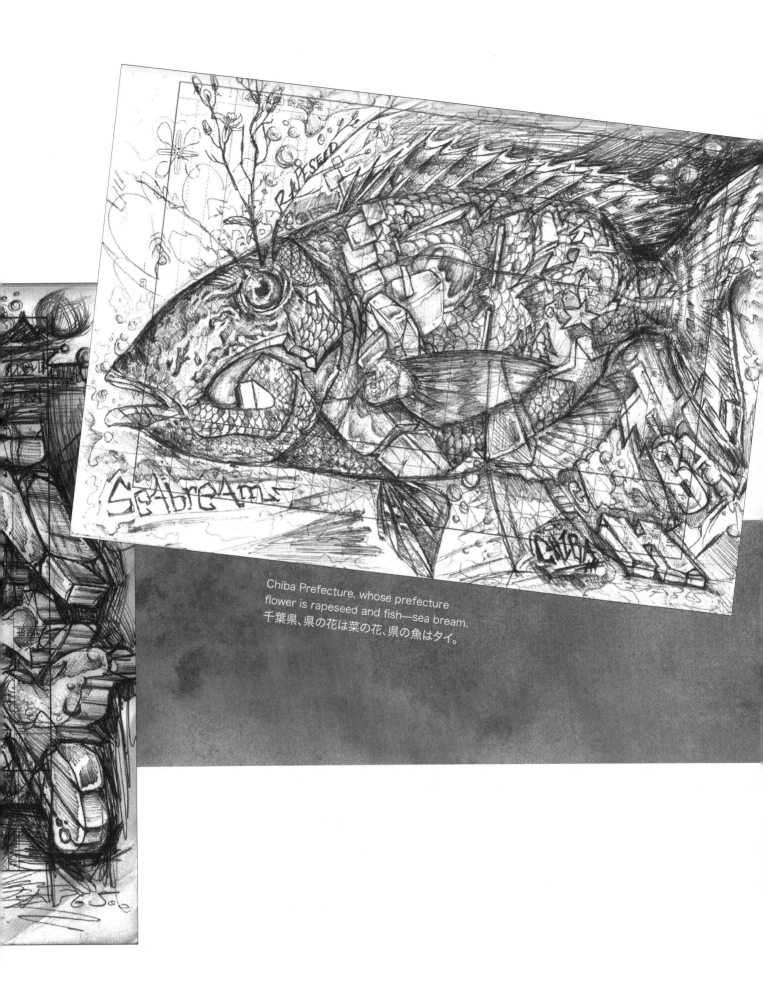

Chiba Prefecture, whose prefecture flower is rapeseed and fish—sea bream.
千葉県、県の花は菜の花、県の魚はタイ。

GIFU. In the old days, especially in the Gensoku Jidae, or warring states period (15th - 17th century), Gifu was an important tactical location in the center of Honshuu, the largest main island of the Japanese archipelago. Thus the popular adage,"Control Gifu, Control Japan," was coined. In the same vein, Gifu was seen as the bridge or crossroads between East and West Japan. The birds depicted are Gifu Prefecture's Rock Ptarmigan. The symbol over the "i" is Gifu's prefectural symbol.

その昔、特に戦国時代には（１５世紀～１７世紀）岐阜は本州の中心に位置することからも戦略上、重要な場所だった。こうして、有名な格言、岐阜を制する者は日本を制す。が生まれた。同じ意味で東日本と西日本をつなぐ架け橋ともいわれている。この鳥は岐阜県の鳥でらいちょうである。「i」の上のマークは岐阜県のシンボルである。

Nagano. Ski season. The best "powder" in Japan. (I'm from Texas. I don't know anything about "powder." So, I'll meet you back at the onsen.)
スキーシーズンの長野。一番いいパウダースノー！僕はテキサス出身だから、パウダーについては分からない。温泉で会おう！

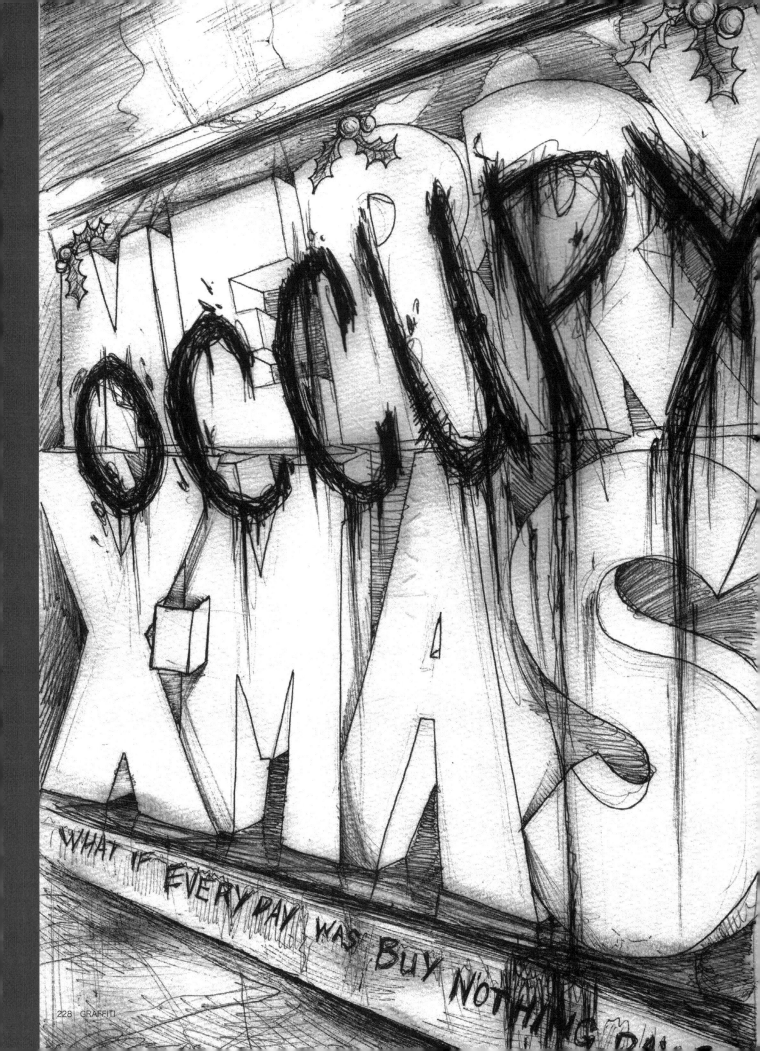

OCCUPY XMAS

WHAT IF EVERY DAY WAS BUY NOTHING DAY

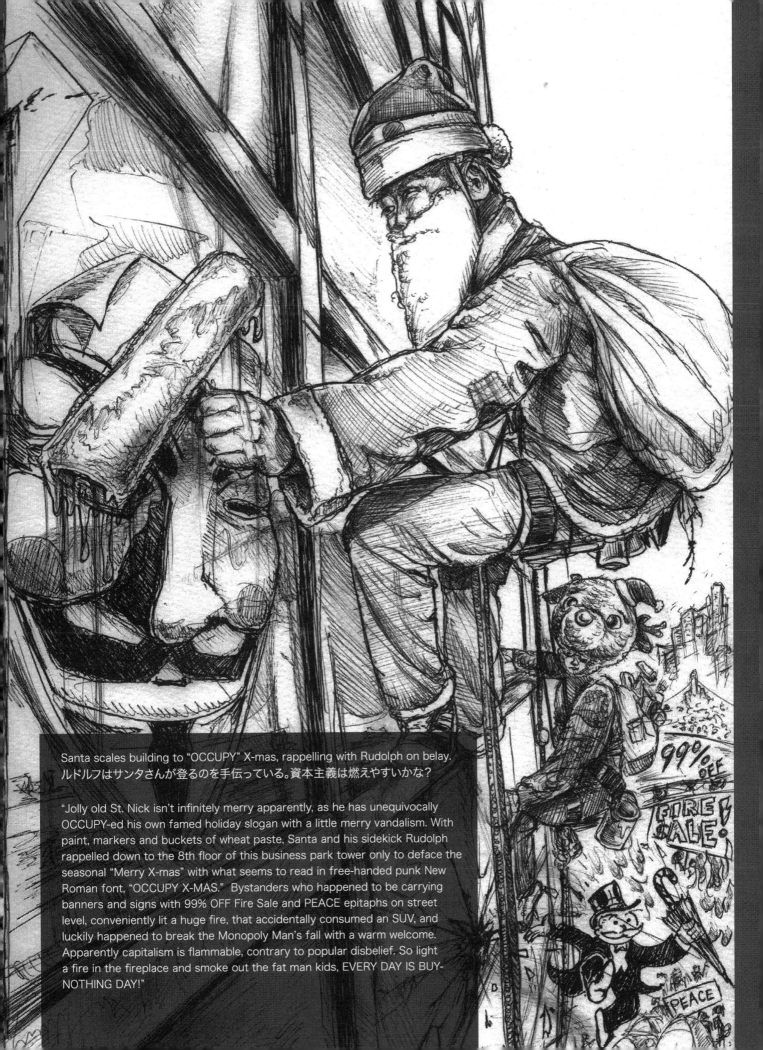

Santa scales building to "OCCUPY" X-mas, rappelling with Rudolph on belay.
ルドルフはサンタさんが登るのを手伝っている。資本主義は燃えやすいかな？

"Jolly old St. Nick isn't infinitely merry apparently, as he has unequivocally OCCUPY-ed his own famed holiday slogan with a little merry vandalism. With paint, markers and buckets of wheat paste, Santa and his sidekick Rudolph rappelled down to the 8th floor of this business park tower only to deface the seasonal "Merry X-mas" with what seems to read in free-handed punk New Roman font, "OCCUPY X-MAS." Bystanders who happened to be carrying banners and signs with 99% OFF Fire Sale and PEACE epitaphs on street level, conveniently lit a huge fire, that accidentally consumed an SUV, and luckily happened to break the Monopoly Man's fall with a warm welcome. Apparently capitalism is flammable, contrary to popular disbelief. So light a fire in the fireplace and smoke out the fat man kids, EVERY DAY IS BUY-NOTHING DAY!"

アート

Ono no Komachi. One of the original "Akita bijin" or Akita "beauties" for which Honshu's northernmost prefecture is so well known. However, this particular mask depicts her as a miserable old lady, not your typical "beauty." Nonetheless, she was still a famous, often erotic, poetess who lived more than 1000 years ago.

小野小町。小野小町は有名な「秋田美人」のうちの一人である。この独特なお面は、彼女をありきたりな美ではなく、まるで憂鬱な老女のように表現している。それでも彼女は1000年以上前に官能的な女流詩人として有名だった。

Mother-of-pearl design on the cover
of a lacquer-ware photo album.
蒔絵 アルバム。

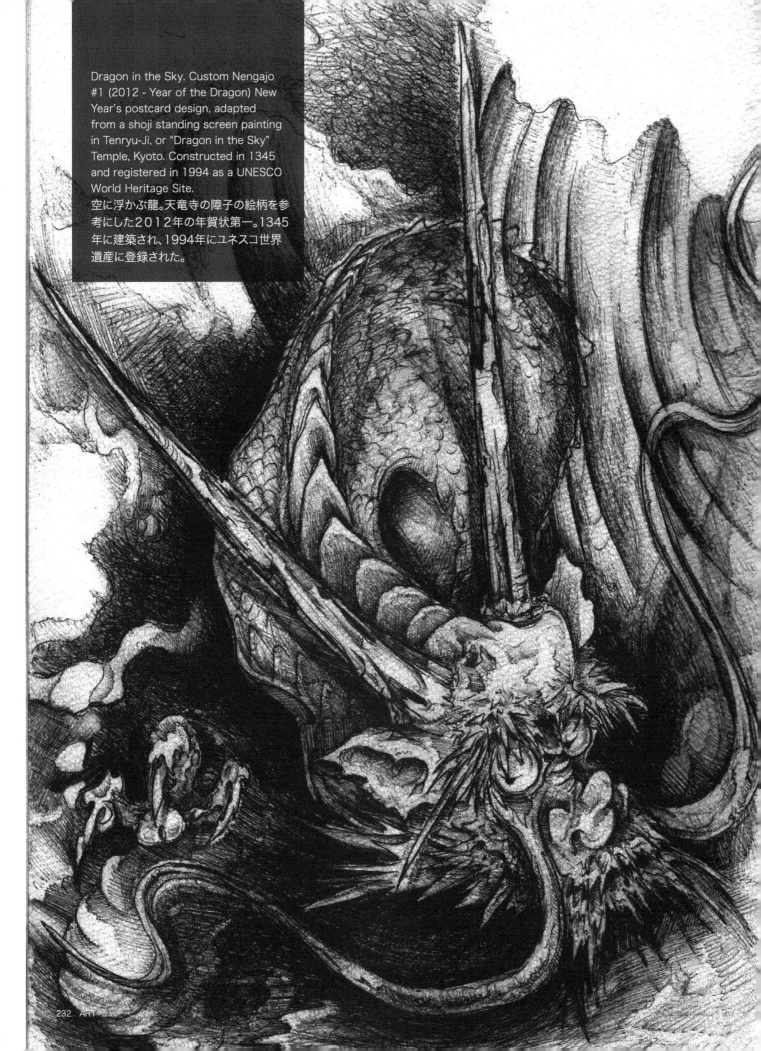

Dragon in the Sky. Custom Nengajo #1 (2012 - Year of the Dragon) New Year's postcard design, adapted from a shoji standing screen painting in Tenryu-Ji, or "Dragon in the Sky" Temple, Kyoto. Constructed in 1345 and registered in 1994 as a UNESCO World Heritage Site.
空に浮かぶ龍。天竜寺の障子の絵柄を参考にした２０１２年の年賀状第一。1345年に建築され、1994年にユネスコ世界遺産に登録された。

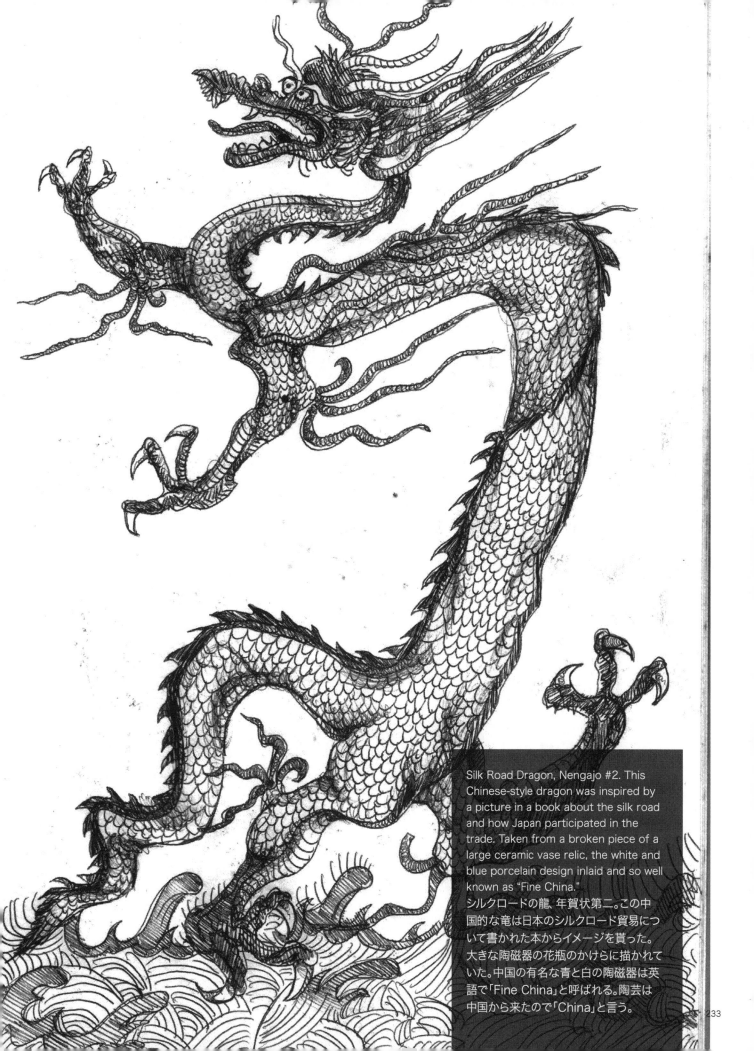

Silk Road Dragon, Nengajo #2. This Chinese-style dragon was inspired by a picture in a book about the silk road and how Japan participated in the trade. Taken from a broken piece of a large ceramic vase relic, the white and blue porcelain design inlaid and so well known as "Fine China."

シルクロードの龍、年賀状第二。この中国的な竜は日本のシルクロード貿易について書かれた本からイメージを貰った。大きな陶磁器の花瓶のかけらに描かれていた。中国の有名な青と白の陶磁器は英語で「Fine China」と呼ばれる。陶芸は中国から来たので「China」と言う。

233

熟田津尓船乗世武登月待者潮毛

今者許藝奴

可奈比沼

◀ Manyoshu. Excerpt from the 3rd volume of the oldest Japanese poem collection by Nukata Okimi, "Collection of Ten Thousand Leaves" (compiled around 759 AD) this one by Takechi Kurohito that translates, "The cry of the crane, calling to Sakurada, it sounds like the tide, draining from Ayuchi flats, hearing the crane cry." It references Aichi's tidal flats, Fuji-mae, an area recently the subject of wetland conservation and reclamation efforts to return it to its natural state and reverse the detrimental effects of land use which began during the Edo period, and which stole millions of migratory and other birds' habitat. 万葉集。最も古い日本の歌集で額田の大君により編集された（759年）。高市黒人が読んだ歌「桜田へ鶴鳴き渡る年魚市潟潮干にけらし鶴鳴き渡る」 歌の意味、桜の田の方へ鶴が鳴いて渡ってゆく、年魚市潟の潮が引いたようだ。愛知県の藤前干潟は近年湿地帯を保護する活動が盛んで江戸時代から続いた埋め立てにより多くの渡り鳥の住処が失われできた。

▲ Hinomaru bento, or a Japanese box-lunch with a serving of white rice and a dark red pickled plum (ume-boshi) plopped in the middle. Nickname for the nation's flag, a big red circle on a white rectangle. (Sorry, I couldn't find a red ball pen.) Official legislation slaked this design as the nation's flag since 1999. Although no earlier legislation had specified a national flag, the sun-disc flag had become the de facto national flag of Japan since Buddhist priest Nichiren reportedly gave the flag to a shogun to carry into a 13th century battle when Mongolian forces were invading Japan, one legend says. Sun rises in the East.

日の丸弁当。日の丸弁当は白ご飯と真中に梅干がある。日の丸は日本の国旗のニックネーム。白ご飯は国旗の長方形白部分、梅干は赤い丸。ごめんね、赤いボールペンを見つけられなかった。１９９９年から政府は日の丸を正式な国旗と認定した。その前に、正式な国旗はなかった。日本の日の丸の国旗は１９９９年まで暗黙の国旗だった。ある伝説によると、日蓮というお坊さんが１３世紀のモンゴルの襲来の時に、持って行くために、将軍に日の丸の国旗を上げたそうだ。太陽は東から昇る。

Tower of the Sun, by Taro Okamoto. Okamoto was a Japanese artist noted for his abstract and avant-garde paintings and sculpture. Famous quotes: "Art is Magic" and "Art is Explosion." He studied at Panthéon-Sorbonne in the 1930s, and made many great art works after World War II. A prolific artist and writer until his death in 1996, Okamoto exerted considerable influence on Japanese society through his art. This, one of his most famous works, became the symbol of Expo '70, a World's Fair held in Suita, Osaka in 1970. It depicts the past, present and future of the human race. It still stands today in the center of Expo Memorial Park. Picture taken and shared by Couch Surfer and Roller Derby gal Kiki Kasplat of her leaping boyfriend Takeshi Yoshida.

太陽の塔、岡本太郎。岡本さんは、日本の有名な芸術家で、抽象的で、前衛的な、絵画や彫刻で名を残した。彼の遺した有名な言葉には「芸術は呪術だ」や、「芸術は爆発だ」がある。１９３０年代にパンテオンソルボンヌで学び、第二次世界大戦後に多くの素晴らしい芸術作品を創った。１９９６年に亡くなるまで精力的に芸術家として、作家として活動を続け芸術を通して日本の社会に多大な影響を与えた。これは、彼の、最も有名な作品の一つであり１９７０年大阪の吹田で開かれた万国博覧会のシンボルとなった。この塔は人類の過去と現在と未来をあらわしている。今でも万博記念公園に立つ。カウチサーファ（人の家に泊まって旅をする人）の吉田岳さんによって撮影された。写真：ローラーダービーの女性吉田キキ

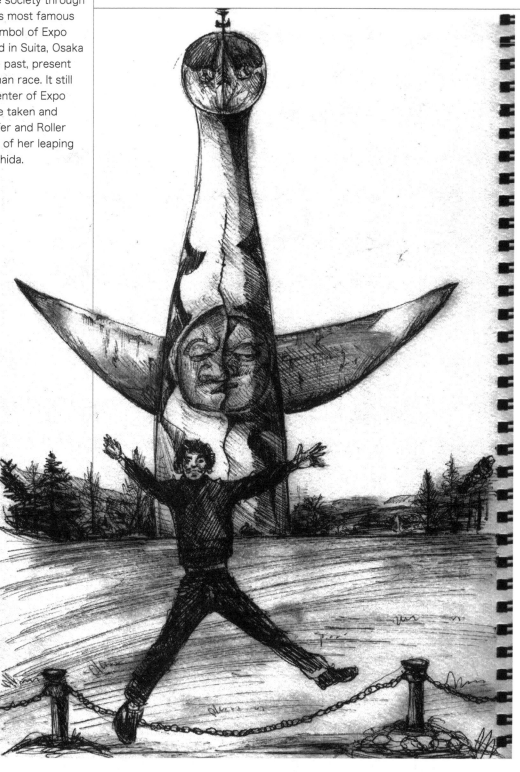

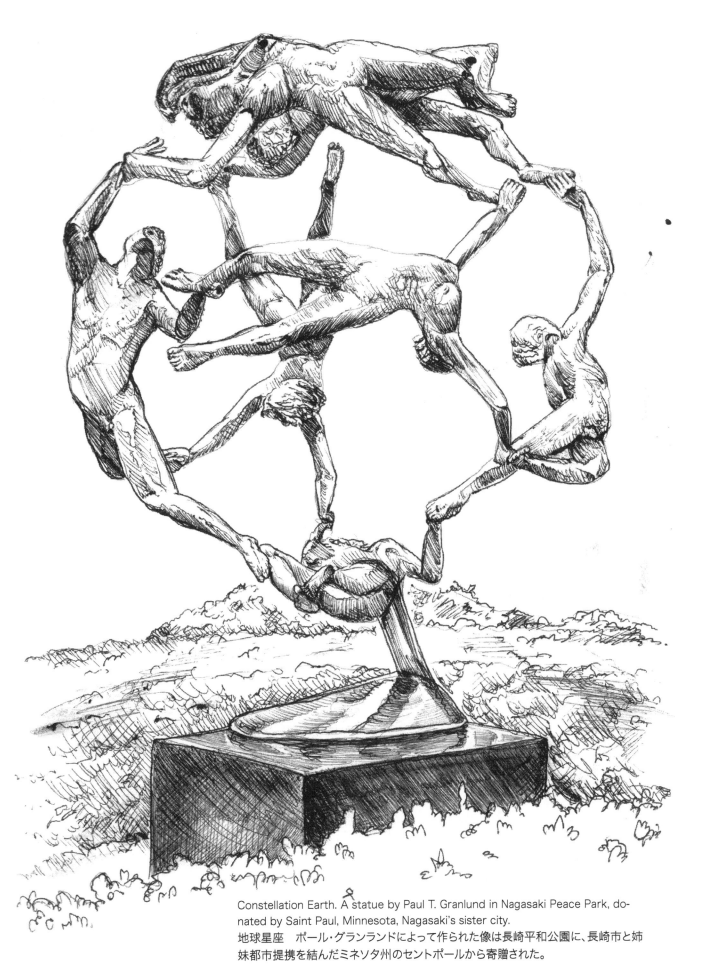

Constellation Earth. A statue by Paul T. Granlund in Nagasaki Peace Park, donated by Saint Paul, Minnesota, Nagasaki's sister city.
地球星座　ポール・グランランドによって作られた像は長崎平和公園に、長崎市と姉妹都市提携を結んだミネソタ州のセントポールから寄贈された。

Amazing sand sculptor at work, drawing unfinished as was his huge sand sculpture on a beach in Akita. This particular artist, a very tan fellow, hailed from Tokyo, and was ridiculously meticulous with a trowel. 信じられないほど手の込んだ作業。砂の彫刻を造っているのは東京のアーティスト秋田県にある浜。

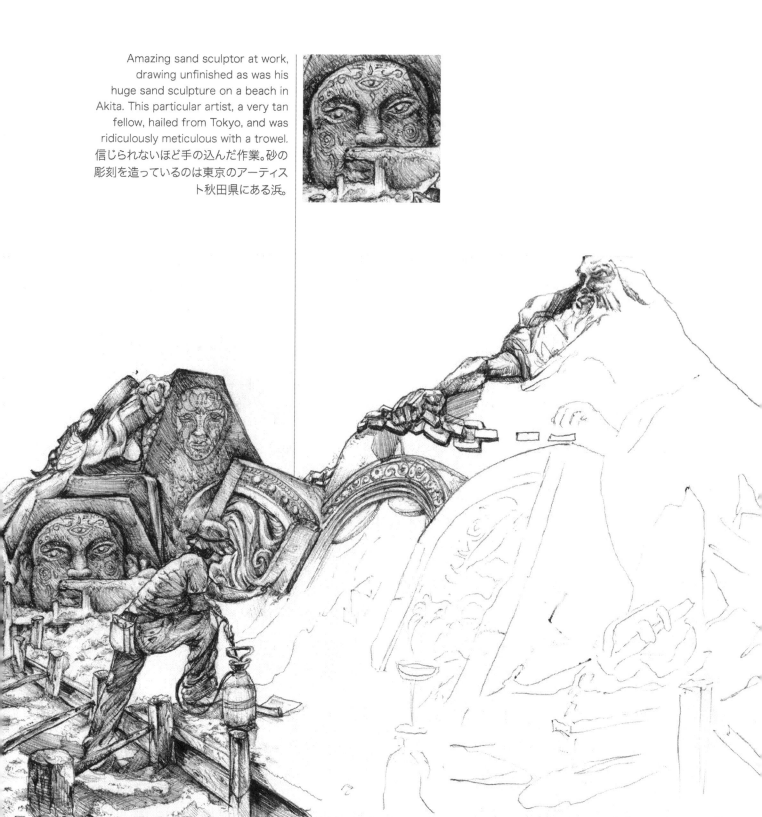

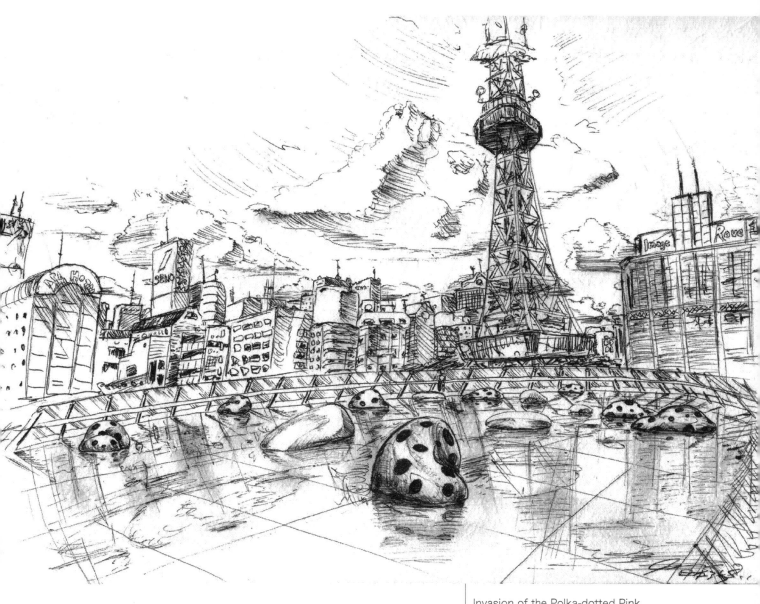

Invasion of the Polka-dotted Pink
Blobs! Nagoya City, Aichi Prefecture
Photo: David A. LaSpina (http://japan-dave.com/)
ピンクの水玉の塊の侵略！愛知県名古
屋市
写真：デイビッド・エイ・ラスピナ

▲ Kameyama Ware jar depicting a 19th century Dutch trading vessel, Nagasaki Prefecture. In 1720, a ban on Dutch books and essentially on Rangaku (the study of "Western learning," especially technology and medicine) was lifted in Nagasaki, prompting a hoard of Japanese scholars to go there specifically to study European science and art. Dejima is also depicted, Japan's artificial outside world island used for foreign trade in the Edo period, significant in an era ruled by sakoku, isolationism policy enacted by the Tokugawa shogunate. Japan was opened to foreign trade in 1854.

19世紀 のオランダ貿易船が描かれている亀山焼（長崎県）。1720に長崎 でオランダの本や蘭学などが解禁となったため、全国から多くの日本人学者が欧州の科学や芸術を勉強するために集まった。鎖国時代に日本で唯一海外との貿易を許された人口の島「出島」も表されている。1854年に日本の鎖国政策が終わり、世界と貿易を始めた。

◀ Wajima Lacquer. Beaded bubbles on a bowl. Photo courtesy Adam Fore, Macro-focus, moisture and famous Wajima lacquer.
Wajima, Ishikawa Prefecture
輪島塗り。輪島　石川県
写真：アダム・フォー

Death Star? Actually it's a drone developed by Japan's Ministry of Defense, the world's first spherical flying machine (60km/h), and cost just $1,400 in spare parts to make! Maybe there's a Youtube tutorial on how to build your own.
スターウォーズのデススター？　実は、日本の防衛庁によって開発された無線操縦無人機で、世界初の球状の飛行物体だ。時速６０キロメートル。部品から作るのにたったの１４００ドルだ。ユーチューブに作り方が書いてあるかも。

Giant Pumpkin on Naoshima Island. A "Pumpkin," (frankly-titled) by Yayoi Kusama looks over the Seto Inland Sea on Naoshima, dubbed "Art Island" by NY Times Travel, where museums, installations and cutting-edge architecture blend with nature in novel ways. Some road-tripping allies add to an excellent album cover photo, a memory worthy of your photo-luminescent phytoplankton scrapbook, courtesy the lovely and talented Eby Harvey. (www.ebyphoto.com)

直島でおっきなカボチャを発見。草間彌生の作品である「かぼちゃ」が見える瀬戸内海の直島は、NYタイムス・トラベルでアートな島として紹介された場所。美術館や最先端の建造物などが自然と融合している。最高な旅の写真、エビー・ハーベイより。

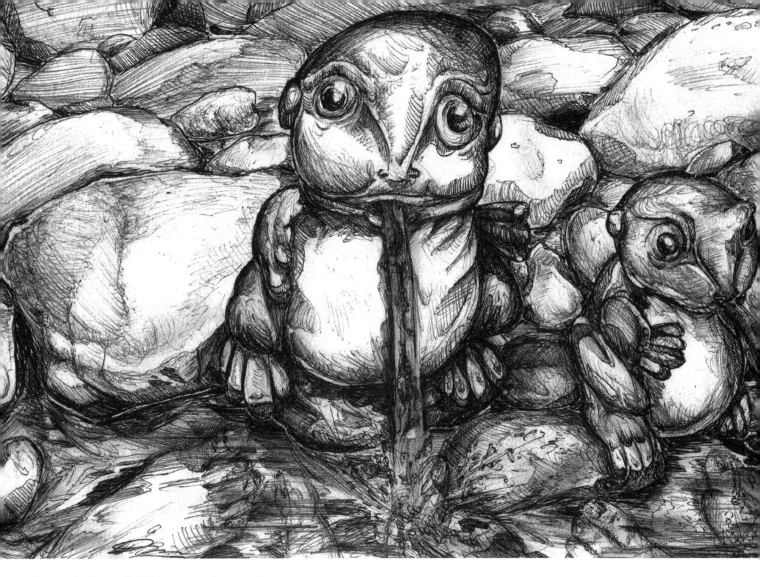

▲ Funny little hot-water-spitting rock
creature of the popular foot onsen
next to Kinosaki station.
人気がある駅の隣に足温泉で小さくて面
白い石動物ということお湯を噴出する。

Himeji Castle (1333). One of the finest ➤
surviving examples of Japanese castle
architecture, eighty-three buildings
with advanced defense systems from
the feudal period. Often called the
"White Egret Castle" because of its
brilliant whiteness and resemblance to
a bird taking flight. Also hosts many
ghost stories from Japanese folklore
like, "The Dish Mansion at Bancho."
A UNESCO World Heritage Site and
designated National Treasure.
Hyogo Prefecture
姫路城(1333年)、現存する日本の素晴
らしい城の一つ。跳びかけている鳥と似
ていることで「白鷺城」と呼ばれる。兵庫
県にある世界遺産。

建築物

ARCHITECTURE

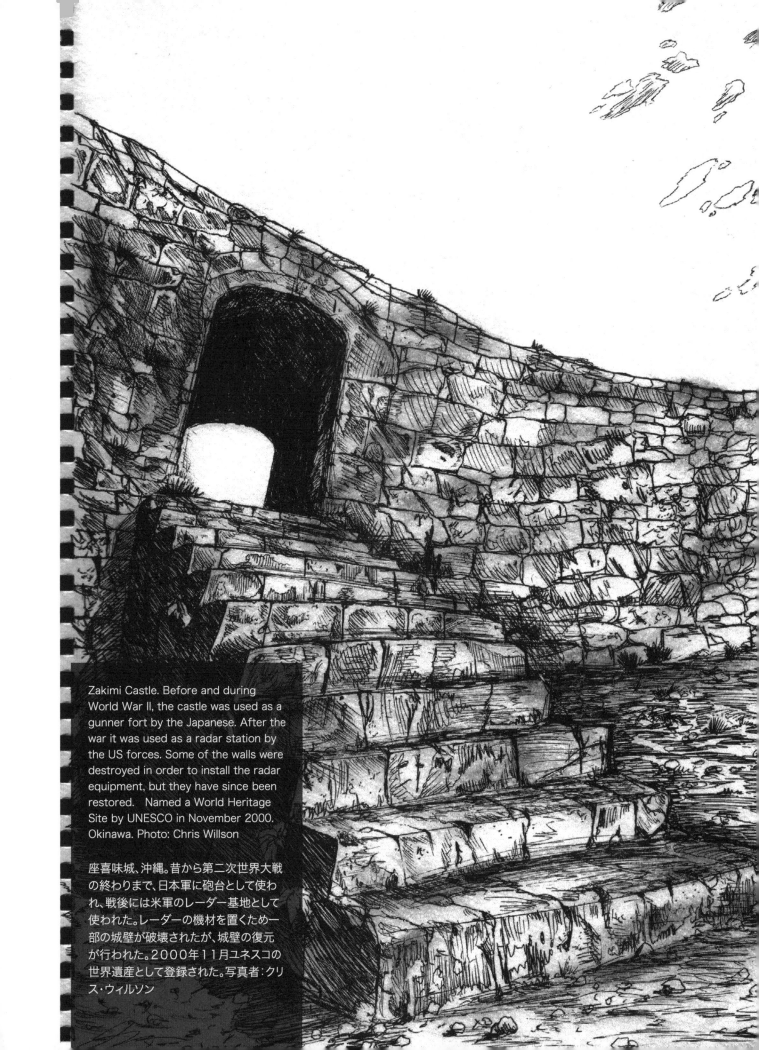

Zakimi Castle. Before and during World War II, the castle was used as a gunner fort by the Japanese. After the war it was used as a radar station by the US forces. Some of the walls were destroyed in order to install the radar equipment, but they have since been restored.　Named a World Heritage Site by UNESCO in November 2000. Okinawa. Photo: Chris Willson

座喜味城、沖縄。昔から第二次世界大戦の終わりまで、日本軍に砲台として使われ、戦後には米軍のレーダー基地として使われた。レーダーの機材を置くため一部の城壁が破壊されたが、城壁の復元が行われた。2000年11月ユネスコの世界遺産として登録された。写真者：クリス・ウィルソン

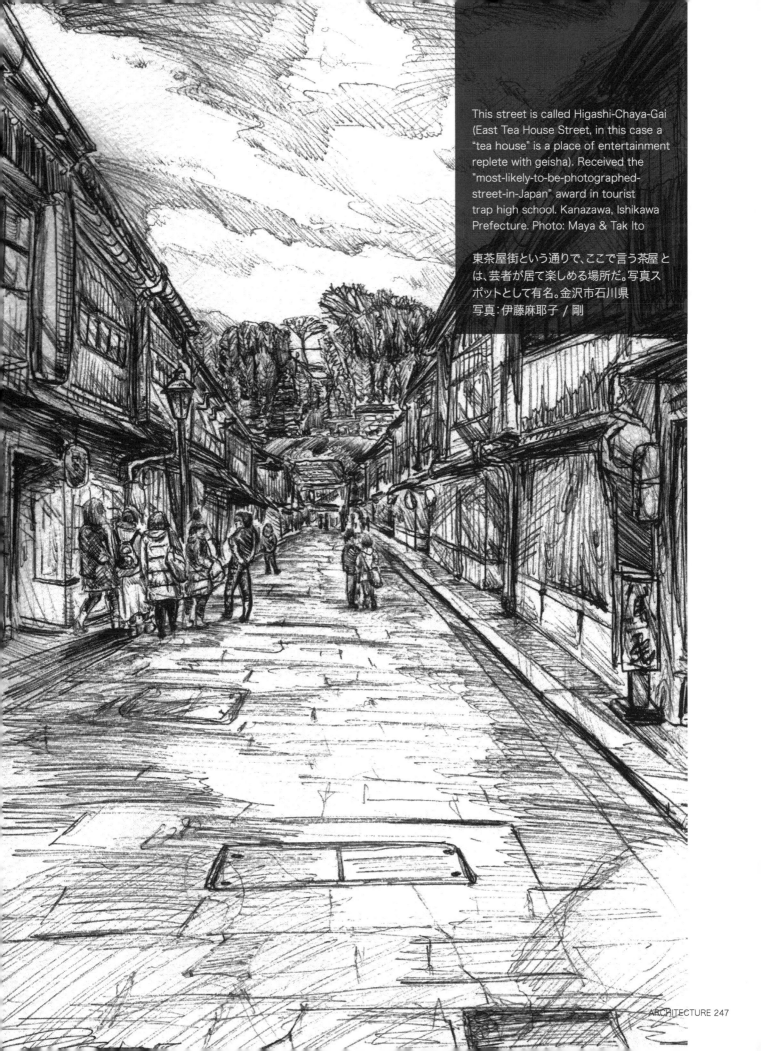

This street is called Higashi-Chaya-Gai (East Tea House Street, in this case a "tea house" is a place of entertainment replete with geisha). Received the "most-likely-to-be-photographed-street-in-Japan" award in tourist trap high school. Kanazawa, Ishikawa Prefecture. Photo: Maya & Tak Ito

東茶屋街という通りで、ここで言う茶屋とは、芸者が居て楽しめる場所だ。写真スポットとして有名。金沢市石川県
写真：伊藤麻耶子／剛

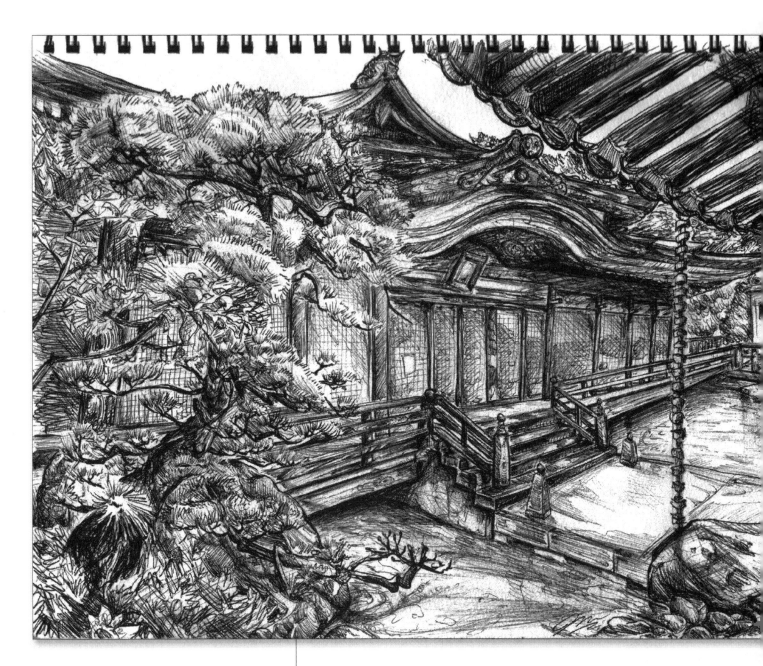

Gosho no Yu Onsen in Kinosaki, Hyogo
Prefecture 御所の湯温泉。城崎兵庫県

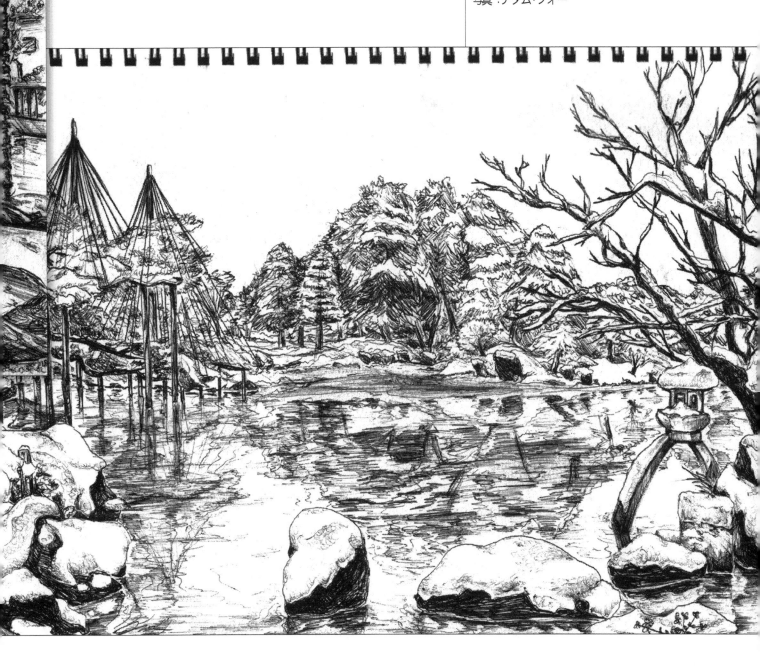

Kenrokuen Garden in winter.
Kanazawa City, Ishikawa Prefecture
Photo: Adam Fore
冬、石川県金沢市の兼六園。
写真：アダム・フォー

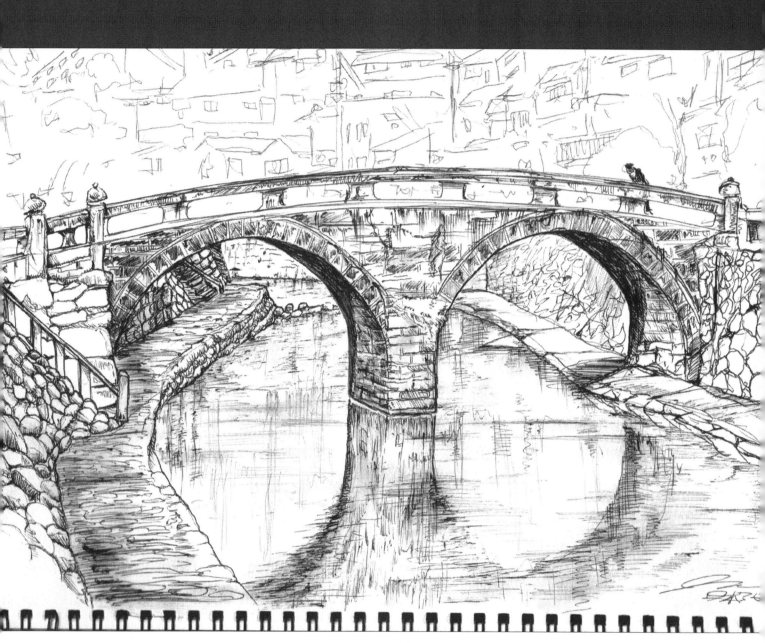

Meganebashi, or Spectacles Bridge, over Nakashima River in Nagasaki. Built in 1634 by a Chinese monk named Mozi of Kofukuji temple. It may be the oldest stone arch bridge in Japan, and thus is designated an Important Cultural Property.

眼鏡橋は長崎市の中島川に、1634年興福寺の2代目の中国からの住職、黙子如定 によって架けられた。日本初の石造りアーチ橋と言われ、重要文化財に指定された。

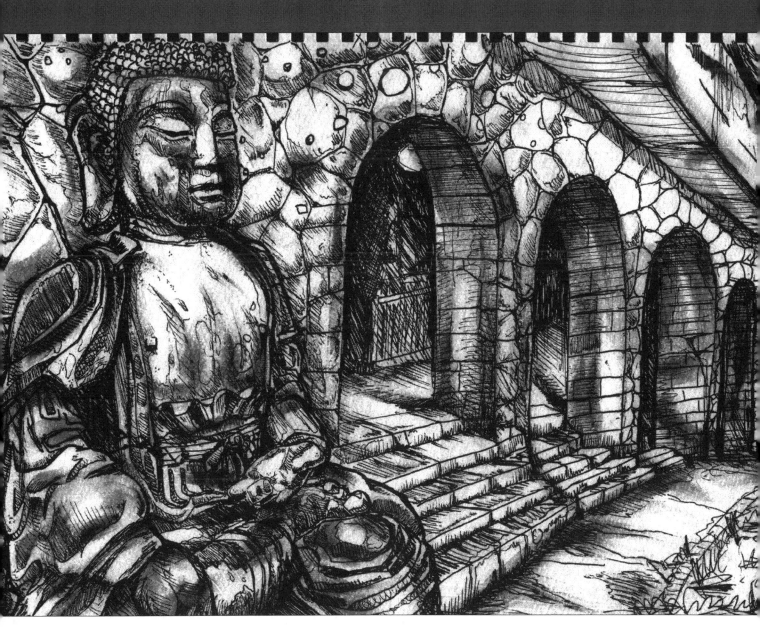

Buddha statue and some rock
archways. 大仏と石造りアーチ。

Museum of Fruit, designed by ➤ Itsuko Hasegawa, in Yamanashi Prefecture. Three shell-shaped buildings symbolize the "fruits" of spiritual sensuality, intelligence and lust. As an expression of contextual ecology, white light shines through a curved, screened exoskeleton in a paradisaical greenhouse. The buildings serve as a metaphor for trees producing fruits of creativity in the visitors who themselves will spread a sensitivity to our frail environment, and hopefully produce green buildings themselves reflecting similar motifs in the future.
(Theoretical explanation from http://architecturerevived. blogspot.com.)

山梨県、長谷川逸子さんのデザインによる山梨フルーツミュージアム。貝殻のような三つの建物は精神的な官能性、知性、そして、性欲をあらわしている。理論的なエコロジーの表現として、楽園を思わせる温室はまるで甲殻類の殻のような丸みを帯びた外壁で囲まれており、白い太陽の光が射し込み輝く。建物は、訪問者の心に創造性の実をつける木を表しており、訪れる人々が、壊れやすい環境への関心を育てそしていつか同じような理念を反映する建築を創造することを鼓舞する。「http://architecturerevived. blogspot.com」から説明をわかりやすく一部引用。

▲ Quite the prolific boxer-turned-world-famous-architect, Tadao Ando's floating head, in a structure he devised (one of many). The Hachikita Mountains of Hyogo Prefecture hosts a wood museum, another of his modern designs that is pleasantly dizzying and appropriately out-of-place.

安藤忠雄。昔彼は偉大なボクサーで、今は建築家だ。兵庫県美方郡に「木の殿堂」という安藤さんデザインの建築物がある。素敵な所だけど、とてもまんまるで、ちょっと目がくらくらするかも？

253

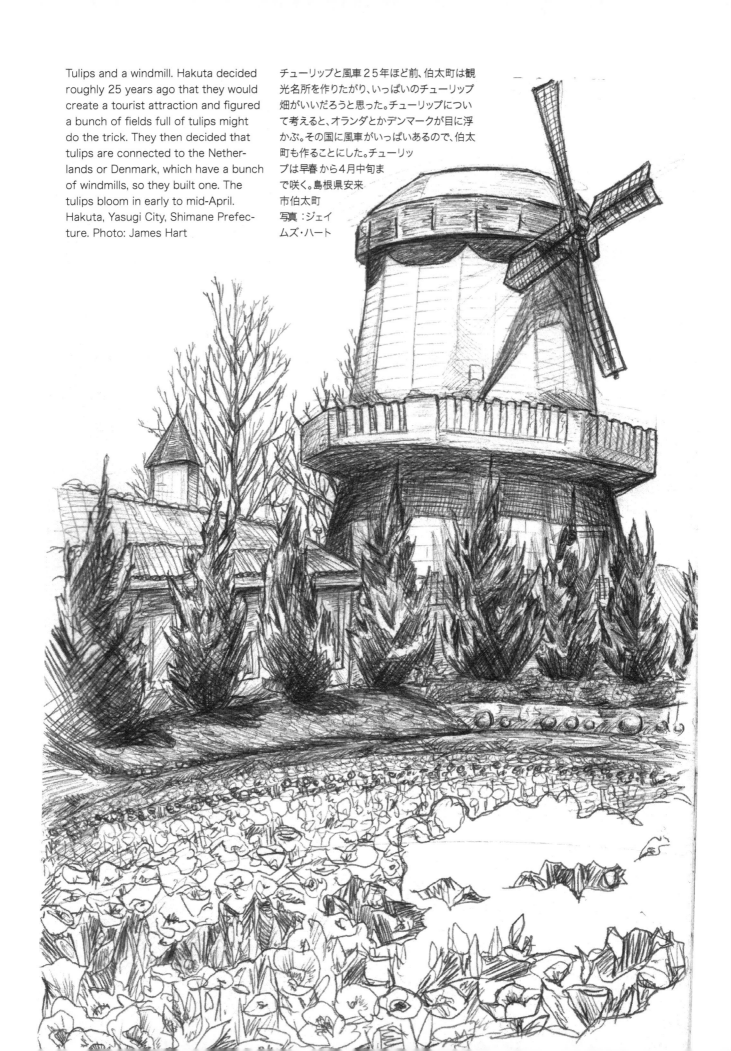

Tulips and a windmill. Hakuta decided roughly 25 years ago that they would create a tourist attraction and figured a bunch of fields full of tulips might do the trick. They then decided that tulips are connected to the Netherlands or Denmark, which have a bunch of windmills, so they built one. The tulips bloom in early to mid-April. Hakuta, Yasugi City, Shimane Prefecture. Photo: James Hart

チューリップと風車 25年ほど前、伯太町は観光名所を作りたがり、いっぱいのチューリップ畑がいいだろうと思った。チューリップについて考えると、オランダとかデンマークが目に浮かぶ。その国に風車がいっぱいあるので、伯太町も作ることにした。チューリップは早春から4月中旬まで咲く。島根県安来市伯太町
写真：ジェイムズ・ハート

Windmills on a beach in Akita.
秋田県の海辺の風車。

255

Tall buildings #1 for Koji's girlfriend.
Shinjuku, Tokyo
Photo: Koji Okuyama

そびえ立つビル No.1。奥山晃次さんの
彼女に捧げる。新宿 東京
写真：奥山晃次

Tall buildings #2, Tokyo Metropolitan
Government Building.
そびえ立つビル No.2。東京メトロポリタ
ンの行政のビル。

Machine Love. "...A handshake, or a pair of glasses onto the ocean, or the consummation of machine love, or if you look closely a fabricated heart." From the window and poetics of Matthew Little, translated by Kadena Tomoko and Nishizuka Wakiko. Iheyajima, Okinawa

「。。。握手をしている機械か、海を見ているメガネまたは、機械の求愛あるいは、ハートの形にみえる。」
写真と説明：マシュー・リトル
訳す：嘉手納知子と西塚和貴子より

▲ View of the Genbaku, Atomic Bomb
Dome in Hiroshima as busy salary
men hurry across a bridge, ironically
in front of a Kit-Kat delivery truck
proffering something else entirely.
広島の原爆ドーム前の橋を急いで渡るサ
ラリーマン。

HOUSE

家

NEXT PAGE, TOP
Ancient mud and straw huts from the Jomon Period (14,000-300 BC).
縄文時代の竪穴住居（紀元前145世紀から紀元前10世紀）

BOTTOM
Gassho-zukuri, these houses are built with dense straw roofs at a steep slant so the heavy snow that falls every year in the region doesn't cause a cave-in from the weight. (Annual average snow fall of 4-5 meters!) Also, because of the high roof, the inside is quite spacious, and utilizing the space efficiently, residents sometimes turn what looks like a two-story house into five or six different levels hosting multiple families. Shirakawa Village, Gifu Prefecture

合掌造り。この地域は豪雪地帯なので（年間降雪量は4−5メートル！）、合掌造りの屋根は雪を落としやすいよう45−60度という急勾配 がある。また、屋根 を合掌造りにすることで、屋根裏に広い空間が生まれ、2階建ての家が5−6階建ての家のように使える。岐阜県白川村

Ladies waiting under shade of noren
curtains for a time that may never
return. Mie Prefecture.
Photo: Amber Hill

のれんの陰に、二度と戻らないかもしれ
ない時を待つ二人の女性。
写真：アンバー・ヒール

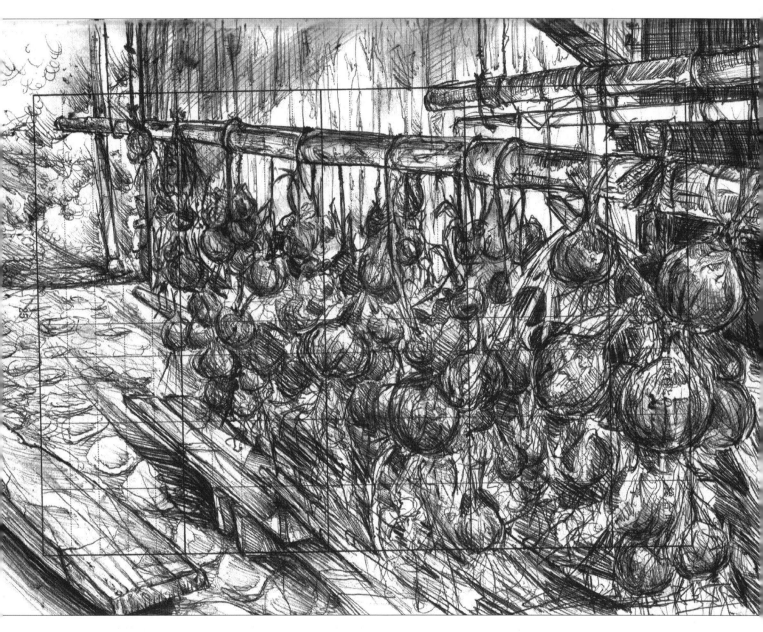

Tamanegi (onions) hang under the wide eaves of houses all year round in a breezy spot so they don't get moldy and are always handy for a stir-fry.

家の軒にぶら下げられるタマネギ。風当たりも良いためカビも生えず、いつでも調理できる。

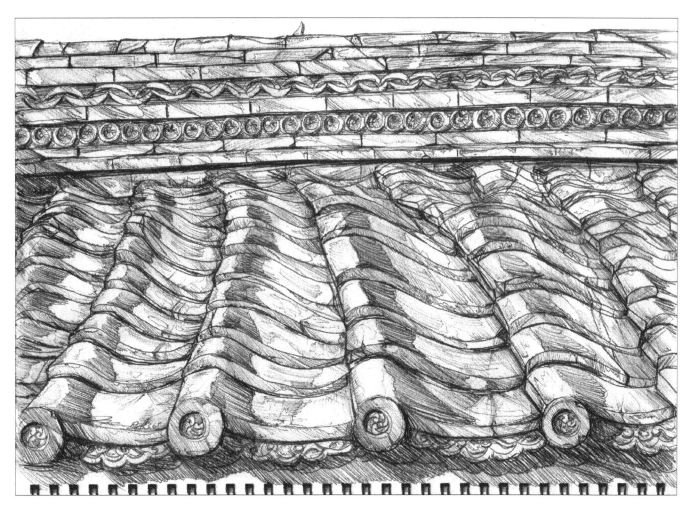

▲ Yane, heavy ceramic roof tiles.
　屋根、重いセラミック瓦。

Shachihoko is a tiger-headed carp-bodied creature, found on the corners of many rooftops, from temples and castles to nursing care facilities and my neighbor's house. It is believed that this animal of Japanese folklore caused rain to fall; thus, it now protects the structure from fire. So "the roof, the roof, the roof is never on fire." The ones found on Nagoya Castle are perhaps the most famous golden Shachihoko and are actually 2.6 meters tall and weigh 1.2 tons!

シャチホコは、姿は鯉で頭は虎という 想像上の動物。屋根の角に取り付けられていて寺院から城、介護施設そして僕のご近所さんの家にまで付いている。雨を呼ぶという伝説から、今では火除けの守り神とされている。 名古屋城には、おそらく一番有名な黄金のシャチホコが付いていて高さ2.6メートル、重さが1.2トンもある！

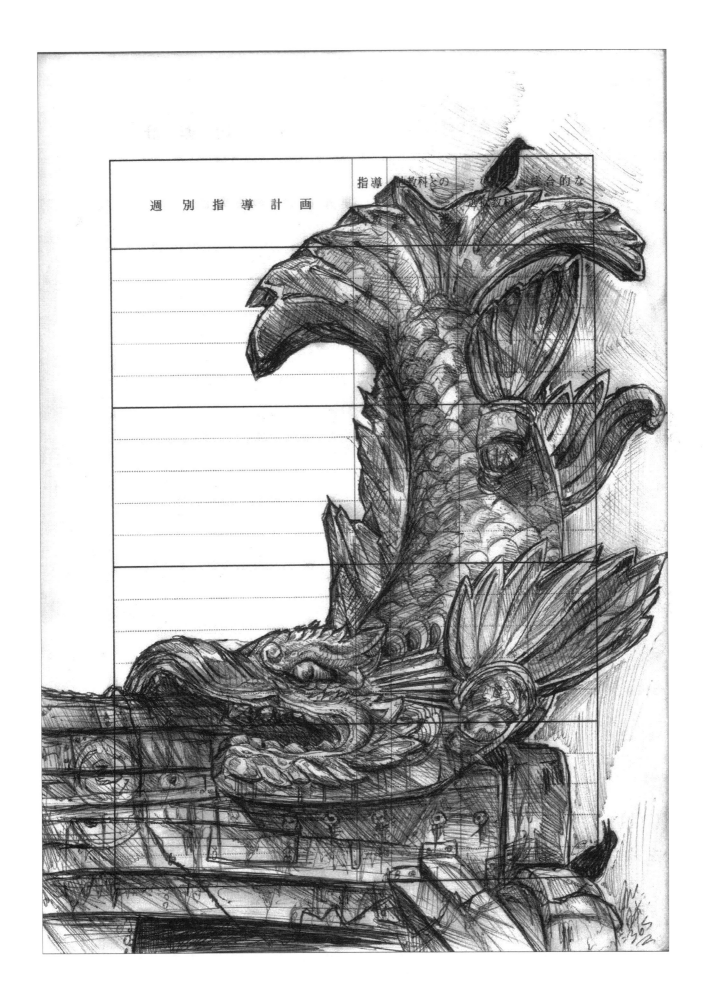

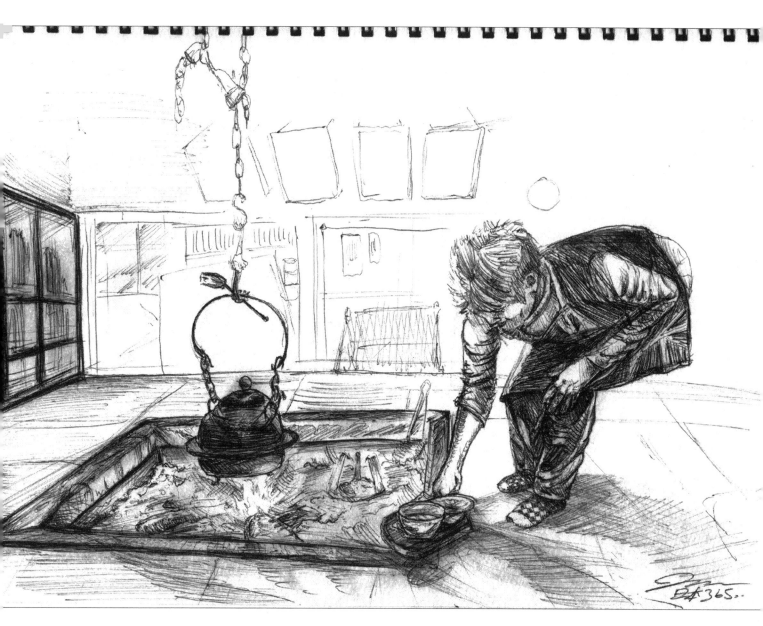

Irori, traditional style fireplace in the floor used for warmth and cooking, a cast iron teapot is always on with hot water to humidify the house and for a steady supply of green tea, countering the dryness of winter weather.

囲炉裏。部屋 を温かくし、料理 もでき、冬 の乾燥から守ることもできる。

Mukade, killer centipedes. One of Japan's deadliest (not really) bugs (they are just gross)! Apparently, ingesting their venom grants victims immunity (some people say). So, if you are bitten by one, quickly catch it with chopsticks, boil it in water, and drink the centipede tea to neutralize the sting. Just don't chop it in half or squish it, as that releases a pheromone (scientifically-proven) which will attract more mukade!

ムカデだ！日本で危険 な虫の１つだ！(嘘、危険ではないけど、メッチャ気持ち悪い) ムカデは自分の毒に免疫があるので、あなたは噛まれたら、そのムカデを箸で捕まえて、お湯でゆでて、そのムカデのお茶を飲んでください。そうすると、痛みがなくなるそうだ。

Sun City, "Pal Town" or "Solar City" as Ota City is known, is one of Japan's sunniest spots. In 2002 the Japanese government sanctioned 9.7 billion yen for an energy study, blanketing three quarters of the city's homes with solar panels.

「晴れの町」か「Pal　Town」か「ソーラータウン」として知られている太田市は日本でもっとも晴天に恵まれた場所の1つ。2002年、日本政府はエネルギー研究のために、97億円を認可して、今市の家の4分の3にソーラーパネルが設置されている。

MUSIC 音楽

Rockin' the Gramophone. A family enjoying music from their Columbia Gramophone record player, made in America (1914). Kanagawa Prefecture

アメリカで作られたコロンビア蓄音器 で音楽を楽しむ家族、大正3年（1914）秋。神奈川県

Manu Chao, hailing from France via Basque and Galician roots, whose heartbeat pumped the capacity crowd at the Palace of Wonders late Saturday night (Fuji Rock Festival 2011) during an epic encore of his and La Ventura's soggy day show on the Green Stage. Close-up photo courtesy Koichi Hanafusa

スペインのバスクとガリシア地方 から来てるマヌ・チャオ。ある土曜日の夜に、フジロックのパレス・オブ・ワンダーでチャオのグループの「ラ・ヴェントゥーラ」がライブをした。大変盛り上がった数百人の観客は、アンコールを求めた。
写真：花房 浩一 (ハナフサ・コウイチ)

Rockin' the Koto (actually, it's a shamisen), drawn specifically as part of a 2011 Fuji Rock Festival special edition postcard set, also including Manu Chao, Digitalism and SBTRKT designs. (I felt that this woman "rocking" and wailing on the shamisen, especially her powerful, carefree, fun, and maybe even a little crazy facial expression captured the spirit of Rock 'n' Roll, 60 years before it was coined a musical genre!)

From a late 19th century photo of a blind gypsy woman playing her shamisen, and wearing the archetypal traveler's umbrella slung on her back. She apparently traveled and performed all over Japan. The photo itself was found in an old album for sale at a thief's market in Warsaw, Poland circa 1975.

女芸人。明治時代〜20年〜30年代。三味線を引きながら大きな声で歌う盲目の旅芸人。傘を背に全国を旅するこうした門付けの姿はよく見られた。所蔵者、東京都世田谷区・鳥山真理子さんが、昭和50年ごろ、ワルシャワの泥棒市で買った蒔絵アルバムの中の四つ切り着色写真の一枚。

Seun Kuti of Seun Kuti & Egypt 80, who came to play Asagiri Jam 2011 at the foot of Mount Fuji. They had the whole crowd dancing and singing, "Plant and make it grow!" Thanks to Julen Esteban-Pretel for an excellent shot from that night. Seun got so worked up hot-stepping that he was literally steaming as he wailed in evening cool.

シャウン・クティ＆エジプト８０が富士山の麓で開催された朝霧ジャムで演奏した。ジュレン・エステバン・プレッテルが素晴らしい写真を撮ってくれた。

Asagiri Jam

The Flautist. Dougyoretsu Festival 2010. Matsue City, Shimane Prefecture. Photo: Greg Ferguson
フルート奏者、２０１０年に行われた島根県松江市の鼕行列。写真：グレッグ・ファーグソン

SBTRKT, a London-based producer who put on a solid show in the Red Tent, Fuji Rock Festival 2011. Naeba Ski Resort, Niigata Prefecture

2011年のフジロックフェスティバル、レッドテントの中、ロンドン市に住んでいる「SBTRKT」と言うミュージックプロデューサーがやってきた。苗場スキー場
新潟県

Fuji Rock Festival

Chemical Brothers, painting the new sound. Fuji Rock Festival 2011, Sunday night headliners on the Green Stage.

ケミカルブラザーズが新しい音を描いている。2011富士ロックフェスティバルで、日曜夜のグリーンステージのメイン。

I Love You Dude! Digitalism from Germany came to play the Red Tent at Fuji Rock Festival 2011. And, interestingly enough, the Digitalism duo is signed to Parisian music/fashion label "Kitsune," the Japanese word for fox; a mystical animal said to have shape-shifting powers in Japanese folklore.

「Digitalism」というアーティストはドイツから２０１１のフジロックのレッドマーキーで「I LOVE YOU DUDE」を演奏した。ところで、「Digitalism」は「キツネ」というパリを拠点としてる音楽とファッションブランドと契約を交わしている。日本では奇怪な狐が体を変化できることを信じられている。

FRF

Goma playing didgeridoo (x2!) with the
Jungle Rhythm Section.
ディジュリドゥ・マスターGOMAの最も熱
く、最も躍れるバンドGOMA&ジャング
ルリズムセクション!

FRF

Goma and the Jungle Rhythm
drummer, Fuji Rock Festival 2011.
フジロックフェスティバル２０１１
年、GOMA＆ジャングルリズムセクシ
ョンのドラマー。

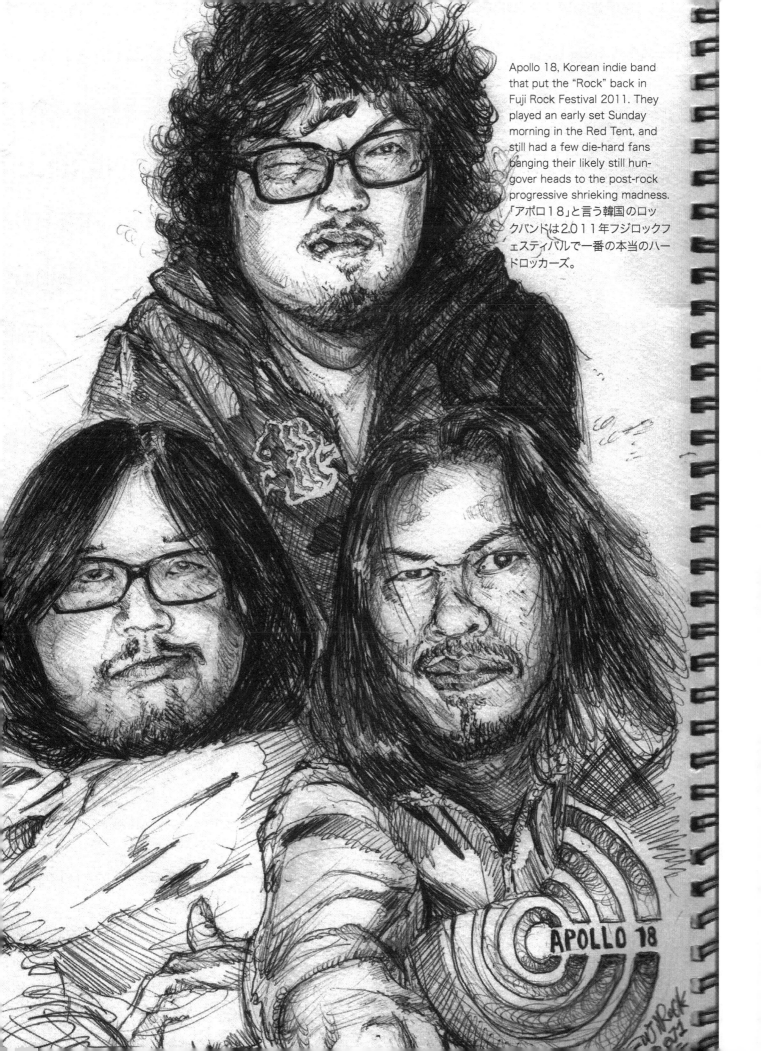

Apollo 18, Korean indie band that put the "Rock" back in Fuji Rock Festival 2011. They played an early set Sunday morning in the Red Tent, and still had a few die-hard fans banging their likely still hungover heads to the post-rock progressive shrieking madness. 「アポロ18」と言う韓国のロックバンドは2011年フジロックフェスティバルで一番の本当のハードロッカーズ。

APOLLO 18

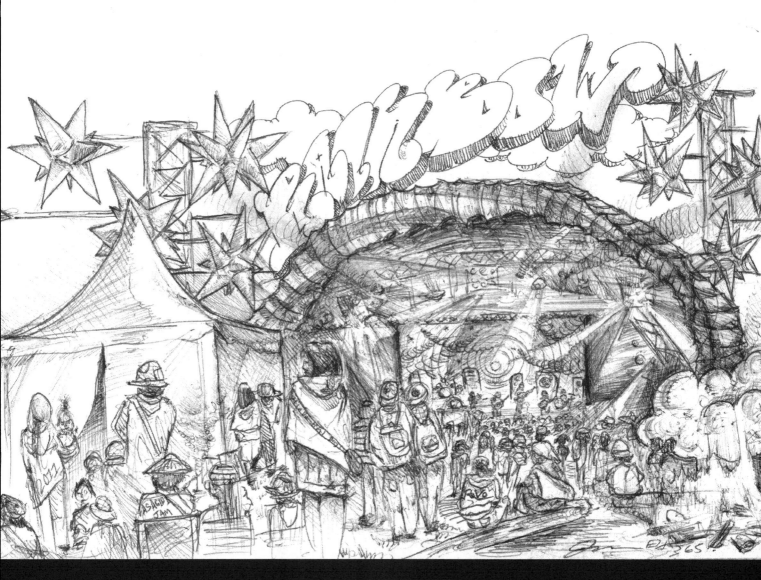

Rainbow Stage, Asagiri Jam Special!
Drawn at the festival sitting by the
bonfire Saturday night, while ROVO
played a progressive set.
朝霧ジャムミュージックフェスティバルに
ある虹ステージ。キャンプファイアーの横
に座って、この絵を描いた。

朝霧JAM

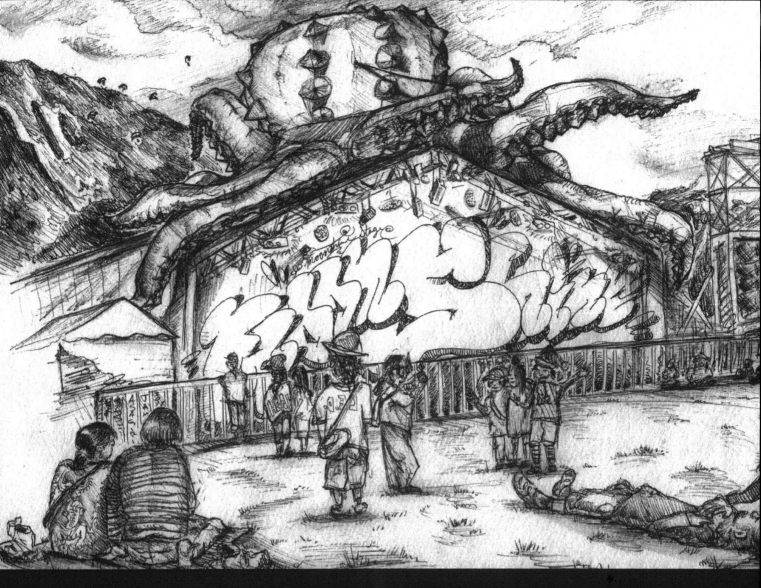

Moonshine Stage, where the 'Designs in Air' Octopus is the real star.
「MOONSHINE」と言うステージの上、本当のスターは「デザイン・イン・エーア」が作った大きなタコ。

DJ Shadow in...The Shadowsphere!
Mind-bending at Asagiri Jam 2011.
アメリカの「DJ SHADOW」と言うDJが
朝霧ジャムミュー ジックフェスティバル
で信じられないビジュアルショーをした。

Cornelius. Experimental, punk, noise, electronic, ambient; this dude does it all. Based in Tokyo, yet his wavelengths penetrate ears the world 'round. (Thanks to the magic of the Internets!)

小山田圭吾（おやまだ けいご）は、日本の
ミュージシャンである。一人だけで構成
される『CORNELIUS（コーネリアス）』
での音楽活動を行っており、日本におけ
る、いわゆる「一人ユニット」の先駆け的
存在。

Steve Aoki. American-born DJ and all-around crazy dude, toured North American college towns in 2010 with guests like Lil' Jon. Needless to say there was plenty crowd surfing, whip cream, bubbles and booty-shaking madness. His father was Japanese pro-wrestler Rocky Aoki, founder of the over-priced and accordingly indulgent/successful Benihana Japanese Steakhouse restaurant chain, while his half-sister Devon is a supermodel and actress. Maybe you remember her as Suki from the movie "Too Fast Too Furious"?

スティーブ・アオキ、日系アメリカ人で電子音楽のDJとして、またドラムとベースでも有名。彼がDJをした日はとても盛り上がる。彼の父親はロッキー・アオキで、アメリカで有名 な日本のステーキレストラン、「ベニハナ」を創立した。彼の姉、デボンはワイルド・スピードと言う映画でスキと言う女性を演じた。

Live music flyer on the wall while
Couch Surfing at Piyo-san's place in
Furano, Hokkaido.
僕をカウチサーフィング（CouchSurf-
ing.com）で泊めてくれた家の壁にかか
っつていた「ライブ」と書かれたポスタ
ー。富良野北海道

TOKiMONSTA. Tokyo-based DJ
東京のDJ「トキモンスター」

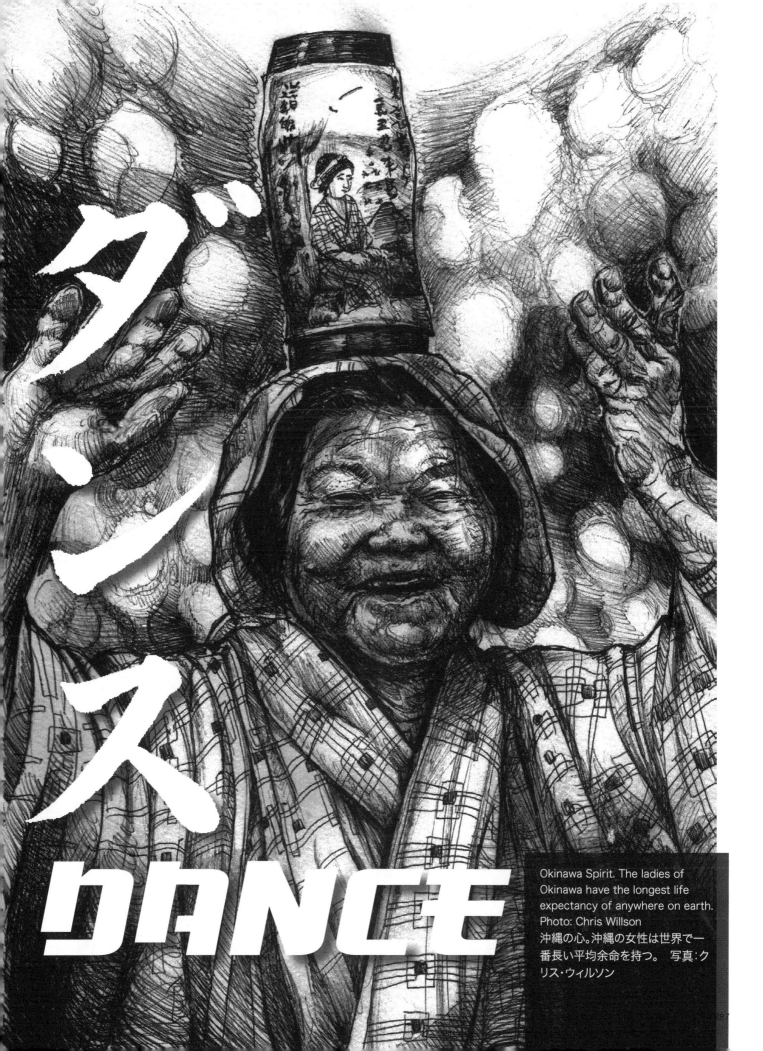

ダンス
DANCE

Okinawa Spirit. The ladies of
Okinawa have the longest life
expectancy of anywhere on earth.
Photo: Chris Willson
沖縄の心。沖縄の女性は世界で一
番長い平均余命を持つ。 写真:ク
リス・ウィルソン

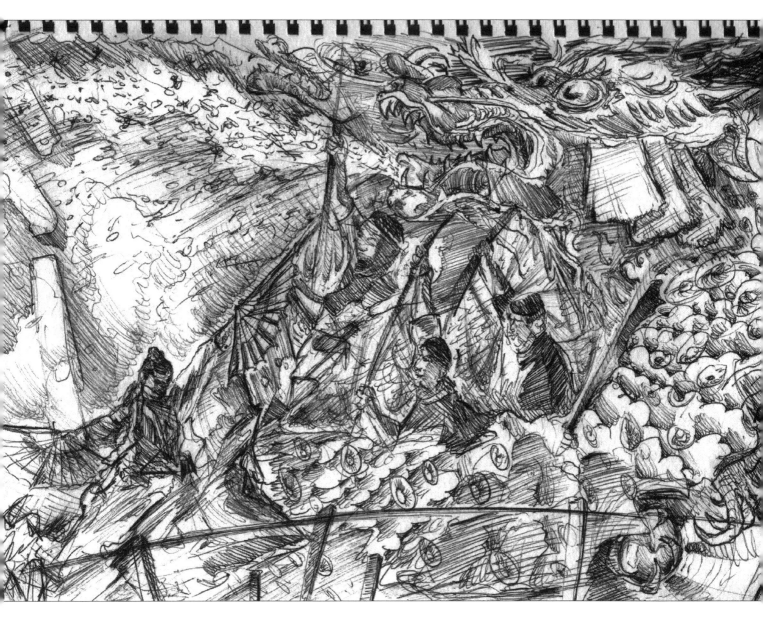

▲ Dragon dance.
龍踊り。

▲ Masked dance in front of Itsukushima
Shrine on the sacred island of
Miyajima. Hiroshima Prefecture
宮島の厳島神社の前に踊り。広島県

▲ Yosakoi! Colorful modern summer dance originated in 1954 in Kochi Prefecture. In the dialect of Tosa province (modern-day Kochi Prefecture) "Yosakoi" means "Come at night."

よさこい！近代的 でカラフルな夏の踊り は１９５４年に高知県 で始まった。高知 県の土佐弁で「よさこい」は「夜に来い」と いう意味だ。

Yasugi Bushi. A man pretends to catch loaches at the 2011 Matsue Dan-Dan Festival as part of the Yasugi Bushi, a traditional dance from the city of Yasugi in northern Shimane. Photo: Greg Ferguson

安来節（やすぎぶし）どじょうすくいは代表的な御座敷芸だ。松江のだんだん祭りにて。安来、島根県北部にて。写真：グレッグ・ファーグソン

Midori Ito. 1989 figure skating world champion and the first woman to successfully land a triple/triple jump and triple axel in competition. Born in Nagoya, Aichi Prefecture.

伊藤 みどり。1989のフィギュアスケートの世界 チャンピオン。試合 でトリプルジャンプとトリプルアクセルを成功させた最初の女性だ。愛知県名古屋市で生まれた。

Foxy lady practicing sick dance moves in front of the o-cha (green tea) in a convenience store.
かわいい狐の面をつけている女性、コンビニのお茶の前でかっこいいダンスを練習している。

Suzushi Hanayagi #1, the experimental years. "When I do classical dance, I don't want to change the movement. I don't want to put my own expression, my own ego, into the classical dance tradition. When I studied with my teacher one-on-one, I felt something very much like Zen meditation; I felt very pure, I didn't feel anything about my own ego or expression."

花柳寿々紫。実験段階の年月。「私がクラッシックダンスをするときは、動きは変えたくないのだ。自分の表現や、エゴをクラッシックダンスの伝統 の中に加えたくはないのだ。私の先生と一対一で学んだときはまるで禅宗の瞑想をしている気持ちになった。とても澄んだ気持ちになって自分のエゴや表現のことは思い浮かばなかった。」

Dance party! Omagari City (1954).
丑湯治の宴、大曲市鶴の湯、1954年 。

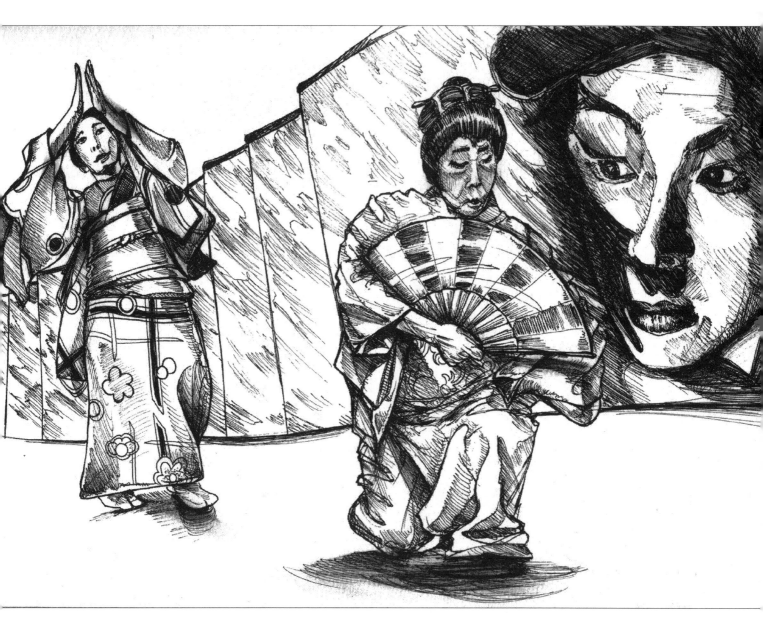

Suzushi Hanayagi #2, a classics mash-up.
花柳 寿々紫、古典的なコラボ。

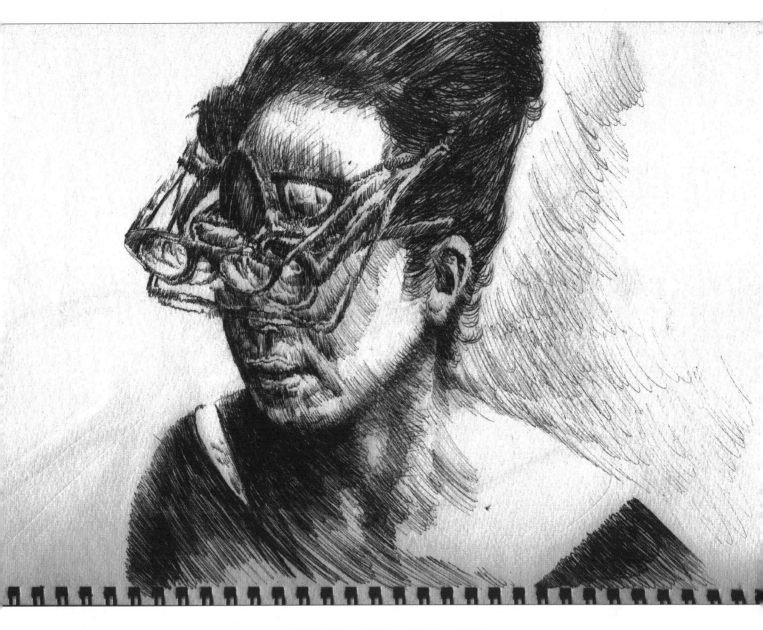

Suzushi Hanayagi #3. Born in Osaka in 1928, world-renowned Japanese classical dancer-turned-contemporary/experimental. Clips of her performance grace The Space In Back Of You, screening in NYC. After a life dedicated to her art, in Japan and abroad, she lives now in Osaka once again, battling Alzheimer's.

花柳寿々紫、1928年大阪生まれ。世界的に有名な日本人の伝統舞踏家。のちにコンテンポラリーで実験的 になった。彼女のパフォーマンスは「ザ　スペイス　イン　バック　オブ　ユー」を飾り、ニューヨークで　上映された。国内と世界で、芸術に人生を捧げた後、今は大阪に戻りアルツハイマーと戦っている。

FASHION

フ
ア
ッ
シ
ョ
ン

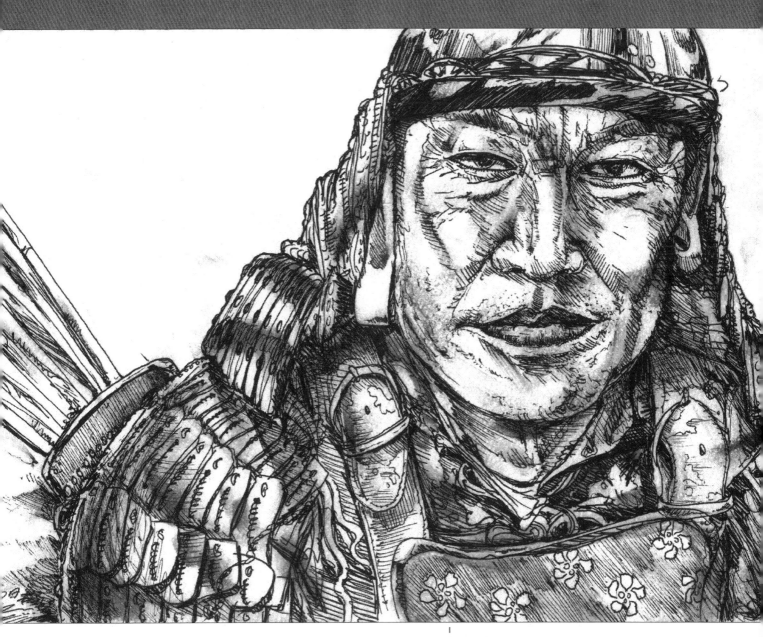

▲ Samurai archer. A strong sly fellow
from Kyoto's Jidai Matsuri, Festival
of the Ages. From the magic lens of
Chris Willson

弓道の侍。京都時代祭。
写真：クリス・ウィルソン

《 Pretzels. A young woman putting on
make-up. 鏡に向かって化粧する女性 。
明治前期。オランダ・ライデン大学所蔵。

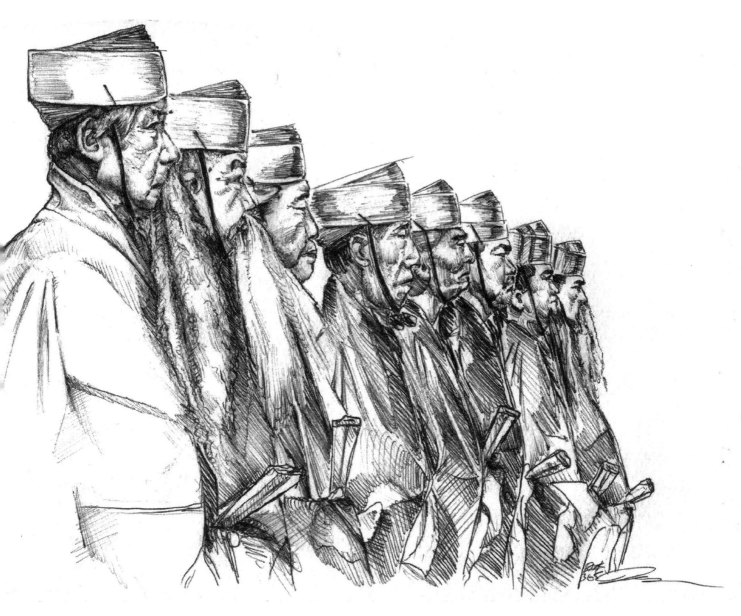

▲ ZZ Top? Not really. Just some old bearded dudes at Shuri Castle Festival on Okinawa. (Three-piece American Rock band ZZ Top hails from Houston, Texas.) Photo: Chris Willson

ZZトップかなー？「ズィーズィー・トップ」は、1969年にアメリカ合衆国テキサス州で結成した、3人のロックバンドだけど、これはそれに似ていておじさんたちが沖縄県の首里城祭に参加している。写真:クリス・ウィルソン

Samurai dress-up at a samurai historic
gathering. Fukushima Prefecture
Photo (and modeling) courtesy Penny
Cameron

侍歴史の会にて、侍の衣装をまとってい
る。福島県。写真とモデル：ペニー・カメロ
ンの好意 により

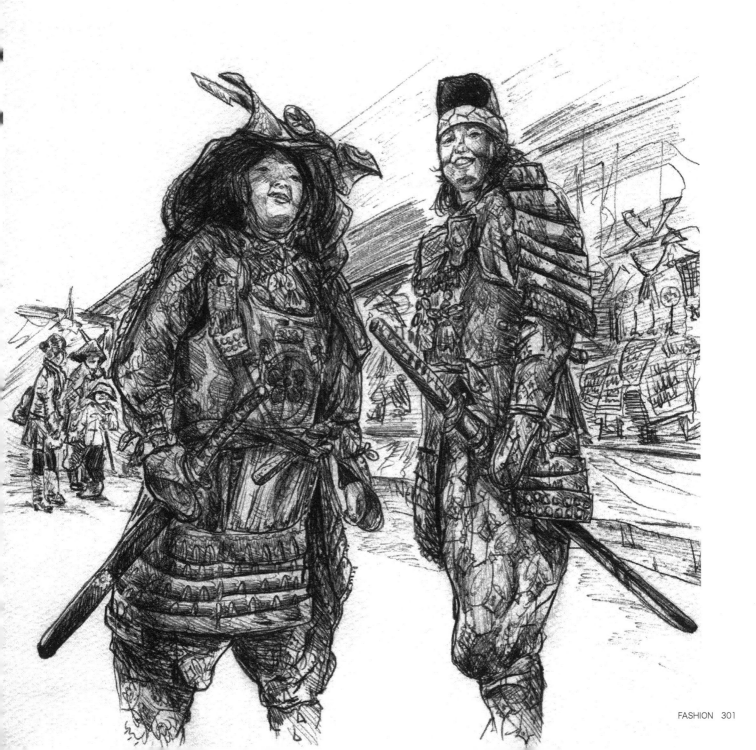

In line for the toilet, that is surprisingly clean, not suffocatingly stinky and well-stocked with TP. Fuji Rock Festival port-a-potties, Japan doing it right.
びっくりさせるほど、清潔であまり臭くなくて、たっぷりなトイレットペーパーがあるフジロックの仮設トイレだった。日本、やるな！

Rubber boots, an indispensable fashion accessory at Fuji Rock Festival.
長靴。フジロックフェステェバルに不可欠な物。地面が濡れていてどろんこであったので。

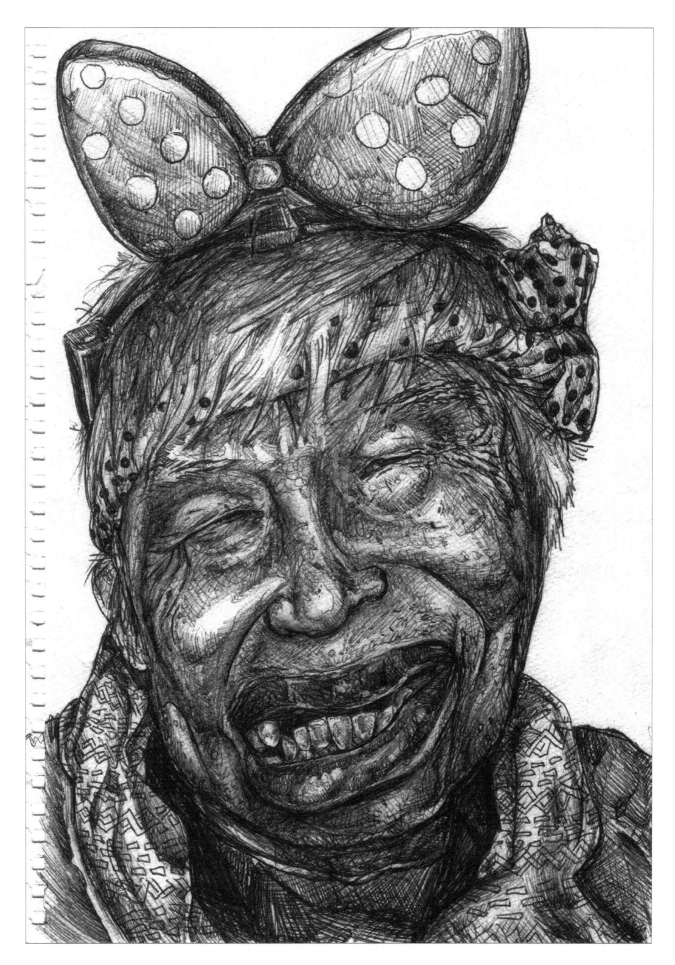

Smile contest winner, wearing a polka-dot headband and hair bow-tie to match.
笑いのコンテストのチャンピオン。水玉の鉢巻きを巻いてリボンをつけてよく似合っている。

Trucker hat design, inspired by a detail of Utagawa Kuniyoshi's 1828 warrior Rouri Hakuchou Choujun, from 'One of the 108 Heroes of the Popular Water Margin Series' (Tsuuzoku Suikoden Gouketsu Hyakuhachinin no Hitori).

トラックの運ちゃんの帽子のデザイン。歌川国芳の「通俗水滸伝豪傑百八人之壱人（水滸伝の中のヒーロー）」の中の浪裡白跳張順より（1828年）

△ Harajuku Style. Hot pink and cerulean blue hair with the lips to match. A pair of archetypal goth-glam fashion aficionados found on the catwalk that is Harajuku, Tokyo.

原宿 ファッション。ショッキングピンクと鮮やかな青色の髪、それにぴったりの唇。東京の原宿で出会った典型的なゴシック系愛好者の二人。

◁ Fifties' dancers at a park in Tokyo.
Photo: James Hart
東京の公園にいた５０年代のかっこうの
ダンサー。写真：ジェイムズ・ハート

Who's the fat cat? Cupcake is neck-tied. そのデブ猫は誰なの？カップケーキちゃんはネクタイをしている。

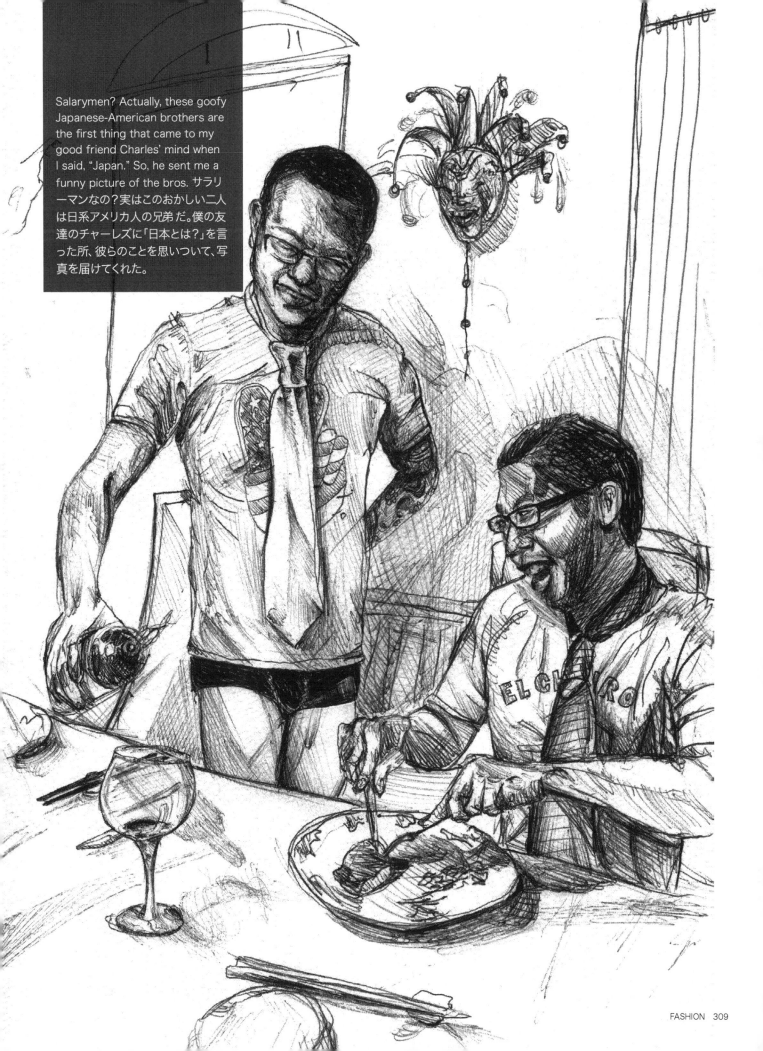

Salarymen? Actually, these goofy Japanese-American brothers are the first thing that came to my good friend Charles' mind when I said, "Japan." So, he sent me a funny picture of the bros. サラリーマンなの？実はこのおかしい二人は日系アメリカ人の兄弟だ。僕の友達のチャーレズに「日本とは？」を言った所、彼らのことを思いついて、写真を届けてくれた。

Blogger's cool Engrish T-shirt.
ブロッガーのおもろい英語が書
かれたTシャツ。

Kabuto-mushi, "helmet bug" or rhinoceros beetle, a.k.a. the Japanese fighting beetle, is trained for battles on a log and racing. Kids catch them and feed them sushi for lean bug muscle mass and eel for fighting stamina.

カブトムシ。日本の戦う昆虫。長いレースのために訓練する。子どもたちは捕まえてきて筋肉とスタミナをつけさせるために寿司と鰻（ウナギ）を食べさせる。

△ Traditional Geta wooden sandals.
Socked-winter feet walking onsen-
to-onsen in Kinosaki town clacking,
"karan-koron, karan-koron."
伝統的な下駄。温泉の町、城崎で「からん
ころん、からんころん」と寒空の下、散歩し
ている靴下をはいた足。

◁ Back piece. (This guy definitely can't get
into onsen.) Chonmage and Irezumi, of-
ten pronounced Iyezumi (Tattoo), from a
photo found in an old album bought by
a Swiss man in England. The Swiss man
promptly contacted the Swiss Embassy
in Tokyo in order to share the photo
with Japanese people.
チョンマゲと入れ墨 明治中期。

Meiji era (1868-1912) Ainu weaver.
明治時代のアイヌの機織り。

KIMONO

Young lady spinning thread.
糸つむぎをする娘。

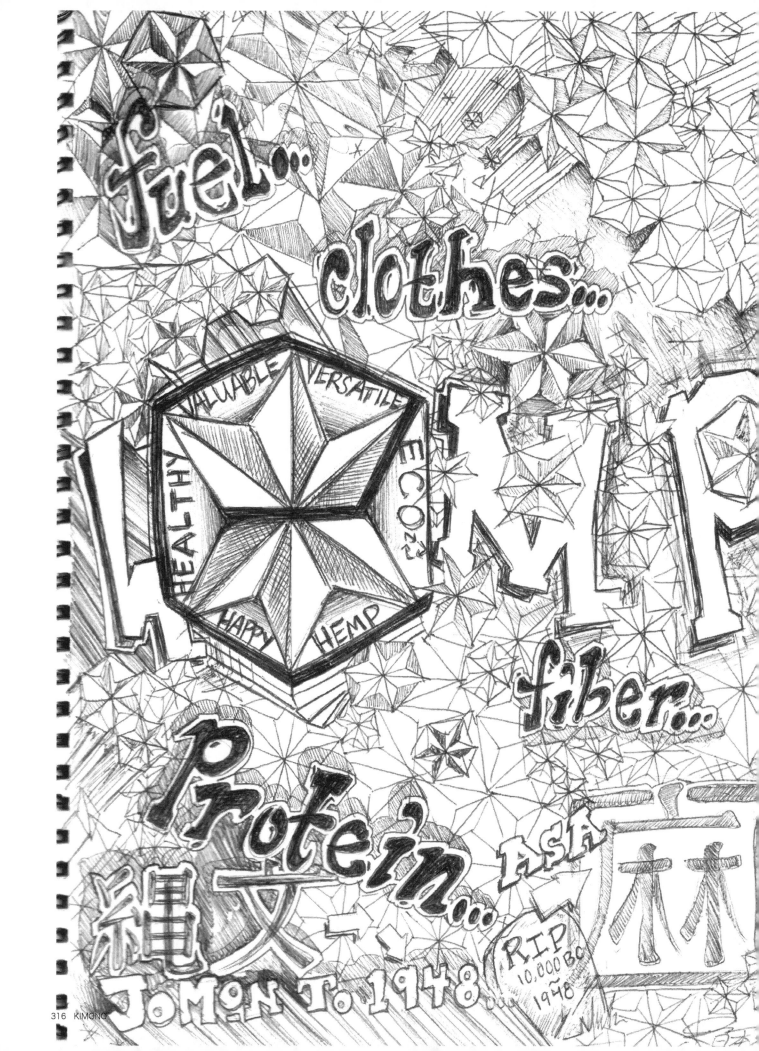

Maiko-san-inspired doll face with birdie. ➤
舞妓さんのような人形の顔と小鳥。

Inspired by a hemp plant design frequently found on kimonos, and the Hemp Car Festival held this summer in Hokkaido. There is a fellow driving a hemp-powered school bus around Japan to promote the plant's use as a clean-burning fuel, among other things. Do a little research, and you will also find hemp's early cultivation in recorded human history, for uses such as fiber (paper, rope, textiles, etc.), food (protein, 80% essential fatty acids), and with no known food allergies, it seems to be a super-crop (does not deplete the soil of necessary nutrients as much as comparable crops either). You don't have to be smoking something to realize this is an extremely useful and beneficial plant that could and should be cultivated legally for many uses; besides getting high as a kite.

着物の柄によく見られる麻のデザインからアイデアを得た。この夏、北海道ではヘンプカープロジェクトが開催され、大気汚染 の少ないヘンプオイルで走るヘンプカーを宣伝しながら日本中を回っていた。少し調べるだけでも、麻の利用価値はとても高く昔から繊維(紙、ロープ、織物など)や食品(タンパク質、80％の必須脂肪酸)として栽培されてきたこと、そして既知の食物アレルギーがないことがわかるだろう。それはまさにスーパー農作物といえる。(他の比較できる農作物ほど、土壌を消耗しない)。大麻を吸ってハイになっていない限り、麻はとても役に立つ有益な植物であり、栽培は合法であるべきだと気づくだろう。

see no evil, hear no

見ざる、言わざる、

"See no evil, hear no evil, speak no
evil." The origin of this phrase comes
from a 17th century wood carving of
the three wise monkeys over Toshogu
shrine in Nikko.
城崎駅の隣にある足湯で、熱いお湯を口
から出している変な石の小動物。

evil, speak no evil
聞かざる

Mother and baby snowy day.
Omagari, Omachi City (1952).
雪の日の母子。大曲市大町、1952年頃。
日本語の字幕

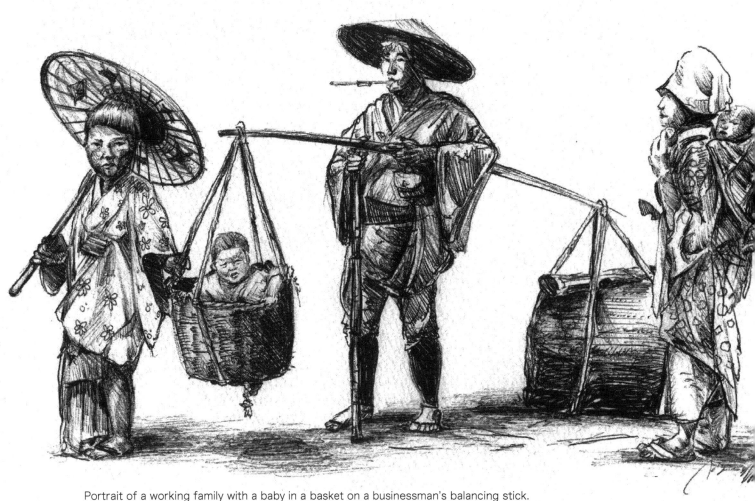

Portrait of a working family with a baby in a basket on a businessman's balancing stick.
子どもをカゴに入れ、天秤棒でかついで仕事へ出かける行商人、明治20年代。

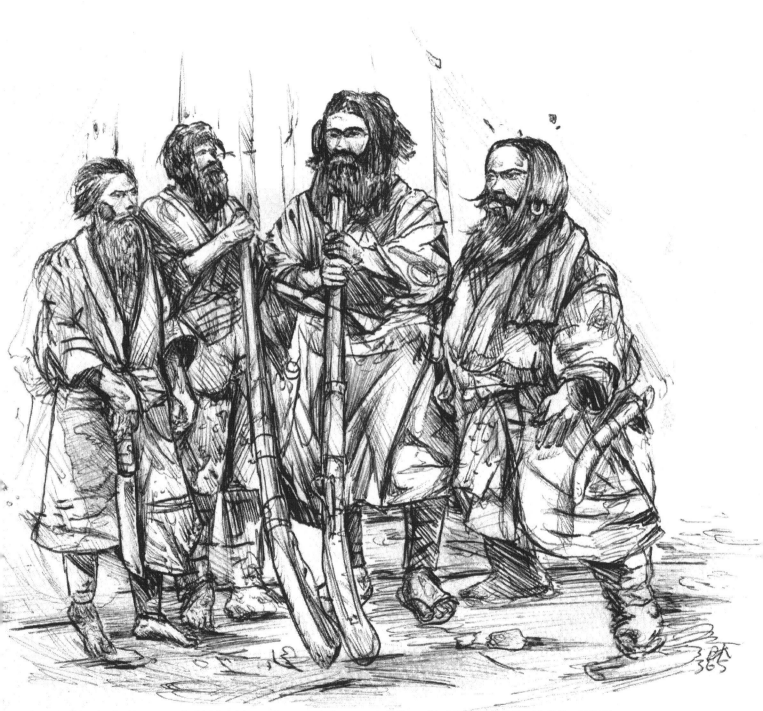

Beardy dudes up north (Hokkaido), an Ainu gun-toting quartet. From the 10th year of the Meiji Era (1880).
長い鉄砲を手にしたアイヌ、明治１０年代。八木正自さん所蔵、東京都・文京区

A fellow wearing the traditional male hakama with his hair in a chonmage,
playing the challenging strategy game GO.
伝統的な男性の着物、袴を着てチョンマゲをして、碁を楽しむ。

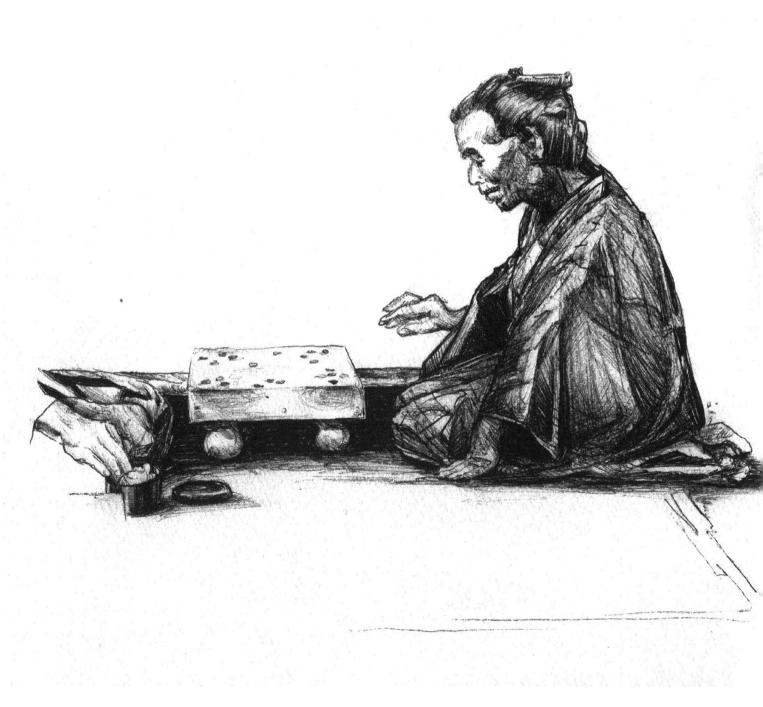

Rockin' the Abacus. Rice wholesaler Mr. Sakurai from Chiba, owner of a successful rice shop in Edo-Yodobashi Village (present-day Shinjuku) calculating his contributions to a Buddhist temple with an abacus. Meiji era (1875).

米問屋の主人、明治8年（1875）ごろ。江戸淀橋村（現新宿）桜井仙蔵

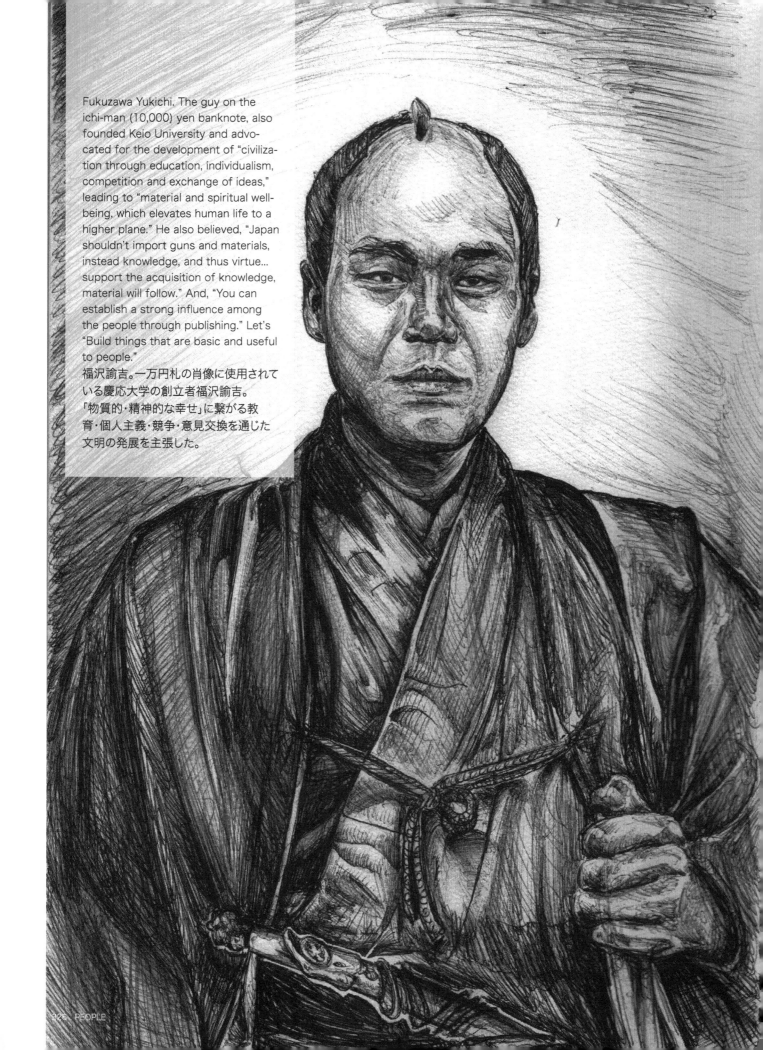

Fukuzawa Yukichi. The guy on the ichi-man (10,000) yen banknote, also founded Keio University and advocated for the development of "civilization through education, individualism, competition and exchange of ideas," leading to "material and spiritual well-being, which elevates human life to a higher plane." He also believed, "Japan shouldn't import guns and materials, instead knowledge, and thus virtue... support the acquisition of knowledge, material will follow." And, "You can establish a strong influence among the people through publishing." Let's "Build things that are basic and useful to people."
福沢諭吉。一万円札の肖像に使用されている慶応大学の創立者福沢諭吉。「物質的・精神的な幸せ」に繋がる教育・個人主義・競争・意見交換を通じた文明の発展を主張した。

Omagari lass (1952). A real Akita "bijin," from a photo taken in 1952 by Genjiro Ono, part of Kimura photo collection. Trying to capture the people's "realism," Jiro Ono was encouraged to take pictures of peasants and working women, just keeping it real.

大曲市の美人（1952年）。木村写真集、大野源二郎が撮影した本当の秋田美人人々の現実を捉えようとして小作農や働く女性の日常生活を映した。

Some rich guy's trained Kaiser 'stache
inspired by Wilhelm II.
カイゼルひげ、大正3-4年ころ。ドイツの
皇帝ウィルヘルムⅡ世をまねた、はやりの
カイゼルひげの医師。

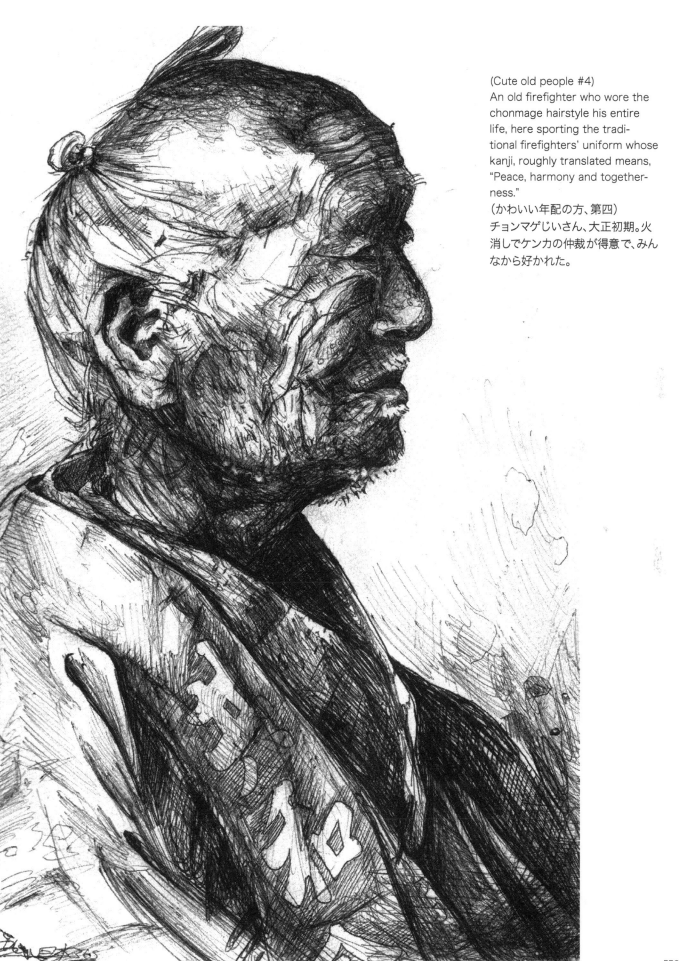

(Cute old people #4)
An old firefighter who wore the chonmage hairstyle his entire life, here sporting the traditional firefighters' uniform whose kanji, roughly translated means, "Peace, harmony and togetherness."
（かわいい年配の方、第四）
チョンマゲじいさん、大正初期。火消しでケンカの仲裁が得意で、みんなから好かれた。

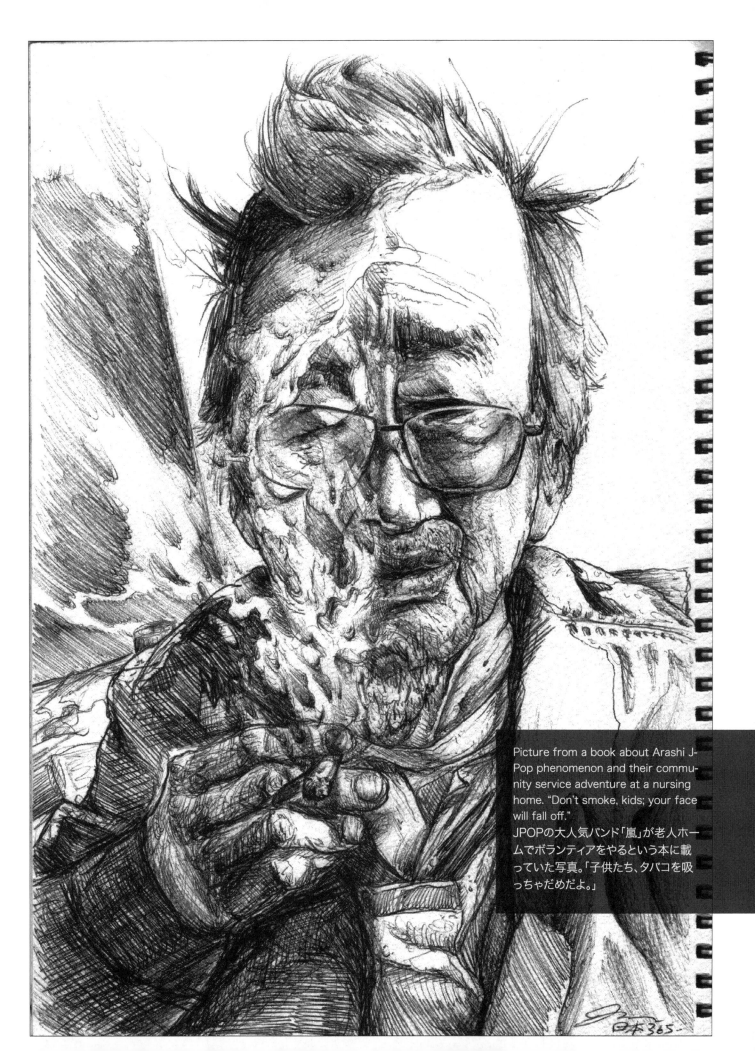

Picture from a book about Arashi J-Pop phenomenon and their community service adventure at a nursing home. "Don't smoke, kids; your face will fall off."

JPOPの大人気バンド「嵐」が老人ホームでボランティアをやるという本に載っていた写真。「子供たち、タバコを吸っちゃだめだよ。」

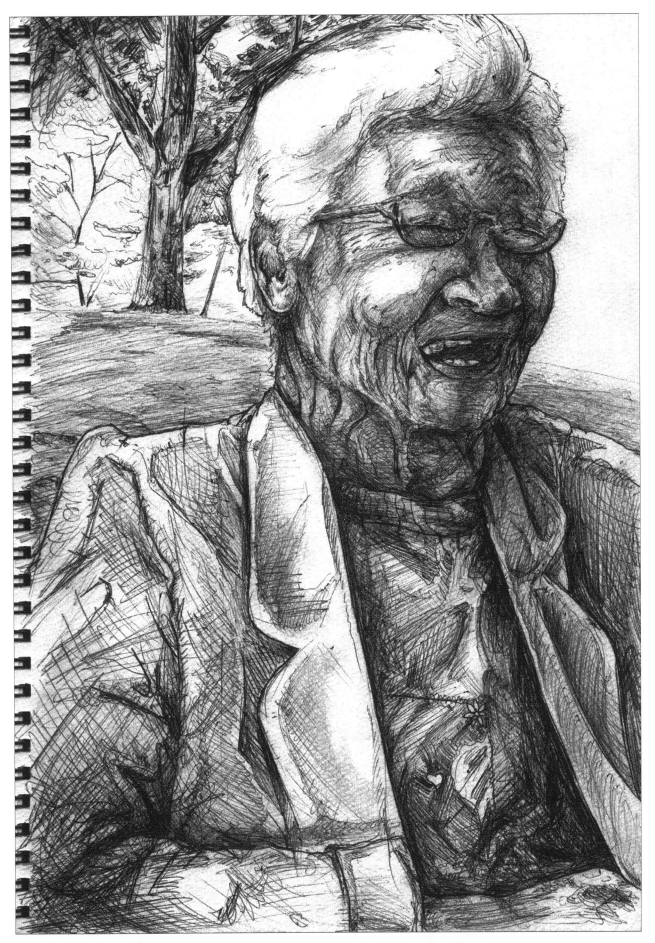

(Cute old people #2) "What joyful!" laughing in the park.
（かわいい年配の方、第二）公園でおばさんが笑っている。

(Cute old people #1)
Lady with the bright left eye.
My co-worker recommended
I draw some old people.
（かわいい年配の方、第一）
左目が光るおばあさん。年配の
方を描くよう同僚に奨められ
たので。

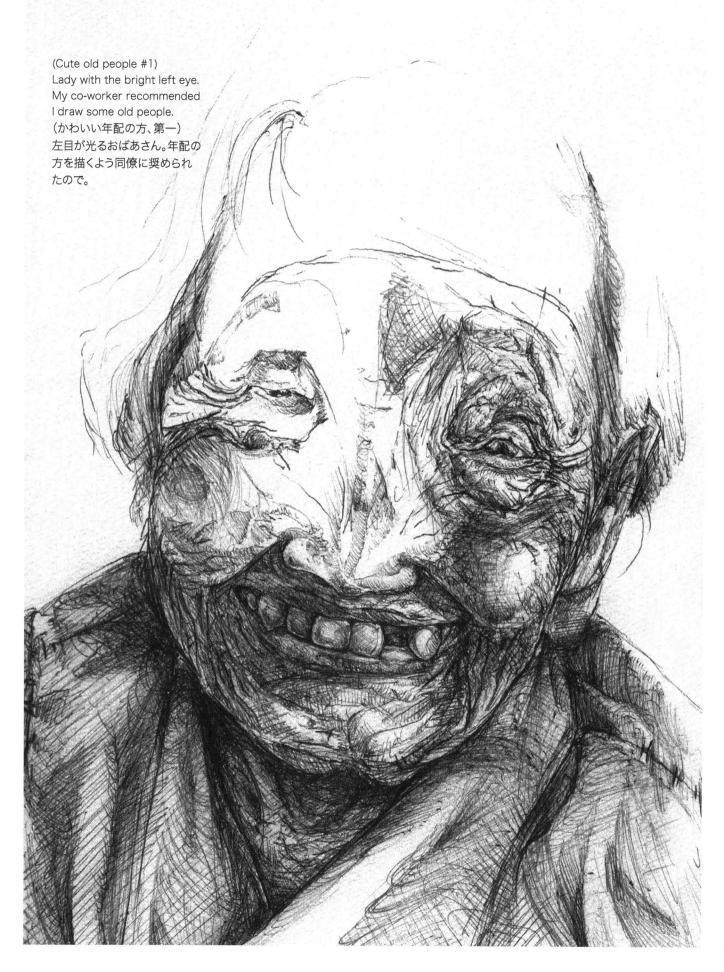

The bow in Japanese culture is a very important gesture, much like the western handshake as a greeting or the recently popularized urban trend of giving "dap" to associates and friends. Salutations only require a slight bow (bent about 15 degrees from the waist), while in more formal occasions one is highly encouraged to bow more deeply (perhaps 30 degrees, and look forward exactly two meters), thus showing gratitude and respect, especially to elders and those of higher professional rank. Forty-five degrees shows even more appreciation and/or an apology, depending on the circumstances. Ninety degrees with a slight bend in the knees is the most reverent, super-polite bow reserved for only the most special occasions. Anything beyond 90 degrees is ridiculous as you are crossing into dangerous hernia territory.

欧米における握手同様、礼は日本ではとても大事な作法だ。挨拶では15度ほど軽く、公式な場や年配者、立場が上の方の前では３０度ほど深くおじぎをする。そ うすることで感謝や尊敬の念が伝わる。４５度まで曲げると、深い感謝や謝罪を表すことになる。９０度まで達すると、謙虚でとても丁寧だが、頻繁には行われない。

礼

▼ An old couple parting at Yokohama Port (1898).
別れ、明治３０年代。横浜港、旅立つ者、見送る者。

Mount Koya Buddhist monks first invented so-called Koya-dofu (dried blocks of tofu) because it got so cold on the mountain that their normal tofu would freeze. I guess fresh tofu isn't any good after that? So this Koya-dofu is dried, can be frozen, and will keep for use during those cold, hard winter months. The lady keeping the tradition alive, and even shipping to Canada, posed for me by a cherry tree.
Koya Mountain Range, Wakayama Prefecture

高野山に住んだお坊さんは高豆腐を発明した。なぜならあの寒い高野山では普通の豆腐が凍結して固くなってしまうから。凍った豆腐はおいしくないでしょう?この高野豆腐は乾燥したもので、凍らせることもできるし、厳しい冬でも、ずっともつ。こちらの女性は高野豆腐の伝統を守っている。カナダにまで売っている そうだ!
高野山和歌山県

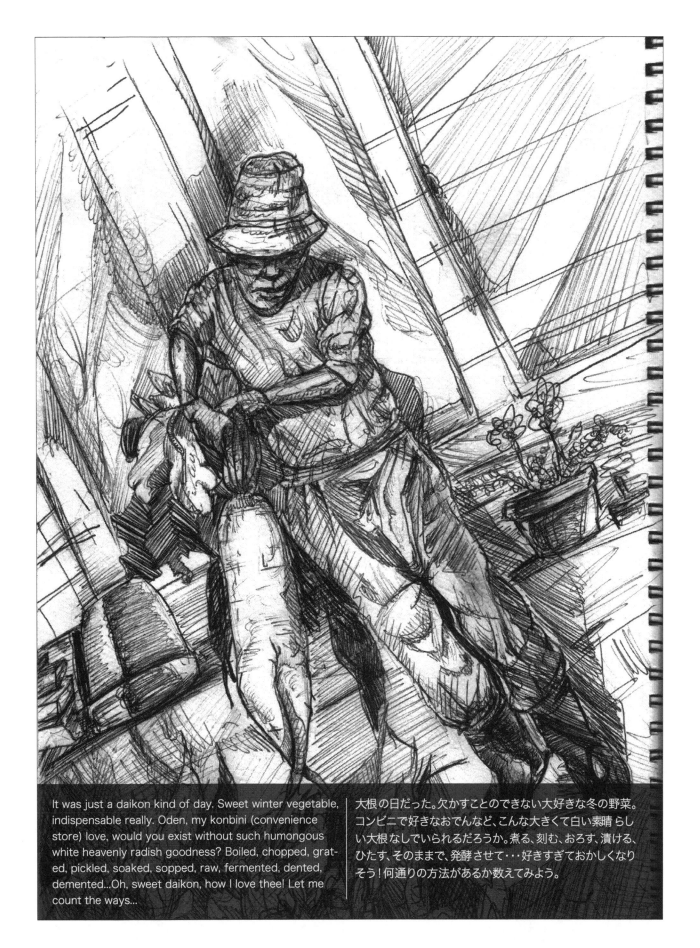

It was just a daikon kind of day. Sweet winter vegetable, indispensable really. Oden, my konbini (convenience store) love, would you exist without such humongous white heavenly radish goodness? Boiled, chopped, grated, pickled, soaked, sopped, raw, fermented, dented, demented...Oh, sweet daikon, how I love thee! Let me count the ways...

大根の日だった。欠かすことのできない大好きな冬の野菜。コンビニで好きなおでんなど、こんな大きくて白い素晴らしい大根なしでいられるだろうか。煮る、刻む、おろす、漬ける、ひたす、そのままで、発酵させて・・・好きすぎておかしくなりそう！何通りの方法があるか数えてみよう。

A Diet Government Representative
from Japan investigating Japanese
immigrants to America visited
Hollywood at the same time Charlie
Chaplin was filming a movie there.
チャプリンと、昭和3年(1928)。

Death By Hanging 2 (1968). Like the proverbial onion, the film peels off the many layers of complex issues surrounding the hanging of "R." Especially, the themes of guilt and consciousness, justice, and the persecution of ethnic Koreans in postwar Japan.

1968年の映画「絞死刑」。日本での戦後の韓国人に対する迫害や罪の意識と良心、正義をテーマにした。

Some 70s movie.
70年代の映画。

松本①ガリたい焼き

Oh, I like this.

Hitoshi Matsumoto, well-known as Mat-chan of the Japanese comedy duo Downtown. He says, "laughter was the only way to get through those [poor, rough] times…" He credits his poverty for giving him a good imagination and sense of play, as it forced him to invent his own games and entertain himself." Also known for his use of the Kansai dialect, wordplay with puns, and a samui or sabui (寒い, サブい) - literally "cold," referring to anything corny and otherwise unfunny - humor sense. Born in Amagasaki, an industrial area near Osaka

松本人志、お笑いのコンビ『ダウンタウン』の『まっちゃん』としてよく知られている。彼にとって芸人は貧しさや苦境から脱する唯一の方法だった。貧しさ故に想像力やあそびのセンスを身につけ、ゲームや楽しみを生み出していった。また、彼の使う関西弁でのダジャレや『サムい』ギャグがウケた。尼崎出身。

Takahashi Naoko, 2000 Sydney
Olympics Marathon Gold Medalist,
set an Olympic record; she ran
away too fast before I could finish
drawing!
高橋尚子。2000年のシドニーオリンピ
ックで記録を更新した金メダリスト。
僕が絵を描き終える前に走り去ってし
まった！

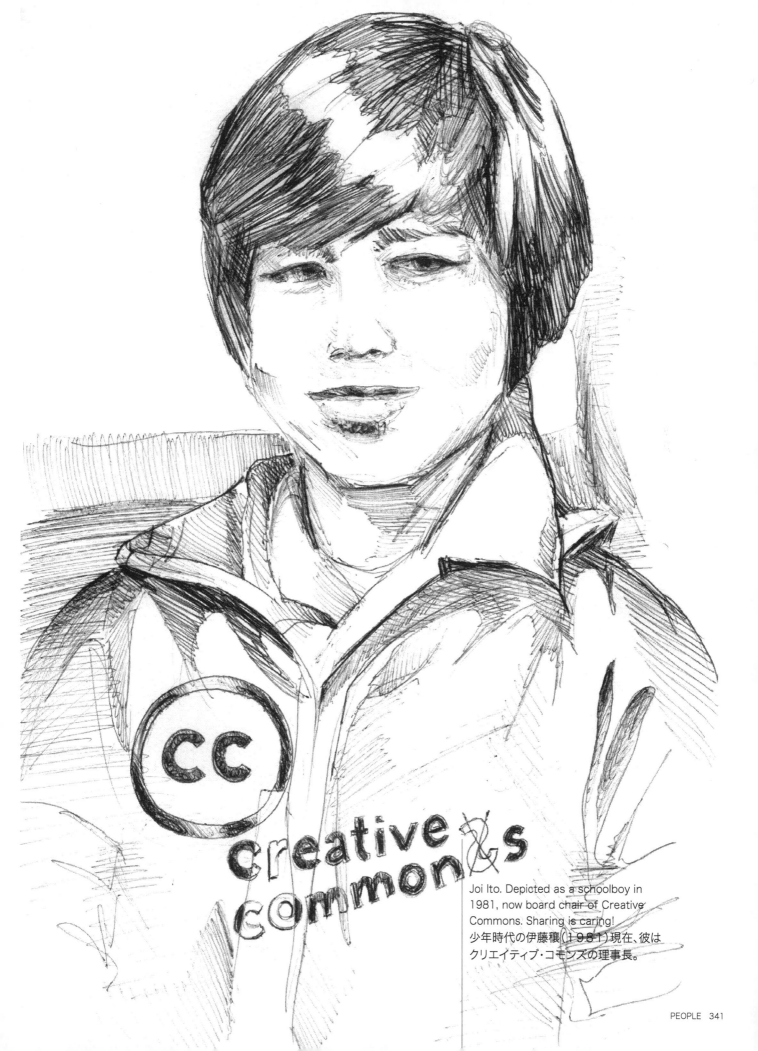

CC

creative commons

Joi Ito. Depicted as a schoolboy in
1981, now board chair of Creative
Commons. Sharing is caring!
少年時代の伊藤穰（１９８１）現在、彼は
クリエイティブ・コモンズの理事長。

> "If you attach a reason to an adventure it ceases to be one."
> 「冒険に理由をつけると、冒険でなくなってしまう」

▲ Naomi Uemura, smiling. He was the first person ever to reach the North Pole solo, the first ever to raft the Amazon solo, and the first ever to climb Mount McKinley solo (although that descent took his life in February 1984). Uemura was a gifted climber and driven adventurer, but also a gentle and modest man who genuinely cared about others.

◀ Naomi Uemura, cold
植村直己、寒冷

植村直己の笑顔。彼は、アマゾン川6000km単独いかだ下り、日本人初エベレスト登頂、世界初五大陸最高峰登頂、犬ぞり単独行で北極点到達など数々の冒険を成功させた。だが、マッキンリー登頂後に消息を絶った。植村さんは大変熱心な登山家・冒険家で、しかも人情深く、優しくて繊細だ。

Soka Gakkai, an organization stemming from Nichiren Buddhism. Here Josei Toda (left) and Daisaku Ikeda (right).

創価学会。日蓮宗に基づく宗教。戸田城聖と池田大作。

P.S. The robot is on the left...or is it?

Who is the ROBOT? Professor Hiroshi Ishiguro of Osaka University created his own twin, a Geminoid android, at ATR Intelligent Robotics and Communication Laboratory in Kyoto. He not only fabricated this 'droid to stand-in for his online video lectures (to be in 2 places at once, essentially) but also to continue to push the HRI (Human-Robot Interaction) threshold and philosophical envelope, designing human-like approximations to reveal what is fundamentally human in us by our reactions to them... Yeah, I just microwaved a pizza!

ロボットはだれだ？大阪大学の石黒 浩教授は自分の双子ジェミノイドアンドロイドを京都の知能ロボティクス研究所（ATR）で作った。彼がアンドロイドを作ったのはオンライン講義のために一人二役をしたかっただけではなく、人間とロボットの交流の出発点とし促進するために開発した。また、人間に酷似した物を作り、ロボットに対する反応によって人間が基本的に何ものであるかを哲学的に明らかにするためでもある。僕はピザを電子レンジで暖められたよ！ロボットは左側だよね？

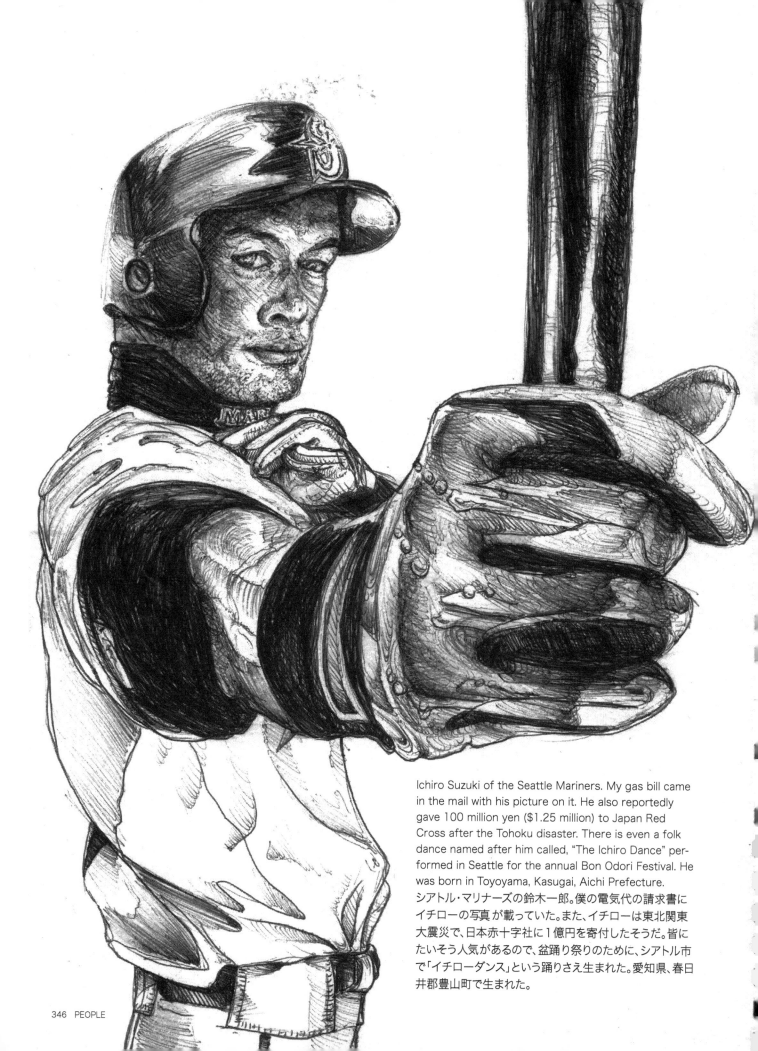

Ichiro Suzuki of the Seattle Mariners. My gas bill came in the mail with his picture on it. He also reportedly gave 100 million yen ($1.25 million) to Japan Red Cross after the Tohoku disaster. There is even a folk dance named after him called, "The Ichiro Dance" performed in Seattle for the annual Bon Odori Festival. He was born in Toyoyama, Kasugai, Aichi Prefecture.

シアトル・マリナーズの鈴木一郎。僕の電気代の請求書にイチローの写真が載っていた。また、イチローは東北関東大震災で、日本赤十字社に1億円を寄付したそうだ。皆にたいそう人気があるので、盆踊り祭りのために、シアトル市で「イチローダンス」という踊りさえ生まれた。愛知県、春日井郡豊山町で生まれた。

Clown performing in a public square overlooking Kobe.
神戸市を見下ろす広場でピエロがパフォーマンスをしている。

"Sometimes you feel like an 'outsider' when living in Japan as a foreigner (who wouldn't), but my daughters are a true link from America to Japan. They fit in either area, and can truly relate one to another. I guess I feel they are living reasons for one country to admire the other. A positive link. There is no better than the other since they are obviously both." - Andy G.
「日本に住んでいると、よそ者だと感じることがある（誰が感じないのだろう）。ただ、娘達はアメリカと日本の本当のつながりを持っている。どちらの国においても馴染んでおり、他者とも良い関係性をつくっている。私は、互いに尊敬し合うために彼女達の存在はあるのだと思う。ポジティブなつながり。どちらも持っている以上に素晴らしいことはないのではないだろうか。」アンディー・G。

Kochi + Ehime + CouchSurfing
高知と愛媛カウチサーフィングの人たち。

Family portrait of Andy and the girls. Sarah and Myla are hafus, half-American and half-Japanese. Andy currently lives in the US, while his daughters share their time between him and their mother still living Tokyo. This situation is indicative of two rising trends in Japanese society: the increase in divorce (separation) rates, and the increase in mixed families in Japan.

アンディーさんと娘の人物画。娘のサラとマイラはアメリカ人と日本人のハーフ。アンディーさんは現在アメリカに住んでいるが、娘たちはアメリカの家とお母さんの住んでいる東京の家を行ったり来たりしている。現代日本社会の傾向を表す二つの事例である。一つは離婚が増えていることで、もう一つは国際結婚だ。

English teacher with a funny statue.
Photo courtesy Joanna Solotaroff
英語の先生、おもろい像と。
写真：ジョアンナ・ソロタロフ

Backpacker Maiko-san, strolling elegantly in 10cm geta sandals and effortlessly carrying her 20kg pack.
旅行中の舞妓さんが10センチの下駄を履いて、軽々と20キロのリュックを担いで優雅に歩く。

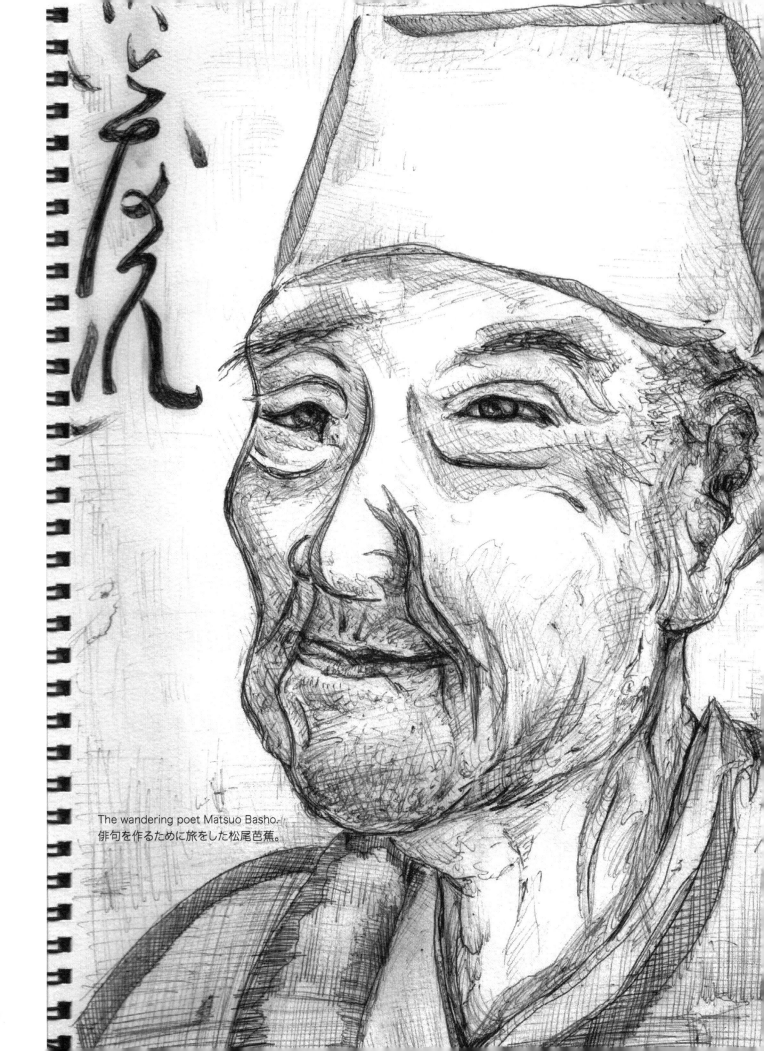

The wandering poet Matsuo Basho.
俳句を作るために旅をした松尾芭蕉。

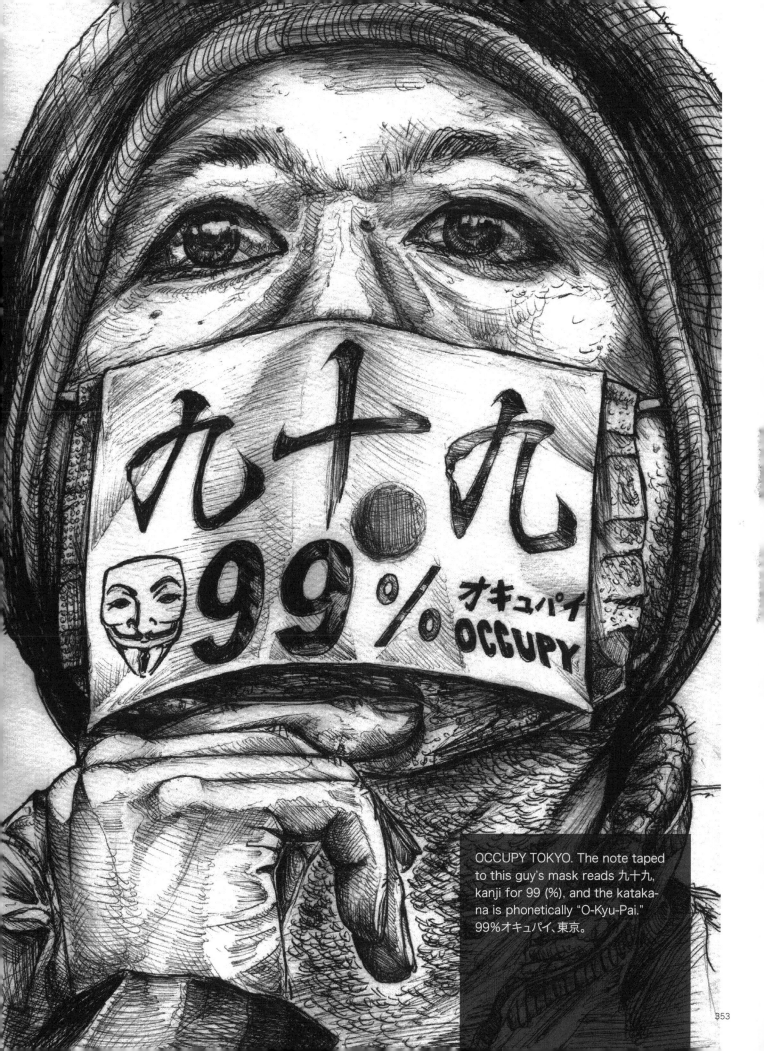

OCCUPY TOKYO. The note taped to this guy's mask reads 九十九, kanji for 99 (%), and the katakana is phonetically "O-Kyu-Pai." 99%オキュパイ、東京。

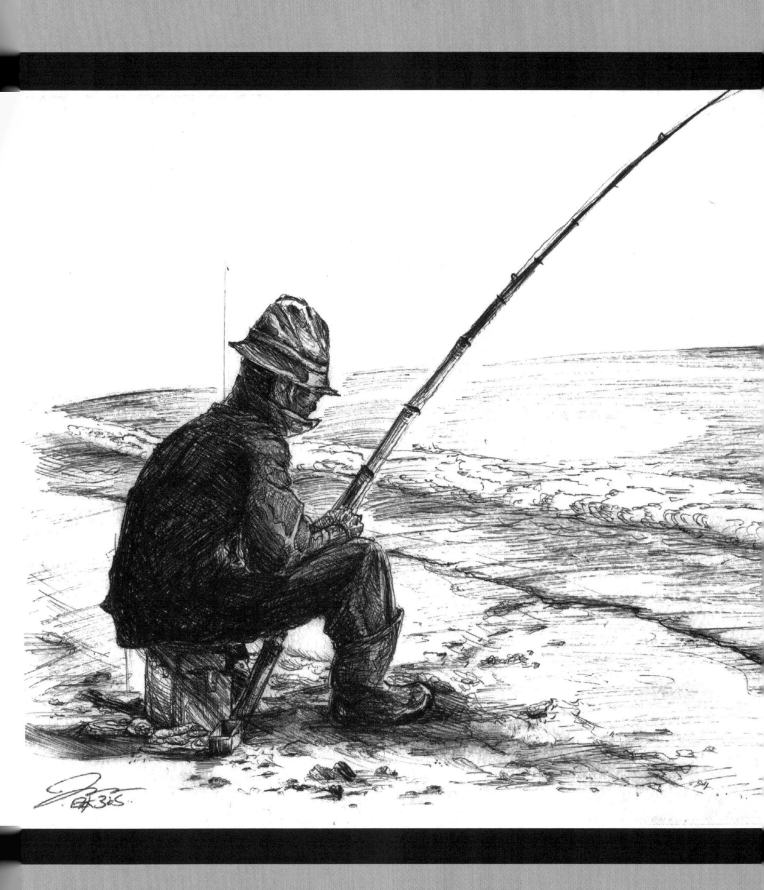

Japanese Fisherman, from a timeless photograph
taken by Don Wolf in 1957, at the time a US Navy man
stationed on aircraft carrier USS Kearsarge, CVA 33.
Don went on a retreat to Kapaun Catholic Religious
Retreat House in Oiso, Kanagawa Prefecture on the
Pacific coast. While there, he took the photo which
inspired this picture.
Photo: Don Wolf (http://don-wolf.artistwebsites.com/)
日本の漁師。時間が止まったような写真は1957年アメ
リカの海兵隊ドン・ウォルフによって撮影された。神奈川県
の大磯にあるカパウンカトリック教会の保養施設に行った
時に、彼はこの写真を撮った。写真：ドン・ウォルフ

CHARACTERS

Gunma-chan! Gunma Prefecture's "super-deformed" horse character, used on oodles of promotional materials and popping up at touristic and other cultural events to grant photo takers a funny fuzzy face to pose with. Maybe rethink hopping on Gunma-chan's back expecting a ride though; I heard there is actually a "Genki" 76-year-old lady in there!

群馬ちゃん！群馬県の馬のゆるキャラで、宣伝や観光や文化的な催しでよく出没する。寝ぼけた面白い顔で写真を一緒にとってくれる。でも、群馬ちゃんの背中に乗ろうとは考えないでください。聞いたところによると、元気な７６歳のおばあちゃんが中に入っているそうだ！

Gen-San! Genbudo Cave Park and
Hyogo Prefecture's hexagonal-head-
ed columnar-joint rock formation
mascot of tourist fun and cookie
fame.
げんさん！玄武洞公園、六角形頭の柱
状節理の岩の形の兵庫県のキャラク
ター、有名なクッキーのキャラクター。

▲ Maneki neko, cute pawing totems made of porcelain for good luck and wealth.
Photo: Shihoko-San (CouchSurfing)
幸運と富裕を集める招き猫。

Nezumi no Yomeiri, The Mouse's Wedding. A Japanese folk children's story about a rich father mouse who wants to find a good, strong, worthy manly mouse for his young daughter. The father mouse goes on a journey to find a mate, and encounters suitors such as the sun, a cloud, wind, the wall; and what-do-you-know! since a mouse can eat through the wall, he is (the mouse species) is actually the strongest of all! I guess, the moral of the story is, marry your own species? Anyway, it was a warm, fuzzy image in their little mouse house. Light a fire in the fireplace and put a pot on for tea. Plus, I was born in the Year of the Rat, so I have a special affinity for Rodentia.

ねずみの嫁入り。この日本昔話では、金持ちのねずみのお父さんはいとしい娘のために何でも日本一のお婿さんを探しに行きだした。お日様と雲と風と壁に会ったが、ねずみは壁を食べるから、やっぱり、ねずみが世の中で一番えらいことが分かってきた。教訓は自分と同じ種族と結婚 するべきということ？とにかく、ねずみの家の場面を見ると心が暖かくなる。いろりで火をつけて、お茶を入れましょう。それに僕は子年に生まれたので、齧歯目（げっしもく）と特別な絆で結ばれるよ。

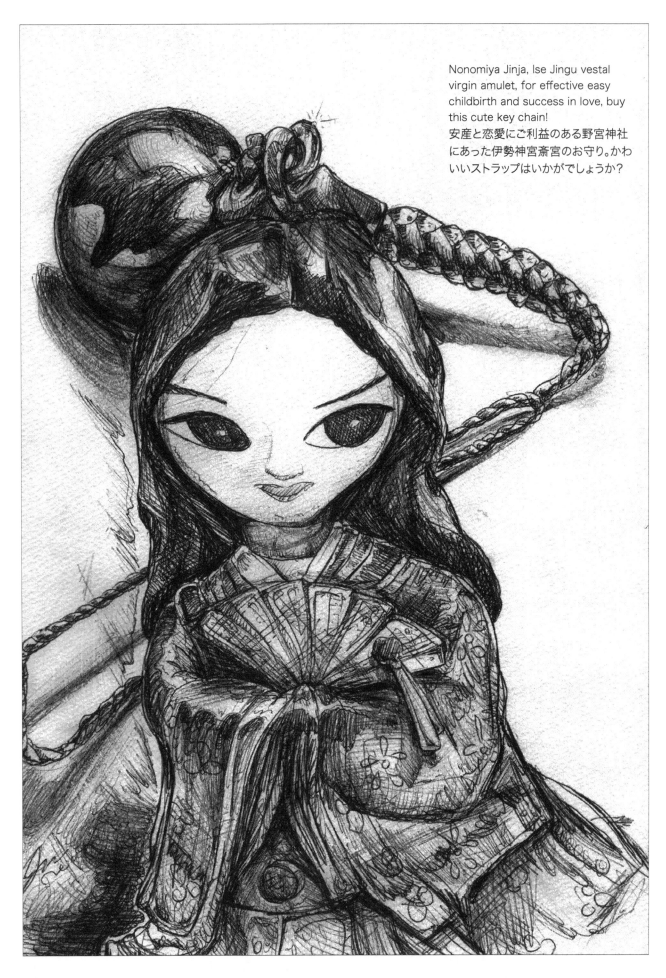

Nonomiya Jinja, Ise Jingu vestal virgin amulet, for effective easy childbirth and success in love, buy this cute key chain!
安産と恋愛にご利益のある野宮神社にあった伊勢神宮斎宮のお守り。かわいいストラップはいかがでしょうか？

2/1/2011

Daikon. Immortalized as a (slightly)
less edible nuigurumi, stuffed "animal."
大根のぬいぐるみ。

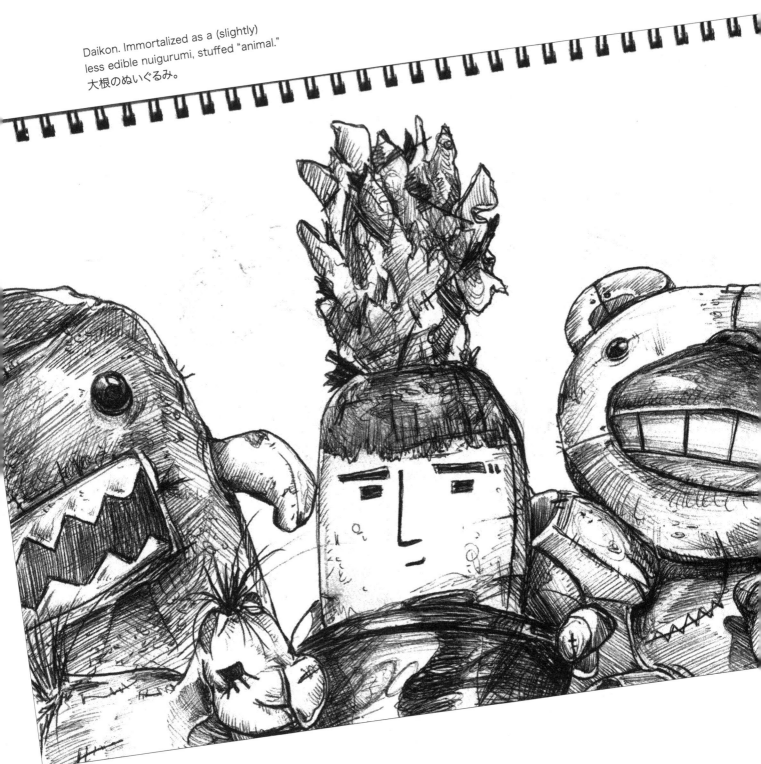

▲ Daruma wish dolls. "We're famous for a few things in Shirakawa, including our daruma (wish dolls). They are famous but they're everyday as well, found in homes, shops, and on key rings on kids' bags!"
Shirakawa City, Fukushima Prefecture
Excellent moment captured by Penny Cameron

『白河で有名なものって、ダルマと何かしかないんだけど。でもだからと言って、自宅やお店、子どものカバンのキーホルダーにもなってるのよ！』
白河市　福島県
写真：ペニー・カメロン

Still-life with AnPanMan, black tea and
keitai (cell phone)
アンパンマン、紅茶と携帯の静物画。

ホホホ

Say it like you mean it, "Ho Ho Ho." A couple of holiday season department store fixtures, even in Japan. The ever-chagrined half-drunk Santa and his loathsome right-hand man Rudolph in a onesie (who quite resembles the delicious and glutinous round-faced superhero AnPanMan).

ちゃんと言って「ホッホホー」。日本でもデパートでは、サンタクロースをクリスマスに飾る。ほろ酔いサンタと腹心 のトナカイ、ルドルフはご機嫌斜 めでパジャマを着ている。ちょっとアンパンマンと似ているじゃない？でしょう？

"Goodbye, Kitty." A child's abandoned Kitty-chan sandal. Yonago-shi, Tottori Prefecture
Photo: Greg Ferguson
「バイバイ、キティちゃん」捨てられたキティちゃんのサンダル。
米子市鳥取県写真：グレッグ・ファーグソン

Velociraptor Robot Santa Claws, Snoopy for scale. Animatronic dino-bot brought to you by Tokyo-based Kokoro Co. Ltd., established 1984.

ヴェロシラプトル・ロボット・サンタ・[コロス]　スヌーピーとの大きさの違いがよく分かる。アニマトロニクの恐竜ロボット、このおもちゃは東京の株式会社コロによる制作。会社設立１９８４年。

367

Super-genki giant blue squid. A
curious little girl checks out what's
"behind" the super-genki giant blue
squid hugging all the cute mothers at
the first big crab festival of the year in
Kasumi, Hyogo Prefecture
ダイオウイカ。祝！香住 の松葉 ガニ初セリ
祭のキャラクター

Nara's cute/weird character mascot Sento-kun reconstructed. Is he deer, Buddha, baby, key chain, organ donor, J-Pop rock star, Swiss cheese?

再生された奈良の不気味でかわいいキャラ「せんと君」。鹿、仏様、赤ちゃん、キーホルダー、臓器提供者、ロックスター・・・いったい何でしょうか?

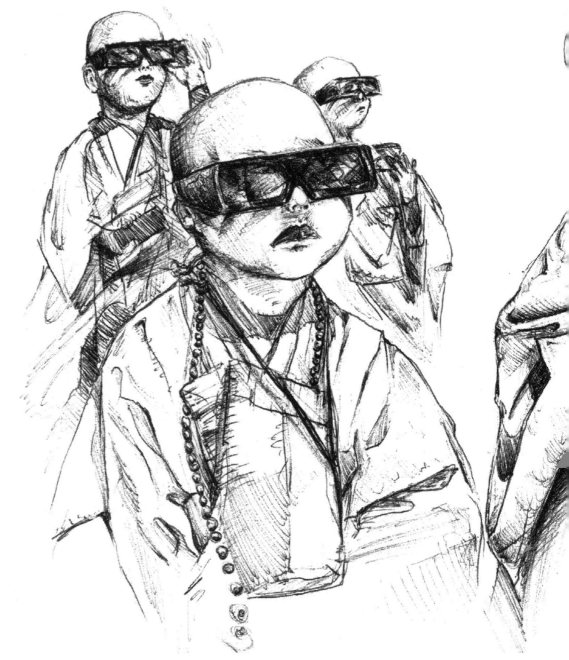

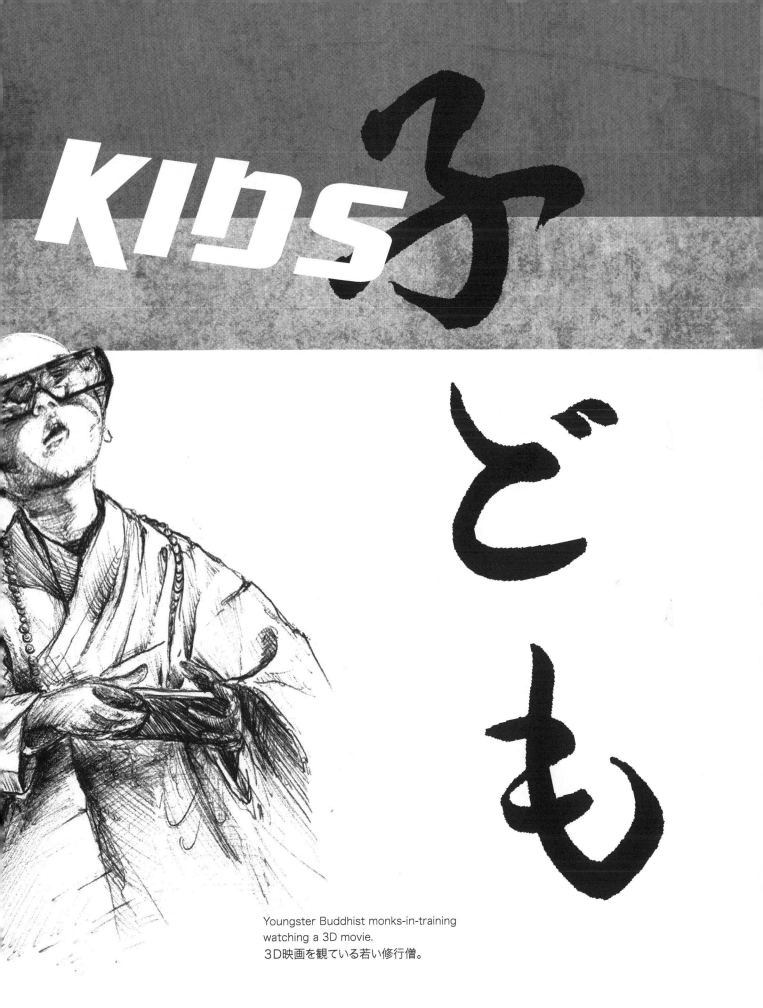

KIDS 子ども

Youngster Buddhist monks-in-training
watching a 3D movie.
3D映画を観ている若い修行僧。

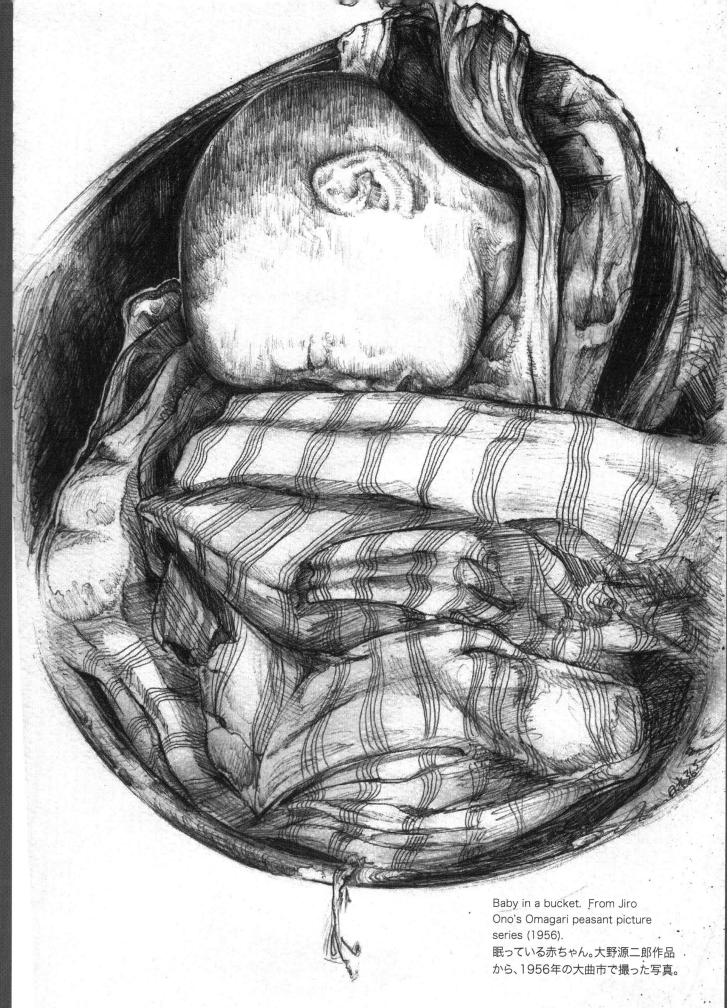

Baby in a bucket. From Jiro
Ono's Omagari peasant picture
series (1956).
眠っている赤ちゃん。大野源二郎作品
から、1956年の大曲市で撮った写真。

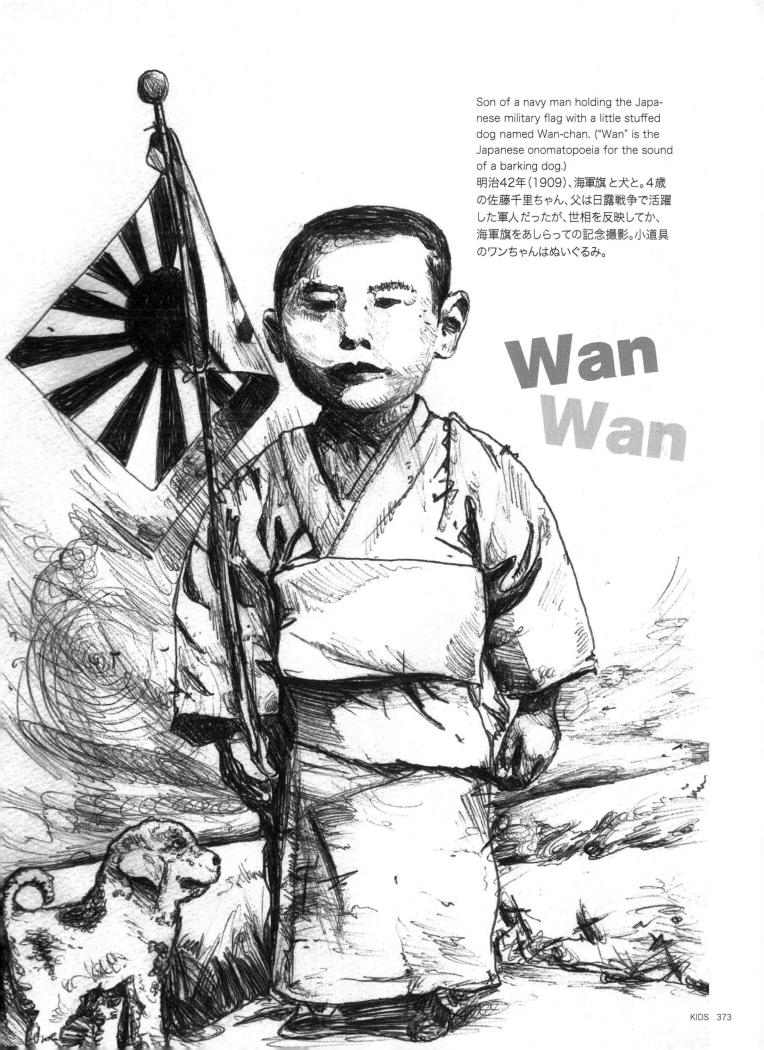

Son of a navy man holding the Japanese military flag with a little stuffed dog named Wan-chan. ("Wan" is the Japanese onomatopoeia for the sound of a barking dog.)
明治42年（1909）、海軍旗 と犬と。4歳の佐藤千里ちゃん、父は日露戦争で活躍した軍人だったが、世相を反映してか、海軍旗をあしらっての記念撮影。小道具のワンちゃんはぬいぐるみ。

Wan
Wan

Child performers from a farm village in Niigata, one doing a sakadachi (handstand) and the other little drummer boy playing shodaiko (a small drum). In the Edo period there were many floods in this area, so villagers often went hungry. Performing like this was a way of life for some children. A man named Kakube forced some children to work in this way and took their earnings; thus the name Kakube-jishi was coined. The kanji for jishi in this instance means lion, taken from the traditional Chinese lion dance performed for special occasions in Japan.

新潟の農村の子供の演技。江戸時代にこの地方に洪水が多くて、飢饉がよくあった。子供たちはこのようにパフォーマンスをしてお金をもうけるのが必要だった。角兵衛という男の人が子供をこのように働かせたことから、角兵衛獅子という名前が出てきた。

A skinhead walking on stilts, or Take-uma (literally "bamboo horse").

竹馬、明治末期。着物に足袋、クリクリ坊主の頭で竹馬に興ずる。ジンバブエの首都ハラレ、M・A・フォーレさん所蔵

Dear J

Manga. This freestyle character was drawn by a very bright and talented junior high school student who wishes to remain anonymous. The young artist was however confident enough to draw this character in my sketchbook, right alongside my other JAPAN 365 ball pen drawings! It is archetypal and indicative of the Manga style, very popular amongst children all over Japan and increasingly throughout the world.
漫画、このキャラクターは大変聡明で才能のある中学生（匿名希望）によって創作され描かれた。この若い芸術家はとても自信に満ちあふれ、その漫画をなんと僕のスケッチブックのJAPAN365ボールペン　ドローイングの隣に描いたのだ！その絵は典型的な漫画を表現しており、漫画の絵は日本の子供たちの間でとても人気が高く、そして今では急速に世界に広がりつつある。

Kids just keeping it real by the rice fields, from another classic photo of rural series (1959) by Iwata Kosuke.
岩田幸助作品、1959年の田舎シリーズにある写真から。田んぼの間に子どもが遊んでいる。

大阪天神祭、日本で二番目に大きな祭。

写真：ジェイムズ・ハート

Little lady, make it rain! Part of Osaka Tenjin Matsuri, the second-largest festival in Japan.

Photo: James Hart

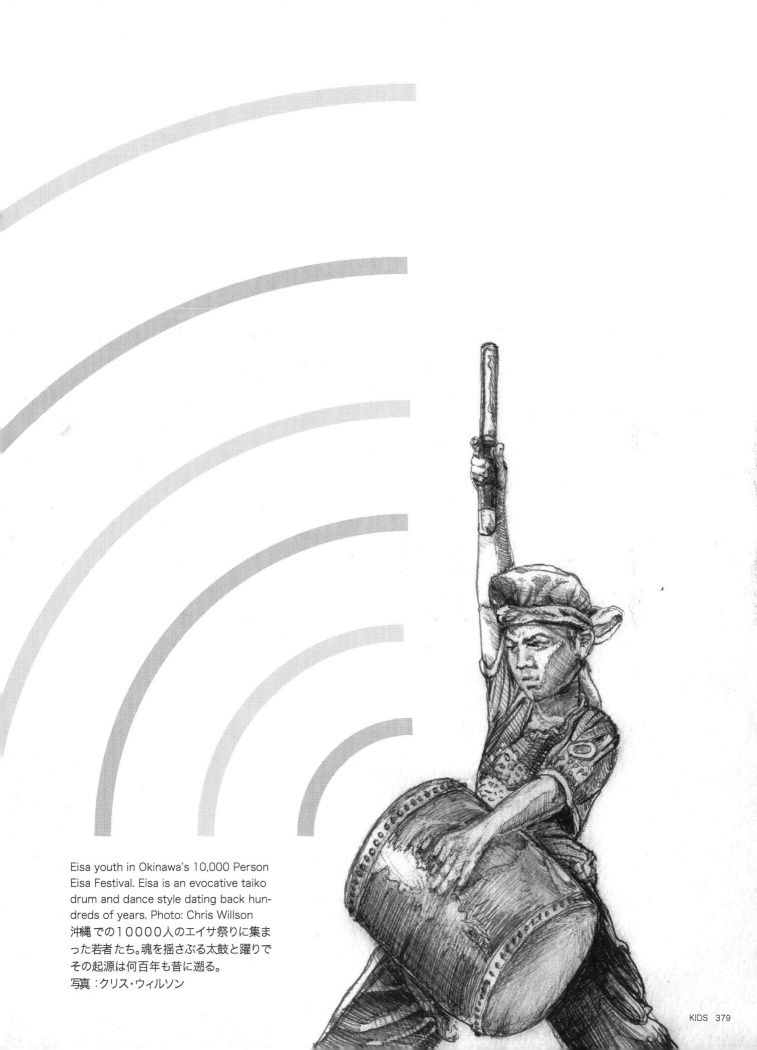

Eisa youth in Okinawa's 10,000 Person Eisa Festival. Eisa is an evocative taiko drum and dance style dating back hundreds of years. Photo: Chris Willson

沖縄での10000人のエイサ祭りに集まった若者たち。魂を揺さぶる太鼓と躍りでその起源は何百年も昔に遡る。
写真：クリス・ウィルソン

Sadako at peace, finally claimed by the leukemia contracted via exposure to radiation after the atomic bomb drop over Hiroshima.

禎子さん、ご冥福をお祈りします。佐々木禎子は広島に落とされた原子爆弾の放射線で白血病にかかって、最後には亡くなりました。

A little girl prays for victims of the atomic bombing in front of a memorial at Hiroshima's Peace Memorial Park, wearing the cutest would-be Couch Surfing cap with the perfect slogan, "Wonderful travel that pursues happiness and peaceful feeling."

広島平和記念公園にて、少女が被爆者に祈りを捧げている。「幸せと平和を追い求める最高の旅」。可愛いカウチ・サーフィングの帽子のスローガンがぴったりだ。

1,000 Cranes For Peace. Sadako was attempting to fold 1,000 cranes because an old Japanese legend says that one will be granted a wish, such as recovery from an illness, if you do so and tie them together with string. The crane is a magical creature in Japanese folklore and is also said to live 1,000 years.

平和のために、禎子さんは千羽鶴を折ろうとしていました。昔の日本の民話では、もし千羽の鶴を折ると、願いが、例えば病気が治るとか、叶うということです。日本の伝説によれば鶴は1000歳まで生きる不思議な生き物だそうです。

A book about Sadako called *Sadako and the Thousand Paper Cranes* states that she only finished 644 and her friends finished the rest after her death and buried them with her. The Hiroshima Peace Memorial Museum says that she finished folding all 1,000 origami cranes before her death. Either way, details aside, an excellent legacy.

「禎子と千羽鶴」という本によると、禎子は644の鶴しか折れなくて、亡くなりました。その後禎子の友達が1000羽まで頑張って折り、千羽が彼女と一緒に埋葬されました。広島平和記念公園によると、1000羽折りきったそうです。

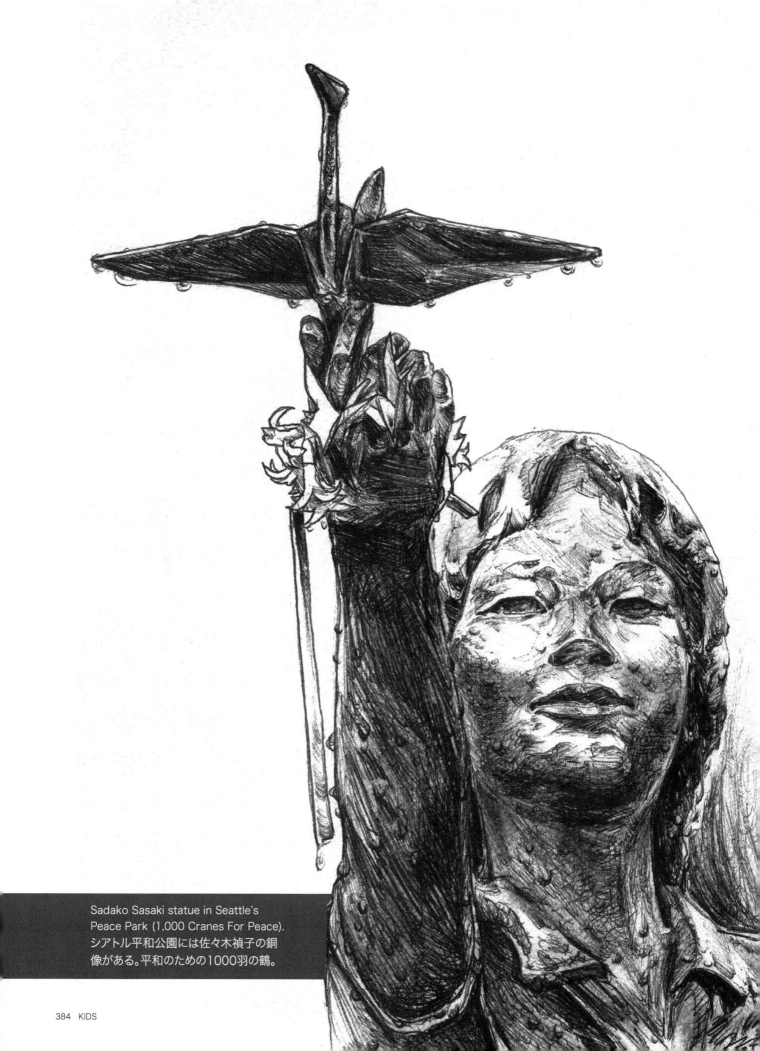

Sadako Sasaki statue in Seattle's
Peace Park (1,000 Cranes For Peace).
シアトル平和公園には佐々木禎子の銅
像がある。平和のための1000羽の鶴。

Tonbo (dragonfly) and a little boy trying in vain to catch one in some lavender fields of Yamanashi near Mt. Fuji. The dragonfly has inspired many artists and poets in Japan and around the world.

とんぼ。富士山の麓の山梨県、あるラベンダー畑でトンボを捕まえ損なったり少年。トンボは日本の歴史においてこれまで多くの画家や俳人、詩人の心にインスピレーションを与え続けてきた。

Togarashi
hane o
tsukereba
akatonbo

Dragonfly
Flying two feet
Then two feet more
-Issa, translated by David G. Lanoue

「唐辛子
羽をつければ赤とんぼ」
芭蕉、訳:パトリシア・ド
ネガン

Tombo ya
ni shaku tonde
wa mata ni shaku

「蜻蛉や
飛んでは又二尺」
一茶、訳:デイビッ
ド・G・ラノー

「とんぼ、柔らかくぼ
んやりとした時間、
異国の地で」
リック・ダッダリオ

the dragonfly
etching circles
in the air
never asks itself
why do I write
-Melissa Allen

「とんぼは宙に円を描いて
いる自分に問いかけたこ
とはあるのだろうかなぜ
描いているのか」
メリッサ・アレン

Red pepper
Put wings on it
Red dragonfly
-Matsuo Basho, translated by Patricia Donegan

Dragonflies
The soft blur of time
In another land
-Rick Daddario

"Oh, Catch it!"
"I heard they eat their own tails."
When I was a child, living on an air force base in Okinawa, it was a common belief, among the elementary school set, a dragonfly would eat itself if you caught it and fed it its own tail. I looked online and didn't find any references to this notion, so maybe we were all sniffing the good Japanese glue. Anyhow, even though we constantly snagged lizards and grasshoppers and cicadas, I never saw anyone ever catch a dragonfly, as common as they were."
-Steve Mitchell

「あ、捕まえて!」

「トンボって自分のしっぽを食べるらしいよ。」トンボが子供のころ、小学生の間では、トンボは捕まえると自分のしっぽを食べてしまうと信じられていた。
インターネットで調べてみたのだが、それに関連するような文献は見当たらなかった。もしかしたら、僕たちは日本の接着剤でも吸って頭がラリッていたのだろうか。とにかく、しょっちゅう僕たちはトカゲやバッタやセミは捕まえて遊んでいたけど、トンボだけは、至るところにいたのにもかかわらず、誰かが捕まえたところを僕は一度も見たことがないまだにない。
スティーブ・ミッチェル

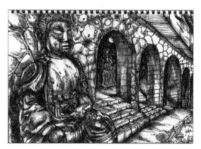
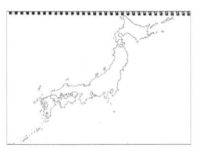

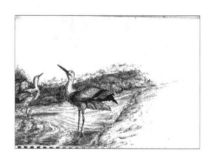
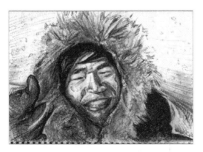

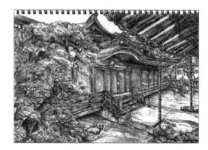
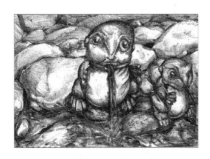
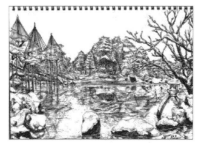
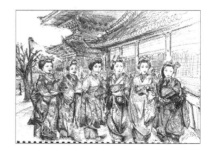

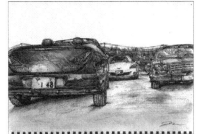

FEBRUARY

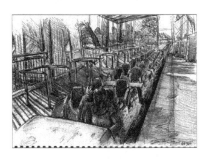
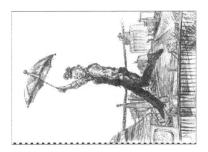

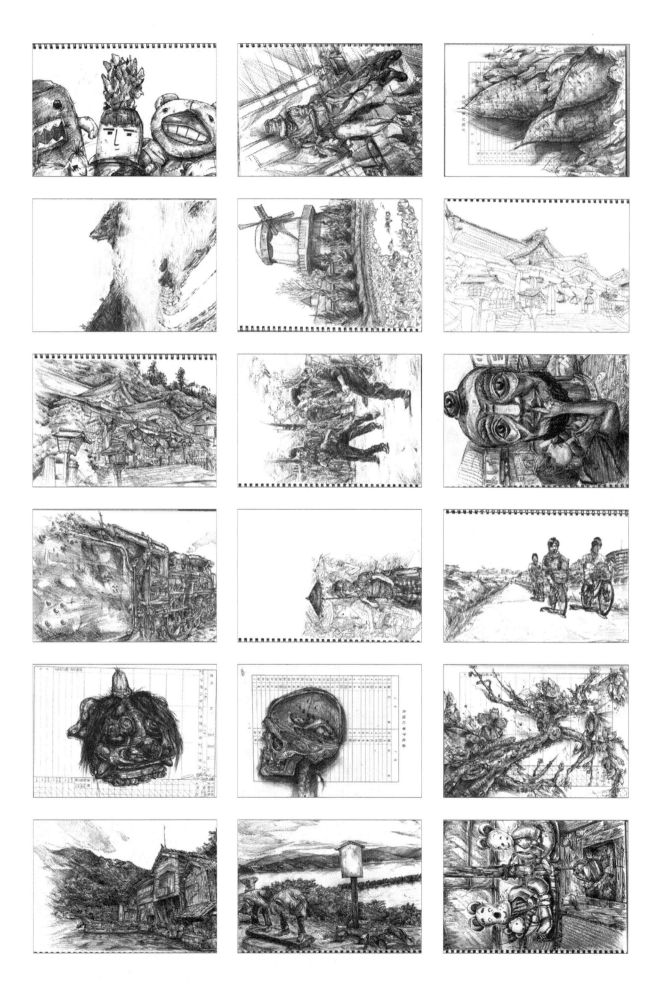

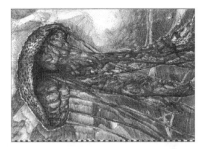

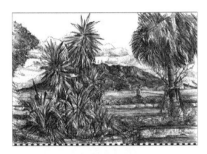

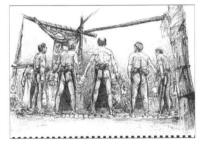

MARCH

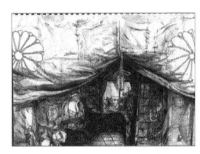

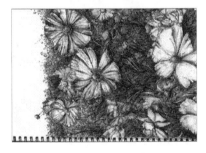

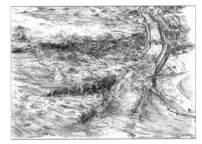

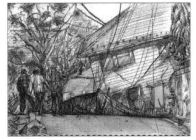

APRIL

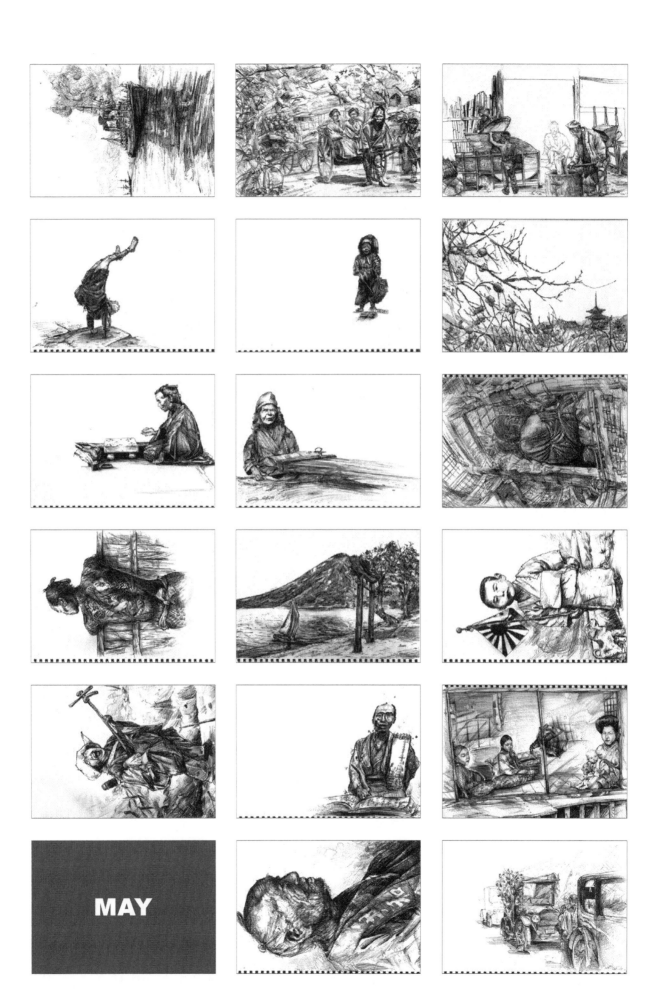

MAY

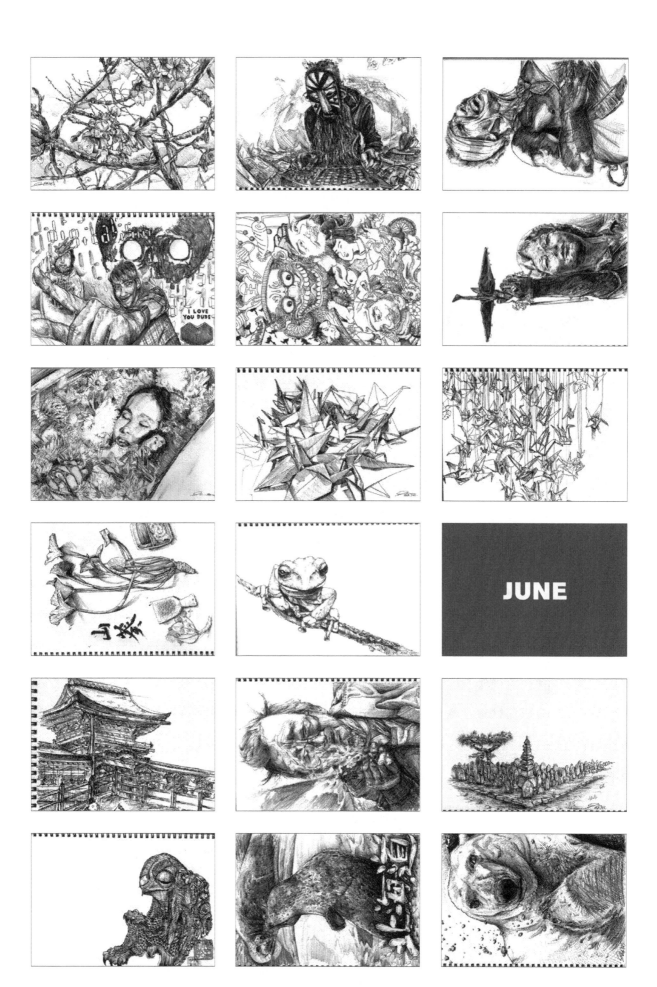

JUNE

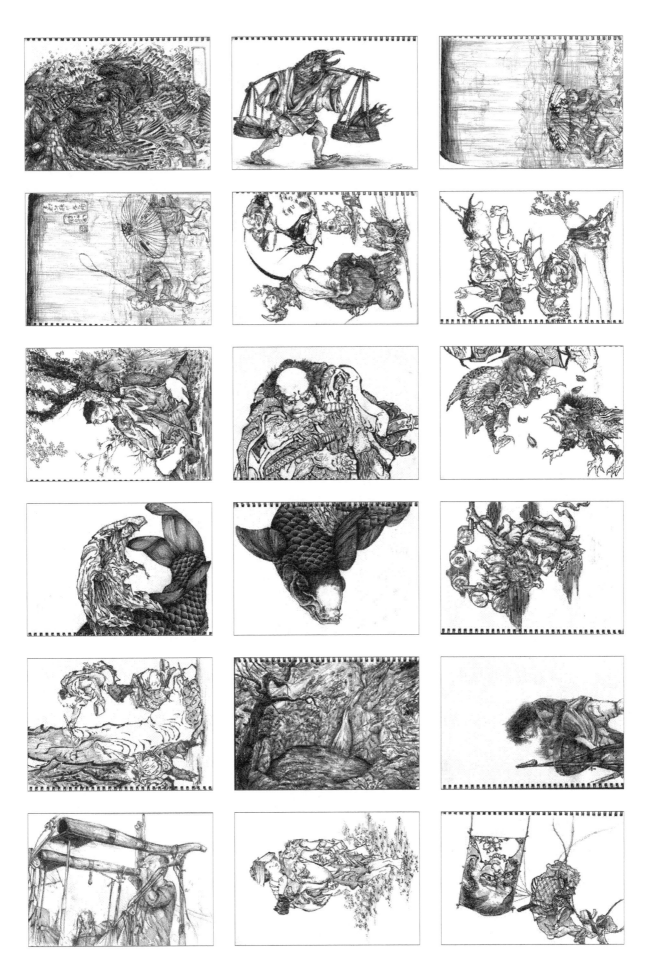

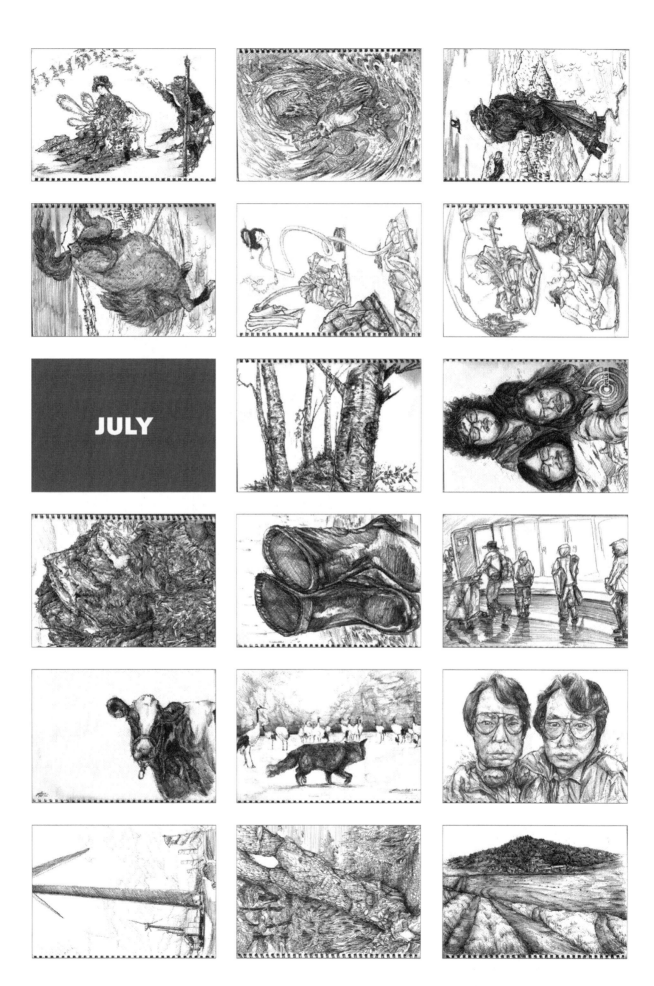

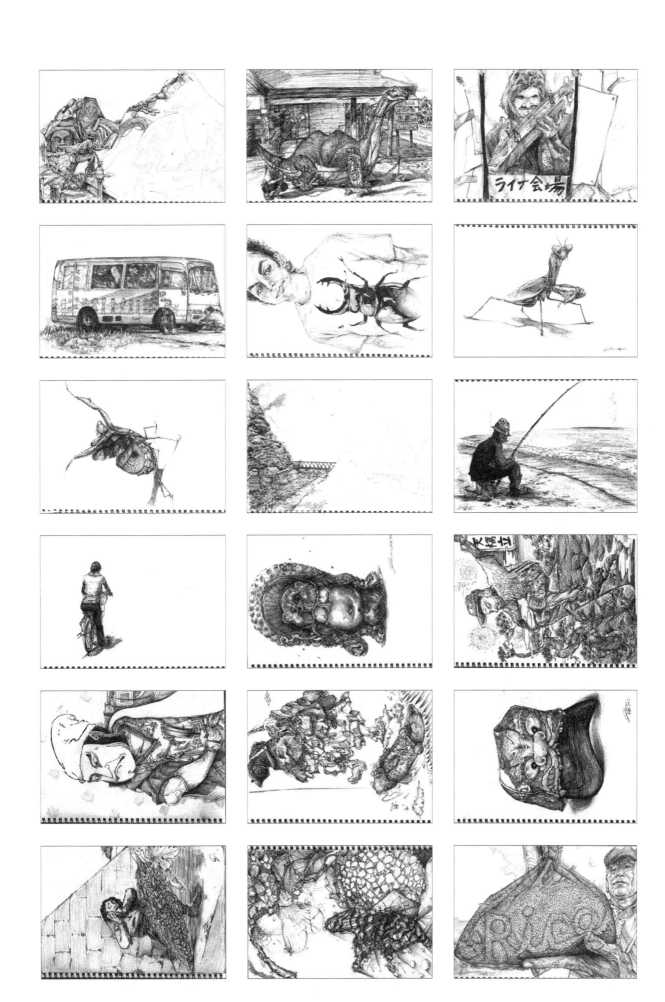

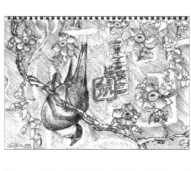

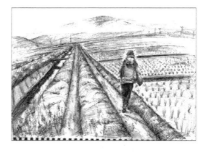

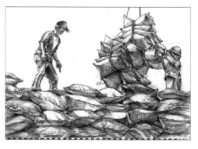

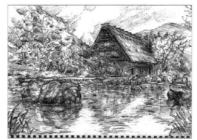

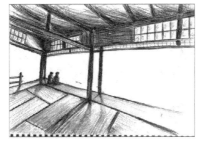

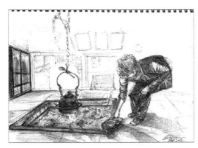

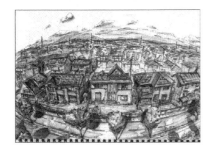
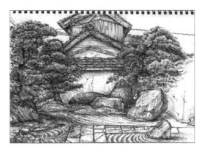
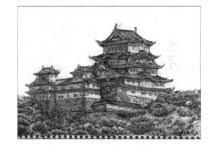

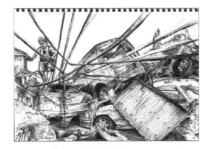

SEPTEMBER

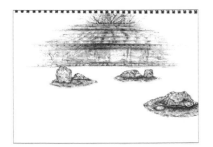

OCTOBER

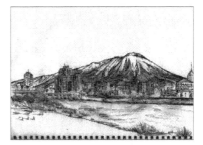

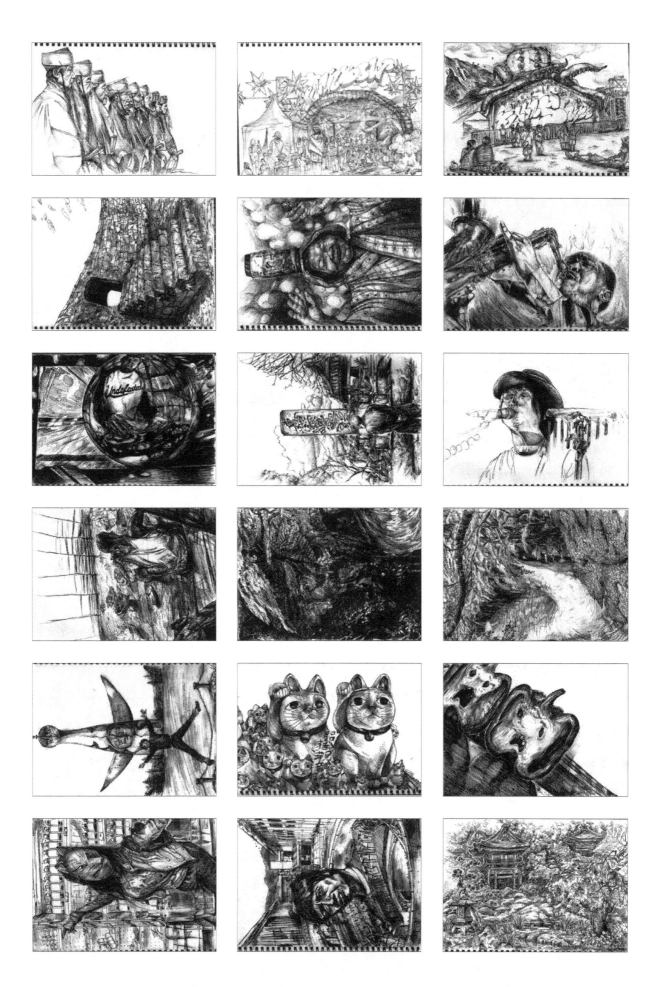

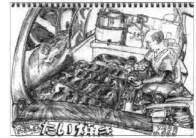
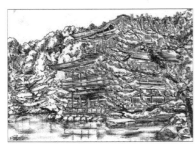

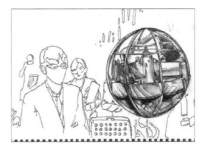

NOVEMBER

DECEMBER

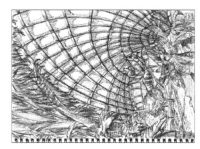

405

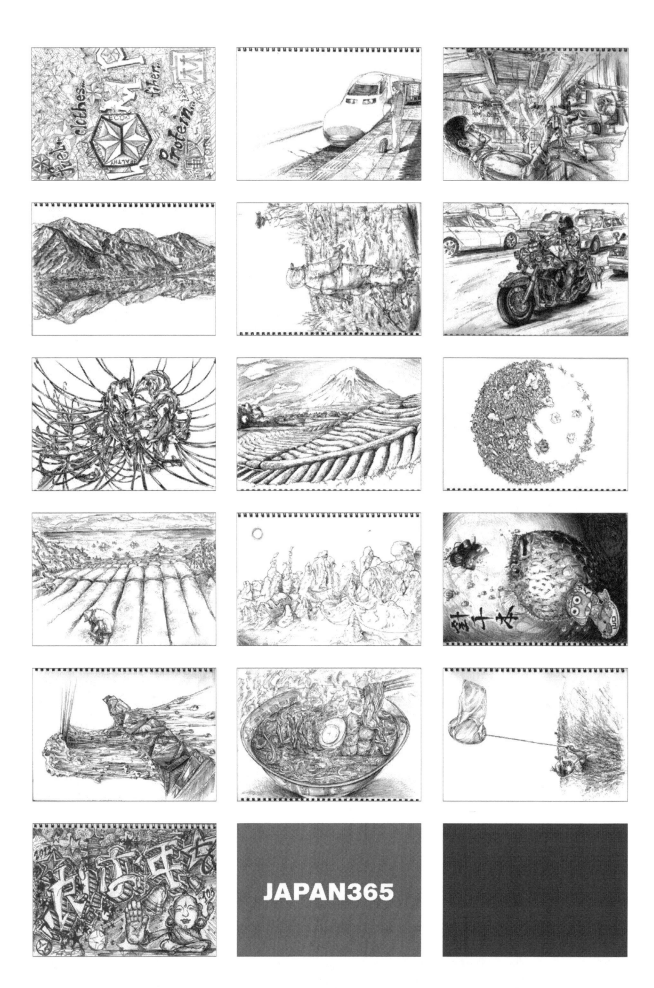

JAPAN365

エンドロール
「コラボ達人」

中村恵美子（Emiko Nakamura）
上野文彦（Fumihiko Ueno）
吉田岳とキキ（Kiki & Takeshi Yoshida）
廣野 弘子 (Hiroko Hirono)
花房 浩一（Koichi Hanafusa）
奥山晃次(Koji Okayama)
高田優希(Yuki Takata)
山科紀代美 (Kiyomi Yamashina) <oo.u.u.oo777@gmail.com>
Greg Ferguson <http://www.flickr.com/photos/fesapo/>
Chris Willson (クリス・ウイルソン) <www.TRAVEL67.com>
Brynmor & Liz Thomas （トーマス・ブリンモアとリズ）
Penny Cameron (キャメロン・ペニー)
David A. LaSpina <www.japandave.com>
Adam Fore （アダム・フォー）
Eby Harvey (イビ・ハビ) <www.ebyphoto.com>
Don Wolf <http://don-wolf.artistwebsites.com/>
James M. Hart <www.harteikaiwa.com>
Amber Hill <amberhill423@gmail.com>
Melissa Allen <http://haikuproject.wordpress.com/>
Rick Daddario <http://rickdaddario.com/>
Arien Muzacz <arien@myLMHC.com>
Julen Esteban-Pretel
Charles Bersola
Jimmie & George Saito
Reed Hauser
Meredith Felton
Matthew Little
Roy Toft
ChenRu Zheng <http://chenru.tumblr.com>

「古い写真」館朝日新聞社1986年日本

「美しい日本の風景1000」日系ナショナル
ジオグラフィック社2011年
97ページ　461番　「団塊登山」　田村
主
91ページ　414番　「ラベンダー」　植村
正春

「海のシルクロードを求めて」　三菱広報委
員会1989年東京都
89ページ元染付双龍扁壺（出光美術館蔵）

Kenneth Clark & Carlo Pedretti, The
Drawings of Leonardo da Vinci in the
Collection of Her Majesty the Queen
at Windsor Castle. Giunti Editore
S.p.A. Italy. 1998.

「レオナルド・ダ・ヴィンチ解剖図」　Giunti
Editore S.p.A. Italy 1998
18ページ　「魂の座」　1489年頃

Basho, Matsuo. Trans. by Patricia
Donegan.

Chiba, Reiko. "The Seven Lucky Gods
of Japan." Charles E. Tuttle Co., Inc.
1966. Rutland, Vermont and Tokyo,
Japan. P. 33.

Craft, Lucille. "Japan's Nuclear
Refugees." Photographs by David
Guttenfelder. P. 100-101. National
Geographic. Dec. 2011.

Death By Hanging 2 (Koshikei). Dir.
Nagisa Oshima. Film. 1968.

"Flag of Japan." Wikipedia. Oct. 2011.
<http://en.wikipedia.org/wiki/Hino-
maru>

Genjiro, Oono. Oono Genjiro Work
Collection. Omagari City, Akita Pre-
fecture. 1952-1956. <http://www.
akita-gt.org>

Gihinari, Sakuragawa. "Actor Ichikawa
Danjurou II as Uirouri Shikishi-ban."
1818-1830.

Goya, Francisco Jose de. "Tantalo."
Print. 1799.

Granlund, Paul T. "Constellation
Earth." Nagasaki Peace Park. 1992.

Hokusai, Katsushika. "Hokusai Manga
Vol. 3. - Fanciful, Mythical and Super-
natural." Seigensha Art Publishing,
Inc. Japan. 2011.

「北斎漫画奇想天外第3巻」2011株式会
社青幻舎

Hokusai, Katsushika. "Goldfinch and
Cherry Tree." Print. 1834.

Hokusai, Katsushika. "The Great Wave
off Kanagawa." Thirty-six Views of
Mount Fuji. Print. 1830.

Isozaki, Arata. "Art Tower Mito." Mito
City, Ibaraki Prefecture. 1990.

Issa, Kobayashi. Trans. by David G.
Lanoue.

Issa, Kobayashi. Trans. Matthew Little.

Iwata, Kosuke. "Village Child." Work
Collection of Kosuke Iwata. Akita
Prefecture. 1959.

Japanese Tea Garden San Francisco's
"About Us" page. Dec. 2011. <www.
Japaneseteagardensf.com>

Jim Breen's WWWJDIC. Monash Uni-
versity. <www.jisho.org>

Kuniyoshi, Utagawa. "Warrior Rouri
Hakuchou Choujun." Print.1828.

Kurohito, Takechi. Excerpt from Vol. 3
of Okimi Nukata's "Collection of Ten
Thousand Leaves" (Manyoshu). 759
AD.

Kusama, Yayoi. "Pumpkin." Naoshima.
2006.
Kyousai, Kawanabe. Print. 1882.

Masterpieces of Ukiyo-e Collection
from the Museum Fur Kunst Und
Gewerbe Hamburg. Kyoto. 2011.
Catalogue. Nikkei, Inc. 2010.

「ハンブルク浮世絵コレクション展」
Nikkei Inc. 2010年

Meyer, Matthew. "Gashadokuro."
The Night Parade of One Hundred
Demons. 2012.

"Nezumi no Yomeiri" (The Mouse's
Wedding). Trans. David Thomson.
Takejiro Hasegawa published under
Kobunsha imprint. 1885.

Okamoto, Taro. "Tower of the Sun."
Expo Memorial Park. Osaka. 1970.

Smith, Daryl. "Sadako." Seattle Peace
Park. 1990.

GLOSSARY

–chan – a suffix attached to young children (esp. girls), small animals, characters, etc.

–kun – a suffix attached to children (usually male)

–sama – honorific suffix attached to people of high status or as in the case of "Mr." or "Mrs.;" also used to make words more polite

–san – a polite suffix attached, akin to "Mr.-" or "Ms.-" used in professional settings in English–speaking countries

–sensei – (lit. master) a suffix attached to teachers, doctors and anyone generally considered a "master" of their craft or trade

Ainu – (lit. "human") indigenous people of Japan and Russia, historically living in Hokkaido, though desperately close to extinction, and plagued with alcoholism, homelessness and violence, akin to Native Americans' plight in North America

Ajisai – hydrangea flowers

Amaterasu – Sun goddess, responsible for the creation of the universe (also Amaterasu Oomikami), the emperor of Japan is said to be a direct descendant of Amaterasu

Azuki (adzuki) – reddish brown beans, sweetened and served as zenzai or in anpan (sweet bean-filled bread)

Bento – Japanese lunch box

Bijin – beauty, lit. beautiful person, referring to a woman

Bonsai – an ancient and patient Japanese art form/meditation growing and grooming miniature trees in containers (lit. bon - "tray" and sai - "planting")

Bonsho – the Buddhist temple bell

Cha – tea (or "o-cha" which refers generally to any type of green tea)

Chonmage – topknot hairstyle

Daikon – variety of large white Oriental radish

Diet – Japan's National Parliament

Eisa – a folk dance style unique to the people of the Ryukyu Islands that involves singing, chanting, drumming and playing a sanshin – an instrument likened to a banjo in that it was a precursor to the shamisen (Japanese 3-stringed guitar)

Fugu – puffer fish, globe fish, blow fish, swell fish

Fune – boat

Furusato – lit. one's hometown or birth place, though recently there is an added nuance of nostalgia and wanting to return to "the good old days" as it were associated with the term

Genbaku – Atomic bomb

Genki – lit. vitality, vigor, robust, healthy, stamina, spirit, courage and pep; though referring colloquially to well-being, health, energy, etc.

Geta – Japanese wooden sandals or clogs

Goma – sesame

Goya – the Okinawan name for bitter melon

Gyoza – crescent–shaped Chinese-style pan-fried dumplings stuffed with minced pork and vegetables

Hachi-sen-bon – balloon fish, porcupine fish (lit. 1,000 thorns)

Hafu – a modern term used to define mixed race Japanese people living in Japan

Hakama – male clothing consisting of a formal, divided skirt

Hanga – Japanese–style woodblock printing famous in artworks of the ukiyo–e style from the Edo period (1603–1867), but also used to print books

Hanko – a kanji character stamp design carved out of wood, stone or rubber and used in place of a signature

Harajuku – (lit. "meadow lodging") an area of Tokyo with a large shopping district and world renowned for its many purveyors of wild and crazy fashion

Hashi – bridge; or chopsticks (sometimes O-hashi)

Hataya-san – a weaver who tends to make kimono fabric

Hi no maru – (lit. outline of the sun) referring to the Japanese flag – white background with a big red circle in the center (Hi no maru bento thus refers to a Japanese lunch box including a portion of white rice with a reddish pickled plum plopped in the center)

Hyaku Monogatari – (lit. One-Hundred Tales) referring to Katsushika Hokusai's rare and intriguing series of 100 prints about ghost stories and other related fantastic themes

Ika – squid or cuttlefish

Ineki – traditional hand-made drying racks for rice farmers made of long thick bamboo

Irori – traditional Japanese fireplace, a depression or hole in the middle of a room

Iruka – dolphin

Iyezumi (or irezumi) – tattoo

Jidouhanbaiki – vending machine

Jinja or Jingu – Shinto shrine or Imperial Shinto shrine

Jishin – earthquake

Jitensha – bicycle (roughly translated, lit. "Self-moving vehicle")

Kabu – turnip

Kabuto mushi – Japanese horned rhinoceros beetle (lit. "helmet bug")

Kaeru – frog

Kaki – Japanese persimmon; oyster

Kakube-jishi – child performers of the Edo period who were forced to work for meager wages and then hand over their earnings to a

Kamakiri – praying mantis

Kani – crab

Kanji – referring to the characters borrowed from Chinese (hanzi) forming the basis of written Japanese, in coordination with hiragana and katakana

Kansai – the south-central region of Honshu comprised of Mie, Nara, Osaka, Wakayama, Kyoto, Hyogo and Shiga Prefec-

tures

Kappa – mythical water-dwelling creature

Karesansui – traditional Japanese (or Chinese) dry rock garden

Karin – quince (a fruit-bearing deciduous tree whose fruit is related to apples and pears, often used to make marmalade)

Keitai – cellular phone

Kimono – lit. "thing worn," though referring to the traditional Japanese clothing style

Kitsune – fox; also a type of udon with fried tofu on top

Koen – park

Koi – (also nishigikoi, brocaded carp) any variety of ornamental carp kept in ponds or water gardens, also symbols of affection, love and friendship

Kome – rice (lit. referring to the husked grains of rice)

Konbini – convenience store

Koto – large 13-stringed Japanese instrument played on the floor

Kurage – jellyfish

Kuri – Japanese chestnut

Maiko – an apprentice geisha or dancing girl

Mame – legume, beans, peas, soya beans, etc.

Manga – Japanese cartoon or comic

Manyoshu – the oldest collection of Japanese poetry circa 759 AD

Matcha – strong, bitter and frothy type of green tea usually served during tea ceremony

Matsu – pine tree

Matsuri – festival

Megane – glasses

Misaki – cape

Miso – fermented bean, rice or barley paste made with salt and the bacteria kojikin (Aspergillus oryzae), the same bacteria used to make sake (an alcoholic drink often referred to as "rice wine" though made by a process more closely resembling that of beer); miso is a staple in the Japanese diet and many people still eat it as soup with rice and fish for breakfast

Mochi – glutinous rice pounded to make a sticky rice cake

Momiji – Japanese Maple (also referring to the general color change occurring on the foliage of deciduous trees in autumn; Japanese tend to revere this season much like the sakura cherry blossom viewing in spring)

Mottainai – impious; profane; sacrilegious; too good; more than one deserves; unworthy of; wasteful. A term used liberally, referring now to not wasting (resources, food, time, energy, etc.)

Mukade – centipede

Namahage – folklore demons of the Oga Peninsula in Akita Prefecture

Natto – soybeans fermented with Bacillus subtilus, creating a sticky food rich in protein and a staple of traditional Japanese breakfast

Negi – leeks (also known as Welsh onion, spring onion, scallion, etc.)

Neko – cat

Nengajo – postcards sent/received on New Year's Day

Nezumi – rat or mouse

Ninjin – carrot

Noren – short sign curtain hung at a shop entrance

Nori – edible seaweed, dried and pressed into sheets, used to make maki-zushi (roll sushi)

Obon – Buddhist Festival of the Dead

Oden – various ingredients such as egg, daikon or konnyaku stewed in soy-flavored dashi, and served at most convenience stores all winter

Odori – dance

Ongaku – music

Oni – demon, ogre, spirit of the deceased; also whomever is "it" in a game of tag

Onigiri – rice balls, often filled with plum, seaweed or fish and wrapped in nori

Onsen – geo-thermally heated hot spring, usually developed as a public relaxation area or part of a ryokan (guesthouse) or resort

Origami – traditional Japanese art of paper folding (lit. ori - "folding" and kami - "paper")

Oshieru – (v.) to teach, to inform, to instruct

Pagoda – referring to the tiered architectural style of structures usually associated with Buddhist temples or sacred sites found throughout East and Southeast Asia

Piman – green pepper

Raijin – god of thunder

Rakugaki – graffiti (lit. scrawl or scribble)

Ramen – Japanese noodle dish, served with Chinese-style wheat noodles and soup made with varied meat or fish broths and topped with chopped leeks, sliced pork, fish cakes, etc.

Rangaku – studies of Western knowledge (lit. Dutch studies)

Rei or O-rei – lit. to bow, in order to show respect, gratitude, appreciation, apology, etc. with many subtle cultural nuances affecting timing and degree of bow depth

Ringo – apple

Rokurokubi – a long-necked character in Japanese folklore, usually a woman

Ryu or tatsu – dragon

Sadou – the art of serving tea (lit. the "Way of Tea"), also refers to the tea ceremony

Sakadachi – hand stand

Sakoku – exclusion of foreigners, referring to Japan's period of national isolation

Sakura – Cherry blossoms

Samurai – warrior; especially those military retainers of the daimyo in the Edo period

Saru – monkey

Sashimi – raw sliced fish, shellfish or crustaceans, served with soy sauce and wasabi

Setsubun – the changing of the seasons, also equinox; though usually referring to the spring equinox holiday based on the lunar calendar occurring early February (around the 3rd or 4th) when houses should dispel demons by throwing soybeans at their doors proclaiming "Oni wa soto! Fuku wa uchi!" or "Demons go out! Good fortune, come in!"

Shachihoko – fish-bodied tiger-headed ornamental roof sculptures said to protect the building from fire

Shamisen – three-stringed Japanese guitar

Shichifukujin – the seven deities of good luck

Shika – deer

Shinjuku – one of 23 special wards of Tokyo that is a major commercial and administrative district, hosting the Tokyo Metropolitan Government building and the busiest train station in the world – Shinjuku Station

Shinkansen – Japanese bullet train

Shinto – the indigenous spirituality of Japan and the Japanese people, connected the past with the present, humans and spirits with the forces of nature, respected and honored through rituals at shrines called Jinja or Jingu (an Imperial Shinto shrine)

Shogun – general (as in leader)

Shoro – belfry or bell tower (of a Buddhist temple) which houses the bonsho

Shoyu – soy sauce

Soba – lit. buckwheat, though simply refers to Japanese buckwheat noodles

Soka Gakkai – worldwide Buddhist network which promotes peace, culture and education through personal transformation and social contribution

Sugi – Cedar tree

Suiboku-ga – watery India ink-painting

Sumi-e – ink-painting style

Sumo – sumo wrestling

Sushi – anything made with vinegared rice

Tai – seabream, Chiba's prefectural fish

Tai yaki – fish--haped pancake filled with bean jam

Taiko – drum (though there are various kinds of taiko drums, this term alone generally refers to the large traditional Japanese drum)

Take – bamboo

Taki – waterfall

Tako – octopus

Tamanegi – onion

Tamatebako – a box that contains magic powers

Tanuki – raccoon dog (Nyctereutes procyonoides), also refers to a mythical shape-shifting creature with huge testicles which brings good luck, wealth and prosperity, and can be found wearing a straw hat, holding a promissory note and bottle of sake in front of many houses, restaurants and other businesses throughout Japan

Tatami – traditional Japanese straw floor coverings

Tera or Ji – Buddhist temple

Tonbo – dragonfly

Torii – gate at the entrance of a shrine symbolizing the portal to a spiritual realm

Tsunami – tidal wave

Tsuru – crane

Tsuyu – rainy season in Japan occurring in early summer

Typhoon – storm or hurricane

Udon – thick white wheat-flour noodles usually served in a soup (ie Kitsune Udon)

Ukiyo-e – lit. "A color print of everyday life in the Edo period," though has since come to define that archetypal Japanese style of artwork

Uma – horse

Ume – Japanese apricot; Chinese plum

Urashima Tarou – a legend about a fisherman named Tarou who rescues a turtle and the ensuing adventure the turtle takes him on far beneath the sea

Ushi – cattle, cow, ox, oxen

Wakame – species of edible seaweed that is usually brown or dark green, thick and commonly used to make vegetarian soup stock as part of the Buddhist monks restricted dietary guidelines called shoujin ryouri

Wasabi – Japanese horseradish, the root of which is ground to produce a uniquely spicy condiment, with a flavor much like mustard

Yane – roof

Yosakoi – a colorful synchronized dance style originating in 1950s Kochi Prefecture

Yu or o-yu – hot water

Zen – a form of Buddhism involving profound meditation

Zenzai – sweet red bean soup made with Azuki beans and usually including a big, soft mochi rice cake, consumed plentifully in winter and during New Year's celebrations

INDEX

Made in the USA
Charleston, SC
27 May 2012